The Empire of the Eye

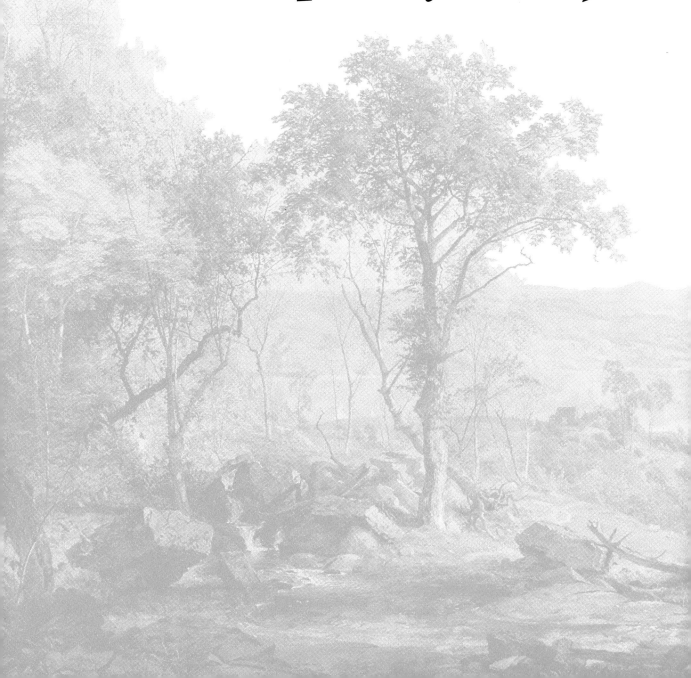

The Empire of the Eye

*Landscape Representation
and American Cultural Politics,
1825–1875*

Angela Miller

CORNELL UNIVERSITY PRESS
Ithaca and London

Published with the assistance of the Getty Grant Program.

First published 1993 by Cornell University Press.

Printed in the United States of America

♾ The paper in this book meets the minimum requirements
of the American National Standard for Information Sciences—
Permanence of Paper for Printed Library Materials, ANSI Z39.48-1984.

Library of Congress Cataloging-in-Publication Data

Miller, Angela L.
 The empire of the eye : landscape representation and American cultural politics, 1825–1875 / Angela Miller.
 p. cm.
 Includes bibliographical references.
 ISBN 0-8014-2830-0
 1. Landscape painting, American. 2. Landscape painting—19th century—United States. 3. Nationalism and art—United States. 4. United States in art. I. Title.
ND1351.5.M53 1993
758'.173'097309034—dc20 92-37226

Title page: Jasper Cropsey, *Indian Summer,* 1866. © The Detroit Institute of Arts, Founders Society Purchase, Robert H. Tannahill Foundation Fund, James and Florence Beresford Fund, Gibbs-Williams Fund, and Beatrice W. Rogers Fund.

Contents

Illustrations

Acknowledgments

I owe professional and personal debts to those people without whose intellectual guidance and exchange, material assistance, and moral support this book could not have been completed. Jules Prown taught me a great deal about how to write and argue; he was both a taskmaster and a mentor whose encouragement of my often unformed ideas helped me through the difficult early stages of my research. He also pointed me in the direction of my current scholarship: to illuminate linkages between form and cultural content in works of art and material culture. David Brion Davis introduced me to both the intellectual rigors and the power of cultural history. Bryan Jay Wolf broadened my awareness of interpretive possibilities in American painting. Michael Smith taught me much about intellectual clarity and honesty which has served me well in work and life.

I received invaluable research support in the initial stages from the Smithsonian Institution and the Woodrow Wilson National Fellowship Foundation (Charlotte Newcombe Fellowship). For my time at the Smithsonian I thank Lois Fink, Lillian Miller, and William Truettner, all of whom contributed, then as now, to a nurturing and stimulating atmosphere for young scholars.

Throughout the long subsequent expansion of my research and ideas several institutions and friendships were of key importance: Washington University, for a summer research grant; the Department of Art History and Archaeology, for a critical leave year; Stanford University, in particular Sonia Moss of Green Library, and Lorenz Eitner and Alex Ross of the Stanford Art Department and Art Library; Margaretta Lovell and the University of California (Berkeley) Americanist Reading Group; Jonathan Harding of the Century Association, New York City; Jim Tottis and Kathleen Erwin of the Detroit Institute of Arts; the Library of Congress and the New York Public Library; the Archives of American Art, in particular Garnett McCoy and Paul Karlstrom; the staff of the Inventory of American Paintings; Cecelia Chin, Librarian of the National Museum of American Art; and Marguerite Lavin of the Museum of the City of New York.

Among those who have generously shared their work and ideas with me or read and commented on drafts of the book are Sarah Burns, Kathleen Diffley, Dana Frank, Vivien Green Fryd, Robert Jensen, Elizabeth Johns, Frank Kelly, Mark Kornbluh, Katherine Manthorne, Amy and Jack Meyers, Alex Nemerov, Susan

Rather, Laura Rigal, Elizabeth Roark, William Wallace, Alan Wallach, and Sherry Wellman. I owe special thanks to Ken Myers and David Lubin, for their painstaking criticism and detailed evaluation of the manuscript in its final stages; Jay Fliegelman, for his creative responses to my work and for challenging me in ways both unsettling and renewing; David Miller, whose own work on landscape, intellectual mentorship, and brotherly support have been central to my life as a scholar; and my editors at Cornell, Bernhard Kendler and Carol Betsch, for their patience, support, and meticulous attention to every stage in the production of this book. I also thank my New Mexico family, Dwight and Mary, for restorative visits, which have reminded me that landscape is ultimately about love of place.

Finally, this book is dedicated to my parents, whose love and constant support of my various enterprises have sustained me through it all.

A. M.

The Empire of the Eye

Take the shortest way round and stay at home. A man dwells in his native valley like a corolla in its calyx, like an acorn in its cup. Here, *of course, is all that you love, all that you expect, all that you are.* Here is your bride elect, *as close to you as she can be got.* Here is all the best and all the worst you can imagine. *What more do you want? Bear hereaway then! Foolish people imagine that what they imagine is somewhere else. That stuff is not made in any factory but their own.*

—Thoreau, *Journal,* November 1, 1858

Introduction

I've always liked Hudson River paintings. I guess that's
because I basically have pretty conservative tastes.
 —Elderly man, Fall 1991

In the decades between 1825—the beginning of Thomas Cole's rise to prominence—
and the 1870s, when the landscape genre declined as a major expression of collective
identity, images of the American landscape carried a new weight of national
meaning for contemporary audiences.[1] This growing burden of significance ac-
counts for the urgency with which artists, critics, and audiences embraced the genre
and wrestled with the formal and representational issues it raised. They invented
new forms and adapted older conventions in their efforts to broaden and deepen its
expressive possibilities.[2] An early historian of American art, H. W. French, felt
compelled to remind his readers: "It should not argue against the skill and rank of
an artist in America, though it often is thoughtlessly allowed to, that he is not a
landscape-painter, simply because that is the prevailing fashion of the day."[3] My

1. These are also the dates of Barbara Novak's major study *Nature and Culture: American Landscape
Painting, 1825–1875* (New York: Oxford University Press, 1980). While I accept the significance of these
dates, I am more wary of using the inclusive term "American" in describing paintings whose
production, patronage, and exhibition structure is so regionally focused in the Northeast. My
emphasis, accordingly, is on the latter term.

2. I am surely not the first to focus on the symbolic and expressive dimensions of landscape art in
the mid-nineteenth century. Most recently Franklin Kelly, *Frederic Edwin Church and the National
Landscape* (Washington, D.C.: Smithsonian Institution Press, 1988), has gone beyond iconography in
exploring the narrative and symbolic programs of Church's self-consciously national imagery. Al-
though I am indebted to Kelly, the concept of the national landscape is for me inherently problematic;
accordingly, programmatic claims are my point of departure rather than my primary explanatory
model.

3. H. W. French, *Art and Artists in Connecticut* (1879), p. 27.

book attempts to explain not only why landscape painting held such a key place in American art but, more precisely, what its role was in the formation of cultural identity.

Until recently, accounts of landscape art have emphasized its relationship to concepts of nature, programmatic expressions of national identity, Emersonian concepts of self and oversoul. Such an emphasis regards painting as a reflection of ideas, which themselves remain the primary expression of culture.[4] While this intellectual content, along with iconography, has occupied much scholarly attention, it is in the dilemmas of representation itself that landscape painting reveals its deepest, most submerged concerns—concerns that parallel the central dilemmas of nation building. Artists, critics, and audiences explored issues of national identity in displaced fashion, through the symbolic content of form and composition, through arguments about what to represent, and through the recurrent issue of the relationship between part and whole.

Not only has the scholarship on the genre neglected its social and political content, but it has also accepted as unproblematic the association between landscape and nationalism so often drawn by nationalist critics from the mid-nineteenth century on.[5] The central explanatory model has been the symbolic and iconographic program of a painting—its own explicit self-presentation—as the ultimate measure of its cultural significance. Yet program is only one dimension of a painting's meaning. Stopping at this level is tantamount to relying exclusively on the artist's and his contemporaries' words to assess the significance of his work.

Chief among the concerns of those who wrote about American landscape in the

4. For a critique of the so-called American Mind paradigm, see Elizabeth Johns, review of Barbara Novak, *Nature and Culture*, in *Art Journal* 41 (Spring 1981): 85–89.

5. Attention to such content in landscape representation is already well established in British scholarship: see John Barrell, *The Idea of Landscape and the Sense of Place, 1730–1840* (Cambridge: Cambridge University Press, 1972); Barrell, *The Dark Side of the Landscape: The Rural Poor in English Landscape, 1730–1840* (Cambridge: Cambridge University Press, 1980); Michael Rosenthal, *British Landscape Painting* (Oxford: Phaidon, 1982); David Solkin, *Richard Wilson: The Landscape of Reaction* (London: Tate Gallery, 1982); and Ann Bermingham, *Landscape and Ideology: The English Rustic Tradition, 1740–1860* (Berkeley: University of California Press, 1986). In American scholarship, studies that consider social content include Roger Stein, *Susquehanna: Images of the Settled Landscape* (Binghamton, N.Y.: Roberson Center for the Arts and Sciences, 1981); Donald D. Keyes, Catherine Campbell, Robert McGrath, and R. Stuart Wallace, *The White Mountains: Place and Perceptions* (Hanover, N.H.: University Art Galleries, 1980); Kenneth Myers, *The Catskills: Painters, Writers, and Tourists in the Mountains, 1820–1895* (Yonkers, N.Y.: Hudson River Museum of Westchester, 1987); and Albert Boime, *The Magisterial Gaze* (Washington, D.C.: Smithsonian Institution Press, 1991). I had not benefited from a reading of Boime's work at the time my book went to press (the similarity in titles is purely coincidental). Also relevant is ongoing work on Thomas Cole by Alan Wallach.

1940s and 1950s was a form of cultural apologetics, an effort to define an area of cultural expression that was uniquely American and beyond the reach of European influence. Nationalistic defensiveness was as much an element of the culture during these years as it was in the middle decades of the nineteenth century. Studied in isolation from other kinds of evidence, landscape paintings do embody the ambitions of a native school. Yet the project of grounding nationalism in nature was challenged from a variety of quarters and by a variety of circumstances. An analysis of these challenges will help correct the one-sidedness of much earlier work in the field.

In the process this book disinters the lost history of how the national landscape came into being, which individuals were engaged in its invention, what their motives were, and what alternatives existed. Identifying such alternatives makes it possible to speak of a genuine diversity of claims in place of the generally accepted view that the expression of national identity in landscape art was both natural and inevitable. There was little that was either natural or inevitable about the process. It was, like all social processes, grounded in particular institutions, and it evolved through discussion and debate that questioned the authority of its claims. The manner in which the idea of a national landscape was constructed is a major theme of this book: how artists, critics, collectors, and men of letters collaborated in devising an institutionalized aesthetic and in implementing a certain critical and stylistic orthodoxy that subsequently appeared as a fully natural development of an emergent nationalism.

I hope to bring to view the extent to which previous scholarship has taken for granted both the nationalist function of the landscape genre and its northeastern bias. Since most normative definitions of nationalism were northern in origin, all discussions that draw on the sources issued by writers, presses, and pulpits have a northeastern regional slant, rendered invisible by contemporary scholarship. In an effort not to perpetuate such biases, I have repudiated the term "Hudson River school" in favor of "first New York school." When I do use the former, it will retain quotation marks that should recall to the reader its historical context.[6]

Ironically, the origins of the term "Hudson River school" directly counter its subsequent usage. Meant to call attention to the provinciality and aesthetic paro-

6. The term also encompasses the Catskill region bordering the Hudson River, a region that Kenneth Myers, "Selling the Sublime: The Catskills and the Social Construction of Landscape Experience in the United States, 1776–1876" (Ph.D. diss., Yale University, 1990), p. 12, cites as "the single most important natural environment in the early history of landscape painting, literature, and tourism in the United States." Myers's work, like my own, however, is concerned with demonstrating the material, social, and aesthetic circumstances surrounding the ascendancy of the Catskill and Hudson River region in landscape representation.

chialism of the painters to which it referred, it subsequently became synonymous with the national school of landscape art.[7] "National school" describes first and foremost a rhetorical construction, and should not be taken as accurately representing either the full range of landscapes produced in these years or the existence of contrasting and alternative modes of landscape representation. My object here is not to analyze these contrasting modes or to show the dissemination of the "national" or Hudson River style across the country to other regions such as California. It is, rather, to analyze the problematic concept itself through its institutional embodiments and its aesthetic forms, and to explore the tensions within its program that drove it forward in search of new, more abiding resolutions that never materialized. The representation of the American landscape was politically charged and contested. It was no small success to create an art form fluid enough to serve the multiple and shifting needs of nationalist sentiment in the decades during which the very concept of nation remained problematic. The ideological consensus now assumed to be an element of landscape art at midcentury, however, was only one fragile end product of a successful consolidation and not the point of origin for the entire process. The traces of these unresolved conflicts are evident in the works themselves.

A politics of representation necessarily presumes more than one party to the process, a struggle between contenders. The struggle to define the national landscape was both inter- and intragenerational. My argument parallels these generational fault lines. The opening chapter focuses on the career of Thomas Cole, isolating an ideological position that contrasts at numerous points with that of the generation of landscape painters who would claim him as their sire.

The consensual impulse behind so much of the scholarship on American art and culture has encouraged a tendency to approach Cole through the retrospective myth of his role in fathering a national school of landscape. While repudiating certain aspects of Cole's art, the succeeding generation elevated him to the status of founder and largely ignored his own philosophic argument with the nationalism that was such a key element in the landscape art of midcentury. Unlike later landscape painters, he resisted placing nature in the service of social or collective motives. He came as close as any artist to animating nature with a psychologically compelling presence. His romantic stance at an adversarial remove from the culture whose values and direction he wished to shape gave rise to prophetic narratives such as *The Course of Empire,* a pessimistic reading of America's imperial ambitions and a series deeply implicated in the political and social milieu of the 1830s.

7. See Kevin J. Avery, "A Historiography of the Hudson River School," and Doreen Bolger Burke and Catherine Hoover Voorsanger, "The Hudson River School in Eclipse," in *American Paradise: The World of the Hudson River School* (New York: Metropolitan Museum of Art, 1987), pp. 3–20 and 71–90.

How Cole's ambition to address the largest issues of national destiny influenced the succeeding generation is the subject of Chapters 2–4. Their dialogue with and constructive misreading of Cole occurred on several levels. The "classic" phase of the New York landscape style involved the formulation of a means other than seriality for incorporating a narrative dimension into landscape, imbuing the mute geography of nature with a cultural program. In this "sequential" landscape specific temporal correlates were assigned to the organizing planes within the image, embedding historical meaning in the very structure of natural space itself. The appearance of new narrative forms greatly enlarged the meanings of landscape art, answering its expanding ambitions and cultural charter.

The dichotomous compositions of Cole in the 1820s and 1830s identify a different pattern, one that would be repeated in other forms and by a wide array of artists. Here, formal divisions convey a radical ambivalence toward the course of American history. Dramas of nature—meteorological, diurnal, seasonal, and geological—furnished compelling visual and natural metaphors for social events. Older iconography was commandeered for the newer purposes, conveying both utopian aspirations and the specter of national defeat. Colean serial allegories also experienced a brief revival in the early 1850s. Yet those who came after him felt compelled to turn his pessimistic projection on its head. The result was a series of paintings conceived in answer to his 1836 *Course of Empire*.

Chapters 5 and 6 explore both the covert and explicit discourse of sectionalism and the crystallization of a specifically northern nationalism in landscape imagery. New England farm scenes, for instance, cannot be understood apart from the sectional polemic concerning free labor and slavery that was being waged in the 1850s. Likewise Yankee genre subjects, and even on occasion wilderness—apparently safe from sectional coloration—would, in the proper rhetorical context, inspire loyalties to a specific region. In the increasingly sensitive political climate that preceded the Civil War, sectional feeling more and more replaced the earlier tolerance for regional diversity and the acceptance of a locally inflected identity. In one final turn of the wheel, northern nationalism as a unity itself proved an elusive construct, as particular regions of the North claimed a special role in national origins. At such times the factional or politicized nature of the process of defining an American landscape becomes clear.

My reliance on the concept of a covert language or subtext—a second layer of meaning running beneath the obvious, programmatic meaning, particularly in the later chapters of the book—is appropriate to the peculiar circumstances of the 1850s. For those who still endorsed the ideal of national unity, to admit to sectional bias, whether northern or southern, bordered on the treasonous. Yet the reality of sectional discord persisted, and with it a pronounced tendency to justify one's own values and way of life as exemplary. Such a tendency was divisive, particularly in the

heated climate of the time. The strategy of sectional self-presentation that evolved in the North as a result of this delicate situation was one in which meanings occurred on two levels: an explicit commitment to a national ideal, and a covert and often invidious message of self-justification for an identifiably northern way of life.

The increasing politicization of the landscape under the pressures of sectionalism and the instrumentalization of nature as the raw material of American empire both contributed in reaction to a new phase of midcentury landscape. Atmospherically unified and spatially resonant, this new pictorial mode, emerging alongside older, classically derived compositional formulas, appears as a dehistoricized realm of strongly feminine and antipatriarchal associations. Such developments embodied a new language of environmental influence and new models of causality. Natural analogies, as a means of explaining social process, engendered belief that social dynamics were themselves regulated by natural laws. The rhetoric of will and ambition that served America's self-appointed historic mission was now matched by the imagery of silent, invisible agencies.

My use of the term "nationalism" and its grounding assumptions bears further explanation. American nationalism has long been distinguished from the European variety, in the minds of many who consult the term, by its primary appeal to a set of founding institutions and principles contained in the Declaration of Independence and the Constitution.[8] The basis of national identity in a common vernacular language, a dynastic legacy of great antiquity, and the shared ethnic roots which formed such a vital element of European nationalisms was necessarily absent from the American version, given the peculiar circumstances surrounding the founding of the United States. Yet it would be a mistake to think of American nationalism as a product of abstract principles alone, for Americans also sought some more essential organic grounding for their national identity. In the beginning "a roof without walls," American nationalism, according to John M. Murrin, "was narrowly and peculiarly constitutional," lacking in any more organic sense of identity.[9] The original act of incorporation had to be imaginatively realized in time and space. The durability of the Union could not depend on political articles of faith alone. The contractual basis of American government, its legal and political origins, was

8. For recent definitions of nationalism/patriotism, see *The Nation* (125th anniversary issue), July 15–22, 1991.

9. John M. Murrin, "A Roof without Walls: The Dilemma of American National Identity," in Richard Beeman, Stephen Botein, and Edward Carter, eds., *Beyond Confederation: Origins of the Constitution and American National Identity* (Chapel Hill: University of North Carolina Press, 1987), pp. 346–47.

merely an abstract guarantee of union. Some more immediately compelling agency was required to secure the political covenant, to root it in the daily experience and sentiments of Americans.

Nationalism, in the New World as in the old, thus sought to particularize identity through race, environment, and history. Americans constructed a national identity through all three, but during the decades of romantic nationalism, environment was preeminent. Since the New World was historically thin, its natural qualities—its scale, its newness, its variety—carried even greater importance. Romantic nationalism found its imperative in the exceptional conditions of nature in the "new" continent, the objective counterpart to Americans' own youthful identity.

Insofar as an articulate position can be deduced from contemporary writings about landscape art, its political intent was to root nationalism in the physical body of the republic. The program of incorporation at the heart of the nationalist enterprise was made literal in the bodily metaphors so often used to describe the relationship between the nation's parts. Lifeblood, sinews, ligaments, heart and extremities, circulatory images all signified the organic interconnectedness of the country's regions. The need for organic bonds was rendered more urgent by the fact that American loyalties remained a patchwork, a coat of many colors not always harmoniously blended. As James Hall put it: "He who would attempt to pourtray [*sic*] the American character, must draw, not a single portrait, but a familypiece, containing several heads."[10] Yet the underlying image of family unity, of a conjoined and harmonious confederation of independent but equal members, was coming unraveled, revealing a new factionalism for which the appeal to family was a sentimental ruse. As early as 1839 the English traveler Captain Frederick Marryat had pointed out with unsentimental directness that the national body was itself fragmented. Americans "are not yet, nor will they for many years be, in the true sense of the word, a nation,—they are a mass of people cemented together to a certain degree, by a general form of government."[11] By the 1850s most serious efforts to achieve a national art were being directed at the problem acknowledged by Marryat—that Americans lacked an organic sense of shared nationality. The possibility loomed larger that even the geopolitical blessings of a nation bound by ties of nature's own making would not hold together a Union divided by two distinct social and economic systems.

In realizing what Benedict Anderson has termed the "imagined community"

10. James Hall, *Letters from the West* (Gainesville, Fla.: Scholars' Facsimiles and Reprints, 1967), p. 236.

11. Frederick Marryat, *Diary in America,* ed. Jules Zanger (Bloomington: Indiana University Press, 1960), p. 36.

underlying a sense of nationalism, Americans, like their European counterparts, relied on a "print-language." To Anderson's crucial definition, I would add the essential role played in the American context by visual images in creating a community transcending bonds of clan, caste, or religion, and working across space and time.[12] Like the written word, images were circulated through prints and periodicals with a national readership or in oil paintings available to more limited, metropolitan audiences. They developed their own national audience, engendering a set of common experiences and creating a set of reference points shared by people otherwise unconnected. This, in theory at least, was their cultural work. The democratic drive to lower the barriers of high culture—the culture, in this instance, of oil paintings—meant that paintings as well as prints could now be enlisted in the cause of a shared identity that transcended class lines. Images were thus central to the formation of American nationalism.

I want to clarify further the main components of romantic nationalism and of the nationalist landscape before turning in the following chapters to close analyses of individual works that both reveal this program in depth and expose the obstacles to its realization. According to this school of thought, enunciated in the major critical writings from the 1820s to the 1850s, the landscape itself served as the birthplace of national sentiment.[13] E. L. Magoon, minister, collector of landscape art, and tireless apologist for the nation, expressed the theme:

> The diversified landscapes of our country exert no slight influence in creating our character as individuals, and in confirming our destiny as a nation. Oceans, mountains, rivers, cataracts, wild woods, fragrant prairies, and melodious winds, are elements and exemplifications of that general harmony which subsists throughout the universe. . . . Every material object was designed for the use and reward of genius, to be turned into an intelligible hieroglyphic, and the memento of purest love.[14]

"Grand natural scenery," he continued, "tends permanently to affect the character of those cradled in its bosom, is the nursery of patriotism the most firm and eloquence the most thrilling." Drawing from the "elastic" air and "granite high-

12. Benedict Anderson, *Imagined Communities: Reflections on the Origin and Spread of Nationalism* (London: Verso, 1983).

13. See William Gerdts, "The American 'Discourses': A Survey of Lectures and Writings on American Art, 1770–1858," *American Art Journal* 15 (Summer 1983): 61–79.

14. E. L. Magoon, "Scenery and Mind," in *The Home Book of the Picturesque; or, American Scenery, Art, and Literature* (1852; reprint, Gainesville, Fla.: Scholars' Facsimiles and Reprints, 1967), p. 3.

lands," "free and joyous as the torrents that dash through their rural possessions," the hardy and enterprising character of Americans was the product of those "glorious regions of rugged adventure they love to occupy." The association between scenery and character, Magoon concluded, was "an universal rule."[15] In what Larzar Ziff has called "the great American brag," nationalists found in the country's geographic scale the measure of their own cultural merit. Such attitudes provoked the sarcasm of foreigners still skeptical of America's exaggerated and often defensive cultural claims. In this debunking spirit Thomas Carlyle remarked that Whitman thought he was a big man because he lived in a big country.[16] Others found in the identification between scenery and character a forecast of corruption. Oliver Wendell Holmes wrote in 1839 that "the mountains and cataracts, which were to have made poets and painters, have been mined for anthracite and dammed for water powers." He feared that it was the anthracite that would soon be shaping American character.[17]

Sustaining the association between scenery and mind was a form of sensationalism, traceable to John Locke, in which the mind and imagination were seen as imprinted with the sensory data of particular environments. Human character was thus the product not of innate qualities but of the accumulated experience of the senses. This belief that national character was the "transcript" of scenery was central to the symbolic importance of landscape in the antebellum decades.[18] The conviction that subjective experience was a natural extension of sensory data supported a nationalist aesthetic because it predicated a realm shared by all Americans. This basic similarity of natural to moral law was expressed by Asa Mahan: "Every fundamental idea in the human mind implies the actual existence of a corresponding reality," without which nature became "a lie."[19] A shared landscape

15. Ibid., p. 25. On the connection between scenery and national character, see Bruce Robertson, "The Picturesque Traveler in America," in Edward J. Nygren et al., *Views and Visions: American Landscape before 1830* (Washington, D.C.: Corcoran Gallery of Art, 1986), pp. 187–211, esp. 206.

16. Larzar Ziff, *Literary Democracy: The Declaration of Cultural Independence in America* (New York: Viking Press, 1981), p. 21; Carlyle's remark appears in R. W. B. Lewis, *The American Adam: Innocence, Tragedy, and Tradition in the Nineteenth Century* (Chicago: University of Chicago Press, 1955), p. 79, n. 1.

17. Oliver Wendell Holmes, "Exhibition of Pictures Painted by Washington Allston," *North American Review* 50 (April 1840): 359. Quoted in Lillian B. Miller, "Paintings, Sculpture, and the National Character, 1815–1860," *Journal of American History* 53 (March 1967): 707. Perry Miller, "The Romantic Dilemma in American Nationalism and the Concept of Nature," in *Nature's Nation* (Cambridge: Harvard University Press, 1967), pp. 197–207, analyzes the predicament to which Holmes alluded.

18. The term is from Magoon, "Scenery and Mind," p. 43.

19. Quoted in D. H. Meyer, *The Instructed Conscience: The Shaping of the American National Ethic* (Philadelphia: University of Pennsylvania Press, 1972), p. 50.

would weld the individual to the general, the concrete to the abstract, the part to the whole. Nationalism was at root a substance, a thing, and not merely a social process. Whether embodied in time or space, it was, like the homunculus of medieval medicine, fully formed in the womb of the nation. Yet, like a newborn, it had to be nurtured and protected, and the conditions had to be created that would allow it to flourish. It existed, however, in the "everlasting hills," in the broad rivers and sweeping plains, as the very substance of nationalist rhetoric.

If nationalism and national character were the product of scenery, then through logical extension one could argue that the inviolability and unity of the scene of nationalism—the land itself—guaranteed that the body politic would resist the forces tearing it apart. As Oliver Wendell Holmes wrote, not long after the secession of South Carolina:

> Our union is river, lake, ocean, and sky,
> Man breaks not the medal, when God cuts the die!
> Though darkened with sulphur, though cloven with steel,
> The blue arch will brighten, the waters will heal![20]

Holmes still called on landscape to fulfill its appointed role within the larger enterprise of romantic nationalism: to ground national unity in the ministry of nature. This was a bond that transcended politics. Convinced that the "slave-holders' rebellion" would be of brief duration, northeasterners such as Holmes looked to nature for traditional reassurances that the divinely consecrated Union would not be torn asunder by misguided human agencies.

The rhetoric that linked nationalism to the geographical unity, breadth, and scale of the New World must be weighed against the evidence of the landscape paintings themselves, which project to modern eyes a view of nature both bounded and contained. Indeed, as Arthur Danto has pointed out, the physical and tactile qualities of the landscapes produced in New York studios, in their stylized and richly foliate gilt frames, their varnished, "oleaginous" surfaces, "their opulence verging at times on corpulence," and their balanced, self-enclosing forms, fully embody the paradoxes of their cultural meaning (figure 1, Jasper Cropsey, *Indian Summer,* 1866).[21] They drew collective inspiration from nature while containing and controlling its meanings. The moral picturesque helped organize the meanings of landscape imagery by imbuing it with literary and religious content. Any unstructured encounter with nature threatened a kind of antinomianism that was

20. "Brother Jonathan's Lament for Sister Caroline" (1861), in *The Works of Oliver Wendell Holmes,* 13 vols. (Boston: Houghton Mifflin, 1892), 12:284–86.
21. Arthur C. Danto, "The Hudson River School," *The Nation,* November 7, 1987, pp. 531–33.

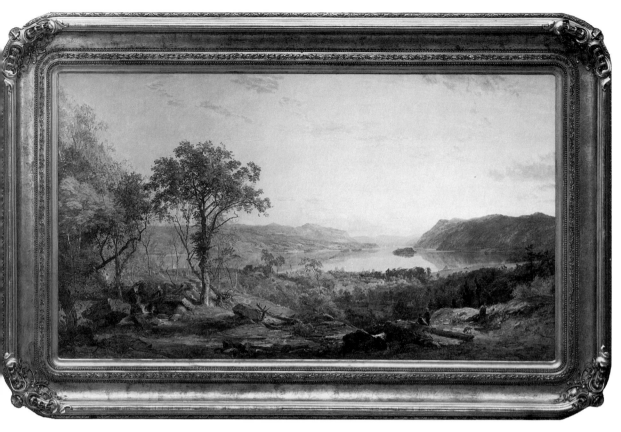

Figure 1. Jasper Francis Cropsey, *Indian Summer* (with frame), 1866. Oil on canvas; 53″ x 95″. © The Detroit Institute of Arts, Founders Society Purchase, Robert H. Tannahill Foundation Fund, James and Florence Beresford Fund, Gibbs-Williams Fund, and Beatrice W. Rogers Fund, 78.38.

the moral or spiritual counterpart of democratic anarchy. The picturesque was the pictorial expression of social containment.

By midcentury, landscape art, far from being the expression of an expansive democracy, was a cultural endeavor directed at consolidating a middle-class social identity utterly bound up with the civilizing mission. The repeated emphasis on the moderating and uplifting function of art suggests that it is time to stop reading landscape paintings so exclusively in terms of cultural attitudes toward nature. To so limit one's discussion gives only a partial, and possibly misleading, picture of their cultural functions, which were less often directed outward toward the object—nature—than inward and back toward the social subject. As scholars learn more about the particular social and political experience of the urban, literate north-easterner in the 1850s, we are able to understand the content of landscape images

not simply in terms of what people wrote about nature, but in terms of how social and political context shaped the meaning of what they said and wrote, and how we in turn may best interpret their writings.

Landscape images served as an arena of symbolic action, a quasi-utopian endeavor that helped to order culturally a space inherently open-ended and unstable. The mid–nineteenth-century enthusiasm for landscape art was motivated by a complex set of associations identifying images of nature with virtue, purity, and uncomplicated harmony, as well as with national unity, pride of place, and a unique identity distinct from that of Europe. Indeed, contemporaries noted the indifference many of the enthusiastic patrons of landscape art felt in the presence of *actual* nature. It is clear that for many Americans, painted nature was more eloquent than the thing itself.

By midcentury, beautiful scenery was accessible to most middle- and upper middle–class New Yorkers, who could travel in ease and comfort to the Catskills and the White Mountains.[22] Thomas Cole bemoaned that "men in this world of what is called utilitarianism are dull to discover beauty in natural scenery—it is a chilling fact that the most lovely passages of nature and easy of access even in the vicinity [of] a large community will mask its [*sic*] beauty unadmired."[23] Few appreciated natural beauty. "As a people," wrote a contributor to the *New-York Home Journal* in 1851, "we are less in the habit of luxuriating in the beauties of nature than any other pretending to civilization. We neither hunt, fish, ride on horseback, indulge in rural sports or athletic exercises. The landscape may decline into the sere and yellow leaf, arrayed in all the glorious tints of autumn, within a mile of Trinity Church, and not ten of the fifty thousand patrons of art of the Bethune class[24] will afford themselves the luxury of casting 'a longing, lingering look behind.'" Wandering over the lovely and widely painted landscapes in easy reach of New York City, the author protested that he had "scarcely met a soul susceptible to the genial influence of an American landscape."[25] Landscape painting obviously expressed more than simple love of nature.

The idea of art as symbolic action was echoed in 1853 by the *New-York Home Journal:* "The fine arts have . . . been among the highest consolations to the inhabitants of cities for the deprivation of the beauties of nature."[26] From his mission of generalized moral uplift and refinement of taste, the artist was saddled

22. Myers, *The Catskills.*
23. See "The Catskill," Archives of American Art, Smithsonian Institution, Washington, D.C., Reel ALC3.
24. George Washington Bethune, a popular midcentury writer on landscape.
25. "Art and Artists," *New-York Home Journal,* June 5, 1851, [p. 3].
26. "The Fine Arts in America," *New-York Home Journal,* February 5, 1853, n.p.

with an almost staggering social burden, as the *Cosmopolitan Art Journal* reminded its readers: "Into the hand of Art is committed dominion over the passions not only of the individual, but of the masses composing the body politic, and he who fails to comprehend or to appreciate the magnitude of the trust reposed in him, lacks the primary qualifications for his profession."[27]

The emphasis on the civilizing and uplifting function of landscape addressed the one fatal weakness that theories of republican government had consistently singled out as the greatest threat to the security and permanence of self-governed states: the moral corruption of both the governed and the governors. The contemplation of nature schooled Americans in moral and civic behavior.[28] Such a concept applied equally well to painted representations. Indeed, images worked better than actual landscapes in inculcating values, for representations could control and shape the landscape. They did not need to trust to the fortuitous qualities of real nature, its accidents of topography, its signs of cataclysm and geological change. They offered an aesthetically controlled order that symbolically enacted cultural and social scenarios impossible to engineer in reality.

Perhaps the most investigated aspect of nineteenth-century landscape representation in relation to nationalism is the formula of the middle landscape, a rural Arcadia gently shaped by the hand of the farmer and aesthetically balanced between the extremes of wilderness and city. The middle landscape implied stability in a period of rapid change; its modulated topography was the expression of a yearning for uncomplicated social relations. But not only did the middle landscape function as an idealized image of a harmonious nature; it also served the cultural dream of a structured transformation of the social order that was Whig in spirit. The emphasis on the stagelike, choreographed vision of landscape scenery realized in the aesthetic of New York painters was implicitly addressed to anxieties about unsupervised, potentially anarchic popular energies that would ravage the wilderness rather than bring it under orderly cultivation. In this sense American landscapes at the time were moral exhortations to restraint and discipline of both self and society, their miniaturizing formulas, their conventionalities, their programmatic circumscription of meaning all serving this basic effort. They associated formal hierarchies, economic colonization, and the domestication of wilderness with the parallel project of containing and socializing the passions of the republic's citizens. The various elements of landscape—its spatial constructions, its passage from near to far

27. *Cosmopolitan Art Journal* (June 1858), quoted in David Huntington, *The Landscapes of Frederic Edwin Church: Vision of an American Era* (New York: Braziller, 1966), p. 39.

28. See Theodore Dwight, Jr., *Sketches of Scenery and Manners in the United States* (1829; reprint, Delmar, N.Y.: Scholars' Facsimiles and Reprints, 1983), introduction by John F. Sears, pp. 3–14.

and light to shade, its combination of various artistic modes from picturesque to beautiful and sublime—embodied a form of *concordia discors,* or harmony of opposing elements, which was the aesthetic correlative of social dynamics in a healthy republic.[29] At periods of national turmoil, however—the Mexican-American War and the boundary disputes in Oregon, the sectional crises of the 1850s, and the Civil War—this harmony of opposites polarized into contending forces as landscape painters struggled to find a visual or narrative resolution to unresolved problems of cultural identity or to test alternative futures. Conflicts between freedom and order, change and continuity, growth and stability could be rehearsed through spatial scenarios.

Landscape as a form of symbolic action, however, was not simply a rear-guard performance directed at containing the forces of cultural disruption or at testing national possibilities. The myth of nature's nation also served a forward-looking economic program. Images of the land gave a natural mooring to an emergent national market. By grounding national identity in a shared nature and by enhancing this identity through the creation of certain common associations, landscape art worked to deflect the forces of localism that threatened the establishment of that market.[30]

In addition, nationalist aesthetics fostered a new set of associations based not on the traditional litany of European cultural riches but on a distinctly American inventory of natural resources. Related to this was an emphasis upon the future rather than the past.[31] This led to a celebration of the wilderness as a stage, necessarily incomplete, in a process of cultural colonization. The theme of nature's transformations was deeply rooted in popular rhetoric. It is only by recovering the contexts of this rhetoric—among them contemporary social theories with their roots in Scottish moral philosophy—that one can begin to recapture this logic of

29. The applicability of this concept to landscape representations was first suggested to me by Jay Fliegelman. I am also indebted to Myers's use of this concept in "Selling the Sublime," pp. 55–63.

30. This situation directly shaped the critical status of American landscape painters in their own time and up through recent decades. Painters who worked beyond the institutional boundaries of the national school remained local figures—in twentieth-century parlance, "topographical artists" who specialized in the scene painting of local views. The one noteworthy exception was Fitz Hugh Lane, who, while in his own lifetime a "local" figure, has been elevated by recent scholarship to a position of honor in the nationalist pantheon. For a critique of this reading of Lane, see my essay "Ideology and Experience in the Making of the National Landscape," *American Literary History* 4 (Summer 1992): 207–29.

31. An example appears in "Mrs. Butler's Journal—Progress of Improvement in America," *New-York Mirror,* June 20, 1835, p. 403: "Where yesterday the majestick woods were standing, and the silent waters gliding in all the solemn solitude of unexplored nature; to day, the sound of the forge and anvil is heard."

incompleteness. Such a logic meant that representations of American wilderness and nature were on some level anticipatory and prophetic, their aesthetic experience shaped by the contrast that viewers would draw in their own minds between present and future. Consistent with this was a habit of creating aesthetic and moral contrasts—verbal or visual pendants that emphasized, sometimes in a nostalgic, sometimes in a celebratory manner, the gulf separating wilderness from future settlement. Landscape artists contributed to reconciling the contradictions within a national ideology that sanctified wilderness at the same time that it glorified an emergent market culture that found little value in untransformed, unimproved nature.

Despite the "unstoried" quality of the American wilderness which cultural nationalists so loudly praised in a compensatory rhetoric addressed to European critics, they continued to search for a depth and weight of historic experience in their own landscape and to devise associations that would engender loyalty. Landscape painting helped stimulate associations with momentous passages in American history that carried patriotic meanings. By the 1850s the memory of the Revolution had ceased to function as an appeal to unity. Its meaning had become one more contested legacy dividing North and South. The Civil War itself ironically furnished the very event that answered this cultural need for a powerful shared historical experience that would forge those "mystic chords of memory" so vital to any sense of national identity.[32]

One reason for the rise of landscape to a position of such importance was that its primary characteristic—its multivalence of meaning—was well adapted to serve a diffuse nationalism without provoking more direct allegiances to place or section, to social class, or to urban polity. A habit of describing things in compositional terms reveals another aspect of this generation's effort to balance local and national, a deep-seated impulse to order and compose, to situate isolated perceptions and experiences within a broader unity. Visual analogies were important precisely because they operated on the principle that what appeared to be discrete and fragmentary was in fact part of something larger. This was the lesson also insisted on by those defending the principle of nationalism and national unity. Ambitious panoramic and composite techniques of composition, in which spatially discrete scenes and elements were synthesized into a unified whole, acted out in artistic terms the political principle of *E pluribus unum,* or plurality of parts within a unifying framework. Landscape images, metaphorically amplified, bore this out.

The sustained analogy between the creation of a republic and the creation of a

32. Abraham Lincoln, "First Inaugural Address," reprinted in Daniel Walker Howe, *The American Whigs: An Anthology* (New York: Wiley, 1973), p. 246.

work of art is evident, although rarely explicit, in the contemporary terms of composition, part and whole, aesthetic (and political) unity. Such terms migrated back and forth between criticism of painting and discussions of nationalism with some predictability. Indeed, the aesthetic problem of part and whole would plague American artists most during the 1850s, when sectionalism—exclusive identification with one economic and political sector over the national whole—was the greatest threat to unity. In a period of less pressing political claims, nature could function for Americans as an enabling myth that made possible belief in the exceptional character of American nationalism. It embodied a sense of identity that was, in theory at least, democratic (that is, non–class specific), morally and culturally redemptive. Belief defined the arena of action and behavior throughout the 1840s. The metonymic equivalence of nature and culture actively militated against an analysis of social institutions and gave historical events the inevitability of natural law.[33]

In the years preceding the war, landscape painters faced a new challenge: how to fulfill their appointed role in creating unifying images of nationalism in a period when nationalism itself was being redefined in exclusionary terms. In the 1850s the Northeast laid claim to being the privileged carrier of national identity. Despite the ideological commitment to an inclusive nationalism, changing personal and public associations burdened landscape images with a new freight of political meaning. Artists could not avoid such associations, and at times used them to celebrate the region. On one level, then, images of American nature offered a hallowed arena safely removed from political dissension and a foundation for national culture more stable and enduring than institutions or legal documents. On another level, however, landscapes produced in the Northeast appealed to a specifically regional definition of the American national ideal.[34]

Visual relationships not only described but also shaped the manner in which

33. The familiar concept of reification defined by Georg Lukács, *History and Class Consciousness: Studies in Marxist Dialectics* (Cambridge: MIT Press, 1971), pp. 83–222, applies well to this specifically American context. For an application of the term to the midcentury cultural context, see Carolyn Porter, "Reification and American Literature," in Sacvan Bercovitch and Myra Jehlen, eds., *Ideology and Classic American Literature* (New York: Cambridge University Press, 1986), pp. 188–217; and Michael T. Gilmore, *American Romanticism and the Marketplace* (Chicago: University of Chicago Press, 1985), pp. 39–41.

34. On the identification of the local with the national, see Lillian B. Miller, *Patrons and Patriotism: The Encouragement of the Fine Arts in the United States, 1790–1860* (Chicago: University of Chicago Press, 1966), pp. 227–28. On the emergence of a sectional orientation in literature, see Benjamin Spencer, *Quest for Nationality: An American Literary Campaign* (Syracuse: Syracuse University Press, 1957), chap. 8, esp. 253–58. The exclusionary basis of northern nationalism in the 1850s had its

people constructed an image of how their immediate environment related to a larger national landscape. When Rufus Choate called for a "near, distinct and accurate, but magnified and ornamental view of the times, people, and country" of early New England, one that was, "as it were, telescope, microscope, and kaleidoscope all in one," he was employing the language of vision to describe a conceptual process of balancing historical particulars with general character.[35] Nationalists had to achieve a similar balance between local interests and abstract ideals, the microscopic and the telescopic, a difficult balancing act that required both intimate particulars and grand ideals.

The arts in large part inherited what was in essence a conceptual dilemma: how to build an integrated national self without sacrificing local identities. Even as late as 1874 Emerson could write that "we must realize our rhetoric and our rituals. . . . Our national flag is not affecting, as it should be, because it does not represent the population of the United States, but some Baltimore or Chicago or Cincinnati or Philadelphia caucus; not union or justice, but selfishness and cunning."[36] Yet Emerson's call for "affecting" national loyalties threatened to override the regional attachments that anchored personal association, memory, and meaning. One solution to this particular impasse was what I call synecdochic nationalism—a metaphoric construction in which part came to stand for whole. As the call for a precise delineation of nature's features appeared alongside composite and generalizing modes of composition, landscape painters devised a kind of compromise allowing for local specificity within a containing framework of symbolic meaning. The form was local, but the program was national. Yet with the opening of the war, political and military realities overcame all efforts at a symbolic resolution of the dilemma.

At the heart of these myriad conceptual difficulties within romantic nationalism was a paradox incapable of resolution. Romantic nationalists located the substance of American nationalism—*the thing itself*—in the context or scene, the natural backdrop, of American society. The paradox inherent in this definition of American nationalism was, to borrow Kenneth Burke's phrase, "the paradox of substance," that is, that an essence can be defined only by its context.[37] In antebellum America this context was the natural scene or stage which nationalists credited with

southern counterpart. See John McCardell, *The Idea of a Southern Nation: Southern Nationalists and Southern Nationalism, 1830–1860* (New York: W. W. Norton, 1979), esp. pp. 141–76.

35. Rufus Choate, "Illustrating New England History," reprinted in Howe, *The American Whigs,* pp. 161–62.

36. Ralph Waldo Emerson, *Miscellanies* (Boston: Houghton Mifflin, 1911), pp. 530–31.

37. Kenneth Burke, *A Grammar of Motives* (1945; reprint, Berkeley: University of California Press, 1969), pp. 21–23.

agency in shaping American culture. American artists, struggling to visualize nationalism in their art, time and again depicted this scene of nationalism, its stage.

In retrospect the search for a nationalism grounded in the landscape seems to have been doomed to fail, in no small part because the landscape was itself contested—its meanings, its possession and use, its representational idioms. If the substance of nationalism was embodied in its context, that context was fragile and historically vulnerable. The land, far from being an unvarying essence, was implicated in the forces changing American society. As such it furnished a precarious ground for a stable nationalism. As the productive and mutual engagement between representation and events grew slack, northeastern landscape painting became increasingly formulaic and brittle. By the 1870s much American landscape of the academic variety lacked freshness and seemed contracted in both intellectual reach and confidence. The most significant landscapes of the postwar decade either depicted relatively unfamiliar regions—the Far West, the Deep South, Labrador, South America—or scaled down their nationalist claims to more modest, indeed diffident, proportions.

Americans' vaunted love of nature proved to be a contradictory amalgam of desire and memory better served by images than by the thing itself, a dream of possession and a sense of loss made more poignant by the recognition of something never itself fully experienced. Landscape images captured this peculiar condition in which the memory of the thing was more powerfully affecting that the pressing realities of a nature undergoing rapid change. The creation of a mental image in a manner that served memory and desire was the object of American landscape art in these decades.

My discussion includes works that are no longer extant, along with works that were described but never executed. The reader who prefers what is to what might have been may be inclined to wonder why one should bother with such works. Quite simply the answer is that they convey a vivid sense of the narrative ambitions of landscape art in the antebellum decades. The surviving descriptions of proposed or now vanished works render their programs explicit. They also provide an invaluable form of exegesis whose terms may be profitably extended to an entire range of other works.

One might also wonder about the necessities that have pushed me to employ such a broad, varied, and uneven body of evidence to make my argument. Shouldn't the encomia of the president of the National Academy of Design be weighed more heavily than the grumblings of a rejectee? Shouldn't a painting such as *Niagara* be granted more powerful testimony than the bitter rantings of an obscure southern journalist? There is little question that the traditionally "weightier" evidence has

carried disproportionate importance in the body of scholarship on American art. By widening the range of evidence to include the dissenters, the malcontents, and the marginal voices, one can also begin to penetrate the monolithic claims of those who have successfully, if retrospectively, won the title of "national school."

There are, however, other aspects of my method for which I have less apparent justification in the material itself. I bring along the peculiar concerns of my own generation, a special way of seeing things that may make me appear at times to be discussing a very different body of work from that which has been the subject of previous studies. For I am of a generation of scholars that is constitutionally skeptical of self-justifying claims, that is inclined to discover multiple and often competing motives where our predecessors took things at face value, that doubts claims to unitary and coherent structures of meaning in works of art or literature and finds deeper ambivalence and complexity often running counter to surface rhetoric. Trained in the methods and assumptions of material culture, I believe that works of art are themselves primary evidence of a society's disposition toward a wide range of issues. Artistic intention represents only one kind of evidence, but one that in no instance should override the primacy of the work itself. My central assumption is that structure and form in art constitute a different and unique kind of cultural testimony. Many of the artists I discuss were remarkably unrevealing of their meanings or intentions in painting landscape. Likewise, contemporaneous criticism often reveals more through its choice of imagery or the language of its critical concerns than through its specific content.

This is not, however, meant to be an argument for simply reading my own agenda into the products of another period. Rather, I am convinced that there is much to be gained, first, from a rereading of standard sources with an eye to particular themes and interests, and second, from a broadened definition of what qualifies as documentation relevant to the study of the American landscape, with an eye to discovering those recurrent images that bind together different levels of cultural discussion—in this instance the political and the artistic. Are such images simply linguistic? Perhaps, but to say so is to underline the powerful impact of language in shaping reality, not only by informing our perception of it but also by limiting and defining the range of possibilities by which we act. Language is a species of symbolic action, and it is with this in mind that I have given equal if separate weight to written sources that reveal the critical assumptions and underlying anxieties at work in a particular context.

One other note concerning personal bias: I came of age at a time when the concept of nationalism was (and is) highly suspect. It has lent its name, on the one hand, to a variety of developments at odds with the growing economic, ecological, and social interdependence of nations with one another. On the other hand (as

Thoreau's words in the epigraph to this book suggest), nationalism seems ill attuned to the deep experiential ties to place that so powerfully organize an individual's emotion and sentiment. Localism and nationalism, however, are not necessarily incompatible. As my argument demonstrates, throughout much of the period under discussion the two were naturally allied, loyalty to the local forming the root of more abstract loyalties to the national. But just as frequently, local habits and loyalties found themselves at odds with national imperatives. Thoreau reminds us that only an identity rooted in the soil of place, particularized memories, and personal associations can keep us true to ourselves and our communities, allowing us to judge national objectives with greater clarity and skepticism.

A note about the term "American": I use it to refer exclusively to the art of the United States. It is merely a convenient shorthand and does not extend to the art of Canada, Mexico, or Central or South America.

1 / Thomas Cole
Self, Nature, and Nation

*The mind that we knew was abroad in those scenes of
grandeur and beauty, and which gave [Cole] a higher
interest in our eyes, has passed from the earth, and we
see that something of power and greatness is
withdrawn from the sublime mountain tops and the
broad forests and the rushing waterfalls.*
—William Cullen Bryant, *Funeral Oration*, May 4, 1848

Thomas Cole (1801–48) has widely been considered the founding father of a
national school of landscape art. Although Cole did not emigrate to the United
States from his birthplace in Lancashire, England, until 1818, those responsible for
constructing an American landscape tradition from its origins in the early nine-
teenth century have claimed him as a fully native figure. Yet close analysis of his
career within its own historical context, rather than through the lenses furnished by
a later generation, reveals marked differences between Cole and those who fol-
lowed. The founding myth that developed around him after his death has muted
the critical substance of his convictions about the role of the artist in the new
republic. This myth has also obscured Cole's ideological and artistic distance from
the landscape painters who succeeded him behind a veil of filiopiety.[1]

Cole symbolized for later artists the arrival of a purely American landscape. The
irony is that, despite his standing as the symbolic father of a national school, Cole
himself repudiated the claims of nationalism and of an art premised on the belief in
American exceptionalism. He remained loyal to an older, eighteenth-century re-
publican mind-set, continuing to believe in the existence of universal truths and
historical laws at a time when the young republic was considered exempt from

1. The process of myth making was under way during Cole's lifetime, however, as is evident from
William Cullen Bryant's poem "To Cole, the Painter, Departing for Europe," ritually repeated by later
scholars. See also Bryant's *Funeral Oration*. Alan Wallach, "The Ideal American Artist and the
Dissenting Tradition: A Study of Thomas Cole's Popular Reputation" (Ph.D. diss., Columbia Univer-
sity, 1973), pp. 27–56, discusses Cole's nineteenth-century image.

them. American landscape artists of the generation that followed him attempted to express America's unique identity as a culture rooted in nature, drawing its virtue from the soil of the continent itself. If Cole contributed to this effort, the larger thrust of his art was cautionary, not celebratory. Although he rejected the myth of nature's nation, it was not without a lingering attachment to the idea of America as a virgin land whose Edenic qualities Cole himself alluded to in his 1835 *Essay on American Scenery*.[2] For him, Americans were not a new chosen people but transplanted Europeans given a fresh start that they could use to their advantage if they heeded the example of history and avoided its mistakes. His experience of life in an expanding democracy, however, convinced him that they would not. Because the human materials remained ever the same, the exceptional conditions of American history only deferred the eventual but inevitable reckoning.

"I think every American is bound to prove his love of country by admiring Cole," wrote the diarist and former mayor of New York Philip Hone in 1833.[3] Cole's status as an artist who rallied national sentiment solidified in the next two decades. Following his death in 1848, the New York *Literary World* proclaimed Cole "the best interpreter of the teachings of American nature," and the figure toward whom the living practitioners of the genre gratefully traced their own origins as a school. His significance for the generation that followed was enormous. It witnessed the institutionalization of landscape art as a cultural expression of national identity. But as this role was worked out in practice, internal tensions and conflicts of value surfaced that would on one plane render the entire concept of a national landscape obsolete, and on another eventuate in the breakup of the union that underwrote the concept.

At the heart of Cole's difference from those who were quick to claim him as their spiritual father was his skepticism toward the belief in American exceptionalism so central to the republic's cultural identity from the beginning of the century. Cole was haunted by visions of national declension that assumed various forms throughout his career. In a journal entry written a little more than a year before his *Course of Empire* (1833–36) opened in New York, Cole described his fears of a massive social collapse, then meditated upon a characteristically American delusion:

2. John McCoubrey, *American Art, 1700–1960: Sources and Documents* (Englewood Cliffs, N.J.: Prentice-Hall, 1965), p. 109.

3. *Literary World*, February 19, 1848, p. 51, as quoted in Ellwood Parry, *The Art of Thomas Cole: Ambition and Imagination* (Newark: University of Delaware Press, 1988), p. 344; entry of May 15, 1833, in *Diary of Philip Hone, 1828–1851*, ed. Allan Nevins, 2 vols. (New York: Dodd, Mead, 1927), 1:93. Hone had been among the earliest admirers of Cole's landscapes, purchasing from William Dunlap one of the first three paintings Cole exhibited in New York.

It appears to me that the moral principle of the nation is much lower than formerly—much less than vanity will allow—Americans are too fond of attributing the great prosperity of the country to their own good government instead of seeing the source of it in the unbounded resources and favorable political opportunities of the nation. It is with sorrow that I anticipated the downfall of pure republican government—its destruction will be a death blow to Freedom—for if the Free government of the U states cannot exist a century where shall we turn? The hope of the wise and the good will have perished—and scenes of tyranny and wrong, blood and oppression such as have been acted since the world was created—will be again performed as long as man exists.[4]

Many similar ruminations were excised from Cole's biography by Louis LeGrand Noble, his minister and the chief guardian of the artist's idealized public image. Yet such passages remain critical to a full understanding of Cole, revealing his fear that the newfound liberties that accompanied a realignment of social authority could thrust the republic rudely back into the cycles of history only temporarily deferred. Cole's awareness that America's political and social success was historically contingent was more commonly articulated by foreign visitors. These opinions, however, ran headlong into the entrenched myth of American exceptionalism.

In the autumn of 1836, Cole opened a private exhibition in New York City of his five-part cycle *The Course of Empire* (figures 2–6). The series was described by a contemporary journal as "a grand epic poem upon canvass, nobly planned and carefully elaborated," representing "the *march of empire,* or the rise, decadence and final extinction of a nation, from the first state of savage rudeness through all the stages of civilization to the very summit of human polish and human greatness, to its ultimate downfall."[5] Blessed with a patron—Luman Reed—willing to indulge his finest ambitions, Cole devised a showcase of historical landscape styles, including marine, mountain, architectural, and pastoral.[6] The series, an enormously am-

4. I am indebted to Kenneth J. LaBudde for his transcription of this August 21, 1835, passage from Cole's journals in a personal correspondence. The passage is now published in Thomas Cole, *The Collected Essays and Prose Sketches,* ed. Marshall Tymn (St. Paul, Minn., 1980), pp. 134–35.

5. "Cole's Pictures," *Journal of Commerce,* Archives of American Art, Reel D6, frame 337; "Cole's Paintings" [no attrib.], Reel D6, frame 345.

6. Reed's commission enabled Cole to realize a conception dating from the late 1820s. On Luman Reed, see Lillian B. Miller, *Patrons and Patriotism: The Encouragement of the Fine Arts in the United States, 1790–1860* (Chicago: University of Chicago Press, 1966), pp. 151–55, 172, 277–78; Russell Lynes, "Luman Reed: A New York Patron," *Apollo Magazine* 107 (February 1978): 124–29; Wayne Craven, "Luman Reed, Patron: His Collection and Gallery," *American Art Journal* 12 (Spring 1980): 40–59; Ellwood Parry, "Thomas Cole's Ideas for Mr. Reed's Doors," *American Art Journal* 12 (Summer 1980): 33–45.

bitious undertaking for any American artist in the 1830s, particularly one self-taught, was a tour de force calculated to seize the attention of New York audiences. Theodore Allen, Reed's brother-in-law, hailed *The Course of Empire* as "the most successful exhibition of works of a single American artist" ever held in New York City.[7] No American artist before him had taken on such a publicly resonant theme as the rise and fall of a great empire with such vividness of detail and narrative command. As he was to do only once again in his career, with *The Voyage of Life* in 1840, Cole combined the language and didactic intentions of elevated art with a sense of spectacle and drama that appealed to popular audiences.[8] Jonathan Sturges, a patron of the artist, wrote to him a few months later that "after what the publik have seen they will not pass you lightly by in the exhibition whether for good or evil—it seems to me that this is the most important point in your career."[9]

The Course of Empire vastly enlarged the expressive and intellectual content of the landscape genre. Exploring the relationship between nature, history, and national identity, the series was also Cole's bid to become the voice of moral opposition to America's materially driven democracy. Among the nation's landscape painters, Cole was the one most directly indebted to the literary themes and oppositional stance of English romantic artists, and most at odds with the utilitarian values of urban-industrial culture. His belief in the social agency of the artist bound him to an intensely serious sense of mission. Art, he wrote late in his career, "is a mighty engine in producing character and affecting the mind of man."[10] Moral and philosophical opposition to utilitarian culture became a hallmark of those who spoke out in defense of art, a position that, in this country at least, was frequently associated with belief in institutional restraints on the individual and on a form of social organicism uneasy with "go-ahead" democratic culture. For such a social

7. Theodore Allen to Cole, December 27, 1836, Archives of American Art, Reel ALC1. Allen estimated that the total receipts of the exhibition, held at the National Academy of Design, came to over $1,289, "and a *Million* in fame," between October 17, when the series opened, and December 15, when it closed. He also observed that Cole's success was even more noteworthy in view of "the season of the year, the short time of the exhibition, and the unexampled scarcity . . . in the money market," a harbinger of the depression of 1837.

8. See William Dunlap, *History of the Rise and Progress of the Arts of Design in the United States*, 2 vols. (facsimile reprint of 1834 ed., New York: Dover Publications, 1969), 2:357, 359, on Cole's preparations as a "scene painter." On his popular sources in dioramas, see Wolfgang Born, *American Landscape Painting: An Interpretation* (New Haven: Yale University Press, 1948), p. 81.

9. Jonathan Sturges to Cole, February 21, 1837, Archives of American Art, Reel ALC1.

10. Thomas Cole, "The Influence of the Plastic Arts," unpublished lecture, Archives of American Art, Reel ALC3. Cole wrote to his patron Samuel Ward: "Heaven knows this community has need of the genial influence of the Fine Arts to soften its hard & utilitarian features." Quoted in Parry, *The Art of Thomas Cole,* p. 251.

vision, art was instrumental in educating the feelings, a much-needed antidote to the "Utilitarian Tide" Cole felt was sweeping the republic along in its current. In addition to the benign influence of nature, Cole therefore began to insist in his later career on the aggressive cultural mission of the arts as a means of defining national identity and spiritualizing communal values.

Cole's distrust of popular democracy played a central role in shaping his vision of history and in contributing to the social subtext of his art, for one cannot easily separate its allegorical content from his highly colored response to the events of his own time. Throughout his career Cole found himself intellectually allied to social conservatives such as Philip Hone and Theodore Dwight. Skeptical of party politics, he was Whiggish in political sympathies and strongly anti-Jacksonian. Cole had supported the Whig candidate William Henry Harrison in the election of 1840 and pronounced his contempt for the party of Jackson. He mourned Harrison's sudden death not long after his inauguration in a letter to William Adams dated April 8, 1841: "I believe since the death of Washington no man has died more lamented by his country."[11] To Robert Cooke he expressed his revulsion at the war with Mexico: "Nobody knows what this *vile* Mexican War will bring about."[12] His cyclical vision of history, his sense of the fragility of self-governed societies, and his insistence that the course of the United States would be shaped by universal rather than exceptionalist historical forces all looked to eighteenth-century republican modes of thought. The fathers of the new nation, steeped in Renaissance theories of republicanism, had struggled to reconcile stability with growth, civic virtue with economic expansion. Cole inherited their intellectual convictions, which distinguished him from the later artists who embraced him as the founder of a national school.[13]

What further differentiated Cole from those who followed him was his vision of the antagonism between the ideal republic consecrated by the founders' visions and

11. Archives of American Art, Reel ALC1. Passage cited in part by Alan Wallach, "Cole and the Aristocracy," *Arts Magazine* 56 (November 1981): 98.

12. Cole to Robert Cooke, July 19, 1846, Archives of American Art, Reel ALC1.

13. On republicanism, see J. G. A. Pocock, *The Machiavellian Moment: Florentine Political Thought and the Atlantic Republican Tradition* (Princeton: Princeton University Press, 1975). Drew McCoy, *The Elusive Republic: Political Economy in Jeffersonian America* (Chapel Hill: University of North Carolina Press for the Institute of Early American History and Culture, 1980), pp. 48–75, discusses the early national debate over how best to achieve stability in a republic; see esp. pp. 48–49, 66–67. A classic expression of the older republican conviction that history moves in cycles is James Bowdoin, *A Philosophical Discourse: Address to the American Academy of Arts and Sciences* (Boston: Benjamin Edes and Sons, 1780), pp. 10–11, which rehearses the standard cycle from "wealth, elegance, and politeness" to "affluence and luxury," then to "corruption, profligacy of manners, and vice," and inevitable dissolution.

the inherently unstable character of history itself.[14] He quarreled with his defensively optimistic contemporaries who projected a republican millennium realized in time. In his eyes they were deluded.[15] Yet Cole was never able fully to renounce the myth of the republic as nature's nation, becoming increasingly bitter at the widening gap between history and ideal. His art embodied this conflict, and its most characteristic form was dramatic.

Each of the five canvases in *The Course of Empire* is framed narratively and compositionally by those that precede and follow it. Establishing the unchanging locale of the series is a jagged escarpment towering directly above sea level and capped with a boulder. As the symbol of natural permanence within the constantly changing stage sets of history, this feature carries much of Cole's moralizing message.[16] In an 1833 letter to his patron Luman Reed describing the projected series, the artist wrote: "It will be well to have the same location in each picture: this location may be identified by the introduction of some striking object in each scene—a mountain of peculiar form, for instance. This will not in the least preclude variety."[17] In the first canvas, *The Savage State* (figure 2), this escarpment is visible in the central distance, its base shrouded in mist rising from a choppy sea. Behind it the meeting of plain and mountain is obscured by low-lying, windswept clouds, whose uneven density broadens out into a luminous sky over the ocean. Waves crash against the mainland, mingling their spume with mist and cloud. This is the elemental setting in which humanity first appears. Across the bay is a small settlement of conical dwellings encircling a fire whose smoke echoes the billowing cloud forms above. Cole's brush stroke is loose and sketchlike, suggesting the inchoate quality of natural forms as they emerge out of this atmospheric tumult.

14. See William L. Hedges, "The Myth of the Republic and the Theory of American Literature," *Prospects* 4 (1979): 101–20.

15. On the history of this idea, see David Noble, *Historians against History: The Frontier Thesis and the National Covenant in American Historical Writing since 1830* (Minneapolis: University of Minnesota Press, 1965); Perry Miller, "The Romantic Dilemma in American Nationalism and the Concept of Nature," in *Nature's Nation* (Cambridge: Harvard University Press, 1967), pp. 197–207; Ernest L. Tuveson, *Redeemer Nation: The Idea of America's Millennial Role* (Chicago: University of Chicago Press, 1968); Arthur Schlesinger, Jr., "America: Experiment or Destiny?" *American Historical Review* 82 (June 1977): 505–22.

16. Louis Noble, *The Life and Works of Thomas Cole*, ed. Elliot Vesell (Cambridge: Belknap Press of Harvard University Press, 1964), pp. 129–30 (hereafter cited as Noble-Vesell, *Life and Works*). A number of other themes such as fire tie together the five separate compositions of the series, as noted in Ellwood Parry, "*The Course of Empire:* A Study in Serial Imagery" (Ph.D. diss., Yale University, 1970), p. 128.

17. Cole to Luman Reed, September 18, 1833, in Noble-Vesell, *Life and Works,* p. 129. Cole had earlier presented the same idea to Robert Gilmor, whose patronage he originally sought for the series.

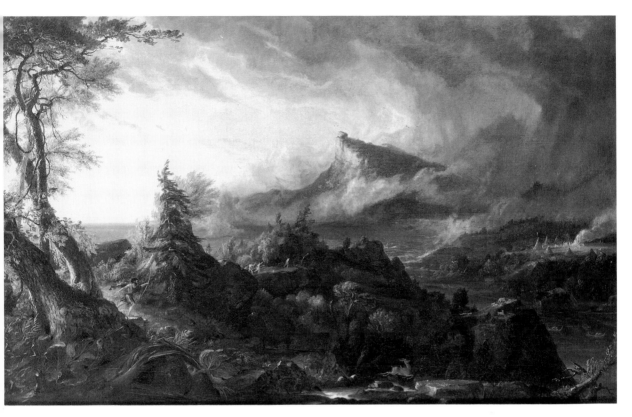

Figure 2. Thomas Cole, *The Course of Empire: The Savage State*, 1833–1836. Oil on canvas; 39½″ x 63½″. Courtesy of the New-York Historical Society, N.Y.C.

In the second canvas, *The Arcadian or Pastoral State* (figure 3), the escarpment now appears on the left side of the composition. The clouds that formerly obscured it have lifted, revealing a pellucid blue sky. Gone is the sublimity of untamed nature. The surface of the bay is unruffled. Avenues of trees, sundials, stone sluices, and other evidence of domestication have replaced the tangled wilderness of the previous canvas. Buildings clustered around the mouth of the bay and nearby a ship under construction indicate the beginnings of urbanism, commerce, and industry, which coexist with the pastoral pursuits that occupy the middle ground. With the domestication of nature comes the genesis of the arts, seen in the various figures who dance, make music, and draw.

On the left an old man making geometric tracings on the ground embodies classicizing reason, the first stage in the process by which natural relationships are abstracted and formalized. The search for order within nature remains benign. Farther back in the painting a druidical temple appears above the bay, its massive

Figure 3. Thomas Cole, *The Course of Empire: The Arcadian or Pastoral State*, 1833–1836. Oil on canvas; 39¼″ x 63½″. Courtesy of the New-York Historical Society, N.Y.C.

stone monoliths echoing the background mountain. Carefully placed between the pastoral landscape of the foreground and the elemental forms of the distant peaks, the temple expresses a religion harmonizing nature and man. The spatial rifts of the first canvas have now been smoothed out, the contours of the landscape reshaped by man. In the right foreground is a tree stump whose spiked heartwood strikes a jarring note in what is otherwise an idealized pastoral vision. With its reminder of the violent forces brought to bear in taming wilderness, the stump carried special relevance for American audiences, quietly drawing attention to the analogy Cole was making between his mythical republic and America in the 1830s.[18]

18. One underlying theme in the second canvas is the opposition of life and death forces in the early stages of empire. The woman in white who carries a distaff and spindle may represent Clotho, the

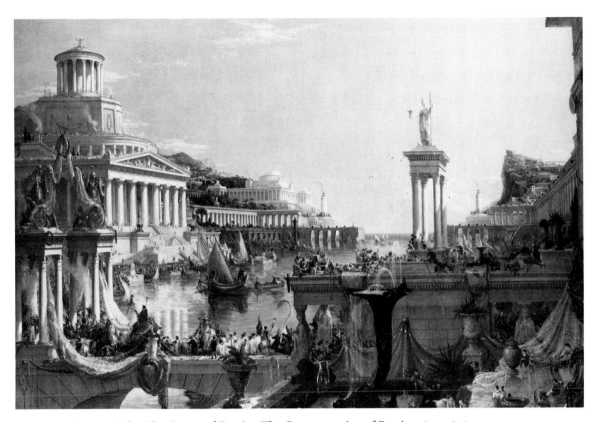

Figure 4. Thomas Cole, *The Course of Empire: The Consummation of Empire*, 1833–1836. Oil on canvas; 51″ x 76″. Courtesy of the New-York Historical Society, N.Y.C.

The stump is one of several other narrative prolepses of the third and central canvas, *The Consummation of Empire* (figure 4), in which culture has fully transgressed its natural origins. The pursuit of abstract reason here appears as a rage to remake nature in the image of man. Elaborate architecture hides the contours of the natural landscape. The pastoral dance has become the glutted pageant of the present scene. Trumpets and cymbals, the instruments of pomp, have replaced the simple wooden flute. Public ritual devised to glorify the emperor has usurped the spontaneous amusements of the pastoral phase. Natural religion has devolved into

youngest of the three Fates, who spins the thread of life, while the helmeted and shielded soldier emerging from behind a bank is associated with war and death. Noted by Emily Reynolds, "Thomas Cole's Microcosm in *The Arcadian State*" (M.A. thesis, University of Delaware, 1978).

a corrupt and idolatrous worship of wealth and power. The escarpment, appearing now on the far right, is reduced in relative scale, its topography regularized by steps, battlements, and terracing. Center stage is held by a colossal statue of Minerva, the goddess of culture and wisdom, under whose auspices the young mercantile empire has defied natural limits. Two huge beacons, or *phari,* marking the mouth of the bay commemorate the dominion of commerce. Inside the entrance to the harbor, the water now forms a reflecting pool.[19] The freshets of the first two canvases have been diverted into stylized fountains. Vegetation, cropped and enclosed in sculptural urns or shaped into festoons that drape the bridges spanning the harbor, reveals its human artificer.[20]

In the foreground a friezelike procession supporting the conquering emperor enters a gateway surmounted by a gilt statue celebrating the arts of war. The harbor is filled with ships of trade carrying the superfluous wealth of the nation. The precipitous angle of entry casts the viewer directly into the full glare of public life. A rigid geometry has been superscribed upon the serpentine lines of the once pastoral landscape. Hanging from the temple on the right is a banner bearing the image of an imperial eagle, its claws extended. The motif recalls the symbol of Roman might, but it also alludes to the American national seal.[21]

In the fourth and penultimate canvas, *Destruction* (figure 5), the axis of vision has once again shifted to the left and is now in line with the mouth of the harbor. The escarpment rears up abruptly at the point in the distance where the landscape dissolves into atmosphere. Smoke mimics the tumultuous cloud shapes of the first canvas, portending the disintegration of classical order.[22] The mirrorlike surface of the harbor is now shattered by waves. The light of the sun penetrating the smoke-

19. This central scene has notable parallels to French and Italian paintings of Napoleon's triumphal entry into the harbor of Venice, bringing to an end its history as an independent mercantile republic. An example is Giacomo Guardi's *Triumphant Arrival of Napoleon Bonaparte in Venice on 29th November 1807* (ca. 1808, Timken Art Gallery, San Diego). I am indebted to Jay Fliegelman of Stanford University for this observation.

20. Parry, "The Course of Empire," p. 108, notes other instances of nature transformed into art, such as the live stag which metamorphoses in the central canvas into a pedimental sculpture on the left side of the painting.

21. For a discussion of the parallels between *Consummation* and Jacksonian political behavior, see Angela Miller, "Thomas Cole and Jacksonian America: *The Course of Empire* as Political Allegory," *Prospects* 14 (1989): 65–92.

22. The vortex-shaped funnel of cloud and smoke at the center of the canvas may have had its source in Turner's *Snowstorm: Hannibal and His Army Crossing the Alps* (1812), which Cole saw and admired during his first trip to London. In both paintings nature itself seems in complicity with the forces of destruction, its inward-spiraling motion mirroring the self-consuming quality of human energies. For Cole's comments on Turner's *Hannibal,* see Noble-Vesell, *Life and Works,* p. 81.

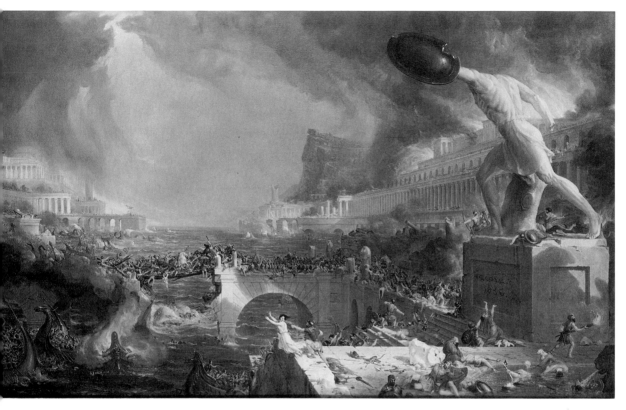

Figure 5. Thomas Cole, *The Course of Empire: Destruction*, 1833–1836. Oil on canvas; 39½″ x 63¼″. Courtesy of the New-York Historical Society, N.Y.C.

obscured sky in diagonal shafts reflects the eerie indifference of nature to human history. In the right foreground a colossal stone warrior strides aggressively into the scene of ruthless slaughter beneath him. His missing head lies shattered on the stone pavement, a symbol of the revenge history takes on the arrogance of reason.[23] He straddles a tree stump.

In *Desolation* (figure 6), the final canvas of the series, a pale moon shrouded in evening mist rises over the harbor. The sun, long an icon of imperial will, has been eclipsed by a feminine symbol of nature. The surface of the bay is once again serene.

23. The motif of the headless gladiator, which Cole based on the Borghese Warrior, recalls not only Shelley's "Ozymandias" but also a passage from "The Fall of Empire," in Timothy Dwight's epic poem of 1794, *Greenfield Hill:* "Soon fleets the sunbright Form, by man ador'd, / Soon fell the Head of gold, to Time a prey; / The Arms, the Trunk, his cankering tooth devour'd: / And whirlwinds blew the Iron dust away." In Augustus D. Evert and George L. Duyckinck, eds., *Cyclopedia of American Literature* (Philadelphia, 1875), p. 377.

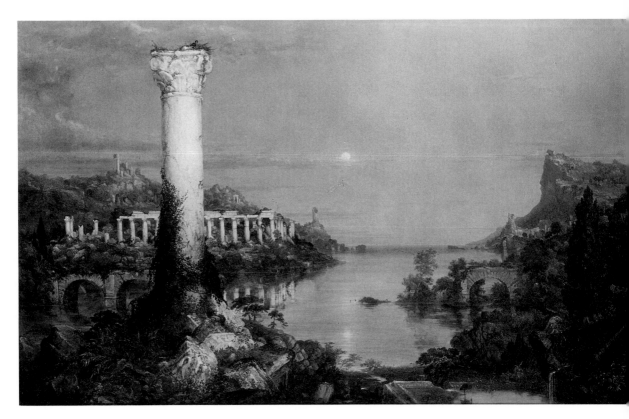

Figure 6. Thomas Cole, *The Course of Empire: Desolation*, 1833–1836. Oil on canvas; 39¼″ x 63¼″. Courtesy of the New-York Historical Society, N.Y.C.

No human presence is evident anywhere. History has been superceded by the cycles of nature. The escarpment, outlined against the dimly lit sky, has recovered its original monumentality. Around its base are clustered frail architectural remains that now mimic the forms of nature. In the foreground a single column, a token of the fallen human order, rises to the sky. A symbol of cultural arrogance, it is now a resting place for birds.[24]

The Course of Empire lends itself readily to the dramatic terms of scene and actor, stage and protagonist.[25] Like many of Cole's major works, the series reveals an

24. A further iconographic analysis of this column and its sources is in Angela Miller, "The Imperial Republic: Narratives of National Expansion in American Art, 1820–1860" (Ph.D. diss., Yale University, 1985), pp. 85–101.

25. Few have actually pursued this analogy. Samuel Isham, *The History of American Painting* (1905; reprint, New York: Macmillan, 1942), p. 225, compared *The Course of Empire* to the plot of a play requiring "several acts for its exposition." See also Miller, "The Imperial Republic," pp. 85–92.

underlying debt to the theater. The five-part structure of *The Course of Empire* parallels the five-part Shakespearean tragedy with its final moralizing soliloquy.[26] Even the manner in which Cole established certain dramatic conditions in the beginning, setting the action into motion to realize its inevitable consequences, suggests a dramatic model, as does Cole's effort to create a sense of continuity from one canvas to another through proleptic symbols pointing to the next phase of history. His approach resembles the manner in which characters in a play intimate to audiences the shape of things to come. Beyond these overt parallels with the theater, Cole's vision of time and history as the unfolding of established forces and conditions is inherently dramatic, as was his habit of personifying abstract agencies and endowing the elements of nature with anthropomorphic qualities.[27] From *The Course of Empire* to the later *Voyage of Life* and the unfinished *Cross and the World*, nature served as stage for allegories first of national and later of spiritual self-definition. But the denouement of the dramatic conditions was already known as part of a familiar narrative of failed republics. To this ready explanation for history's cycles Cole gave a romantic gloss: virtue came from an authentic selfhood discovered in nature. The city, traditionally the locus of civic *virtù*, threatened a loss of spiritual purity, inclining the republic toward overcivilization and debauchery. This romantically updated republican vision was most fully realized in his *Course of Empire*.

The public success of Cole's series was ironically grounded in misunderstanding. Several months before its opening, Cole lamented to his patron: "Very few will understand the scheme of [the series]—the philosophy that may be in them."[28] His anxiety proved well founded, for Cole's public resisted his cautionary message. The drama of imperial decline was retold again and again by delighted reviewers, who carefully avoided acknowledging any parallels between Cole's imaginary empire and contemporary America. "Parents," wrote one critic, "will bring their children here and explain to them the *Course of Empire*, and tell them stories of other lands."[29]

26. Shakespeare was a mainstay of the New York stage in Cole's time. See George C. D. Odell, *Annals of the New York Stage* (New York: Columbia University Press, 1927–1949), vols. 3 (1821–1834) and 4 (1834–1843).

27. Cole wrote to his wife in 1841 from the Swiss Alps: "And here, I have been *repeopling* my mind with nature" (emphasis added). Quoted in Howard Merritt, *To Walk with Nature: The Drawings of Thomas Cole* (Yonkers: Hudson River Museum, 1982), p. 47.

28. Cole to Luman Reed, March 6, 1836, Archives of American Art, Reel ALC1. Quoted in part in Noble-Vesell, *Life and Works*, p. 160.

29. "Remarks," in *Catalogue of the Exhibition of the New York Gallery of the Fine Arts* (New York, 1844), p. 5, Archives of American Art, Reel D6, frame 867. One notable exception to this general

This collective denial of Cole's real subject—America in the 1830s—was part of what a later historian aptly termed a "confession and avoidance syndrome," in which Americans ritually repeated the lessons of Old World history only to deny their present applicability.[30] "The migration, on the path of the ages, of all that constitutes national greatness is a salient historical fact, which renders the proof of progress exceedingly difficult," admitted a contributor to the *North American Review* in 1846, a decade after Cole's series opened, going on, however, to deny its implications for America in a typical volte-face.[31] Such a vision rested on an enormous historical double standard, perpetuated by the popular press, by schoolbooks, and by congressional rhetoric. America would soon boast a stature equivalent to that of the greatest empires of the Old World, but the exceptional conditions of its expansion—peaceful, nonaggressive, republican, and blessed with an inexhaustible wilderness—guaranteed that the nation would avoid the fate drawn by Cole.

Embarking on a vigorous course of widening democratic and economic opportunities and expansion into new lands, Jacksonian Democrats looked to Rome to validate their distinct combination of republican institutions and vigorous growth. Rome had long provided cultural precedents for America's youthful civic identity, architecture, and oratory. In Rome, the arts of citizenship had developed into the foundation of a powerful empire. Yet Rome also symbolized a colossal defeat of republican objectives. Couching his national allegory in ancient Roman garb, Cole reminded Americans that the imperial analogy they drew between themselves and the second great republic of the Old World was double-edged.

In 1829 Cole traveled to Europe, soon after Andrew Jackson was elected to his first term as president. Three years later he returned to a changed country. New York's rapidly accumulating wealth had earned it a number of revealing sobriquets,

pattern was James Fenimore Cooper, who, in a letter to Louis Noble dated January 6, 1849, praised Cole's work but thought little of his power as a social critic: "The criticism of this country is not of a very high order—and is apt to overlook the higher claim of either writer or artist else would this series have given Cole a niche, by himself in the temple of Fame." The letter is reproduced in full in *The Letters and Journals of James Fenimore Cooper*, ed. James Franklin Beard (Cambridge: Harvard University Press, 1960–1964), 5:396–400. Louis Noble characteristically omitted this revealing passage from his transcript of the letter in his biography of Cole.

30. Fred Somkin, *The Unquiet Eagle: Memory and Desire in the Idea of American Freedom, 1815–1860* (Ithaca: Cornell University Press, 1967), p. 66. America's double position as the last of the world's great empires and the first to realize millennial prophecies on earth supported the somewhat nervous logic of American exceptionalism.

31. "The Progress of Society," review of Thomas Arnold, *Introductory Lectures on Modern History*, *North American Review* 63 (October 1846): 337.

from "the American Tyre" to "Babylon" and Cole's own disparaging "Babel."[32] Even in the midst of prosperity, middle-class Americans wondered where they stood within the familiar republican cycle from chasteness to luxury and enervation which informed the visual rhetoric of Cole's commercially glutted empire. Wrote a contributor to the Whig *American Review:* "As for luxury, sometimes represented as the highest proof and fairest flower of civilization—it is rather its gangrene and plague-spot. It presupposes civilization as death presupposes life. . . . all history conspires to teach that great wealth is not an indispensable means, nor is luxury a healthy symptom of a high degree of civilization."[33] It was perhaps with such ideas in mind that Jasper Cropsey described the Catskill studio of Cole, the artistic prophet of republican virtue, as a chaste and wholesome retreat having "no appearance of Luxurie and wealth."[34]

Anxieties about America's future frequently surfaced in catastrophic scenes from the Old Testament, which regularly appeared in giftbook literature and popular prints from the 1830s through the 1850s. Subjects such as Washington Allston's *Belshazzar's Feast* had earlier served as veiled commentaries on contemporary events.[35] The themes of the Deluge and the plagues of Egypt, inspired by the example of the English painters Francis Danby and John Martin—the latter an early influence on Cole—played on the Protestant guilt of middle-class audiences luxuriating in a new sense of prosperity and material abundance. Martin's lurid paintings expressed a pervasive Anglo-American fear that commercial prosperity, pride, and empire would culminate in a national day of reckoning. The final moments of Rome and Carthage were vividly captured in the mid-1830s for New York readers, treated to lurid tales of glutted and corrupt empire, followed by

32. See Timothy Flint, *Recollections of the Last Ten Years' Journeyings in the Valley of the Mississippi,* ed. George Brooks (Carbondale: Southern Illinois University Press, 1968), pp. 389, 394, for comments on New York City; Cole to Charles Parker, January 8, 1844, Archives of American Art, Reel ALC1.

33. "Civilization: American and European," *American Review* 3 (June 1846): 613. See also "The Neglect of Moral Science," *Knickerbocker* 3 (February 1834): 97. Suspicion of luxury, however, was not exclusively Whig; James Fenimore Cooper, a Democrat most of his life, penned a similar attack on luxury in *Chainbearer; or The Littlepage Manuscripts* (New York, 1845), p. 39. Republican anxieties about the impact of abundance persisted throughout the century. See George B. Forgie, *Patricide in the House Divided: A Psychological Interpretation of Lincoln and His Age* (New York: Norton, 1979), pp. 71–77; T. J. Jackson Lears, *No Place of Grace: Antimodernism and the Transformation of American Culture* (New York: Pantheon, 1981), pp. 4–5.

34. " 'The Brushes He Painted With That Last Day Are There . . .': Jasper F. Cropsey's Letter to His Wife, Describing Thomas Cole's Home and Studio, July 1850," *American Art Journal* 16 (Summer 1984): 82.

35. See David Bjelajac, *Millennial Desire and the Apocalyptic Vision of Washington Allston* (Washington, D.C.: Smithsonian Institution Press, 1988).

meditations on the hauntingly silent specter of ruin that ended the imperial drama.[36] Engravings of cities glittering profanely with the wealth of subject nations, of clouds gathering in summary fulfillment of divine edict, of thousands fleeing earthquakes and volcanoes spewing forth ashes and brimstone regularly greeted the sedate middle-class readership of gift books and special illustrated editions of the Bible. Such visions of corrupt pagan empires driven by their pride and ambition to a wrathful encounter with Providence furnished a convenient foil to the religious and political enlightenment readers credited to their own rising nation. Yet such images also betrayed a thinly disguised social hysteria, channeled into evangelical crusades and pulpit jeremiads against wealth, warning that the nation was recapitulating the familiar historical cycle. Such apocalyptic biblical themes were collective calls to moral vigilance.[37]

The year that Cole unveiled *The Course of Empire* before New York audiences, Noah Webster, youthful revolutionary turned conservative patriarch, wrote of his nation: "We deserve all our public evils. We are a degenerate and wicked people."[38] Webster's pessimistic feeling that America had lost touch with its virtuous origins characterized the broader dissent that accompanied Jackson's administration. To men such as Hone, Webster, and Cole, the uncontrolled migration of Americans toward the frontier undermined traditional restraints on individual passions. This "go-ahead" spirit produced a blind pursuit of self and a thoroughgoing immersion in the present. The disorder of the frontier, in their eyes, was only one manifestation of a reckless spirit that mindlessly embraced new technology, speculated rashly, and, like Holgrave in Hawthorne's *House of the Seven Gables,* would have each generation build its own house anew. Whigs saw the breakdown of deference toward the natural aristocracy of intellect and talent to which the earlier Federalist party had looked as a falling away from the past.[39] It was not expansion itself but its

36. See, for instance, "A Day at Carthage," by M[ordecai] M[anuel] Noah, *New-York Mirror,* March 28, 1835, which closely resembles the last three canvases of Cole's series. Noah's sketch concludes on a moralizing note characteristic of the genre: "Ambition—proud, anxious, restless ambition— might here receive a salutary lesson." Other examples are "The Minute-Book: A Series of Familiar Letters from Abroad: Rome," *New-York Mirror,* April 18, 1835; and "Original Sketches of Ancient Rome: A True Tale of the Coliseum," *New-York Mirror,* February 3, 1836.

37. On the currency of apocalyptic themes in nineteenth-century Anglo-American culture, see Curtis Dahl, "The American School of Catastrophe," *American Quarterly* 11 (Fall 1959): 380–90; Morton D. Paley, *The Apocalyptic Sublime* (New Haven: Yale University Press, 1986).

38. Cited in Richard Rollins, *The Long Journey of Noah Webster* (Philadelphia: University of Pennsylvania Press, 1980), p. 1.

39. Peter Dobkin Hall, *The Organization of American Culture, 1700–1900: Private Institutions, Elites, and the Organization of American Nationality* (New York: New York University Press, 1983). Hall's

rate, manner, and social results that provoked dissent among the "party of Memory."[40] Cole too was frequently repulsed by the manic quality of American life in the 1830s, telling William Dunlap, after his visit to Italy, that he admired Florence's "delightful freedom from the common cares and business of life—the vortex of politics and utilitarianism, that is forever whirling at home."[41]

For those who shared Cole's mind-set, the years surrounding the exhibition of his series were full of ominous signs: economic and social afflictions including a cholera epidemic in 1832 (and again in 1849), frequent fires that took many lives and consumed millions of dollars in property, and a devastating depression in 1837 that left behind ruined careers and powerful resentment against the ruling Democratic party of Andrew Jackson.[42] Even as *The Course of Empire* was being hung, the financial bubble of speculation was about to burst, exposing Americans to the revenge that prosperity takes on its children. The depression brought with it a growing awareness of economic cycles of expansion and contraction that seemed to contradict belief in linear development. Emerson's law of compensation was born of this experience.[43] The social and financial condition of the nation mimicked Cole's series. Years later Henry Ward Beecher, minister laureate to the nation in the generation after Cole's, evoked the extraordinary sense of ruin and desolation that accompanied the depression of 1837. Following a "summer of prosperity" promising "a realization of oriental tales," came "storms, and blight":

> Men awoke from gorgeous dreams in the midst of desolation. The harvests of years were swept away in a day. . . . The wide sea of commerce was stagnant. . . . Cities were ransacked by troops of villains. . . . The world looked upon a continent of inexhaustible fertility, (whose harvest had glutted the markets, and rotted in

book focuses on New England, but its argument may be usefully extended to the older mercantile elite of New York. See also Daniel Walker Howe, *The Political Culture of American Whigs* (Chicago: University of Chicago Press, 1979).

40. The phrase is Emerson's; see also R. W. B. Lewis, *The American Adam: Innocence, Tragedy, and Tradition in the Nineteenth Century* (Chicago: University of Chicago Press, 1955), p. 7 and passim.

41. Dunlap, *Rise and Progress of the Arts*, 2:364.

42. See Charles Rosenberg, *The Cholera Years: the United States in 1832, 1849, and 1866* (Chicago: University of Chicago Press, 1962); Samuel Rezneck, "The Social History of an American Depression, 1837–1843," *American Historical Review* 40 (July 1935): 662–87; William Charvat, "American Romanticism and the Depression of 1837," *Science and Society* 2 (Winter 1937): 67–82. Numerous references to the depression appear in the *Diary of Philip Hone* for 1836 and 1837.

43. Ralph Waldo Emerson, "Compensation" (1841), in *Essays: Second Series* (Columbus, Ohio: Charles E. Merrill Standard Editions, 1969), p. 95.

disuse,) filled with lamentation, and its inhabitants wandering like bereaved citizens among the ruins of an earthquake, mourning for children, for houses crushed, and property buried forever.[44]

In Beecher's biblical imagery the depression was an affliction visited upon an errant people. To Philip Hone, Jackson played the part of a corrupt Old Testament ruler in a quasi-biblical drama of retribution. His administration had produced "a wider desolation than the pestilence which depopulated our streets [in 1832], or the conflagration which laid them in ashes [in 1835]."[45] Hone's conflation of natural disasters—earthquakes, fires, and plagues—with financial panic and urban disorder was a turn of mind apparent in the elemental upheaval that accompanies the demise of Cole's empire.

Such economic cycles differed in one crucial respect from Cole's pictorial cycle: the former were inherently unpredictable and unstable. Seen in this light, Cole's series was an effort to impose form and sequence on the fluctuations of the market, a new reality that seemed to fall outside the boundaries of the eighteenth-century rationalist universe. He gave a moral significance to amoral realities—the laws of credit, the economic behavior of Americans scrambling to realize their opportunities, the internal contradictions of a market culture.

The tendency to moralize economic patterns of growth and collapse was common among Cole's circle. Whig merchants such as Hone associated expansion with sudden contraction, growth with eventual collapse. Seeing that Jackson's policies were encouraging the rapid settlement of western lands and the empowerment of a new class of entrepreneurs, they feared that social as well as economic values would be set adrift.[46] The fears of national collapse were proportionate to the sense of vulnerability that surrounded republican forms of government. Private pursuits had preempted a sense of civic responsibility. New York Whigs recalled regretfully the founding vision of a nation whose social parts fit together in a smooth hierarchy, where growth was restrained by reason, and in which culture was legislated from above.[47] The imperial aggressions of the Mexican-American War in the ensuing decade further confirmed their forebodings.

Cole's negative construction of empire was the product of older attitudes more

44. Henry Ward Beecher, *Lectures to Young Men* (New York: M. H. Newman, 1849), pp. 51–52.

45. Entry for October 28, 1837, in *Diary of Philip Hone*, p. 281. Following a rash of bank failures in 1837, Hone predicted "ruin, revolution, perhaps civil war" (p. 255). See also Bjelajac, *Millennial Desire*, pp. 130–31; Miller, "Cole and Jacksonian America."

46. For cultural responses, see Somkin, *Unquiet Eagle*; Douglas Miller, *The Birth of Modern America, 1820–1850* (New York: Pegasus, 1970), esp. pp. 42–66; and Miller, *Jacksonian Aristocracy: Class and Democracy in New York* (New York: Oxford University Press, 1967), p. 121.

47. Wallach, "Cole and the Aristocracy," pp. 94–106.

than contemporary definitions. The rise of the landscape genre in the 1820s coincided with the beginnings of a recasting of the meanings of empire. From the 1820s to the 1870s *Webster's Dictionary* defined the term as "supreme power in governing; supreme dominion; sovereignty; imperial power," and as "the territory, region or countries under the . . . domination of an emperor." Sometime between 1860 and 1870 the word "imperialism" entered the lexicon for the first time, conventionally defined as "the power, authority, or character of an emperor." Alongside this, however, appeared a newer definition: "the spirit of empire." *Webster's* merely codified a shift in meaning that had been occurring over the decades, and that transformed empire building from an arrogant autocratic policy into a benign democratic program.[48] The 1828 triumph of Jackson and the expansionism he sponsored marked the beginning in this transformation of meaning. Although more traditional associations of empire with arbitrary power persisted, there was now the further meaning of a mystical imperative rooted in the life of an entire culture. Ironically, however, Cole, the artist most associated with the beginnings of a native landscape tradition in the United States, was also the least inclined, both philosophically and politically, to accept this emergent definition of "nature's nation" as an empire—a definition embodied in the landscape genre he inspired. The painters who followed him, however, came of age in the belief that expansion was a natural and benign process fully necessary to the consummation of America's national destiny.

The narrative devices and overt theatricality of Cole's allegorical series at first glance share nothing in common with his views of native scenery. Yet in one major instance—*View from Mount Holyoke, Northampton, Massachusetts (The Oxbow)* (1836, plate 1)—the dramatic structure more explicitly worked out in his *Course of Empire* informed an *American* landscape. In this instance, at least, what Barbara Novak and others have interpreted as a division in Cole's art between history painting and native views may be understood as a diverse expression of a unitary impulse central to Cole's imagination—the need to dramatize, upon changing stage sets, the interaction between culture and nature.[49] The dramatic structure of his serial painting persisted as a key element in these native scenes.

48. The earliest cited example of the term "imperial" given by the *Oxford English Dictionary* is from the October 1858 issue of the *Westminster Review*. Despite the general shift in meaning, it continued to serve as a term of opprobrium, particularly among Whig writers. In "The President and His Administration," *American Review*, n.s., 1 (May 1848): 439, the term is used to criticize the behavior of the Democratic administration during the Mexican-American War.

49. Barbara Novak, *American Painting in the Nineteenth Century* (New York: Praeger, 1969), pp. 61–80, esp. 79. See also E. P. Richardson, *A Short History of American Painting* (New York: Thomas Crowell, 1963), pp. 124–29; Alan Wallach, "Thomas Cole: British Aesthetics and American Scenery,"

Cole completed *The Oxbow* in the same year that he exhibited his *Course of Empire*, yet the painting appears to be worlds apart from the series's historical props and apocalyptic vision.[50] Cole's most ambitious "native" landscape up to that time, *The Oxbow* offers a striking panoramic prospect evidently without narrative content. Here, as in *The Course of Empire*, Cole employed the varieties of landscape, ranging from the wild to the settled, the sublime to the picturesque and the pastoral. Nowhere is there a hint that he intended anything more programmatic. Nonetheless, having devoted his energies for the previous two and a half years to *The Course of Empire*, Cole carried to the composition of *The Oxbow* a version of the story already told in his five-part imperial cycle, as if to test his historical thesis on American soil. On one level *The Oxbow* furnished Cole a temporary respite from the demands of a complex historical composition, allowing him to summon his creative energies once again before making the final onslaught on his series. Yet the historical issues explored in *The Course of Empire* cast their shadow on his landscape.

That Cole was thinking in narrative terms when he turned to the composition of *The Oxbow* is clear from a remark he made about the work in a letter to Luman Reed, dated March 2, 1836, in which he explained both his choice of subject and his decision to employ a large canvas—the same used for the sketch of *Consummation*—for the work: "Inclination if not judgement urged me to paint the larger, for having but one picture in the exhibition, & that painted expressly for it & understanding there will be some dashing landscapes there, I thought I should do something that would *tell a tale*."[51] He concluded gloomily: "You must not be surprised if you find the picture hanging in my rooms next year." Cole's motive was to construct a narrative with both a protagonist and a dramatic structure. Quite clearly present in *The Course of Empire*, this narrative is less obvious in *The Oxbow*.

The central dramatic episode here is the storm front moving across the landscape. Beyond this, however, the subject of Cole's *Oxbow* is the confrontation between wilderness and the colonizing energies of American agriculture at a particular moment in history, a theme that is cast in the metaphor of natural

Artforum (October 1969): 46–49; Franklin Kelly, "The Legacy of Thomas Cole," in Kelly and Gerald L. Carr, *The Early Landscapes of Frederic Edwin Church, 1845–1854* (Fort Worth: Amon Carter Museum, 1987), p. 36.

50. The circumstances in which Cole decided to paint *The Oxbow* are detailed in Osvaldo Rodriguez Roque, "The *Oxbow* by Thomas Cole: Iconography of an American Landscape Painting," *Metropolitan Museum Journal* 17 (1984): 63–73. See also Roque, entry in *American Paradise: The World of the Hudson River School* (New York: Metropolitan Museum of Art, 1987), pp. 125–27.

51. The emphasis is Cole's; Archives of American Art, Reel ALC1. The letter is reproduced in full in Roque, entry in *American Paradise*, p. 126.

process. The only figure in the 1836 landscape is that of the partially concealed artist nestled in a slight concavity in the center foreground and signaled by a camp stool and folded umbrella on a nearby rocky outcropping. Cole's artist is a passive observer witnessing the grand natural spectacle that unfolds before him, a miniature version of which is presumably on his easel in a form of visual *mise-en-abîme*. Far from assuming the posture of a mute witness, however, he turns his head to gaze back toward the audience of his painting. The gesture suggests a type of artistic double consciousness in which the painter is both a witness or spectator of the natural landscape and a participant or actor in our world. He straddles not only the worlds of art and nature but the worlds inside and outside his painting. By turning to encounter the viewer, Cole's artist interrupts the fiction of passive absorption in nature. On one level Cole playfully creates the impression that the artist has been startled by our presence as we force our way through the underbrush in order to enter his picture. On another level our raised prospect places us in a more advantageous position than the artist, still ensnared within the difficult terrain of the mountaintop. By striking up a mute dialogue with the viewer, Cole introduced a new element of self-consciousness into the absorptive panoramic spectacle of nature. This spectacle presents itself at first glance as a view, with its attendant condition of neutral and nonparticipatory spectatorship. Cole's presence in his own painting, and his glancing encounter with the viewer, further undermines the illusionism of the painted landscape as a mirror of nature by depicting the process of artistic production—the painted image on the easel. The curious transaction between artist and viewer prompts us not only to consider the natural drama that is the subject of the painting but the aesthetic formulas that shape our encounter with nature. We are made aware of the relationship of the artist to his audience, an important constituent in how meaning is produced. Drawn into an encounter with the artist, we are simultaneously brought to a fresh consideration of the subject.

Where Cole differs from those who later followed his narrative program was in challenging both the passivity of the observer and the resulting image of a landscape progressively transformed by a natural and inevitable process of cultural colonization. By calling attention to the act of spectatorship, Cole is also probing the role of the human observer as a historical actor. His act of witnessing carries with it as well the charge of interpreting the moral meaning of events. Yet the animate energies of nature in *The Oxbow* threaten to compromise the creative power of the artist. It was only through an identification with nature's power that Cole could subdue this threat of artistic annihilation and secure his own creative voice. The large scale of the painting, its panoramic reach and masterful directing of the various actors in the drama all ensure that Cole's power as a witness is never subsumed by the power of what he represents.

Although the ostensible protagonist of the tale told by *The Oxbow* is the artist figure, his observer stance leaves the stage open for another, more active and vital presence. Nature emerges in *The Oxbow* once again as both scene and actor, yet for perhaps the first and only time in nineteenth-century American landscape painting, these become one. The point is more readily understood if we compare *The Oxbow* to earlier and later landscapes. In the former case, such as Thomas Doughty's *In Nature's Wonderland* (1835, figure 7), nature remains a static representation, never emerging as a fully dynamic realm with its own self-generating organic laws. Any references to the processes of history are banished, despite the presence of a human observer. Such an observer passively absorbs a nature which, though wild and untenanted, paradoxically remains neatly contained and bounded. The misty softness of outline and dim lighting of the painting remove the viewer from the subject and substitute implied mysteries for a more forceful handling of forms. Doughty's painting could be a setting for an American *Midsummer Night's Dream*.[52]

At another extreme is the dominant mode of midcentury academic landscape art in the northeastern United States (a topic explored in Chapter 2). In Asher B. Durand's *Progress* of 1853 (see plate 5), for instance, nature is the stage on which the various phases of settlement occur, such as clearing the forests and establishing canal, river, and rail links to other parts of the republic. Although natural stage and human actor are dynamically interrelated in the historical process of settlement, the fundamentally destructive character of settlement is disguised by the pastoral aesthetics of the middle landscape, which smooths over the contest between nature and culture. Despite the ideological effort to disguise the invasive impact of the American on the land, iconographic traces—tree stumps—remind the viewer of the conflict inherent in colonizing efforts.

What occurs in Cole's *Oxbow* fits neither of these contrasting patterns. The meteorological drama that constitutes the main action of the painting is both a natural metaphor for the transformation of wilderness into cultivated farmland and a subject in its own right, its sublimity diminishing the visual power of the settled landscape. Human agency is evident in the carefully tilled fields. These, however, are pushed into the background, their pale hues contrasting with the dark, saturated forest greens of the left side. The drop into the distant agricultural prospect is precipitous rather than gradual, for Cole dispenses with the Claudean devices that he brought to his Catskill views of the later 1830s, with their almost poignant sense of nostalgia for a tranquil, harmonious nature.[53] The effect of this

52. On Doughty, see Frank Goodyear, *Thomas Doughty, 1793–1856: An American Pioneer in Landscape Painting* (Philadelphia: Pennsylvania Academy of the Fine Arts, 1973).

53. These include Cole's *View on the Catskill—Early Autumn* (1837, Metropolitan Museum of Art) and *River in the Catskills* (1843, M. M. Karolik Collection, Museum of Fine Arts, Boston). See Kenneth

Figure 7. Thomas Doughty, *In Nature's Wonderland*, 1835. Oil on canvas; 24½″ x 30″.
© The Detroit Institute of Arts, Founders Society Purchase, Gibbs-Williams Fund, 35.119.

sudden drop is to create a sense of rupture which is not only spatial and aesthetic but also historical, separating a nature viewed as a self-generating realm from one that, by being "domesticated," is also deprived of any agency distinct from the human and social forces that colonize it. Cole's *Oxbow* contrasts a fully autonomous, cyclically self-renewing nature with one that is dependent on the humanly

LaBudde, "The Rural Earth: Sylvan Bliss," *American Quarterly* 10 (Summer 1958): 142–53; Roque, entry in *American Paradise*, pp. 128–29; Kenneth Maddox, "The Railroad in the Eastern Landscape, 1850–1900," in Maddox and Susan Danly Walthers, *The Railroad in the American Landscape, 1850–1950* (Wellesley, Mass.: Wellesley College Museum of Art, 1981), pp. 18–19.

shaped rhythms of agriculture. Unlike the natural cycles shown on the left side of *Expulsion from the Garden of Eden* (1827–28, figure 8), a nightmarish image of a world without grace, the weather cycles of *The Oxbow* are manifestations of natural vitality and self-renewing power.

Cole's panoramic contrast between wilderness and settlement was artistically contrived for the sake of his pictorial—and historical—drama, and should not be seen as an accurate transcription of the site. In 1837, a year after he completed his painting, an estimated two to three thousand visitors enjoyed the same view as Cole's artist. As early as 1821 a shelter atop Mount Holyoke furnished tourists with protection from the weather.[54] The complexity of Cole's treatment is evident in comparisons of *The Oxbow* with later views of the same sight, based for the most part on William Bartlett's "View from Mount Holyoke," a print in *American Scenery* (ca. 1837–38, figure 9). Bartlett's view came to epitomize the pastoral ideal, somewhat ironically, given the proliferating industry along the Connecticut River. Populated by well-dressed tourists, his version of the Oxbow minimizes the transition between Mount Holyoke and the valley of the Connecticut River.[55]

The point, however, is not that Cole was less accurate than those artists who chose to emphasize the pastoral character of the site, but rather that each artist chose a treatment that served the tale he wished to tell.[56] The two halves of the *Oxbow* recapitulate, in terms of the contemporary American landscape of the 1830s, the stages through which culture overtook nature in *The Course of Empire*. Although it pauses at the pastoral phase of the second canvas, the historical dynamic generating the further domestication, and transgression, of nature in *The Oxbow* is nonetheless implicit.[57]

The panoramic format of *The Oxbow* collapses the sequential narrative of *The Course of Empire* into a single image, transforming temporal into spatial terms.[58]

54. Hans Huth, *Nature and the American: Three Centuries of Changing Attitudes* (Berkeley: University of California Press, 1957), p. 77; Martha J. Hoppin, ed., *Arcadian Vales: Views of the Connecticut River Valley* (Springfield, Mass.: George Walter Vincent Smith Art Museum, 1981), pp. 15–19.

55. Frederic Church's painting of the Oxbow (ca. 1844–1846) was based not on Cole's painting but on Bartlett's print. On Bartlett's influence, see Hoppin, ed., *Arcadian Vales*, pp. 54–59, 65, 86–88.

56. Elsewhere, however, Cole responded to the pastoral qualities of the Connecticut River valley in his "Essay on American Scenery," *American Monthly Magazine*, n.s., 1 (January 1836): 1–12, reproduced in John McCoubrey, ed., *American Art: Sources and Documents* (Englewood Cliffs, N.J.: Prentice-Hall, 1965), pp. 98–109, esp. 106.

57. Cole's letter to Luman Reed states: "I could not find a subject very similar to your second picture [*The Pastoral State*] & time would not allow me to invent one," suggesting that he had had *The Pastoral State* in mind when conceiving *The Oxbow*.

58. Parry, *The Art of Thomas Cole*, p. 176, links the movement of the storm front with "the continuous motion and dramatic orchestration of a moving panorama."

Figure 8. Thomas Cole, *Expulsion from the Garden of Eden,* ca. 1827–28. Oil on canvas; 39″ x 54″. Gift of Mrs. Maxim Karolik for the Karolik Collection of American Paintings, 1815–1865. Courtesy, Museum of Fine Arts, Boston.

This image may be read from left to right, instinctively, as one would read a text. Were the painting panoramically extended to the right, one can easily imagine that it would trace the successive stages of urbanization.

The spatial organization of the landscape in *The Oxbow* introduces further ambiguities that only deepen the paradoxes of a nature that is simultaneously self-generating and contingent, actor and acted upon. The implied narrative of the landscape calls for a left-to-right movement of the gaze not only because of reading habits but also because of the underlying theme of wilderness transformed into settled landscape. According to this reading *The Oxbow* challenges neither the

Figure 9. William Bartlett, "View from Mount Holyoke." Lithograph in Nathaniel Parker Willis and William Bartlett, *American Scenery; or, Land, Lake, and River Illustrations of Transatlantic Nature*, volume 1 (London: George Virtue, 1840).

viewing habits nor the ideological assumptions of its audiences concerning the foreordained passage of nature into culture. Yet it remains for the viewer to decide whether the storm front is moving from right to left, emphasizing nature's more benign face and promising that the wilderness, now cast in the shadow of the storm, will shortly be bathed in the light of human dominion, or from left to right, in which case the sunny agricultural landscape will soon be engulfed in storm clouds. The painting's title, which specifies that the view is taken *after* the thunderstorm has passed over, encourages the more optimistic understanding of the work, but the habit of reading images from left to right counters this interpretation.[59] By leaving

59. The narrative use of weather was not confined to Cole; James A. W. Heffernan, "The Temporalization of Space in Wordsworth, Turner, and Constable," in Heffernan, ed., *Space, Time, Image, Sign:*

the choice to the observer, Cole once again challenges the assumption of a passive stance before the image.

The programmatic ambiguity of meaning in the painting is evident not only in a structural and narrative sense but also in the motifs and markings within the natural landscape. Its main subject—the oxbow of the subtitle—forms a giant question mark. After virtually looping back upon itself, the river is obscured by the mountainside in the left half of the canvas. Cole was the only artist to exploit the symbolic ambiguities contained in this curious natural convolution by associating it with the structural and narrative ambiguities already described. The image of a river appearing to reverse its course accounted in some part for the touristic interest the spot had enjoyed since the 1820s. In another sense, however, the reference was to an association rooted in the popular emblem tradition between rivers and the flow of time and history, a linkage later exploited by Cole's *Voyage of Life*. In the latter series, however, the river itself has been transformed into a purely emblematic device. In *The Oxbow* the naturalistic and topographical properties of the scene are given a weight at least equal to its symbolic properties. Yet these remain, with their allusion to the flow of history and the as yet unanswered questions at the heart of American identity. The prospect of a river reversing course and changing direction, as the Connecticut appears to do in Cole's painting, evokes a historical moment of transition from wilderness to settlement. For Cole, this transition was neither gradual nor harmonious.

The oxbow further alludes to the tool for harnessing the oxen that brought the land under cultivation, an association that would have been readily recognizable to a contemporary audience still only a step removed from agricultural realities.[60] The domesticated natural topography thus bears an integral if symbolic relationship to farm animals and their human masters.

A 1981 interpretation of *The Oxbow* has revealed that the painting may be quite literally "read." Inscribed upon the surface of the deforested hill in the central distance of *The Oxbow*, in what appear to be random plough markings, are the Hebrew letters for *Shaddai*, or "the Almighty."[61] This explicit allusion to the covenant between God and his chosen people spells out what is at stake in the historical dynamic enacted on the stage of nature, further evoking the retributive

Essays on Literature and the Visual Arts (New York: Peter Lang, 1987), p. 67, points out that Constable too employed "transitional weather patterns . . . that would signify what had preceded and what would follow them" and that therefore carried narrative significance, with possible national or political overtones.

60. The *Oxford English Dictionary* gives this as the primary definition of "oxbow."

61. Matthew Baigell and Allen Kaufman, "Thomas Cole's *The Oxbow*: A Critique of American Civilization," *Arts Magazine* 55 (January 1981): 136–39, first made this observation.

powers of the Old Testament divinity.[62] It also plays upon the element of choice implicit in the bifurcated landscape. *The Oxbow,* however, does not present its historical dilemma in those absolute terms assumed by earlier split compositions such as *The Choice of Hercules,* clearly an either-or proposition for the central figure.[63] Instead the historical dilemma raised by *The Oxbow* is the aesthetic and cultural incompleteness of both the landscapes that it represents. The very autonomy of the wilderness on the left bars the active participation of the artist in any creatively fertile sense, while the agricultural farmland to the right is so stripped of the natural energies associated with wilderness as to offer little food for his imagination. The result is that what at first appears to be an either-or choice is revealed to be a neither-nor dilemma that can be only ambiguously resolved at best. The alternative to reading the painting in terms of simple polarities is to interpret it as a testament to Cole's prophetic vision, a power that elevates him above and beyond the center of the storm engulfing American society in change. The peculiar force of *The Oxbow* is that it retains the dynamic qualities of its subject, resisting the temptation to adopt the Jeremiah-like stance that Cole assumed elsewhere. The power of Cole's painting rests in its vision of an unstable present that preserves choice rather than giving way to the apocalyptic alarm of his *Course of Empire* on the one hand and, on the other, to the celebratory visions of a republican millennium characteristic of the coming decades. *The Oxbow* is neither apocalypse nor millennium but a summons to greater self-consciousness in the presence of the choice.

Cole's grappling with the historical forces transforming the wilderness became the exception rather than the rule for later landscape artists, for whom natural metaphors more often functioned to naturalize a historical and social process. Cole's *Oxbow* preserves the tension between nature and culture that characterized his own strain of adversarial romanticism. He graphically revealed historical processes more generally disguised through pastoral conventions that denied the powerfully unsettling effects of deforestation and agriculture on American nature. His recognition of the human actor generating historical change distinguished his form of romanticism from that of his younger contemporaries, for whom such processes were inevitable, sanctioned by both nature and Providence. If for Cole nature and nation remained antagonists, for those who followed the United States *was* nature's nation.

62. Roger Stein, *Susquehanna: Images of the Settled Landscape* (Binghamton, N.Y.: Roberson Center for the Arts and Sciences, 1981), p. 133, n. 5.

63. See, for instance, Annibale Carracci's treatment (Pinacoteca Nazionale, Naples). The relevance of this compositional type and its relation to the "Choice of Hercules" theme has also been explored by Parry, *The Art of Thomas Cole,* pp. 349–51.

Yet paradoxically this later generation frequently denied nature a truly constitutive role in the construction of a national self. Its power remained totemic. The landscape genre permitted symbolic expression of nature's power, a ritual invocation that prepared the way for the actual work of economic transformation that was the order of the day.[64] And as settlement irreclaimably altered the landscape, it lost much of its authority as a viable agent of nationalism. The idea that nationalism was the product of nature was violated by the very process of cultural implantation that the myth of nature's nation helped, in circular fashion, to authorize.[65]

With a better grasp of the exploratory and critical content of Cole's art, we can consider his early work in light of his later, more developed concerns. Cole's genius for dramatizing issues of national identity was first tested in a series of paintings done in the late 1820s. *Expulsion from the Garden of Eden* (see figure 8) is his earliest representation of historical cycles.[66] As with *The Oxbow*, a narrative dimension is implied in the passage from one side of the composition to the other. To the left of the enormous central rock arch is the tumultuous landscape of the fallen world into which Adam and Eve are banished, while to the right a pastoral Eden reminds the viewer of what has been lost. With its Gothic profile, the rock arch forms a templelike transition between the wilderness without and the sanctum sanctorum of Eden.[67] The spears of light emanating from the arch accentuate the sensation of forced ejection and turbulent change, implying that movement through it can occur in only one direction—from Eden to the howling wilderness beyond. This world is rent from within by eruptions, lightning, and gravity propelling the chute of water downward. Tumultuous movement supplants the immobility of Eden. Metamorphosis replaces stasis as forms twist and turn anthropomorphically. Volcanoes erupt and black clouds billow forth, arching over the landscape in a great vortex. The cascading river in the center of the painting and the rain-laden clouds above form a continuous weather cycle. Cole's post-Edenic world is defined by

64. See Myra Jehlen, "The American Landscape as Totem," *Prospects* 6 (1981): 17–36.

65. See Miller, "The Romantic Dilemma in American Nationalism," an important and still relevant discussion of the problem.

66. On *The Garden of Eden* and the *Expulsion*, see *The Correspondence of Thomas Cole and Daniel Wadsworth*, ed. J. Bard McNulty (Hartford: Connecticut Historical Society, 1983), p. xvi; and Cole's letter to his patron Robert Gilmor, May 21, 1828, quoted in Howard Merritt, ed., *Studies on Thomas Cole: An American Romanticist*, vol. 2 of *Baltimore Museum of Art Annual* (Baltimore: Baltimore Museum of Art, 1967), p. 58.

67. See Albert Gelpi's suggestive interpretation of this painting in "White Light in the Wilderness: Landscape and Self in Nature's Nation," in *American Light: The Luminist Movement, 1850–1875* (Washington, D.C.: National Gallery of Art, 1980), p. 295.

process, change, and cyclical repetition which offers no point of rest, and which produces an oppressive sense of dread and uncertainty. The tiny figures of Adam and Eve mimic the blasted trees buffeted by the wind. These spiked, bent, and tortured forms convey a deep sense of anxiety. The monochromatic palette and swirling energies convey entrapment in a closed, pathless wilderness of precipitous chasms and razorlike ridges.

Whereas the landscape of the fallen world on the left resists visual penetration, the linear and planar perspective established by Eden carries the eye back through space in a continuous and gentle recession. The swans of Eden that meander slowly downstream in sinuous curves are emblems of motionless harmony.

Cole's description of his *Garden of Eden* (figure 10) in a letter to his patron Daniel Wadsworth dated November 26, 1827, visually links Eden with the spatial modulations of the beautiful: "There are in it lofty distant Mountains, a calm expansive lake . . . undulating grounds, a meandering river, cascades, gentle lawns, . . . banks of beauteous flowers . . . harmless and graceful animals."[68] A contemporary review of Cole's "well-known picture" likewise described "a landscape of gorgeous luxuriance, embued [*sic*] with the very spirit of repose, beauty, and happiness, and awakening the mind to a thousand delightful associations."[69] From a modern perspective the landscape of the fallen world seems, like Milton's Satan, to be far more interesting than the landscape of Eden, a dream of escape from moral revelation and growth that unwittingly affirms the concept of the *felix culpa*, or fortunate fall into knowledge.[70]

The contrasting aesthetic modes of the beautiful and the sublime, evident in the Edenic and fallen landscapes of the *Expulsion*, reappeared throughout Cole's career, acquiring a rich moral and political coloration as his art developed. *Expulsion from Eden* embodies better than any other early work by Cole what these contrasting aesthetic modes meant in the moral terms of his art: the static condition of an imagined arcadia, and the entrapment in history, with its accompanying burden of moral growth and awareness. If the first lacked the moral complexity necessary for artistic creation, the second seemed to entrap the spirit in mortal coils. Yet in its image of calm immobility Eden is far less imaginatively and spiritually compelling a place than life outside the gates.

Cole's recognition of moral complexity and of the inherently divided character

68. This painting, previously known only from a print based on it, resurfaced and was purchased by the Amon Carter Museum in 1990. Cole's description of the painting to Daniel Wadsworth is cited in Cole and Wadsworth, *Correspondence*, pp. 18–20.

69. "The Fine Arts: The National Academy of Design," *New-York Mirror*, May 7, 1831, p. 350.

70. For a discussion of the relevance of this concept to nineteenth-century Americans, see Lewis, *The American Adam*, pp. 60–62.

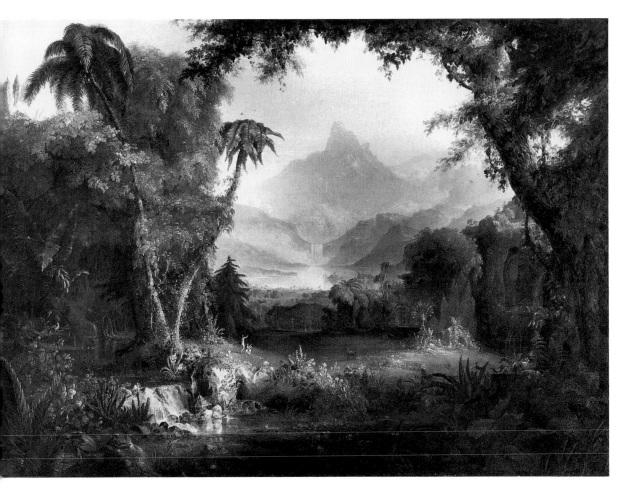

Figure 10. Thomas Cole, *The Garden of Eden,* 1827–28. Oil on canvas; 38½″ x 52¾″.
Amon Carter Museum, Fort Worth, 1990.10.

of history was matched by a nostalgic longing for a pastoral refuge, safe from psychic turmoil and the disequilibrium in the fallen world between the human and the natural.[71] In its cloudless beauty his *Garden of Eden* anticipates the sentimentalism of the Victorian landscape vignette. Poised between the extremities of wilderness and overcivilization, the pastoral moment promised an escape from history into a mythic republic where such moral polarities were resolved. Cole's Eden is the

71. For further discussion of this nostalgic impulse, see Arthur P. Dudden, "Nostalgia and the American," *Journal of the History of Ideas* 22 (October–December 1961): 515–30; and Miller, "The Imperial Republic," pp. 117–19.

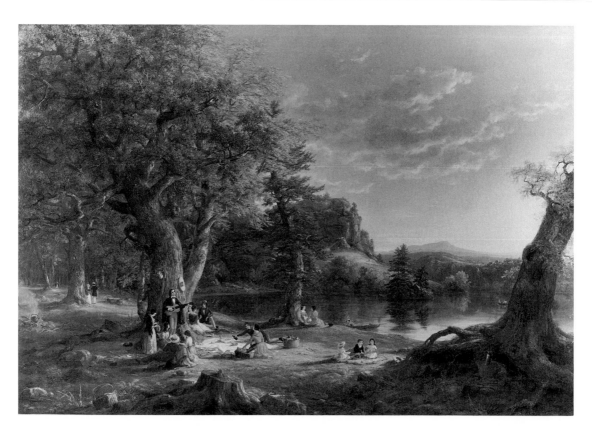

Figure 11. Thomas Cole, *The Pic-Nic*, 1846. Oil on canvas; 44⅞″ x 71⅞″. The Brooklyn Museum, 67.205.2, A. Augustus Healy Fund.

first in a series of imagined Arcadias unsullied by ambition and sectarianism which appeared in his art and his writings over the next two decades.[72] In the 1830s and 1840s, fleeing the social and political turbulence of Jacksonian America, he sought out new native versions of Arcadia in works such as *The Hunter's Return* (1845, Amon Carter Museum), *The Old Mill at Sunset* (1844, Collection of Jo Ann and Julian Ganz, Jr.), *The Pic-Nic* (1846, figure 11), and *Home in the Woods* (1847, Reynolda House, Winston-Salem, North Carolina). Yet lacking the tensions and

72. On Cole's arcadian landscapes, see Earl Powell, "Thomas Cole's *Dream of Arcadia*," *Arts Magazine* 52 (November 1977): 113–15. Cole's compiled list of subjects, written over the course of his career, includes "The Golden Age—The Age of Iron &c from Hesiod & Ovid," as well as a theme entitled "Grandeur and Decay." See Merritt, "Studies on Thomas Cole," pp. 82–100. On the pastoral, see Herbert Lindenberger, "The Idyllic Moment: On Pastoral and Romanticism," *College English* 34 (December 1972): 335–51; H. Daniel Peck, *A World by Itself: The Pastoral Moment in Cooper's Fiction* (New Haven: Yale University Press, 1977).

ambiguities of the *Expulsion* or *The Oxbow,* these paintings appear nostalgic and retrospective visions of a lost world.[73]

One other early work of 1829, *Subsiding of the Waters of the Deluge* (plate 2), registers the philosophical dualism that characterized Cole's imaginative response to the myth of New World redemption. It is a drama of destruction and rebirth—a new dawn of hope which on closer analysis reveals a more qualified and ambiguous reading.[74] As with the *Expulsion* of two years earlier, Cole took *Subsiding of the Waters* from Genesis. His choice of the biblical book most concerned with origins is significant, in view of the opportunities such subjects permitted him indirectly to explore the issue of the nation's own originating covenant with God.

Subsiding of the Waters depicts the moment when forms once again coalesce after the watery apocalypse of the Deluge. The dramatic chiaroscuro, rough textures, and tumultuous movement of the foreground landscape starkly contrast with an atmospheric and motionless distance. An oval rock formation, hanging suspended and dimly threatening, frames the majestic, cathedrallike forms on the horizon. The composition shifts eerily back and forth between these jagged foreground rocks and the distant forms that loom in the background, giving to the image an unsettling quality of spatial dislocation. The only living object in the entire composition is a low-flying bird, the dove of Genesis that heralds the dawn of a new postdiluvian world. Perhaps its appearance echoes a colonial pun linking *columbina*—the Latin word for dove—and Columbus, a correlation that enhanced the typological significance of the New World discovery within the soteriological schedule.[75] With the exception of the dove and the waterfall on the left, the painting suggests a temporal vacuum drained of all generating motion.

73. Cole also explored mythical Arcadias in later works such as *The Dream of Arcadia* (1838, Denver Art Museum) and *Evening in Arcady* (1843, Wadsworth Atheneum, Hartford). See Parry, *The Art of Cole,* pp. 294–95, on the latter painting. About *The Dream of Arcadia,* Cole wrote a humorous letter to his friend Asher B. Durand, quoted in Parry, *The Art of Cole,* p. 203, describing a dream that reflects ironically on the painting and the human possibilities for Arcadia.

74. *Subsiding of the Waters,* exhibited at the National Academy of Design in 1829 and again in 1831, was lost throughout most of this century, not coming to light until 1974. See Ellwood Parry, "Recent Discoveries in the Art of Thomas Cole," *Antiques Magazine* 120 (November 1981): 1156–65, on the sources for the work. Cole may have painted a pendant to *Subsiding of the Waters,* although its authenticity is disputed. *The Deluge* (1829–30?, Alexander Gallery, New York City), though not included in Parry's 1988 monograph on the artist, has been authenticated by Howard Merritt, according to Alexander Acevedo (personal conversation, New York, summer 1989). *The Deluge* contains only one figure—the last survivor of the Flood—who, entrapped within an eerie vortex of mist, will shortly succumb to the rising waters. An ark is visible through the mist.

75. Sacvan Bercovitch, *The Puritan Origins of the American Self* (New Haven: Yale University Press, 1976), p. 98.

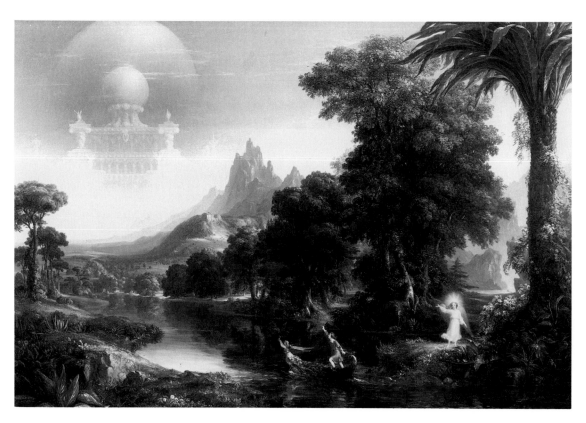

Figure 12. Thomas Cole, *The Voyage of Life: Youth*, 1840. Oil on canvas; 52½" x 78½". Munson-Williams-Proctor Institute Museum of Art, Utica, New York.

Cole's symbolism thus evokes parallels with America but shadows their meaning with questions about the possibility of temporal redemption. In the lower foreground of the composition is a skull, a memento mori roughly aligned with both the ark and the soaring rocks in the distance. Along with the time-carved rocks and the waterfall—an image of flux-in-stasis—this skull is part of a symbolic landscape of temporality that echoes the fallen world of the *Expulsion*. The fragments of stone poised against gravity, broken tree limbs, and cascading water all recall the earlier work.

The cathedrallike rocks on the horizon, lit from behind by the rising sun, signify a realm of hope and future renewal. Yet viewed from the framing perspective of the time-ravaged foreground, they appear inaccessible—a geological counterpart to the airborne white palace that lures the youthful pilgrim onward in the second canvas of *The Voyage of Life*, painted eleven years later (figure 12). A visionary mirage

located at the vanishing point in the exact center of the composition, these rocks, softened by distance, seem elusive and unreal. Framed by the foreground landscape of mutability, they suggest not a rebirth but a constantly retreating illusion. Like all such apparitions in Cole's art, this distant mirage impels the human actor forward with the promise of future attainment. Yet like the Heavenly City to which the earthbound pilgrim aspires in Cole's late unfinished cycle *The Cross and the World*, these rocks may be reached only beyond the boundaries of time and history.

Several details confirm a powerful sense of unattainability. Apart from the rock bridge connecting foreground and background, the strangely ominous apparition of the ark, with its coffinlike profile, is virtually the only object between the foreground skull and the distant rocks. It seems to offer a mode of conveyance between foreground and background, present and future. Yet aligned with the skull, the ark symbolically positions human community between the extremes of hope and resignation, neither offering escape from the cycles of history nor limiting the spirit within a closed circuit of unending process. It proffers at best a qualified salvation.

Subsiding of the Waters achieves its power by translating more traditional narrative devices into formal terms. It also signals a departure from the histrionics of Cole's earlier *Expulsion,* to which he would return in *The Course of Empire.* Moral struggle and stasis are synthesized and momentarily balanced more succinctly in *Subsiding of the Waters* than perhaps in any other example of Cole's art. In this richly symbolic work Cole evokes an entire history of destruction and renewal. As with the later *Oxbow,* he offers no resolution. The very structures of the painting, however, suggest the forces of history militating against the realization of millennial hopes.[76] Cole's personal and artistic preoccupation with these motive forces eventually drew him to the serial format of *The Course of Empire,* which signaled the breakup of the taut polarities in the earlier painting. His 1829 painting expressed a growing sense of history as a never-ending movement toward a goal continually redefined by time itself. Painted at the dawn of America's great age of cultural nationalism, *Subsiding of the Waters* sounded a warning, like a skull planted amidst the profuse offerings piled upon the nation's table. *Subsiding of the Waters* anticipated *The Oxbow* in its realization that creation and destruction were interlinked. The birth of the new order came about only through the death of the old in a constant cycle of organic transformation and difficult moral development. In 1829, however, Cole had only an intuitive foreboding of the problems besetting American nationalism.

76. For more about Cole's ambivalence toward the New World myth and contemporary America in the 1830s, see Baigell and Kaufman, "Cole's *Oxbow.*"

Cole's fascination with vortices—the spiraling energies that entrap the human subject—point to his uncertainty about the possibility of an earthly Eden or a purely secular salvation. Yet in another sense the vortex, formed by simultaneously expanding and contracting energies, symbolized the dilemma of a nation drawn forward by its millennial expectations—as well as by its economic and social expansion—while being pulled backward into the past by a longing for stasis.[77] Americans' Janus-faced relationship to history—facing forward while looking backward—threatened to capsize the ship of state through a strange and confusing amalgam of memory, desire, and fear. The disaster came in the form of a fratricidal war many both dreaded and anticipated.

Cole's sense that all republican utopias were ultimately elusive only deepened in his later career, along with his quasi-Augustinian conviction that the city of man and the City of God remained barricaded from each other by history itself. He was predisposed against the idea of a collective redemption within the framework of history. The Bible furnished him with types of salvation that could be realized only beyond human time. Such a disjunctive typology reflected Cole's personal skepticism toward the millennialist rhetoric of apologists for the new nation.[78] His deepening spiritual crisis culminated in his 1842 entry into the Episcopal church; given his childhood within the English dissenting tradition, his membership in the most conservative and ritualistic denomination of Protestantism marks a clear shift. The sense of isolation and emotional exile that permeates his journals and letters was reinforced by his belief that the republic had betrayed its wilderness covenant. Its "enterprise sublime," as he termed it elsewhere, had become a triumph of mere enterprise. Utilitarian disregard for nature, political and social factionalism, demagoguery and irreligiosity all reaffirmed Cole's conviction that overweening national ambition ensured the eventual demise of the republic.

If in his early years Cole had been heralded by contemporaries as an artistic radical, in the latter part of his career he emerged as an institutional conservative. The deep doubt and discouragement about his adopted country which Cole expressed was itself proportionate to his earlier sense of promise, the immigrant's

77. The vortex was also an image for the devouring force of history; see "The Neglect of Moral Science," *Knickerbocker* 3 (February 1834): 98, where the writer, concerned with the need for moral development, concludes that "it is what we ourselves as a nation may and must attain, if we are to escape that devouring vortex which has engulfed the most splendid political fabrics of former ages."

78. See Bercovitch, *Puritan Origins of the American Self*, pp. 56–59, on the Augustinian emphasis on individual salvation through the church in place of the post-Reformation placement of the millennium within time. On the distinction between disjunctive and conjunctive typology, see Tuveson, *Redeemer Nation*, pp. 33–34.

naive optimism about the country in which he had invested his hopes for the future.[79] Following his marriage to Maria Bartow in 1836, he isolated himself in his modest Catskill home. Domesticity became a refuge from the demands of New York City, which he preferred to keep at arm's length. His extensive writings demonstrate an increasing turn away from the unmediated, direct, and personal involvement with nature which characterized his early romanticism toward an emphasis on the cultural reshaping of human nature, inclined to greed, egoism, and vanity. Increasingly in the latter part of his brief career Cole shifted his artistic ambitions to allegories of loss and salvation, moral and spiritual pilgrimages through an essentially hostile world.[80]

In the earlier part of his career Cole connected personal with communal salvation. Yet in the final decade of his life he returned to the pessimism of his English childhood within the culture of dissenting Protestantism.[81] As he wrote in a letter to the New-York Art Reunion in 1848, the year of his death: "An artist should be in the world, but not of it; its cares, its duties he must share with his contemporaries, but he must keep an eye steadfastly fixed upon his polar star, and steer by it whatever wind may blow."[82] His *Weltschmertz* and his renunciatory religion were reinforced by the earlier influence of English romanticism, absorbed prior to his family's move to the United States in 1818. As a young artist Cole had reinvigorated the dramatic potential of landscape painting with a visual language that displaced onto nature his psychic struggle for artistic and personal self-generation. In a form of psychomachy, or spiritual conflict, elements of the natural scene act out the interior drama.[83] He later directed an English romantic critique of utilitarian culture at American society.[84] In Wordsworth he would have found the romantic expression

79. Cole told William Dunlap, "I would give my left hand to identify myself with this country, by being able to say I was born here." Dunlap, *History of the Rise and Progress of the Arts of Design*, 2:351.

80. Cole's private journal entry on the death of his infant daughter is revealing: "Its pilgrimage in this world has been short and sinless. God, in His great mercy, has taken it unto Himself before the world could defile its spiritual garments." Quoted in Parry, *The Art of Thomas Cole*, p. 327.

81. On this subject, see Wallach, "The Ideal American Artist and the Dissenting Tradition."

82. Cole to John Falconer, published in *Literary World*, April 8, 1848, pp. 186–87; also quoted in Noble-Vesell, *Life and Works*, p. 284.

83. Bryan Wolf, "Thomas Cole and the Creation of a Romantic Sublime," in *Romantic Revision: Culture and Consciousness in Nineteenth-Century American Painting and Literature* (Chicago: University of Chicago Press, 1983), pp. 177–236.

84. On the romantic artist as critic of his times, see Raymond Williams, *Culture and Society, 1780–1950* (New York: Harper and Row, 1966), pp. 30–48, 83–84; on the figure of the artist-prophet, see Ann Uhry Abrams, *The Valiant Hero: Benjamin West and Grand-Style History Painting* (Washington, D.C.: Smithsonian Institution Press, 1985), pp. 37–39; Bjelajac, *Millennial Desire*, pp. 47–48, 120; Kenneth LaBudde, "The Mind of Thomas Cole" (Ph.D. diss., University of Minnesota, 1954), pp. 146–58.

of his Protestant conviction that self and society, spiritual authenticity and worldly experience, opposed one another. An additional influence that set Cole at odds with the next generation was that of late eighteenth-century republicanism, with its ideological distrust of growth, empire, ambition, and the mechanisms by which the nation-state consolidated its objectives.

These three sources of influence—dissenting Protestantism, English romanticism, and eighteenth-century republicanism—shaped an art that, despite its stylistic and iconographic influence on later painters, spoke in a language as foreign to the nationalist artists of the 1850s and 1860s as that of the founders was to the loosely institutionalized democracy of midcentury.[85] Cole's intellectual influences guaranteed that he would feel a certain skepticism toward the celebratory concept of a national landscape. Although Cole was a conservative in politics, his personalistic approach to art was rooted in a Wordsworthian belief in the artist as visionary, a truth teller in a world of artifice corrupting natural sensibilities. Imagination was the benign force that would bridge the distance between self and nature caused by the original Fall, the subject of his *Expulsion*. Yet imagination was also a usurping faculty, allied to pride and ambition in its arrogation of power properly belonging to the divine. By reminding the individual of his or her position in creation, nature checked this usurping power.[86] As nature's influence diminished, artifice—the product of the ambition to impress one's own image on nature—gained the upper hand. The end result of such arrogance was demonstrated in *The Course of Empire*.[87]

Miller, "The Romantic Dilemma in American Nationalism," addresses American romanticism and its relation to the predominant utilitarianism of American culture. With few exceptions, American scholars have taken insufficient account of Cole's debt to English romantic thought, and a full appraisal remains to be written. See Alan Wallach, "Cole, Byron, and *The Course of Empire*," *Art Bulletin* 50 (December 1968): 375–79; Wallach, "British Aesthetics and American Scenery"; and Earl Powell, "The English Influences in Thomas Cole's Work" (Ph.D. diss., Harvard University, 1974), which deals primarily with aesthetic theory rather than with literary influences. At his death at least one English art journal was quick to claim him as "English by birth, parentage, and, to a great extent, by Art-education, we believe." Quoted in Parry, *The Art of Thomas Cole*, p. 229.

85. On this transformation, see Robert Wiebe, *The Opening of American Society, from the Adoption of the Constitution to the Eve of Disunion* (New York: Knopf, 1984).

86. Typical of this sentiment is a poem dated November 1834: "A holy calm pervades/The rural earth; where men/Assemble there is turmoil, but these shades/Are unto me a solemn sacred place/Where Envy—malice and pride can never come/Or coming, quickly all that demon race/Languish and die—the wild wood is their tomb." In *Thomas Cole's Poetry*, ed. Marshall Tymn (York, Pa.: Liberty Cap Press, 1972), no. 24.

87. Cole epitomized the conflict between man and nature in an undated verse fragment: "Through our creations wilderness has taken wing." Archives of American Art, Reel ALC3.

To remove society from close contact with nature was thus to give free rein to its worst impulses. The health and durability of any culture depended on maintaining the equilibrium between imagination and nature. Without the spiritualizing agency of nature, "the destroyer, Man," as he put it in a poem, threatened to become a tyrant ruthlessly imposing his will on the world around him; nature without man, however, remained wilderness in the biblical sense. The pastoral aesthetic that increasingly characterized Cole's work of the 1840s pictured an ideal balance between the human and the natural in a manner that anticipated much midcentury landscape art. Yet Cole resisted the tendency to instrumentalize nature as a source of boasting national pride.

Cole left what is perhaps the richest store of personal writings—diaries, letters, poems, and essays—of any landscape artist of the century, demonstrating his commitment to self-exploration and revelation through the written word. It was in this arena that his conception of the self crystallized as a subjective realm removed from the corrupting pressures of public life. The topos of the questing self out of harmony with the workings of history and society was central to Cole's thinking. Imagination remained a faculty of private reckoning, not an instrument of communal identity. The deepest knowledge was always knowledge of the self, direct, nonmediated, attuned to the finer rhythms of experience—rhythms that were private and spiritual rather than public and national.

Cole's belief in the intimate alliance between self and nature, bridged by imagination, meant that artistic fecundity depended on natural fecundity. At its most expressionistically sublime, as in the *Expulsion,* Cole's image of a barren landscape reflected his fear of personal and artistic sterility, of exile from the sources of beauty as the penalty for creative arrogance. Settlement and rural industry had deforested much of the northeastern landscape. Such marks were visible wounds on the face of nature. The recently settled areas surrounding the Catskill Mountains where Cole lived were transitional zones whose unfinished and crude appearance assaulted pastoral sensibilities. Basil Hall, an English traveler journeying through the eastern United States in 1827 and 1828, wrote: "The newly-cleared lands in America have, almost invariably, a bleak, hopeless aspect . . . the edge of the forest, opened for the first time to the light of the sun, looks cold and raw;—the ground, rugged and ill-dressed, has a most unsatisfactory appearance, as if nothing could be made to spring from it." No parallel for such a scene, he concluded, existed in the older countries of Europe.[88] Americans caught up in the dynamic process of development tolerated far more aesthetic dissonance in their scenery than foreigners such

88. Basil Hall, *Forty Etchings, from Sketches Made with the Camera Lucida, in North America in 1827 and 1828* (Edinburgh, 1829), plate 9.

as Hall.[89] For Cole, however, the symbolism of a parched and denuded land, of "waste" places, connoted not only the destructive physical taming of the wilderness, but the withering impact this process had on the mind and imagination of the artist. In 1829 he noted that "nothing is more disagreeable to me than the sight of lands that are just clearing with its prostrate trees—black stumps—burnt and deformed. All the native beauty of the forest taken away by the improving man."[90] As is apparent from the imagery of prostration, blackness, and deformity, Cole associated the forest with personal potency, trees serving as a form of artistic signature. In its pristine state, nature symbolized psychic wholeness and integration, while its destruction threatened the sources of his creativity. Yet in a paradoxical sense the urge to paint was the result of the spiritual fissure caused by the rupture between man and nature, paradigmatically expressed in the Fall. In a perfect world he would not have to paint. The imagination, searching for form, thus became the token of loss and an unfulfilled desire for spiritual wholeness. Later landscape painters would lose sight of this connection between representation and absence, associating imagination with the plenitude of nature on which it modeled its own activities.

Cole eventually came to see the devastation of nature as both the cause and effect of artistic sterility: cause, since nature was the artist's inspiration and an important source of subject matter, and effect, since imagination was a generative force whose suppression led to the exploitation of nature.[91] The utilitarian American appropriated nature's means for his own ends, recreating the world in his image and sacrificing nature in the process.[92] In a letter of 1834, Cole wrote: "In . . . utilitarian-

89. For examples of this tolerance, see passages in Cooper's *Chainbearer,* pp. 97, 101, 103.

90. Sketchbook, dated May 1, 1829, Archives of American Art, Reel D39.

91. In an undated journal fragment Cole wrote: "The lord of the creation has forgotten his high privilege he has sunk into the filth of [avarice] and . . . is blinded. . . . He vaunts his capacity for enjoyment for improvement gazing on himself in vanity and prides himself upon the March of intellect. It is a vain pride he has learned to continue but not to enjoy. This world is a paradise but man makes it a purgatory.—He toils that he may produce more with which to toil. He accumulates in order to aggrandize . . . he endeavours by . . . inventions to be independent of those limbs that nature has given him to exercise—To walk a mile is a labour too great to bear . . . little does he know in his present artificial state what story of beauty and delight exist in the world. Nature is neglected." Accordingly, Cole dedicates himself to teaching the beauties of nature: "If I can only induce a single soul to forget for a time his worldliness and to look on nature with a loving eye I shall be fully recompensed for my labour. If but one can be made to know that there is something else in the world worthy of being known beside the state of the stocks or the latest inventions of the steam boat." Archives of American Art, Reel ALC3.

92. A review of the National Academy of Design exhibition, *Literary World,* May 15, 1847, p. 348, associated the arrogance of the utilitarian spirit with the destruction of the wilderness. The article

ism as it is understood there is a great need of softening influences everything seems done for comfort and convenience of the animal man—*but the intellectual nature has many wasted places.*"[93] The "wasted places" of the American spirit, like nature's scorched hillsides and denuded forests, resulted from the quest for gain that would produce "that barrenness of mind, that sterile desolation of the soul, in which sensibility to the beauty of nature cannot take root."[94]

Cole's faith in the power of the wilderness to transform national character sounded an appealing note to those who held a pronounced distaste for democratic culture, ranging from Francis Parkman to the New England Whig Theodore Dwight, who corresponded with Cole.[95] Writing to Cole in 1835 in praise of his "Essay on American Scenery," Dwight acknowledged the importance of the nation's wilderness: "Happy will it be for our countrymen, when they shall be persuaded to think and feel amongst the scenery of our fields and forests, in which we have a portion of our American birthright."[96] Like his fellow conservative Philip Hone, Dwight saw love of nature, rather than its crude subjugation, as the proving ground of an organic nationalism. Dwight identified the failure to appreciate scenery as a moral blight. A year later Stanton Dorsey, a Philadelphia Quaker, wrote to Cole: "The taste which thee is endeavoring to inculcate should prevail, universally. How would it create a lovely enthusiasm for the works of Nature and through them to Nature's divine architect—elevating the feelings above the *grovelling propensities* of the mere animal, now so ardently sought to be gratified in a hundred different ways,

described the great titans of the forest "made to figure in the shape of deal boards and rafters for unsightly structures on bare commons, ornamented with a few peaked poplars, pointing like finger-posts to the sky." Such imagery of natural emasculation recalls Cole's own complex response to the sight of deforested hills.

93. Cole to Simeon DeWitt Bloodgood, September 23, 1834, cited in LaBudde, "The Mind of Thomas Cole," p. 145 (emphasis added).

94. Cole to Luman Reed, March 26 and 28, 1836, quoted in Noble-Vesell, *Life and Works,* pp. 160–61.

95. Parkman's journals are sprinkled with contemptuous allusions to the native residents of certain regions he deemed too beautiful for them. "There would be no finer place of gentlemen's seats than this," he wrote of the countryside around Lake George, "but now, for the most part, it is occupied by a race of boors about as uncouth, mean, and stupid as the hogs they seem chiefly to delight in." Quoted in Yi-Fu-Tuan, *Topophilia: A Study of Environmental Perception, Attitudes, and Values* (Englewood Cliffs, N.J.: Prentice-Hall, 1974), pp. 63–64. Other examples of such attitudes include George Templeton Strong's *Diary,* ed. Allan Nevins, 4 vols. (New York: MacMillan, 1942), August 1, 1837, 1:72, and May 28, 1844, 1:236; and Thomas Addison Richards, *Romance of the American Landscape* (New York: Leavitt and Allen, 1854), p. 240. On the association between social class and landscape appreciation, see Angela Miller, "Everywhere and Nowhere: The Making of the National Landscape," *American Literary History* 4 (Summer 1992): 207–29.

96. Theodore Dwight to Cole, April 21, 1835, Archives of American Art, Reel ALC1.

inconsistent with the Harmony of nature, and at variance with the beneficent designs of Providence."[97] Not only do the prose and diction have the flavor of the eighteenth century, but the sentiments are infused with Enlightenment deism: balance and harmony should regulate one's relations with nature, a balance transgressed by irrational and selfish impulses and "grovelling propensities."

Cole's own philosophical debt to the eighteenth century is mirrored in the response of men such as Dwight and Dorsey to his art. Their notion of harmonious balance between emotion and intellect, and their belief in moral and social hierarchy, were central to a conservative postfederalist conception of the enduring society. Dwight's and Dorsey's sentiments were typical of a gentry class whose mercantile connections and religious beliefs separated them from the speculators, pioneers, and entrepreneurs who were profiting in one form or another from the settlement and exploitation of the wilderness. In the beleaguered condition of the wilderness Cole and his admirers may have glimpsed themselves, caught in the undertow of a new democratic culture.[98] Along with asserting this personal and empathetic response to a wilderness under attack by the forces of economic development, Cole's patrician circle appealed to the aesthetic and intellectual faculties as a way of reclaiming Americans from self-interested present pursuits.

Cole's vision of the social changes transforming American culture from within inevitably undermined his faith in the redemptive potential of wilderness.[99] Nature proved to be a vulnerable and fragile foundation on which to build the spiritual strength of the nation. Rendered opaque by the egoism of men, nature no longer offered a means of access to experience beyond the self, a common point of reference for the collective selves of democratic culture. His famous outburst in 1836 against the "dollar-godded utilitarians" who were cutting down his beloved trees is symptomatic of the anger Cole directed against the self-motivated and greedy commercial energies so manifest in the 1830s.

In an unpublished lecture titled "The Influence of the Plastic Arts," Cole cited one aspect of this cultural mission: to neutralize "the sordid—grovelling propensities of society." Cole's choice of words is the same as Stanton Dorsey's in his 1836 letter to the artist, revealing the extent to which the ministry of art had taken the

97. Emphasis added. The letter is dated June 9, 1836. Archives of American Art, Reel ALC1.

98. Wallach, "Cole and the Aristocracy," makes a similar argument.

99. Instances of this change in Cole's thinking appear in journal entries such as this observation made during an excursion in the Catskills: "I remarked that, although American scenery was often so fine, we feel the want of associations such as cling to scenes in the old world. Simple nature is not quite sufficient. We want human interest, incident and action, to render the effect of landscape complete." Entry of May 30, 1841, in Noble-Vesell, *Life and Works*, p. 219. Cole's preference for inhabited landscapes reflects a more general shift in aesthetic taste toward midcentury.

place of the ministry of nature.[100] His gospel of art now furnished the spiritual salve that would draw the nation back onto its rightful course. At the same time, it realized Cole's earlier romantic conception of the artist as the soul and conscience of society. "Art," he wrote, "has been called *divine* and its power to affect and modify the passions, sentiments and institutions of men has been acknowledged in all ages."[101]

Arguments about the socializing role of art assumed a new relevance as the nation expanded westward. "The great and solemn question" of the day, according to an article in an 1849 issue of the Whig *American Review,* was whether "this boundless physical development [would] subserve the moral and spiritual perfectionment of man and society; or is it, on the contrary, to lead to a . . . gigantic wickedness?"[102] An expansive democracy was dangerously volatile and weak in internal controls: "A godless self-willed world, armed with the more than gigantic powers over nature which modern science gives, may rear heaven-climbing towers, only in the end to be crushed in the fall of their own toppling erections."[103] Cole anticipated such visions of social destruction. In a nineteenth-century transvaluation of republican values, he argued that the culture of the emotions and the sentiments through art and religion could now play the role that reason and civic *virtù* had earlier played. He called upon art and cultural institutions, not nature, to furnish moral ballast for an unstable democracy.[104]

While in these later years Cole did invest art with great significance as a reforming agent, he nonetheless qualified his faith in it by insisting that its efficacy "depends chiefly on the religious political and literary constitution of the nation

100. "The influence of the Plastic Arts." The lecture continues: "Let us endeavor then to lift up the prostrate standard of Art and make a stand against this needling Utilitarianism which prevails. Let us try to convince our fellow Citizens that the pursuit of the beautiful is as essential to our well being as that of *Gain.*" See Paul Baker, *The Fortunate Pilgrims: Americans in Italy, 1800–1860* (Cambridge: Harvard University Press, 1964), p. 222, on the antebellum belief in the importance of the arts, along with the primary institutions of government, religion, and family, in inculcating public virtue.

101. Untitled lecture, Archives of American Art, Reel ALC3.

102. "California," *American Review* 16 (April 1849): 335.

103. Another contemporary expression of this feeling fixed on the familiar image of the American as Titan: "We may trace alarming moral deficiencies in the spirit of our times. Ours is not an age of reverence. Its great men, its strong men, are too often mere Titans, children of the earth, who renew their vigor from their parent soil, and not by converse with a higher sphere of being. There is too much of self-reliance, too little of faith and trust." "The Progress of Society," p. 350.

104. On this transvaluation, see Lillian Miller, "The American Revolution as Image and Symbol in American Art," in John Browning and Richard Morton, eds., *1776* (Toronto: Stevens, Hakkert, 1976), pp. 87–88. For a further discussion of changing attitudes toward the social role of art, see Neil Harris, *The Artist in American Society* (New York: George Braziller, 1966).

and time in which it develops itself." Art, he explained, "is the ship and not the pilot . . . its character is a consequence rather than a cause" which required the support of other socializing institutions.[105] Cole's own version of cultural organicism linked him to English contemporaries such as Coleridge and Carlyle. Like the Anglican Coleridge, Cole was a late convert to a highly formalized religion; with Carlyle, he took a dim view of nineteenth-century progressivism and its empiricist creed. His earlier faith in the autonomous self gave way gradually to a recognizably Victorian belief that selfhood was institutionally structured and realized only through socially mediated experience. In this respect Cole anticipated the conservative thought of influential mid-Victorian figures such as the American Congregational minister Horace Bushnell. The authority of historic forms would leaven an undisciplined democracy, just as cultural and political institutions would shape and contain individual impulses. The danger was that the imperial self would usurp the authority properly belonging to institutions and would—like the imperial nation— eventually fall victim to the universal laws of history. Such was the lesson of Cole's final, unfinished series, *The Cross and the World*. Institutions maintained the proper balance between the fragment self and the social whole.

Cole was never content simply to repudiate popular opinion and enjoy the modest fruits of his patrons' generosity. His deepest instincts were those of an artist-citizen whose ultimate service was to an ideal of individual virtue and social harmony. Yet this vision continued to elude him throughout the final decade of his life. His ministry of art proved as ineffective as the ministry of nature had been in turning the utilitarian tide and stemming the excesses of popular democracy. Underlying his growing sense of isolation from American culture in the 1840s was his conviction that his apostleship of art and nature was being ignored.[106]

105. Cole, "The Influence of the Plastic Arts."

106. In a letter to his wife, Maria, dated January 29, 1843, Cole complained of "growing heartlessness in the community"; it was his "impression that pictures do not have the same influence on society that they did have some years since." Cited in Wallach, "The Ideal American Artist," p. 158.

2 / The National Landscape and the First New York School

Ideology is produced through the conflict of stories.
—Alan Sinfield, "Cultural Plunder," 1989

It is not in the nature of founding myths to take into account the complexities of an individual's life. Cole's ambivalence and his rejection of nationalist pride therefore found little room in the myth of the artist as the patriarch of the American school that developed following his death. It is important that we in turn not confuse Cole's own development as an artist with what he came to symbolize for later artists. Earlier scholars of American art often have done just that, reading the elements of the myth back into the life and work of the artist rather than measuring these against the myth. Cole's writings and works reveal an art out of step with the institutionalized aesthetic of the succeeding generation. Had Cole lived into the 1850s, one can only guess whether he would have been received as an honored member of the New York school or as an anachronism rendered irrelevant by the coalescence of a self-proclaimed American landscape style he purportedly fathered.

An academic manner appropriate to large-scale and highly finished exhibition pieces was the established *juste milieu*[1] of American landscape painting, as it had also become in both England and France. This New York–centered landscape

1. I appropriate this term from its French context to refer to the middle ground between the extremes of radical pleinairism, as represented by the American Pre-Raphaelites, and Colean allegories, which witnessed a revival in the 1850s. On the French context of the term, see Albert Boime, *The Academy and French Painting in the Nineteenth Century* (London: Phaidon Press, 1971), pp. 10–11, 15–17, 188. For a related application of the term to American painting, see Angela Miller, "Nature's Transformations: The Meaning of the Picnic Theme in Nineteenth-Century American Art," *Winterthur Portfolio* 24 (Summer 1989): 113–38.

style fused topographical, German and English romantic, and seventeenth-century French and Italo-Dutch influences into an American idiom characterized by its linkage of naturalism, nationalism, and Protestant piety toward nature as the revelation of deity. Cole had synthesized several of these sources for the first time into an affecting and original new style in the 1820s. His death in 1848 opened the way for others to assume positions of leadership, and at the same time called for both the preservation and the transformation of his legacy.

Cole's status as the father of the American school was double-edged. His significance for the next generation ranged from the filiopiety of his artistic offspring in the National Academy of Design to the oedipal rage of those who, like the radical *New Path* American Pre-Raphaelites, were struggling for an independent voice.[2] Undoubtedly the lowest critical estimation of Cole was the *New Path* condemnation of his painting as "hopeless imbecility."[3] Cole's significance for the next generation was his power to authorize a particular vision of nature through landscape art at a time when this vision remained contested. Married to nature, the symbolic father figure of the New York landscape school, Cole challenged the generation that followed him to possess the mother—that is, to win the proprietary, institutional rights to nature by controlling the mode and manner of her representation.

To the National Academy of Design was entrusted the official guardianship of Cole's legacy. Following his death his studio assumed a shrinelike aura for the younger artists who later emerged as the major landscape painters of the National Academy.[4] After a visit to the Catskill studio in 1850, Jasper Cropsey wrote to his

2. A similar challenge faced the generation of American statesmen who came of age in the 1850s; see George B. Forgie, *Patricide in the House Divided: A Psychological Interpretation of Lincoln and His Age* (New York: W. W. Norton, 1979).

3. "The Artist's Fund Society, Fourth Annual Exhibition," *New Path*, no. 8 (December 1863): 98. The author, probably Clarence Cook, went on to express his wish "that disinterested spectators might learn, once for all, how empty are this man's much vaunted claims to high artistic rank." On Cook and his circle, see also Linda S. Ferber and William H. Gerdts, *The New Path: Ruskin and the American Pre-Raphaelites* (New York: Schocken Books, 1985), pp. 13, 21.

4. Benjamin Bellows Grant Stone, a student of Benjamin Champney's, rented Cole's studio in the 1850s with plans to complete Cole's unfinished series *The Cross and the World*, still in the family. Frederic Church sketched Cole's studio after his death in 1848, possibly intending to do a painting; see Ellwood Parry, *The Art of Thomas Cole: Ambition and Imagination* (Newark: University of Delaware Press, 1988), p. 363. John Falconer, the painter-scholar who wrote a pamphlet explaining the artist's *Titan's Goblet*, also exhibited a view of Cole's Catskill studio in 1882 at the National Academy of Design. See Richard J. Koke, *American Landscape and Genre Paintings in the New-York Historical Society* (Boston: New-York Historical Society in association with G. K. Hall, 1982), 2:20. See also Kenneth Myers, *The Catskills: Painters, Writers, and Tourists in the Mountains, 1820–1895* (Yonkers, N.Y.: Hudson River Museum of Westchester, 1987), p. 185; Sandra Phillips and Linda Weintraub,

wife: "Though the man has departed, yet he has left a spell behind him that is not broken." Sanford Gifford, according to the testimony of his fellow artists, underwent a conversion to landscape painting while in the presence of the studio, "around which," as Worthington Whittredge put it later, "we may well believe there was a halo of light that morning, which lighted up the path which he was to follow."[5] A notice on the death of Cole asserted that the artist "has advanced [landscape art] beyond the point at which he found it among us, and, more than this, he has demonstrated its high moral capabilities which, hitherto, had been, at best, but incidentally and capriciously exerted."[6] By 1850 the New York essayist Charles Lanman could write that "the servile imitators of Cole may now be numbered by dozens." He added prophetically that Cole's student Church, the bright hope of the succeeding generation, would rise above these legions to a more original achievement.[7]

At the same time, however, Cole's legacy was subtly undermined from within as the rising generation repudiated Colean allegory and its imposition of ideas that did not grow directly out of the feeling for nature. By midcentury the necessity Cole felt to exalt landscape through association with ideas foreign to it had become a source of embarrassment for those who turned to his example.[8] The artist Ben-

Charmed Places: Hudson River Artists and Their Houses, Studios, and Vistas (New York: Harry N. Abrams in association with the Edith Blum Institute, Bard College, and the Vassar College Art Gallery, 1988), pp. 64–66.

5. " 'The Brushes He Painted With That Last Day Are There . . . ': Jasper F. Cropsey's Letter to His Wife, Describing Thomas Cole's Home and Studio, July 1850," *American Art Journal* 16 (Summer 1984): 81. In an untitled address on what Cropsey termed "Natural Art," he called Cole "the first American landscape painter of eminence, who stands at the head of the *Art*." Typescript, Newington-Cropsey Foundation, Greenwich, Conn. In his journal from Rome, Cropsey proposed a memorial to Cole following his sudden death in 1848. See Barbara Novak et al., *The Thyssen-Bornemisza Collection: Nineteenth-Century American Painting* (New York: Vendome Press, 1986), p. 72. Gifford's conversion is recounted by Worthington Whittredge, "Address," in *Gifford Memorial Meeting of the Century* (New York: Century Association, 1880), p. 34, Archives of American Art, Reel 2813, frames 117–229.

6. *The Literary World,* February 19, 1848, p. 51; quoted in Parry, *The Art of Thomas Cole.*

7. Charles Lanman, "Our Landscape Painters," *Southern Literary Messenger* 15 (May 1850): 279.

8. The reaction against allegory had begun as early as 1845, when a review in the *Broadway Journal* called Cole's *Course of Empire* "sermons in green paint; essays in gilt frames," complaining that "the charm of nature is destroyed." See Parry, *The Art of Thomas Cole,* p. 312. Other examples of the reaction against allegory in favor of naturalism are "Allegory in Art," *The Crayon* 3, pt. 3 (April 1856): 114–15; "Fine Arts: National Academy of Design," *The Albion,* April 27, 1850, p. 201; "Thomas Cole," *National Magazine* 4 (April 1854): 312–21, which complained that "a true work of art always explains itself; just so far as it comes short of this requisition, it fails in an art point of view." See also "The National Academy," *Putnam's Monthly* 5 (May 1855): 506–7, which placed Cole with America's "Old

jamin Champney's qualified admiration was typical; he called Cole's art "more thoroughly American than any landscape work perhaps yet accomplished," but also voiced an increasingly frequent criticism of his allegories as "comparatively a failure, because such a thing [to illustrate allegory through landscape form] is hardly within the province of landscape art."[9]

Among the challenges faced by the painters who followed Cole was to retain the place of honor he had won for landscape in the search for a significant national voice without remaining overly dependent on his example, as well as to recast the meaning of landscape for a new generation. Referring to Church and Cropsey—two representative figures among the younger artists—one writer noted in 1851 that although their work at first "seemed wedded to the qualities of Cole," they "are laboring now in distinctly different ways."[10] The sentiment may be read on two levels; Church, Cole's student, symbolically ended his apprenticeship to Cole with the highly successful exhibition of *New England Scenery* in 1851 at the American Art-Union, a painting whose detailed naturalism signaled the direction Church's art would take over the next decade and his own newly won filial independence.[11] On another level, however, the declamatory nationalism of the painting contradicted the spirit of Cole's critical romantic stance toward American culture, and his deep discomfort with what he considered his contemporaries' failure to acknowledge the fragility of their self-proclaimed historic mission. Church, as Franklin Kelly has demonstrated, was Cole's "legitimate" heir, continuing his example of a landscape art deeply engaged with the loftiest issues of America's moral and national destiny. Yet for Church this enterprise, in the beginning at least, was a celebratory rather than a critical one. His coming of age as an artist involved transforming and re-creating Cole's legacy. In the case of Cropsey the reviewer's

Masters" as "leaves" of an older tradition whose triumphs "consisted in creditably rivaling their masters" rather than "in developing new and peculiar features of artistic wisdom." Cole was also criticized by the nationalistic *Bulletin of the American Art-Union* in "Development of Nationality in American Art," 4 (December 1851): 139, and "Twenty-Sixth Exhibition of the National Academy of Design," 4 (May 1851): 22–23. Constable, a painter with a pronounced influence on midcentury American landscape, had earlier repudiated allegory for "attempt[ing] to tell that which is outside the reach of the art." See "The Dutch and Flemish Schools," in *John Constable's Discourses,* comp. R. B. Beckett (Ipswich: Suffolk Records Society, 1970), p. 64.

9. Benjamin Champney, *Sixty Years' Memories of Art and Artists* (1900), ed. H. Barbara Weinberg (New York: Garland, 1977), p. 142.

10. "Twenty-Sixth Exhibition of the National Academy of Design," p. 23.

11. The reviewer apparently overlooked the naturalistic current in Cole's later work, evident in paintings such as *The Mountain Ford* (1846, Metropolitan Museum) and *Genessee Scenery* (1847, Rhode Island School of Design), as an important element in his legacy to later artists, including his student Church.

assessment was premature, for in 1852 Cropsey exhibited two very Colean pendants, *The Spirit of War* and *The Spirit of Peace.*

Primary among the needs felt by the painters who followed in Cole's path was to recast his national parable in terms not of cultural defeat but of triumph. The impulse produced serial allegories in the manner of *The Course of Empire* as well as American landscapes structured narratively in the manner of his *Oxbow.* It also attempted to resolve the antagonism central to Cole's art between nature and culture, millennial expectations and temporal realities.

One result of this transvaluation of Cole's legacy was that later artists recast nature as a communal rather than a private spiritual resource, reasserting its value with a variety of institutional dressings that largely stripped it of its personalistic charge. The artist-romancer, endlessly questing after an elusive sense of spiritual plenitude, gave way to the artist-nationalist, for whom selfhood and nationhood were finally united. The problems of personal ambition and sin increasingly resolved into the fiction of a transparent self in which private actions contributed through the unitary law of physical and moral progress to the development of the community. Indeed, economic and political thinking increasingly collapsed the moral and the social, the individual and the collective, into one. The conservative economist Henry C. Carey, for instance, could write that "the highest civilization is marked by the most perfect individuality and the greatest tendency to union, whether of men or of nations."[12] One's individual moral growth and one's commitment to communal values were, in theory, complementary qualities in these decades. Cole's fragmented self was made whole as personal destiny was assimilated into a larger framework of national development. His symbolic and iconographic program of a self divided against the world, of nature set against nation, was no longer relevant by midcentury. In its place was a quest for a unified national body, albeit one played out on a contested stage. Yet in the end the concept of a unitary self was as elusive and fictitious as the concept of a united collectivity, especially so as the obstacles to political and national unity intensified.

Other major generational changes had occurred between the height of Cole's career and the middle of the century. By the 1850s the appreciation of nature attested less to one's moral character than to one's social standing within an establishment dedicated to the idea of scenery as a unifying national ideal. If Cole

12. Forgie, *Patricide in the House Divided,* p. 195, argues that through associationism "people could be made to feel, for instance, that the problem of the Union was actually their own personal problem and that they had a stake in the way it was resolved." Carey quoted in Robert Wiebe, *The Opening of American Society from the Adoption of the Constitution to the Eve of Disunion* (New York: Knopf, 1984), p. 282.

had found his ideological counterparts among an older generation of republican doubters, the painters who followed him carried a very different sense of historical possibilities better suited to the newly empowered urban entrepreneurs and industrialists eager to ground their social and economic transformations in a sacralized vision of nature. By this point a primary cultural function of art was to serve the modern and the national, the "spirit of the age." "Grand method" painting, according to a *Putnam's* review of the 1855 National Academy exhibition, represented "the rear guard of the school of the past, which at present we [artists] ignore."[13] Painting shifted from prescription and moral uplift to accommodation. An 1847 article in *Godey's* urged that "instead of regarding the spirit of trade and the cause of art as altogether inimical—which in some respects they doubtless are—it is the part of wisdom to endeavor to render them mutually serviceable."[14] The younger generation of landscape painters carried on a less judgmental, more intimate dialogue with their public than had their predecessor Cole. They rarely questioned that their role was to express the concerns of their contemporaries. They were advocates, not adversaries, responsive to a public that embraced the fruits of their labor. John Durand, the son of one artist who benefited from the new status of the landscape painter, later wrote about these years: "Art opened another road to new men ambitious of social distinction, and 'many there were who travelled that way.'"[15] The interests of artists and public were fully complementary as they had never been for Cole. The northeastern urban public could take pride in evidence of its growing cultural sophistication. The artists, by contrast, could now claim the status of insiders with their own institutions for promoting professional interests, their own apologists—men of material and moral stature such as Asher B. Durand and Daniel Huntington—and their own forms of exhibition and patronage. This mutuality of interests linked artists with their public just as they were linked with writers in a network of complementary social and professional interests. The appearance of professional ties betokened the formation of an artistic and cultural community rooted in New York and embodied in the major institutions responsible for promulgating a "national" aesthetic.

The materialist assumptions underpinning the later role of landscape art are evident from contemporary descriptions of the new art. "Enterprise" was a term commonly associated with the landscape endeavors of the period by critics and apologists both, applied in particular to Cole's student Church, the most important

13. "The National Academy," p. 509.

14. "Our Artists," *Godey's Lady's Magazine* 34–35 (1847): 246.

15. John Durand, *The Life and Times of Asher B. Durand* (1894; reprint, New York: Da Capo Press, 1970), p. 168.

figure of his generation. With Church in mind, James Jackson Jarves wrote in 1869 of the admirable "enterprise of the sensational landscapists, in seeking out Nature's marvels" in distant parts, concluding, however, that such works were "bold and effective speculations in art on principles of trade; emotionless and soulless." For the early historian of American art Henry Tuckerman, writing in 1867, enterprise was also "a prominent characteristic of Church," but the term here referred to the scientific and "explorative" spirit peculiar to the nineteenth-century expansion of knowledge, appropriately extended to the field of landscape art. Tuckerman's sympathy with Church is evident in the subtitle of his study of artist life, "an historical account of the rise and progress of art in America."[16] This history was parallel to, if not identical with, the course of Americans' own expansive spirit of enterprise.

Such entrepreneurial measures of artistic success were alien to Cole. The pose of marginality was a part of the romantic baggage that he never entirely relinquished.[17] A later generation of artists, from Church to Cropsey and Bierstadt, would build domestic monuments to themselves, material proof that they were central figures in the nation's cultural life. For Church the material *was* the spiritual, not a refractory and clouded medium as it was for Cole.[18] He felt none of the anxieties over patronage, none of the instinctive distrust over worldly success, that characterized Cole.

Cole's moralizing mind-set was unsuited to the conditions of a culture that judged the success of both self and nation according to standards of the market— the transformation of raw materials into finished goods—and the successful integration of the personal and the public, the imaginative and the social. For Cole, such convictions fearfully confused the secular with the spiritual. His conception of the self as both spiritually fractured by the Fall and riven by the competing demands of the world and the spirit revealed its debts to older forms of Protestant

16. James Jackson Jarves, *Art Thoughts* (1869), ed. H. Barbara Weinberg (New York: Garland, 1976), p. 299; Henry T. Tuckerman, *Book of the Artists* (1867; reprint, New York: James F. Carr, 1966), pp. 370, 384; Jarves, *The Art-Idea* (1864), ed. Benjamin Rowland, Jr. (Cambridge: Belknap Press of Harvard University Press, 1960), pp. 194–95.

17. Cole did punningly allude to the economic underpinnings of his artistic activity in a letter to his early patron Daniel Wadsworth referring to two ambitious religious paintings (*The Garden of Eden* and *The Expulsion from the Garden of Eden*) as his "Paradise speculations." See *The Correspondence of Thomas Cole and Daniel Wadsworth,* ed. J. Bard McNulty (Hartford: Connecticut Historical Society, 1983), pp. 54–55.

18. For an analysis of the philosophical and religious differences between Cole and Church, see David C. Huntington, "Church and Luminism: Light for America's Elect," in *American Light: The Luminist Movement, 1850–1875* (Washington, D.C.: National Gallery of Art, 1980), pp. 155–90.

self-reckoning at a time when selfhood in the United States was being refashioned as a unified and autonomous whole, freed from the constraints of a punitive religion and a hierarchical social order.

Given the flexibility of the landscape metaphor in imaging a variety of cultural processes, it is not surprising that it should also share qualities with this emergent model of the socialized and integrated self. For the generation of the 1840s and 1850s, the creation of a socially assimilated self was essentially a process of proper landscaping—adjusting the picturesquely savage passages of nature and blending them into the more domesticated stretches of scenery in a smooth transition. At the heart of the landscape was the house, the center of sociability and the physical projection of the socialized self. The balanced, harmonious middle landscape was formulated and expressed in texts on landscape gardening, in the vignetted landscape views that found their way into popular prints and gift books, and in the words of painters of the American *juste milieu* such as James McDougal Hart's *Picnic on the Hudson* (1854, figure 13). The nation was the collective expression of this integrated selfhood, a federated system in which each state retained its essential independence while forming part of a transcendent whole.

The pastoral republic that materialized in the middle landscape was one of smooth transitions from rural to urban scenery, from wilderness to civilization, with no sudden ruptures, no hidden chasms, and little access to nature's subterranean self. By the 1850s the operative metaphor, in landscape as in personality, was that of integration—of a national market, of country with city, of locale or region with nation—an integration expressed in aesthetic choices as well as in a new concept of the self whose "center of exchange" was its firm but flexibly adaptive social identity.

The ideological divide between Cole and his successors is further evident in how each viewed the process of artistic composition.[19] Cole's working procedure involved assimilating the perceptual data of the first encounter with nature into artistic and compositional formulas that conformed to his inherited aesthetic ideals:

19. On Cole's drawings, see Jo Miller, *Drawings of the Hudson River School, 1825–1875* (Brooklyn, N.Y.: Brooklyn Museum, 1969); Howard Merritt, *To Walk with Nature: The Drawings of Thomas Cole* (Yonkers, N.Y.: Hudson River Museum, 1982); Theodore E. Stebbins, Jr., *American Master Drawings and Watercolors* (New York: Harper and Row, 1976), pp. 108–35, esp. 109, 113; *An Unprejudiced Eye: The Drawings of Jasper Cropsey* (Yonkers, N.Y.: Hudson River Museum, 1979). David Sellin, *American Art in the Making: Preparatory Studies for Masterpieces of American Painting, 1800–1900* (Washington, D.C.: Smithsonian Institution Press, 1976), pp. 17–29, skirts the topic.

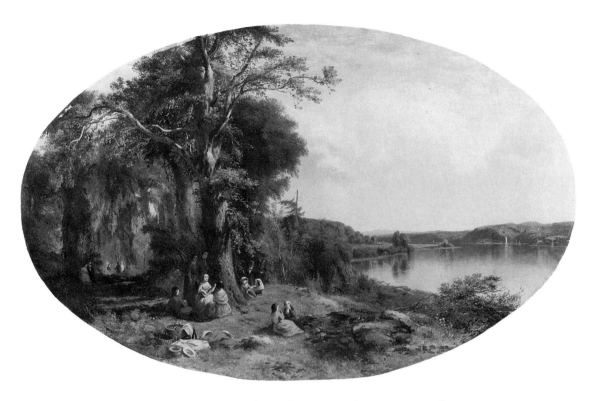

Figure 13. James McDougal Hart, *Picnic on the Hudson,* 1854. Oil on canvas; 33½″ x 55⅞″.
The Brooklyn Museum, 46.93, Dick S. Ramsay Fund.

He [the artist] must go to the centre, and work outwards . . . he must not first
skim the surface, and touch the outline, reversing the order of the vital processes of
nature, but must begin, as nature herself begins, at the heart, and move outward
and upward to the extremes, seeking the principle under the fact,—coming up with
the living spirit through the earth, the stone, the water and the wood,—rising . . .
from minutest details and particulars to general forms. . . . According to this
thought he worked: it was henceforth his law of procedure, and the path to a great
mastery over nature, both in her sublime unity, and in her infinite and beautiful
variety.[20]

The idiosyncratic, selective eye of the individual merely collected the raw material.
It took time before the impinging data of nature, absorbed privately and often in
solitude, found their place within learned, remembered, and generalized forms.

20. Noble-Vesell, *Life and Works,* pp. 23–24.

Cole's much-quoted letter to Asher B. Durand ("I never succeed in painting scenes, however beautiful, immediately on returning from them. I must wait for time to draw a veil over the common details, the unessential parts") merely restates this essential process by which individual perception—in its rawest form the riot of sensations one experienced in nature—was disciplined into a language of meaning that was communally shared.[21] Cole's approach to art making emphasized the imagination as a controlling faculty whose function was to organize the competing data of external reality into categories that reaffirmed the moral order.

Much has been made of the midcentury movement away from Colean compositional methods and into a more empiricist approach to nature, which gave far greater value to the isolated fact.[22] Yet this has not always been understood for what it was—a transition away from Cole's artistic emphasis on the overall structure of knowledge as a cultural inheritance and the necessity of policing individual sensation.[23] It would be a mistake to suggest, however, that empiricism held the day. As Durand's "Letters on Landscape Painting" made clear, study from nature—the careful record of natural particularities—was merely the first stage in the evolution of the final artistic product. The natural facts registered in the plein-air study from nature were, like individual identity, accorded their own discrete authority. At the same time, the full measure of meaning accorded to isolated facts rested in their placement within a larger composition, just as the full measure of an individual's meaning was only realized through alliances with others of similar interest in loose institutional networks. Landscape now had to balance the insistence of individual facts against the competing claims of other facts as well as the requirements of artistic order, which still demanded the intervention of imagination as a superintending faculty.[24] In the end, the midcentury model of integration conveniently fostered belief in the conquest of unruly nature for both social and economic uses. One expression of this integration was the aesthetic confidence in the ability to hold opposites—wilderness and culture, secular and redemptive history—in productive tension. Too often, however, these opposites collapsed into each other. Instead of wilderness crystallizing a sense of the settled landscape, the two blended into a

21. Quoted ibid., p. 185.

22. See Ferber and Gerdts, *The New Path;* Franklin Kelly, *Frederic Edwin Church and the National Landscape* (Washington, D.C.: Smithsonian Institution Press, 1988), p. 21 and passim.

23. This emphasis in Cole, who, along with Allston, was the most romantic of American artists, reveals the neoclassical bias in much nineteenth-century American art, a bias formalized in Reynoldsian treatises on art theory such as Samuel F. B. Morse's *Lectures on the Affinity of Painting with the Other Fine Arts,* ed. Nicolai Cikovsky, Jr. (Columbia: University of Missouri Press, 1983), delivered during his presidency of the National Academy of Design in 1826.

24. Asher B. Durand, "Letter No. 8," *The Crayon,* June 6, 1855, pp. 354–55.

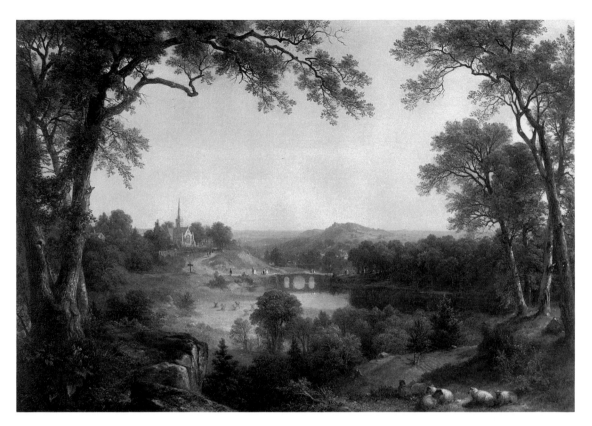

Figure 14. Asher B. Durand, *Sunday Morning*, 1860. Oil on canvas; 28″ x 42″. From the collection of the New Britain Museum of American Art, Connecticut, Charles F. Smith Fund. Photo: E. Irving Blomstrann.

bland continuum, like that of Durand's *Sunday Morning* (1860, figure 14). Such blandness found a later expression in the monotonous heaven of Wallace Stevens's "Sunday Morning" (1915). Just as often, opposing possibilities polarized. Rather than productively modifying each other, they became anxious adversaries offering not accommodation but conflict and uncertain resolutions. Before exploring this phase in landscape art in the next chapter, however, I turn first to a closer examination of the institutionalization of landscape aesthetics in the generation that followed Cole.

The remainder of this chapter will make explicit what has thus far been only implicit: that the realization of a national landscape occurred in the Northeast—specifically in New York—and that its coming of age in the 1850s materialized in a recognizable formula and ideological program governing its aesthetic practices.

The two developments—the institutionalization of the concept of a national school and the emergence of one widely used compositional formula for the national landscape—were closely interlinked.

The term "Hudson River school" is now generally synonymous with what scholars and public alike identify as the national landscape style. An unsympathetic critic coined the term around 1879 as the phenomenon it described was gradually being eclipsed by a newer artistic culture far more indebted to contemporary European art.[25] The term portrayed the older generation of New York academicians as quaintly provincial, irrelevant "old fogies" whose preeminence was contested by "young Rads," in the words of James Smillie.[26] "Genius is cosmopolitan; its school is the world, with no restrictions of time or place," declared John Ferguson Weir in 1873.[27] With the rise of a new generation of artists trained in Munich and Paris, the piously native tones in which the older members of the National Academy still spoke cast them as academic stalwarts resisting the siren song of foreign influence. The workshop of these younger artists was no longer nature but the contrived interior space of the studio, filled with exotic artifacts, a personal retreat for the delectation of the artist and his friends. This new artistic culture was indifferent to the exalted public imagery of the nationalist garden.[28]

The academic or "school" character of New York landscape painting was most evident during its eclipse.[29] In 1878 an article on Frederic Church described the Catskill region retrospectively as "Nature's great Academy of American landscape

25. On the history of the term, see Kevin Avery, "A Historiography of the Hudson River School," in *American Paradise: The World of the Hudson River School* (New York: Metropolitan Museum of Art, 1987), pp. 3–7.

26. As quoted in Rona Schneider, "The Career of James David Smillie (1833–1909) as Revealed in his Diaries," *American Art Journal* 16 (Winter 1984): 13.

27. "American Landscape Painters," *The New Englander* 32 (January 1873): 151. The attribution to Weir was made by Ila Weiss, *Poetic Landscape: The Art and Experience of Sanford R. Gifford* (Newark: University of Delaware Press, 1987), p. 102.

28. On the generational division among New York painters, see Doreen Bolger Burke and Catherine Hoover Voorsanger, "The Hudson River School in Eclipse," in *American Paradise,* pp. 71–90, and Mary Sayre Haverstock, "The Tenth Street Studio," *Art in America* 54 (September–October 1966): 55. Symptomatic of the shift is the frequency of the artist's studio as a subject. See Nicolai Cikovsky, Jr., "William Merritt Chase's Tenth Street Studio," *Archives of American Art Journal* 16 (1976): 2–14.

29. This "school" character was noted by Avery, "A Historiography of the Hudson River School," pp. 16, 19. See also "American Landscape Painters," pp. 140, 143; John I. H. Baur, ed., "The Autobiography of Worthington Whittredge," *Brooklyn Museum Journal* 1 (1942): 53–54. Samuel Isham, *The History of American Painting* (New York: Macmillan, 1927), pp. 232, 252–53, defined the school character of the Hudson River artists, and associated them with the city of New York, as distinguished from painters in Boston and Philadelphia.

art," an image that probably never would have occurred to someone of Cole's generation.[30] James Jackson Jarves referred to New York painters such as Durand in terms of the "inherent tendency of an academy" toward "exclusivism, dictation, and narrowness," asserting that the New York academy was "controlled by a *dilettante* clique . . . having no life-giving control over the young democratic art of the land." Its adherents were technically accomplished rather than original.[31] The National Academy of Design, Jarves implied, was out of step with an independent and vigorous artistic spirit springing up beyond its walls. Such criticisms suggest that it is misleading to take at face value the rhetorical claims of New York landscape painters to purity of spirit, lack of artifice, and a spontaneous, unfettered expression of feeling for nature, claims central to its identity as a "national" school.

New York functioned as a clearinghouse for artistic talent from around the nation. Here aspiring young artists went to learn how to translate the raw materials of their social and regional experience into finished cultural goods whose consumption would be the key to a shared nationality. Beginning in the 1840s, landscape practice was increasingly defined within a growing network of institutions and loosely affiliated interest groups, composed of New York's intellectual and business elite. First among these was the National Academy of Design, founded in 1826, whose mission to encourage a native American art was supported, and occasionally challenged, by the American Art-Union (1839–1853). The earned status of National Academician was one measure of an artist's success in achieving membership in the national school. Supporting the cultural mission of the NAD and the AAU were a variety of more informal social and intellectual gatherings such as the Sketch Club and its successor, the Century Association (founded in 1847, incorporated in 1857), as well as the Union League Club.[32] These various institutions for promoting art and culture in New York were intimately allied through overlapping memberships and common goals. In the first hundred years of the National Academy's history, all of its presidents were Centurions.[33] So prominent in

30. "American Painters—Frederic Edwin Church, N.A.," *Art Journal*, n.s., 4 (1878): 65.

31. Jarves, *The Art-Idea*, pp. 188–89.

32. The founding members of the Century Association included twenty-five members of the Sketch Club. See Neil Harris, *The Artist in American Society* (New York: Simon and Schuster, 1970), pp. 270–71, 279, 308, 398, n. 100; John Durand, "Prehistoric Notes of the Century Club" (New York, 1882). On the Union League, see Will Irwin, Earl Chapin May, and Joseph Hotchkiss, *A History of the Union League Club* (New York: Dodd and Mead, 1952).

33. Frank Jewett Mather, "The Century and American Art," in Allan Nevins et al., *The Century, 1847–1946* (New York: Century Association, 1947), p. 156. Mather, noting the absence of prominent Boston and Philadelphia painters in the membership of the Century, concluded that it "was distinctly a New York institution for its first fifty years" (pp. 154–55). James Thomas Flexner, *Paintings on the*

the cultural and artistic life of New York was the Century—"the most unspeakably respectable club in the United States, perhaps," according to Mark Twain—that the Reverend Henry Bellows compared membership in it to membership in the French Academy.[34] "If we could not invite kings of foreign lands, we had the greatest of this country within our walls,—like Lincoln, Grant, Sherman, Sheridan, and many other beloved and honored men, at our monthly meetings," wrote the painter Louis Lang years later. Out of this alliance of "distinguished men, Judges, Literary men, doctors, Artists, Architects, and great Merchants of liberal disposition" flowed commissions for the landscape painters among the group.[35] Institutions such as the Century self-consciously identified with New York in their cultivated urbanity. Centurions in particular delighted in poking fun at the provincialism of their rivals in Boston. The poet Bayard Taylor thought New Englanders "a tribe of Schoolmasters and Preachers," while John Durand, addressing his fellow club members some time later, satirically compared the Century's sybaritic leanings with New England's puritanic moralism and abstinence.[36] Ironically the Century, home to many of the leading artists of the New York school, helped shape a new cultural cosmopolitanism that would eventually render obsolete the whole conception of a national art and culture which it helped crystallize.

Supporting the institutional networks of the National Academy and the Century Association were artists' receptions held at the Tenth Street Studio building beginning in 1858, one year after it first opened, and at Dodsworth House.[37] The Tenth Street Studio had a particularly intimate relationship with the National Academy. By 1861 half of its thirty residents were National Academicians, and another seven were Associates of the National Academy.[38]

Century's Walls: An Address Delivered at the Monthly Meeting of the Century Association, March 7, 1963 (New York, 1963), p. 5, claimed that "the pictures [of the so-called native school] are built historically into the very structure of [the] club."

34. Mark Twain to *Alta California,* quoted by Allan Nevins, "The Century, 1847–1866," in Nevins, *The Century,* p. 27; Bellows's remark was reported by John Durand in his facetious address "Prehistoric Notes of the Century Club," pp. 12–13.

35. Louis Lang, "Reminiscences of Artistic and Social Life in the Century Association, New York, 1847–1891," manuscript, Century Association, New York City. I am indebted to Elizabeth Roark for bringing this manuscript to my attention.

36. Leonard Bacon, "Poets and the Century," in Nevins, *The Century,* p. 188; Durand, "Prehistoric Notes," pp. 12–13.

37. On the role of the Tenth Street Studio building in the artistic life of New York, see Haverstock, "The Tenth Street Studio"; Garnett McCoy, "Visits, Parties, and Cats in the Hall: The Tenth Street Studio Building and Its Inmates in the Nineteenth Century," *Archives of American Art Journal* 6 (January 1966): 1–8; Annette Blaugrund, "The Tenth Street Studio Building: A Roster, 1857–1895," *American Art Journal* 14 (Spring 1982): 64–71.

38. McCoy, "Visits, Parties, and Cats in the Hall," p. 2; Haverstock, "The Tenth Street Studio," p. 51.

Along with these formal and informal institutions for fostering art and its position in public life were less tangible but no less significant aesthetic attitudes which shaped the specific artistic procedures and defined the terms through which landscape painters conversed with their audiences. Poets, patrons, and critics flooded the press with tributes to the role of landscape art in expressing national identity. As landscape imagery proliferated in the sentimental and popular gift-book annuals, periodicals, and prints, it paradoxically embodied a romantic ideology of spiritually uplifting nature in a form eminently suited to a socially and materially complacent eastern middle class.

Only by identifying and analyzing the main intellectual components and visual structures employed to carry nationalist meaning in the landscapes of the "first New York school" is it possible to assess alternatives and their relationship to the guiding assumptions of this institutionalized aesthetic, and to evaluate how well the members of the school realized their proclaimed nationalist aims.[39] The coalescence of this version of the national landscape occurred in the context of the National Academy of Design in New York City and with a group of artists, centering on Asher B. Durand, who acquired for themselves and their art the title of "national school."

A vital ingredient of nationalist aesthetics was the theory of associationism. Through the second quarter of the nineteenth century, the associational power of images reinforced a developing nationalist ideology. While preserving nature's totemic function, it simultaneously placed it in the service of the powerful colonizing energies of American settlement and industry by linking landscape to a specific cultural narrative. A key component of nationalist aesthetic theory was the associational psychology of Archibald Alison's *Essays on the Nature and Principles of Taste,* first published in Scotland and Ireland in 1790.[40] The primary tenet of association-

39. In denominating the composed sequential landscape of midcentury the preferred vehicle of nationalist ideology, I am deemphasizing other important developments with a less explicit ideological content, such as the plein-air naturalism that Durand and others advocated. This remained, however, an influential concurrent mode in landscape, and one that seems in some sense to represent an antithetical impulse to the panoramic composed landscapes that form the major focus of this chapter. I will have more to say on the artists of the *New Path* in this period in Chapter 7; for a very suggestive analysis of the significance of this movement in the context of cultural and aesthetic change, see David Miller, *Dark Eden: The Swamp in Nineteenth-Century American Culture* (New York: Cambridge University Press, 1989), pp. 142–50.

40. On the influence of associationism on American art and culture, see William Charvat, *The Origins of American Critical Thought, 1810–1835* (New York: Barnes, 1961); Ralph N. Miller, "Thomas Cole and Alison's Essays on Taste," *New York History* 37 (July 1956): 281–99; Roger Stein, *John Ruskin and Aesthetic Thought in America* (Cambridge: Harvard University Press, 1967); Earl Powell, "The English Influences in Thomas Cole's Work" (Ph.D. diss., Harvard University, 1974); and Powell,

ism was that aesthetic pleasure proceeded not from the inherent qualities of images but from the ideas that attached to them. Alison's theories undermined the universalist assumptions behind neoclassicism by proposing that aesthetic responses were conditioned by time and place, and were therefore historically and culturally specific.[41] By extension, aesthetic feeling could be shaped through a form of cultural encoding. In the American context, where the emergence of native romanticism was from the beginning inseparable from the search for national meaning, associationism theoretically guaranteed that the external fabric of ideas informing works of art would be shaped by public rather than by private memories, by historical rather than by personal experience.

Timothy Dwight responded to the landscape of the Northeast in ways that demonstrate the role of associationism in the formation of communal, public values. For Dwight, who left an extensive chronicle of his travels through New England, and his nephew Theodore, the landscape was a "school for associations." The student and chronicler of the landscape taught his audience to translate visual experience into social and moral values. Dwight anticipated a time in the not-too-distant future when the dreary solitudes of nature in New England would "be measured out into farms enlivened with all the beauties of cultivation."[42] Writing of the settled scenery of the Connecticut River Valley, Theodore Dwight associated the physical with the social landscape: "Providence seems rather to have spread before our eyes a display of extraordinary beauty and fertility, the better to lead us to appreciate the blessings he has conferred on the land, in the institutions for government, religion, morality and learning."[43] He remained uncomfortable with "the majesty and awfulness of the wide forest, the naked summit, the prone rock, and the overhanging precipice." The "view of vast magnitudes, and useless extensions of height, depth, or level surface" excited painful "feelings of sublimity" only relieved "by our recurring to milder, calmer, and more encouraging objects . . . the comforts of a cottage, the pleasant aspect of a river's margin, the green nibbled turf."[44]

Such aesthetic preferences were rooted in the Dwights' conservative social vision. The settled landscape assured them that the energies unleashed by the American

"Thomas Cole and the American Landscape Tradition," *Arts Magazine* 52 (February 1978): 114–23; (March 1978): 110–17; (April 1978): 113–17.

41. Aspiring history painters such as Morse (see *Lectures,* p. 44), however, remained true to Reynoldsian dictates, which emphasized the universal, nonlocal character of meaning.

42. Timothy Dwight, *Travels in New England and New York* (1821), ed. Barbara Miller Solomon, 4 vols. (Cambridge: Belknap Press of Harvard University Press, 1969), 2:94.

43. Theodore Dwight, *Sketches of Scenery and Manners in the United States* (1829; reprint, Delmar, N.Y.: Scholars' Facsimiles and Reprints, 1983), p. 10.

44. Ibid., p. 63.

Revolution had been safely channeled into the creation of a pious, domesticated republic evident in the physical forms of the landscape.[45] The selective eye of the educated traveler discovered in the landscape visual proof of the nation's own progress from the unsettled wilds of the revolutionary period to the stable pastoralism of the early republic.[46] Associationism ensured the moral and social content of landscape and its representations. But in the process it addressed concerns about the latent power of images.

Unlike language, which, according to the accepted Lockean wisdom of the period, relied on conventional, assigned, and therefore fixed meanings, images were surrounded by indeterminate thoughts and memories.[47] Assigned *natural* rather than *conventional* status, images possessed considerable ontological authority, yet they lacked the cultural fixity of language, according to this argument. They were vulnerable to the vagaries of the private imagination, possessing an irrational power capable of subverting the received order of knowledge. Deeply ambivalent about the role of imagination uncontained by traditional forms of knowledge, the northeastern arbiters of artistic nationalism carried Puritan iconoclasm into the nineteenth century. Distrusting images, they attempted to control them by insisting on literary or historical associations.[48] Imagination was the mental faculty of

45. John Sears, preface, ibid., pp. 4–14; Sears, "Timothy Dwight and the American Landscape: The Composing Eye in Dwight's *Travels in New England and New York*," *Early American Literature* 11 (Winter 1976–77): 311–21. See also Peter M. Briggs, "Timothy Dwight 'Composes' a Landscape for New England," *American Quarterly* 40 (September 1980): 359–77; Robert Lawson-Peebles, *Landscape and Written Expression in Revolutionary America* (Cambridge: Cambridge University Press, 1988), pp. 146–50.

46. A similar contrast between the humanly ordered pastoral present and the violence and human cost of the past shaped the perception of the Wyoming Valley on the Susquehanna River. Jasper Cropsey exhibited his painting *The Wyoming Valley* with verses from Thomas Campbell's poem "Gertrude of Wyoming," which recalled this violence. See Roger Stein, *Susquehanna: Images of the Settled Landscape* (Binghamton, N.Y.: Roberson Center for the Arts and Sciences, 1981), pp. 60–62.

47. For further discussion on this point, see W. J. T. Mitchell, *Iconology: Image, Text, Ideology* (Chicago: University of Chicago Press, 1986), pp. 60, 121–22; Mitchell, "Going Too Far with the Sister Arts," in James A. W. Heffernan, ed., *Space, Time, Image, Sign: Essays on Literature and the Visual Arts* (New York: Peter Lang, 1987), pp. 1–11.

48. James Jackson Jarves, *Art-Hints: Architecture, Sculpture, and Painting* (New York: Harper Bros., 1855), p. 304, attributed the American distrust for the "sensuous beauty" of images somewhat incongruously to "the combined influence of Puritanism and the doctrines of William Penn." See also Charvat, *The Origins of American Critical Thought*; Harris, *The Artist in American Society*, pp. 3–6, 28–53. The enthusiastic reception of *Modern Painters* in the 1850s points to a more ready embrace of imagination, which Ruskin defends as invention in "Of Turnerian Topography," in volume 4 of *Modern Painters*; see *The Works of John Ruskin*, ed. E. T. Cook and Alexander Wedderburn, 39 vols. (London: George Allen), 6:27 and passim. Here once again, however, imaginative invention is guided by deep piety and does not act on its own behalf.

unlimited expansion, an absence of boundaries that inspired a form of mental agoraphobia.[49] Associational psychology answered the need to contain the fluid and unauthorized possibilities opened up once the search for meaning began to respond to the promptings of the private self. The northeastern critical establishment preferred programmatic, culturally scripted forms anchored in widely accessible meaning. Painting's relationship to its audience was thus defined by these fixed patterns of mental association. Works that appealed to the private, occult imagination, in which aesthetic pleasure was not balanced by literary, narrative, or other associative content, were suspect.[50]

This persistent distrust of images was matched by northeasterners' uneasiness over vast, measureless spaces, an uneasiness both exploited and charted by Edgar Allen Poe. Works such as his *Narrative of Arthur Gordon Pym* turn on circuitous, inward-funneling landscapes that ultimately collapse the unknowable regions of earth and self into one terrifying image; they defy the domesticating force of the picturesque and its moral content. Both the physical and imaginative landscape of northeastern Americans had to be plotted and mentally organized according to recognizable cultural themes. The emergence of a landscape art aspiring to primacy as a national form produced a concern with inscribing a cultural and social text upon nature.

The second major element in this construction of the national landscape was the presence of a sequential narrative whose function was to delineate America's progressive triumph over nature. The peculiar contribution of midcentury landscape was to organize space along an implicit temporal axis. The most influential precedent was established by the French artist Claude Lorrain (1600–1682), characterized by smooth spatial transitions between foreground, middle ground, and distance, framing *repoussoirs,* and aerial perspective.[51] These devices all emphasized movement back into the illusionistic depth of the picture space. Such inherited formulas provided an armature around which eastern painters developed their own pastoral landscape mode. The measured progression from the foreground into the distance furnished the key to both the form and the cultural content of the work.

49. In "The Imagination; Its Seat, Its Disposition, Its Pleasures, Its Pain, Its Powers," an author in the *Southern Literary Messenger* 21 (1855): 228 called the imagination "the most illimitable monarch that reigns." Quoted in Forgie, *Patricide in the House Divided,* p. 96, n. 23.

50. Characteristic of this suspicion toward the antinomian aspects of the self and toward the free play of imagination is the American distrust of Byron. See William Ellery Leonard, *Byron and Byronism in America* (Boston: Nichols Press, 1905), pp. 102–3.

51. Kenneth Clark, *Landscape into Art* (Boston: Beacon Press, 1949), p. 64, briefly discusses the elements of Claudean composition.

The narrative could also be read parallel to the picture plane, as in Cole's *Oxbow*.[52] In both forms of narrative, however, space serves as an image of time, in which nature, the raw material of culture, was progressively transformed by the civilizing mission of Americans. This spatiotemporal landscape mode answered the ideological and nationalistic needs that landscape painters felt called upon to serve as part of their artistic mission.

As new formulas were refined, painters drew a more explicit analogy between landscape and visual text. Narrative cues announced a plot line leading toward a grand conclusion. Contemporary discussions of landscape art were shaped by the language of literary structure. Plots and subplots, incidents, and moral hierarchies gave the text an apparent unity of purpose and the controlling pattern of a drama. Such devices rendered landscape art readable. The concept of literary plot, with its initial conditions (wilderness), its generating action (the energies of American settlement), and its climax or resolution (the creation of a new mythic republic), beautifully served the call for a nationalistic art that would express the unfolding drama of nation building itself. The difference between Cole's narrative landscapes and those of the succeeding generation was the ideological uses they served in each instance.

This emphasis on literary, narrative structures of meaning was taken at times to literal extremes. In 1849, for instance, a writer for the *Bulletin of the American Art-Union* drew a direct analogy between literary plot and the spatial structure of the landscape. The well-composed landscape, like the well-constructed tale, was one in which detail, or subplot, remained subordinate to overall effect:

> The great principle seems to be that in all landscapes there must be a direct road or air line of attraction, where the eye shall naturally fall, and where it can expatiate with a sense of freedom. Here . . . must the scene tell upon us with its full poetic power; all its beauty or all its grandeur must surround and depend upon this central track of observation; this must be as a grand plot, to which all the incidents, hills, trees, clouds, cattle, groups, &c., must relate, and to carry out the purpose of which they must be introduced. We may have underplots too, so many . . . that they shall almost overpower the main story—*but story there must be, or we have no landscape*.[53]

52. On this habit of reading and its relationship to the panoramic format, see Ellwood Parry, "Landscape Theater in America," *Art in America* 59 (November–December 1971): 52–61.

53. "Some Remarks on the Landscape Art," *Bulletin of the American Art-Union* 2 (December 1849): 18. The insistence on story was likewise made by Jervis McEntee, quoted in G. W. Sheldon, *American Painters* (1881; reprint, New York: Benjamin Blom, 1972), p. 52.

The landscape was structured around motifs—"hills, trees, . . . cattle, groups"— and connected by a variety of means first used in the pastoral landscapes of the seventeenth century: serpentine bodies of water, paths or roads, delicate aerial perspective. Yet artistic unity was conceived as much in literary as in spatial terms, the product not only of compositional but of narrative coherence which governed the relationship of part to whole. Movement through space is prompted by particular forms whose function, aided by association, was to discipline the random motions of the eye in conformity with a culturally meaningful sequence. As Henry Bellows put it, "Nothing indicates the culture, taste, or attributes of the beholder more than the habit of his eye."[54]

Friend and companion of numerous New York landscape painters, Bellows also made explicit the correlation of spatial properties—distance and recession—with the phases of time and history. This description by Bellows of a landscape could apply to works such as Durand's *View of the Hudson River Valley* (figure 15) or Cropsey's *Valley of Wyoming* (figure 16):

> Between the undefined, but luminous distance that makes the future of our life, and the clear but shaded foreground that represents our present, there is a mild and half revealed intermediate region, representing those superior interests short of eternal ones, which hold their rewards in store for us. . . . Thus the present, the intermediary, and the future all have their proper *perspective,* and their due light and shade; the far future fascinating the eye with its glorious indefiniteness; the nearer future beckoning it away from the grosser and more tangible objects nearest at hand, and the present, while rewarding the closest and most careful notice, yet forbidding the vision to dwell otherwise than cursorily upon its large but shaded objects.[55]

Bellows's temporalization of landscape space reveals a contemporary tendency to approach both the individual moral and the national life as in a condition of perpetual becoming. Bellows leads the reader restlessly through the temporalized space of the landscape, shifting back and forth between horizon and foreground, future and present, in a syntactic expression of his own anxiety over the elusive and nonlinear quality of time and history. The future in Bellows's landscape is undefined if luminous, the present "clear but shaded." There is no area that corresponds to the past which would furnish a relative measure of progress. Bellows can

54. Henry Bellows, "Moral Perspective," *The Crayon* 4 (February 1857): 34.

55. Ibid., p. 34 (emphasis added). On the importance of "perspective" to moral philosophy and aesthetics in the mid-nineteenth century, see Richard S. Moore, " 'That Cunning Alphabet': Melville's Aesthetics of Nature," *Costerus,* n.s., 35 (Amsterdam: Editions Rodopi B. V., 1982).

Figure 15. Asher B. Durand, *View of the Hudson River Valley*, 1851. Oil on canvas; 32″ x 41½″. Herbert F. Johnson Museum of Art, Cornell University, Ernest I. White Endowment Fund.

only offer a nervous assurance that perspective—a relative rather than an absolute measure of space—holds the key to solid moral understanding. Forbidding us to dwell on the present, Bellows consigns us to an unceasing oscillation between foreground, middle ground, and distance, between the here and the hereafter. The generating power behind his image is a quest for resolution, which, like the landscape polarities explored in Chapter 3, is dynamized by uncertainty.[56]

56. On the varied interpretations of the relationship of past, present, and future, and the changing meaning of the "national trust" over the course of the nineteenth century, see Paul Nagel, *This Sacred Trust: American Nationality, 1798–1898* (New York: Oxford University Press, 1971), esp. chaps. 2 and 3.

Figure 16. Jasper Francis Cropsey, *The Valley of Wyoming*, 1865. Oil on canvas; 48½″ x 84″. The Metropolitan Museum of Art. Gift of Mrs. John C. Newington, 1966.

The most literal example of how space was temporally apprehended came from the world of the popular arts. The moving panoramas of the 1840s and 1850s covered a wide variety of subjects, from the journey down the major rivers of America and Europe to a balloon voyage along the Oregon Trail, a trip to California via the tropics, voyages through the "Great West," Canada, and Europe, and tours through biblical history. In the absence of surviving works it is difficult to know to what extent such entertainments were true narratives rather than chronicles or anecdotal records. At least one major instance of the panorama vogue—the panoramas of the Mississippi River dating from the later 1840s—combined anecdotal material with an underlying plot, employing the natural structure of the landscape to set forth a developmental and progressive view of the settlement of the Mississippi Valley.[57]

57. The subject of panoramas is discussed in Angela Miller, "The Imperial Republic: Narratives of National Expansion in American Art, 1820–1860" (Ph.D. diss., Yale University, 1985), pp. 265–435. With this exception, the larger dimensions and cultural significance of the vogue for moving panoramas in America remains mostly uninvestigated.

The vehicle of the grand plot embedded within American landscape was the road, or its fluid counterpart, the river, connecting the incidents of the landscape in a unified whole. By the 1840s and 1850s the road and the river had become collective emblems of the nation's westward mission. They were the carriers of history, the physical structures on which America's continental identity was built. Manifest destiny furnished the grandest plot line of all. In each of these instances space, by being metaphorically or literally temporalized, reinforced and naturalized an ideology premised on economic growth and the development of a national network of trade and transportation. The Sister Arts concept, as we shall see, found its fullest consummation in the realm of landscape. Painting was the mute poetry of national destiny, while poetry and rhetoric realized in vivid word paintings the march of American culture across the grand sweep of the continent.

The textual reading of landscape found reinforcement in the concept of a "great book of Nature."[58] By extension, art was a form of scriptural commentary on nature's book. Durand's "Letters on Landscape Painting" emphasize the proper disciplining of the artist through close study of nature and through a step-by-step progression from details to the composition of the whole.[59] This emphasis reflects his larger effort in the "Letters" to provide a lucid syntax or grammar with which to convey nature's meaning. In his words, "All the technicalities above named are but the *language and rhetoric* which expresses and enforces the doctrine—not to be unworthily employed to embellish falsehood, or ascribe meaning to vacuity."[60] For Durand the central doctrine, truth to nature, remained unproblematic. The role of artistic means was to furnish a transparent expression of natural truth. Yet the very terms he employs—the conjunction of rhetoric with falsehood—themselves raise the possibility of deception, of a visual text that is meretricious or morally misleading. Embedded within his anxious qualifiers is the admission that the grammar of

58. The phrase was used by Asher B. Durand in Letter 3, "Letters on Landscape Painting," *The Crayon*, January 31, 1855, p. 66. See also E. L. Magoon, "Scenery and Mind," in *Home Book of the Picturesque* (New York, 1852), p. 5, on the metaphor of the book of nature. Joni Kinsey, *Creating a Sense of Place: Thomas Moran and the Surveying of the American West* (Washington, D.C.: Smithsonian Institution Press, 1992), discusses John Wesley Powell's vision of the Grand Canyon as geological and divine text.

59. See, for instance, Professor Hart, "Lectures on Painting," *The Crayon*, March 28, 1855, pp. 197–99; "View-Taking," *The Crayon*, April 15, 1855, p. 236; Champney, *Sixty Years' Memories of Art and Artists*, pp. 141–42.

60. Durand, Letter 3, "Letters on Landscape Painting," p. 66. On the textual-scriptural underpinnings of American identity and their extension to romantic attitudes toward nature, see Sacvan Bercovitch, "The Biblical Basis of the American Myth," in Giles Gunn, ed., *The Bible in American Arts and Letters* (Philadelphia: Fortress Press, 1983), pp. 224–25.

painting could serve ends unrelated to truth as he understood it. Despite the claims of transparency, Durand admitted the manipulations of the artist but insisted on their proper uses and ends.

Operating within Durand's image was the presumption that the natural world, subjected to disciplined vision, was a coherent and readable structure. Such a presumption supported both a religion of nature that read "sermons in stones" and a politics of vision in which aesthetic appropriation went hand in glove with cultural possession. In both instances nature's text was made legible through the rhetorical skills of the landscape painter.

The literary model served multiple cultural functions for landscape artists. It addressed the critical call for a didactic and elevating art; it appealed to the reading habits of an increasingly literate audience; and it provided artistic legitimacy through its association with the linked concepts of nature as a divine text and progress as the law of American history.

The emphasis on the legibility of landscape painting was also a response to a growing public audience. William Sidney Mount explained that "it is not necessary for one to be gifted in language to understand a painting if the story is well-told—It speaks all the languages—is understood by the illiterate and enjoyed still more by the learned."[61] Legibility—the appropriate fit between form and content—was in a larger sense a defining aspect of nineteenth-century academic art, in both Europe and America. John Ferguson Weir remarked that "the popular craving, in art, as in literature, is for that which is easily understood."[62] More and more reliant on their public reception, artists working in an academic milieu in the United States, as in Europe, turned to narrative devices, popularizing older Renaissance concepts of *istoria* and decorum by applying the standard of appropriateness of gesture, costume, and attitude to contemporary subjects. Such concerns, albeit at several historical removes from their origins, formed part of the painterly preoccupations of northeastern artists as they attempted to win the plaudits of critics and audiences demanding more accessible, nationally meaningful images. The influence of public taste on the artist's choice of subject was asserted by an anonymous contributor to *The Crayon,* the main arbiter of artistic values in the 1850s: "Exhibitions do not display the merits of particular works of Art and the progress of individual artists so much as they do the nature of public taste. . . . It is a mistake to suppose that artists are free to paint what pleases them best. . . . The truth is, that artists are compelled to meet the public by consulting its likes and dislikes."[63]

61. Quoted in Lillian B. Miller, "Paintings, Sculpture, and the National Character, 1815–1860," *Journal of American History* 53 (March 1967): 701.

62. [Weir], "American Landscape Painters," p. 148.

63. *The Crayon* 6 (June 1859): 189.

A second factor influenced the concern with narrative legibility in landscape: the need to compete with genre painting for the attention and enthusiasm of the public. "With these evening crowds," observed one visitor to the exhibition rooms of the American Art-Union, "Durand's misty noontide of landscape, or Kensett's clear, bold grouping of rock and river, are less popular than Edmonds's *Strolling Musician* and Glass's *Equestrian Scenes.*"[64] Genre, with its engaging anecdotal dimension, carried an easy appeal with audiences that landscape painting only poorly matched. For a work to hold its own beside genre painting in the public galleries of the National Academy and the American Art-Union meant being able to command a parallel kind of readability.

Much early scholarship on American art, by dwelling on sublime wilderness scenes loftily beyond the reach of human or historical associations, has overlooked the many ways in which space operated in narrative terms for nineteenth-century audiences.[65] The exceptions to this general view are significant and numerous enough to qualify the inherited wisdom about American landscape at midcentury as a celebration of wilderness.

The paintings of the White Mountain region in New Hampshire and the popular writings of Thomas Starr King demonstrate that aesthetic control, acting out cultural colonization, was at the heart of the sequential narrative landscape in these years. So normative was the association between the place and a certain canonized aesthetic that Melville used it with telling irony in *Moby-Dick,* as the very type of the contained and pastoral inland landscape. Perhaps satirizing the White Mountain school, Melville described a painting of the Saco Valley whose elements border on the banal: "trees . . . meadow . . . cattle . . . [and] cottage," "a mazy way" winding "deep into distant woodlands . . . reaching to overlapping spurs of mountains bathed in their hillside blue."[66]

There were several reasons for the popularity of the White Mountains for both

64. "The Art-Union and Its Friends," *Bulletin of the American Art-Union,* November 25, 1848, pp. 44–45. Maybelle Mann, *The American Art-Union* (privately published, 1977), pp. 23, 29, notes the American Art-Union's emphasis on story telling in the choice of paintings to be engraved, and suggests that this may account for the small number of landscapes chosen prior to 1851, when three landscapes were engraved.

65. Exceptions to this tendency are James Moore, "The Storm and the Harvest: The Image of Nature in Mid-Nineteenth-Century American Landscape Painting" (Ph.D. diss., Indiana University, 1974), and Stein, *Susquehanna,* p. 40 and passim.

66. In the chapter titled "Loomings," in *Moby-Dick,* ed. Harrison Hayford and Herschel Parker (New York: W. W. Norton, 1967), p. 13. The passage is analyzed by Moore, "'That Cunning Alphabet,'" p. 66. Moore's study furnishes an excellent summary of midcentury aesthetics relevant to my reading of the White Mountain picturesque formula.

artists and tourists. Since the 1820s the region had served as a showcase for national scenery, offering a rich combination of sublimity, accessibility, and patriotic associations with the founding fathers of the republic. It satisfied a growing taste for aesthetically modulated landscapes. Its sublimity was tempered by beautiful vales watered by rivers such as the Saco. The painter George Loring Brown dubbed it "the Switzerland of America."[67] All these factors combined to make it second only to the Hudson River valley as the locus of an emergent nationalist landscape. Less exclusively dominated by New York academicians than the Catskill painters, the so-called White Mountain school of artists focused friendly rivalries between artists from New York and Boston, and had at least an equal claim to being a national school. Yet despite the wider variety of its regional membership, its aesthetic formulas were those of the nationalist New York painters. Here the tensions between wildness and civility, aesthetic and utilitarian concerns, nature's power and culture's imperatives were dramatized in the artistic representation of the landscape.

There is a revealing disparity between visitors' responses to the White Mountains between the 1820s and 1840s and those that characterized the midcentury. Romantics such as Thomas Cole and Francis Parkman took genuine pleasure in the wild nature of the region. Cole, when he traveled through the White Mountains in 1828 on his second visit, was most impressed with the picturesque cragginess of the mountains festooned in clouds, and with the storm-ravaged forests and other evidence of tumult. He later wrote that he had climbed Mount Chocorua "for ideas of grandeur." A major portion of Cole's sketches of the region are taken from the vantage point of a mountainside, looking down upon a valley. The effect is to dramatize the contrast between rugged foreground and smooth distance, shrinking the signs of settlement in the valley to a Lilliputian scale. While later White Mountain painters preferred a graduated progression from pastoral foreground and middle ground to mountainous distance, Cole was temperamentally drawn to the wildest and most difficult passages of scenery.[68] By 1841, when Francis Parkman

67. Best known for his "Old Master" views of Italy, Brown produced an enormous panoramic view of Mount Washington, *The Crown of New England,* bought by the Prince of Wales in 1861 (now lost). See Donald Keyes et al., *The White Mountains: Place and Perception* (Hanover, N.H.: University Art Galleries, 1980), p. 82.

68. Detroit Institute of Arts, Sketchbook 39.559, 1827; Cole, "Sketch of my tour to the White Mountains with Mr Pratt" (1828, Detroit Institute of Arts, 39.559). I am indebted to Kathleen A. Erwin of the Detroit Institute for kindly permitting me to see her transcription of these notebook pages, now published in the *Bulletin of the Detroit Institute of Arts* 66 (1990): 27–33. In addition, Cole exhibited a *View from the Summit of Mount Washington* at the National Academy of Design (no. 107) in 1828 (currently unlocated). See also Catherine H. Campbell, "Two's Company: The Diaries of Thomas Cole

traveled to the White Mountains on summer vacation from his Harvard studies, his coach companions included adventurous ladies anticipating the region's growing fashion among urban tourists from Boston and New York. Parkman felt compelled to push farther toward the Canadian border for "a taste of the half-savage kind of life necessary to be led, and to see the wilderness where it was as yet uninvaded by the hand of man."[69] By the time Thomas Starr King published *The White Hills* (1859), his widely read guide to the region, the sublime experiences that had occupied the foreground of Cole's and Parkman's accounts had been pushed into the remote distance and replaced by descriptions of a gentle, quasi-arcadian landscape, the very scenic consummation of the republican pastoral.

King, Boston's emissary of Ruskinian beauty, as well as a minister, writer, and traveler, furnished an appropriate literary gloss on the region that added to its legendary status.[70] King's *White Hills,* a classic of travel literature at the time, educated its readers by carefully prescribing the proper mode of viewing the region. His descriptions of the mountains perfectly parallel the visual formulas employed by the painters from Boston and New York who made the region their sketching ground each summer, beginning with the arrival of Benjamin Champney in 1851. Both writer and painters contained nature's raw power aesthetically through scale adjustments, atmosphere, distance, and graduated movement. King described North Conway, in the heart of the White Mountains, as a "scene of plenty, purity, and peace" presided over by "Jovelike" Mount Washington, rising above a host of lower peaks, a solemn if benign patriarchal presence. The valley of North Conway was a natural lesson in landscape composition, "a little quotation from Arcadia," which softened through distance the sublime monotony of unfiltered mountain scenery.[71]

Adopting the proper point of view was the essence of scenic enjoyment—the ability, that is, to perceive the inherent order of the landscape. King's selective and literate sensibility plays the same role as the perspective that set a painting into

and Henry Cheever Pratt on Their Walk through Crawford Notch, 1828," *Historical New Hampshire* 33 (Winter 1978): 109–33.

69. Francis Parkman, "1841 Journal," in *The Journals of Francis Parkman,* ed. Mason Wade (New York: Harper and Bros., 1947), 1:31.

70. White Mountain legends included the snowbound death of a young woman while pursuing her faithless lover through the desolate wilderness; a spiral of vengeance between white settlers and native inhabitants, culminating in the dramatic suicide of the Indian chief Chocurua and his dying curse; and most famous of all, the devastating rock slide in Crawford Notch in 1826, which destroyed an entire family of settlers. See Chapter 4. Such legends highlighted the area's appeal as a scenic mecca for urban northeasterners.

71. Thomas Starr King, *The White Hills: Their Legends, Landscape, and Poetry* (Boston: Crosby, Nichols, Lee, 1860), pp. 158–59, 152, 175.

focus at the proper distance. Seen through "large intervening depths of air," the rough surface of the mountains, like the blotchy, "coarsely contrasted hues" upon a canvas, resolved into "grandeur and . . . beauty."[72] To look beyond irregularities to underlying symmetry and uniformity was the essence of well-trained aesthetic appreciation of landscape.

Among the most noteworthy features of the book is the sustained analogy between landscape and art. King repeatedly describes the natural view as a gallery of pictures or a "diorama." Employing the new vocabulary of "proof impressions" and cloud "photographs," he calls for "clear pictures" rather than "dissolving views."[73] He emphasizes the importance of positioning oneself for the finest view and repeatedly invokes the manner in which nature imitates art, resulting in the virtual collapse of the two into a unitary image of nature as a painting.

So closely associated were visual and written expression in the 1850s that the White Mountain school legitimately includes not only painters but King as writer and aesthetic guide to the region. The characteristic form of both painting and writing was the mediated, sequential landscape in which a mountain is visually approached across a pastoral meadow or intervale, and softened by atmosphere. Such a formula modulated the sublime visual encounter with the mountains into a genteel exchange.

The most complete expression of the reliance on extravisual forms of meaning was the Sister Arts concept, which closely allied painting with poetry.[74] Since antiquity, theories of painting had drawn heavily upon expressive concepts grounded in poetry which endowed painting with the exalted function of portraying humanly meaningful action.[75] Among American academicians the theory of the Sister Arts

72. Ibid., p. 6.

73. Ibid., pp. 7–8, 173, 327, 342, 18–19.

74. The literature on this specific aspect of American aesthetics is extensive: see Donald Ringe, "Kindred Spirits: Bryant and Cole," *American Quarterly* 6 (Summer 1954): 233–44; Ringe, "James Fenimore Cooper and Thomas Cole: An Analogous Technique," *American Literature* 30 (March 1958): 26–36; Ringe, *The Pictorial Mode: Space and Time in the Art of Bryant, Irving, and Cooper* (Lexington: University of Kentucky Press, 1971); James T. Callow, *Kindred Spirits: Knickerbocker Writers and American Artists, 1807–1855* (Chapel Hill: University of North Carolina Press, 1967); William Cullen Bryant II, "Poetry and Painting: A Love Affair of Long Ago," *American Quarterly* 22 (Winter 1970): 859–82; *William Cullen Bryant and the Hudson River School of Landscape Painting* (Roslyn Harbor, N.Y.: Nassau County Museum of Fine Art, 1981); Franklin Kelly, *Frederic Edwin Church and the National Landscape* (Washington, D.C.: Smithsonian Institution Press, 1988), pp. 28–31.

75. See Rensselaer W. Lee, *"Ut Pictura Poesis": The Humanistic Theory of Painting* (New York: W. W. Norton, 1967); Mario Praz, *Mnemosyne: The Parallel between Literature and the Visual Arts* (Princeton: Princeton University Press, 1970).

still carried enough authority to uphold the traditional affinities between painting and poetry long after European theorists such as G. E. Lessing had challenged the concept.[76] As we have seen, for them the literary dimension of landscape was a means of controlling the image, retaining its vivid power to hold the eye while compelling the mind and associations toward predetermined meanings.[77] Cole embodied the painter-poet ideal for later artists. As Louis Noble put it: "He was always the poet, when he was the painter—which . . . is to say almost more than can be said of any landscape painter that has appeared."[78]

The most complete visual statement of the Sister Arts ideal is Asher B. Durand's *Kindred Spirits* (1849, figure 17), a romantic transformation of the older Horatian doctrine of *ut pictura poesis,* which located a shared basis of both painting and poetry in the representation of human nature and action. Romantic theorists, assisted by associationism, redirected the exalted moral function of the arts from history painting to landscape and the representation of nonhuman nature. As they stand gazing out on the Clove of the Catskills, Cole and Bryant pay tribute as painter and poet to a higher master, nature itself, the indisputable authority and grounding of all cultural productions.[79] Durand's painting commemorates a friendship dating to the 1830s and 1840s, yet it does so in terms fully meaningful to the succeeding decade.[80] Durand would become as fully Bryant's kindred spirit in

76. The expressive equivalence of painting and literature was only seriously challenged in 1766, when Lessing published his influential essay on the relationship of the arts, *Laocoon: An Essay on the Limits of Painting and Poetry* (New York: Bobbs-Merrill, 1962), which drew a sharp distinction between painting and literary genres. Lessing based his challenge to the Sister Arts theory on the claim that painting was instantaneously apprehended, while in poetry meaning developed over time: "It remains true that succession of time is the province of the poet just as space is that of the painter" (p. 91).

77. An official promulgation of the Sister Arts concept was Morse's *Lectures on the Affinity of Painting with the Other Fine Arts.* In the same year William Cullen Bryant delivered his "Lectures on Poetry" for the same series of Atheneum lectures, thus sealing the connection between the arts that was the subject of the series. There were, of course, passages in American art criticism that did not accept the traditional equivalence of the two arts. See "Art and Artists in America," *Bulletin of the American Art-Union* 4 (November 1851): 131.

78. Noble-Vesell, *Life and Works,* p. 52. A similar statement was made by William Dunlap in "The Fine Arts. The Studio of Cole," *New-York Mirror,* April 18, 1835. Cole's reputation as the poet-painter had assumed a negative charge well before 1873, when [Weir], "American Landscape Painters," p. 141, described him thus: "Cole's sympathies were rather those of a poet than an artist."

79. Morse, *Lectures,* p. 71, articulated this concept at the beginning of his third lecture: "The sister arts perform each in her own peculiar way upon the same harp of Nature."

80. See, for instance, the series of articles in *The Crayon* on the major poetic figures of the day: "The Landscape Element in American Poetry—Bryant," 1 (January 1855): 3–4; "Street," 1 (January 1855): 39–40; "Lowell," 1 (March 1855): 179–80; and others in the same series.

Figure 17. Asher B. Durand, *Kindred Spirits,* 1849. Oil on canvas; 46″ x 36″. Collection of The New York Public Library, Astor, Lenox and Tilden Foundations.

the 1850s as Cole had been in earlier decades.[81] Like his political counterpart Henry Clay, Durand was the great compromiser, forging a middle road between plein-air naturalism and the grand European tradition of the composed landscape. Damning the artist with faint praise, a reviewer for the *New York Tribune,* probably George William Curtis, wrote in 1852: "His position is assured. A quiet, pastoral Poet—a Thomson on canvas—always soothing, never inspiring—sure to please, equally sure not to surprise."[82] Never demanding too much of his audiences, he also linked the generations. An older contemporary of Cole, Durand had his greatest influence among the younger generation of the 1850s, especially with the publication of his "Letters on Landscape" and his presidency of the National Academy.

A key component of the theory of the Sister Arts for painters of the time was the ideal of a transparent representation, in which subject and object, mind and nature, were fully commensurate.[83] Such an equivalence between mind and nature was a central assumption of common sense moral philosophy. The equivalence helped keep at bay the dangers of subjectivism and moral antinomianism by placing imagination under the higher jurisdiction of an objectively verifiable natural law.

Daniel Huntington's portrait of Durand, painted in 1857 (plate 3), turns upon this identity between nature and imagination, placing both in the service of nationalism. The ties between the painter and his subject are made not through literary association but through formal and compositional means. Huntington presents Durand, the exemplar of one half of the Sister Arts, and over sixty at the time, in front of an easel bearing his nearly finished painting *White Mountain Scenery, Franconia Notch* (1857). The portrait was donated to the Century Association by members in 1864 as a tribute to both Huntington—a highly respected president of the National Academy as well as apologist for American art—and Durand for their prominent role in New York's cultural life.

Falling within the older tradition of the studio portrait, Huntington's painting shows the artist with the materials of his art—palette, pigment, brushes, easel, and canvas. The painting-within-a-painting motif further emphasizes the theme of artistic self-representation. Yet what is noteworthy is the extent to which the theme

81. Sheldon, *American Painters,* p. 129, drew the comparison between "the aims and the methods" of Durand and Bryant in what would later become a scholarly commonplace. Bryant claimed: "There are no landscapes produced in any part of the world I would more willingly possess than [Durand's]." Quoted in John K. Howat, *The Hudson River and Its Painters* (New York: Viking, 1972), p. 38.

82. "Fine Arts. Exhibition of the National Academy," *New York Tribune,* May 20, 1852, p. 5, col. 6. The attribution to Curtis was made by Franklin Kelly.

83. See D. H. Meyer, *The Instructed Conscience: The Shaping of the American National Ethic* (Philadelphia: University of Pennsylvania Press, 1972), on the Scottish common sense background of the eastern cultural establishment and its guiding beliefs.

of art as the craft of representation is subsumed within a native idiom of nature that asserts the transparency of representation: the painting becomes a window to nature, which is in turn a window to higher realities. By its agency one sees through natural types to their moral and spiritual source. In this studio portrait Durand's workshop is nature itself, in a denial of the social and material conditions shaping cultural production. The portrait represents the act of painting the landscape as part of an ideal continuum connecting nature and art. The horizon line in the painting within a painting coincides almost precisely with the "real" painted landscape behind it, suggesting not only affinity but identity between the thing itself and its representation. The physiognomy of the landscape on the easel, fringed in muted gray mountains, resembles that of Durand, with his beard-fringed face. Both are soft and idealized.[84] Situated at an oblique angle to the real canvas, the easel mirrors the angle of Durand's head and body and his slightly averted gaze. The arc of the tree that brackets the figure of the artist is echoed by the graceful arc of the tree in his painting of Franconia Notch.[85] Such passages assert the reciprocity between the painting and the landscape—represented and real nature—and between the painter and his work.

Yet this implied continuity between nature and art is incomplete. The painting asserts the natural and yet betrays the artificial, and artifactual, quality of art by calling attention to its own means. The thematic connection between nature and art is simultaneously asserted and compromised in numerous ways. The act of painting is represented as a kind of spontaneous creative ejaculation whose energy is directed from the painter to his canvas. Yet the creative act is constrained by both the formality of its presentation and its mediated nature, represented by paintbrushes and pigment. Instead of transparency there is a densely painted, somberly colored portrait of the dean of the "youthful" American school as an Old Master. The appeal to a youthful culture in the tones of seasoned middle age was the crux of George Santayana's later observation that America was a young country with an old

84. The physiognomic metaphor was common to descriptions of the landscape. Samuel Osgood commented that Kensett's "remarkable studies of cloud and sky . . . seem like the vision of the face of a departed friend, a restoration of the very countenance with its lights and form, its thought and feeling." *Proceedings at a Meeting of the Century Association, in Memory of John F. Kensett, December 1872* (New York, 1872), p. 22. Theodore Winthrop, describing Mount Katahdin in Maine, in *Life in the Open Air* (Boston: J. R. Osgood, 1871), p. 71, wrote that the "grey of his scalp [was] undistinguishable from the green of his beard of forest."

85. According to both John Durand, *Life and Times of Asher B. Durand*, and Daniel Huntington, *Asher B. Durand: A Memorial Address* (New York: for The Century, 1887), Durand himself painted the Franconia Notch landscape in Huntington's portrait of him. The portrait was engraved and used as a frontispiece to Huntington's *Memorial Address*.

mentality.[86] The autumnal colors of Huntington's portrait—browns and tawny golds—suggest the waning rather than the waxing phase of the national school, and anticipate the subdued mood of the postwar "Brown Decades," an era of containment, institutional restraint, and renewed ancestor worship.[87]

At the heart of the composition is the palette of the painter. Here the suppressed meanings of Huntington's portrait of Durand come together in a complex play with its programmatic symbolism. The foreshortened circular form of the palette complicates the continuous flow of energy between nature, artist, and work—both connecting and separating Durand and his easel. Paintbrushes shoot like spokes from the palette to the canvas. One of these brushes points to the landscape beyond, calling attention to the flatness of the canvas at the same time that it asserts a formal connection with the nature it is used to represent.

Yet the materials of art, the pigments themselves, constitute the portrait's most visually charged passage, in vital contrast to the generality of the landscape and of Durand himself. These neatly placed, sperm-shaped globules of white, red, black, and brown pigment are carefully arrayed around the circumference of the palette, the raw stuff of art prior to their assimilation into the painted image, where they lose their materiality in veils of muted and somewhat muddy color.

Huntington's painting sublimates Durand's institutional role, and the process of artistic production, into an image of art as an unmediated expression of a nationalism rooted in nature. Through the apparently seamless movement from painted canvas to nature, the mediating function of art and the constructed character of the painted landscape are denied by the assertion of transcendence.

The portrait of Durand thus presents the viewer with two distinct messages, on the one hand announcing the transparent relationship between art and nature, and on the other calling attention to the physical materials of cultural production. The palette is an artifact not only of aesthetic but of national creation, containing the raw material out of which national meanings are produced. Henry Tuckerman praised Durand's preference for subdued color harmonies, which he compared favorably to the colors of nature, wherein "every variety of hue is so admirably disposed as to contribute to a general and pleasing unity, so that we do not note

86. George Santayana, "The Genteel Tradition in American Philosophy," in *The Genteel Tradition: Nine Essays by George Santayana*, ed. Douglas L. Wilson (Cambridge: Harvard University Press, 1967), p. 39.

87. Sometime before 1887 Huntington repainted his canvas, aging Durand and making him more thickset. In a 1940 restoration these repaintings were removed. Conservation report, Century Association. I am indebted to Elizabeth Roark for sharing with me her own work on Huntington's portrait of Durand.

each in our sympathy with all."[88] The concept of nationalism drew force from such natural analogies, and the possibility that social like perceptual experience could be based on a principle of integration. The paintbrushes bear none of the messy marks of the struggle to appropriate nature's forms for the language of art. Instead they draw attention to the finished product. Unlike Cole's *Oxbow,* Huntington's portrait maintains the central artistic myth of the national school—the illusion of an unmediated relationship of nature to art. Paint and brushes are cultural agents recruited to the cause of nationalism. Yet although the program of the painting submerges their identity within the final product, the constituent parts remain visually insistent, forming an aureole of raw color at the very center of the canvas, recalling the unassimilated elements in the nation's own incomplete identity. Seeping through the controlling structures of the painting is another level of meaning that reveals a perhaps unconscious fascination with how the national myth of nature is produced, and of what materials it is constituted.

Huntington also produced a portrait of Bryant whose similarities to his portrait of Durand, in format, background, and palette, suggest that Huntington may have thought of them as matching public images of the nation's painter and poet laureate. Indeed, Huntington's portraits of the two men serve more as tributes to their cultural importance than as records of individual character. In his portrait of Bryant (1866, figure 18), the poet, venerably white-haired and seated in the interior of a wood, leans his arm upon a lichen-covered boulder.[89] The image completes the act of miniaturization represented by Huntington's earlier portrait of Durand. Bryant, book in hand, is the exegete of American nature. The natural backdrop of the portrait appears like a private chamber. The poet's crossed hands and partially closed book imply a contracted, circumscribed meaning. The nature about which he writes is intimate and domesticated. This more bounded view suggests a drawing in of the expansive energies of nation building. From Huntington's eastern vantage point the process of colonizing nature was a purely aesthetic and formal act, remote from the actual process of economic development.

Huntington's portraits of Durand and Bryant assert a closed circle of references: painter to poet and poet to painter, nature to art and art to nature.[90] The parallels

88. Henry Tuckerman, *Artist-Life: or, Sketches of American Painters* (New York: D. Appleton, 1847), p. 88.

89. Bryant was intimately involved with New York institutions active in promoting American art and fostering ties between artists and writers. See David Shapiro, "William Cullen Bryant and the American Art-Union," and James T. Callow, "William Cullen Bryant and the Early Sketch Club," in *William Cullen Bryant and His America: Centennial Conference Proceedings, 1878–1978,* vol. 4 of *Hofstra University Cultural and Intercultural Studies* (New York: AMS Press, 1983), pp. 85–95, 67–83.

90. Durand also painted a portrait of Bryant in 1854 (Historic Hudson Valley, Tarrytown, N.Y.).

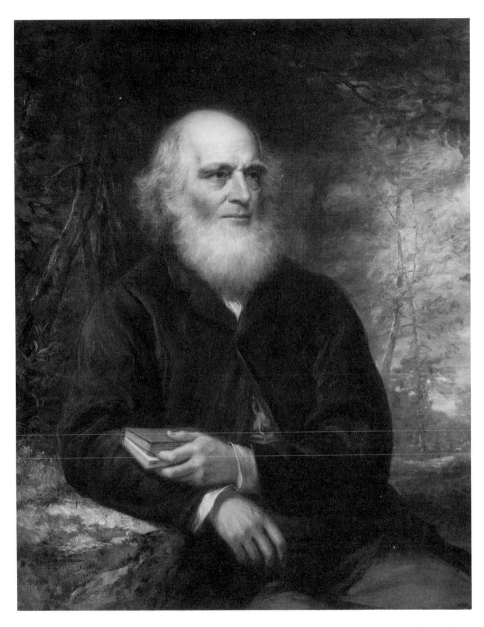

Figure 18. Daniel Huntington, *William Cullen Bryant,* 1866. Oil on canvas; 40″ x 32⅛″. The Brooklyn Museum, 01.1507. Gift of A. Augustus Healy, Carll H. DeSilver, E. G. Blackford, C. W. Seamans, H. J. Morse, R. B. Woodward, James R. Howe, W. B. Davenport, F. S. Jones, A. Abraham, and C. A. Schieren.

between Durand and Bryant appear in other forms as well. Artist and poet were each honored by New York's artistic and literary worthies. Durand's seventy-sixth birthday in 1864, seven years after the completion of Huntington's commissioned portrait, was celebrated in an "impromptu" staged picnic. Bryant's seventieth birthday, also in 1864, dropped all pretense of informality in favor of a highly organized show of admiration and thanks to the nation's poet of nature in the midst of the Civil War. The event reveals a great deal about the political function of a nationalist ideology grounded in nature—its role, that is, in promoting the cultural solidarity of the North in the wartime years.

The celebration was arranged by members of the Century. Attended by over four hundred artists, writers, and other cultural figures from throughout the nation, the event brought together lifetimes of literary and artistic friendships.[91] The birthday, however, was also a tribute to northern unity. When Emerson declared Bryant to be the "joint possession" of both New York, "your imperial state," and Massachusetts, he was pointedly laying aside decades of rivalry between the two major cultural centers of the North in the interests of a higher bond. His gracious concession bespoke the new spirit of generosity that underwrote northeastern nationalism as it was being redefined during the war years. Bryant was "one of those etherial [*sic*] hoops which binds these States inseparably in the perilous times." More than any other cultural figure of the nineteenth century, the poet was linked in the public mind with the American ideal of nature to which he had dedicated his talents. At a time when the hallowed concept of union rested in the balance, "while the mountains and the oceanside ring with the tramp of cavalry and the din of cannon," in the words of the Century president, George Bancroft, this rallying around the quasi-iconic figure of Bryant reasserted the value of the American Union and the cultural ideals that underwrote it.[92] Bryant's birthday celebration demonstrated the

91. On Durand's picnic, see John Durand, *The Life and Times of Asher B. Durand,* pp. 201–2; Sheldon, *American Painters,* p. 130; Garnett McCoy, ed., "Jervis McEntee's Diary," *Archives of American Art Journal* 8 (July–October 1968): 4. Parke Godwin, *A Biography of William Cullen Bryant* (New York: D. Appleton and Co., 1883), 2:214–20, furnishes an account of Bryant's birthday; see also Weiss, *Poetic Landscape,* p. 102. Major literary figures included Oliver Wendell Holmes, Richard Stoddard, Julia Ward Howe, and George Bancroft; the list of the invited was a literary Who's Who. The artists who presented Bryant with a portfolio of fifty or so landscape works included Durand, Kensett, Eastman Johnson, Church, Gifford, Samuel Colman, Emanuel Leutze, Bierstadt, Jervis McEntee, and others.

92. *The Bryant Festival at "The Century"* (New York: D. Appleton, 1865), pp. 16–17, 6–7. Perhaps the most consistent note of the proceedings was the theme of freedom, sounded by Oliver Wendell Holmes in a poem written for the event: "His last fond glance will show him o'er his head/The Northern fires beyond the zenith spread/In lambent glory, blue and white and red,—The Southern cross without its bleeding load,/The milky way of peace all freshly strowed,/And every white-throned

commitment of the community of northeastern painters and poets to their traditional alliance, an alliance that had done so much to exalt nature to the level of a national faith.[93]

Bryant's wartime poem "My Autumn Walk" affirms the essential morality of nature and its power to give authority to political and national events. The color red in the poem links the changing colors of autumn to the spilling of the nation's blood, an association with seasonal cycles that redeems and sanctifies collective sacrifice.[94]

By midcentury landscape painters were able to draw upon certain "internalized absolutes" that Americans of a certain class and race shared. Like other cultural endeavors such as institutionalized religion and education, landscape images worked their power over viewers, in theory at least, by formalizing values that unified people of similar social backgrounds across geographic lines.[95] In the nation's metropolis painters gathered to develop a broad visual language susceptible to metaphoric and iconographic elaboration. But in the final analysis the effort to contain the meanings of images proved impossible.

Landscape painters frequently relied on historical associations to give the fullest weight of meaning to their art. As a theory of meaning, however, associationism served not only national but local and at times sectional interests that were at cross-purposes with national feeling. Associationism also prepared the way for uncontrolled subjectivity, since aesthetic qualities were inherent not in the object itself but

star fixed in its lost abode!" "Bryant's Seventieth Birthday," ibid., p. 46. John Greenleaf Whittier, Richard Henry Dana, and Henry Tuckerman all echoed the theme of freedom in their tributes to Bryant. Emerson drew the association between Bryant and "our northern landscape" (p. 17).

93. Huntington, in *Bryant Festival,* p. 41, in a characteristic sentiment, called Bryant "our poet-brother in the divine art" in presenting him with the folder of artists' sketches.

94. William Cullen Bryant, "My Autumn Walk," in *Poetical Works of William Cullen Bryant,* ed. Parke Godwin (New York: D. Appleton, 1883), 2:146–48. The theme of a triumphant northern nationalism grounded in nature is at odds with the questioning, genuinely tragic quality of Herman Melville's wartime poetry. In his *Battle-Pieces and Aspects of the War* (1866; reprint, Gainesville, Fla.: Scholars' Facsimiles and Reprints, 1960), the neat effort of closure in Bryant's poetry gives way to deep and unanswerable ironies. See, for instance, "The Stone Fleet" and "Malvern Hill."

95. Wiebe, *The Opening of American Society,* pp. 299, 374, argues that nationalism as a descending hierarchy of national and local concerns never existed before the Civil War: "hard local attachments" simply coexisted with "the soft glow of the Union." In the terms of my own argument, the appeal to the Union, served by landscape imagery, was a necessary counterbalance to localism. Localism was one result of democratization, which diminished the power of centralized authority, allowing concrete loyalties to place to persist alongside a diffuse and nonspecific nationalism.

in the imaginative response to it.[96] Nationalist texts on landscape such as *American Scenery* and later *The Home Book of the Picturesque* attempted to contain landscape associations within certain limits. Yet the possibility remained for a democratic unleashing of private or local meanings.[97] Images carried within them a broad range of interpretive possibilities for contemporary audiences which could subvert the programmatic search for a national landscape.

The interpretive instability that inhered in the theory of associationism is demonstrated through some alternative readings of Frederic Church's early painting of 1849, *West Rock, New Haven* (figure 19). I choose this painting in particular because it has been interpreted as an example of nationalist aesthetics at work. As such it furnishes an instance of how scholars have accepted unproblematically the programmatic claims of New York artists, as well as scholarly failure to consider the issue of audience reception—that associative range an audience brought to bear on an image and its tendency to override programmatic intentions.[98]

At first glance *West Rock* presents a straightforward topographical view with an agricultural scene in the foreground. Franklin Kelly has interpreted the painting in terms of its historical associations with the two English seventeenth-century regicides Whalley and Goffe, fleeing the avenging agents of Charles I by hiding in a cave in West Rock, where they were preserved from danger by the people of New Haven.[99] This larger emblematic meaning is contained in the main landscape motif—the recognizable form of West Rock in the distance.[100] By the mid-nineteenth century the story of the regicides had assumed its place as an episode within the larger historical struggle for liberty on the newly settled continent. According to associational theory, for those familiar with the historic episode

96. All theories of meaning contain a subjective dimension. In identifying the problems associationism posed in the creation of shared meanings, I am actually pointing to the larger dilemma inherent in any system of critical interpretation, particularly one that attempts to bridge the personal and the public realms of meaning. What localizes this dilemma, however, is the depth of the anxiety that subjectivism posed for Americans intent on creating a national culture, and the resulting insistence, from numerous quarters, that images be read in terms of a literary gloss, or, in the extreme case, that images remain subordinate to text.

97. See Moore, " 'That Cunning Alphabet,' " pp. 15, 19, 134, on how associationist psychology and the notion of a community of taste held in check the tendency toward subjectivity. For an excellent critical discussion of associationism and its subversive potential, see Miller, *Dark Eden*, pp. 133–39.

98. I am referring here to Franklin Kelly's important iconographic reading of *West Rock* in his *Church and the National Landscape*, pp. 22–24. The exemplary nature of the painting for Kelly is evidenced by its use on the jacket of the book.

99. Kelly, *Church and the National Landscape*, pp. 22–24.

100. The story is recounted by Mary E. Field, "West Rock, New Haven," in *The Home Book of the Picturesque; or, American Scenery, Art, and Literature* (1852; reprint, Gainesville, Fla.: Scholars' Facsimiles and Reprints, 1967), pp. 137–41.

Figure 19. Frederic Edwin Church, *West Rock, New Haven*, 1849. Oil on canvas; 26½″ x 40″. From the collection of the New Britain Museum of American Art, Connecticut, John B. Talcott Fund. Photo: E. Irving Blomstrann.

evoked by West Rock the landscape itself served as a constant reminder that the rewards for past trials resided in the peaceful "harvests" of the present. The background form of the rock hovers above the foreground pastoral landscape, a material emblem of New England's moral history casting its shadow upon the present.[101]

Yet such an association remained more vital for local New England audiences

101. Church may have gotten the idea for the subject from Cole, who listed the English regicides as a possible subject for a painting, although he numbered them as three, no. 46 in "Thomas Cole's List 'Subjects for Pictures,'" in Howard Merritt, ed., *Studies on Thomas Cole: An American Romanticist*, vol. 2 of *Baltimore Museum of Art Annual* (Baltimore: Baltimore Museum of Art, 1967), p. 87. See Kelly, *Frederic Edwin Church*, p. 24; Christopher Kent Wilson, "The Landscape of Democracy: Frederic Church's *West Rock, New Haven*," *American Art Journal* 18 (Summer 1986): 20–39.

than it did for New Yorkers, whose more immediate frame of reference would have been the events of the Revolutionary War and, more remotely, the colonial history of their own state. The associations with West Rock were regionally specific, and while the intention may have been to evoke a landscape of shared national meaning, there was nothing intrinsic to the image to ensure that this secondary level of meaning would be preserved in the painting's reception by audiences outside Connecticut. Indeed, for New Yorkers the great swelling and scarred surface of West Rock could easily have carried very different—indeed inimical—associations. If they were familiar with the historic episode of the regicides, their reaction to the execution of Charles I would not necessarily have been linked by the same train of associations to the origins and defense of New World democracy. A more recent memory would have been the anti-rent wars that unsettled the upper Hudson River valley in the early 1840s, in which traditional lines of authority—the patriarchal, quasi-feudal relationship between landowners and tenants—violently broke down. For more conservative members of Church's audience, regicide was a symbolic form of patricide, the first link in a chain leading not to democracy but to revolution. For them the great mound, carpeted in green but carved away by natural forces to reveal the ribbed, rust-colored rock beneath, could be read as a gaping wound.

West Rock usurps the horizon, looming up over the forests and agricultural fields of New Haven. A dark shadow across the middle ground of the painting is caused by a rain cloud passing overhead, temporarily threatening the pastoral harmony of the scene. The cloud, an image long associated with social turmoil, is juxtaposed against the serene vision of agricultural labor. It also carried numerous associations—most of them negative—with the unsettlement of industrialization, class unrest, and labor militancy, all of whose transforming impact had already been felt by New Yorkers to some degree by the late 1840s. A transient moment in nature carried an array of emblematic meanings, and above all introduced a sense of precariousness that applied not only to the present but to the past. The meaning of history was unstable, continually shifting in response to an evolving present. The significance of this or any image was therefore never firm. Images whose symbolic program was meant to draw audiences together through common associations could produce divergent, even politically conflicting responses, making history's lessons appear contradictory and susceptible to many readings. Associationism potentially set loose the very anarchy of private experience and memory it was first recruited to contain.

Beyond this, by privileging the programmatic over the incidental or personal associations of Church's painting, later historians have assumed that Church's New York audience constituted the same body of readers as an audience from Connecticut. It was only three years later, in 1852, with the publication of *Home Book of the*

Picturesque, that a text published in New York and nationally distributed to a wide popular readership first drew the connection between West Rock and the English regicides. The possibility of a national landscape depended, in this instance as in others, on a national readership, which the painting lacked when it was first exhibited in 1849.

The symbolic and nationalistic agenda of the first New York school was challenged from within by the associative play and visual complexities of the works themselves, qualities that revealed contradictions within the ideology of nationalism and ultimately compromised the assumed unity of their visual program. Only by playing programmatic intent against the actual visual performance, with its multiple messages and its oblique and coded relationship to social experience, is it possible to probe fully the meaning of the nationalist landscape. For artistic nationalism was as ideologically conflicted as political nationalism in its intention of recomposing the elements of individual or local experience into a unitary whole. Always remaining was a residue that resisted assimilation by asserting its power to obstruct the organizing and controlling reach of an institutionalized aesthetic.

Ultimately the literary structuring of landscape art succumbed to its own contradictions: the "national" landscape style employed the imagery of nature to authorize a socially constructed story of the nation's transformation from wilderness into pastoral millennium. But the success of the "official story"—that is, the story sanctioned by some of New York's leading institutions—depended on everyone's reading it in the same way. This was, at the start at least, a reasonable assumption, given that the picture-viewing public tended to be literate, white, middle class, and northeastern.

Yet herein lay the source of a conflict that the literary structure of landscape could not resolve. Plot entailed continual development. One's involvement in the incidents, episodes, and phases of the story necessarily carried its own complications, counterplots, and associations. The sequential landscape of the national school was a formula developed to assist the landscape artist to pass from the foreground to the background in an illusionistically convincing way. The distant horizon was the conclusion of both the visual and the literary plot line. It was also, in the language of the day, the expression of the future, and the banner of millennial expectations. The problem for landscape painters was to balance the requirements of a readable plot against the historical closure implied in the horizon. The gaze of the spectator traveled restlessly through the landscape as unfolding history, and back and forth from foreground to distance in a visual enactment of millennial longing. Historical process and millennial stasis, the demands of plot and the desire for aesthetic closure, wrestled for priority within the symbolic space of the landscape, conveying not only an artistic and aesthetic dilemma but a national one as well.

3 / Millennium/Apocalypse
The Ambiguous Mode

Let us be thankful that God is bringing so much good
out of the terrible evil that has fallen on us.
 —William Cullen Bryant, 1862

Cole had demonstrated the possibilities of a morally uplifting landscape art rich enough to explore the evolving dilemmas of personal and national identity. Later artists translated his romantic dramas of conflict, retribution, and redemption into a language suited to the aesthetic culture and context of the era. But Cole had left a divided legacy. On the one hand, his native views such as *The Oxbow* furnished valuable examples of the metaphoric possibilities within naturalism, the subject of the present chapter. On the other hand was the example of his allegorical style.

The generation of the 1850s registered the impact of Cole's allegorical legacy in a variety of ways. His moralizing pendants *The Departure* and *The Return* (1837, Corcoran Gallery of Art) and *The Past* and *The Present* (1838, Mead Art Museum, Amherst College) inspired works such as Asher B. Durand's *Morning of Life* and *Evening of Life* (1840), and his *Thanatopsis* (1850), as well as Jasper Cropsey's *Spirit of War* and *Spirit of Peace,* and his *Days of Elizabeth* (1853, Newington-Cropsey Foundation) and *Return from Hawking* (unlocated).[1] Frederic Church's earliest works—*The Deluge* (1846), *Christian on the Borders of the Valley of the Shadow of Death* (1847), *Christian and His Companion by the River of the Water of Life* (1848), *The Plague of Darkness* (1849), and *Moses Viewing the Promised Land* (1851)—reveal the impact of Cole's biblical and allegorical paintings on his student. In addition, Cole's early "sublime" landscape style of the 1820s and early 1830s was briefly

1. A related pendant pair is Cropsey's *Olden Times—Morning* and *Olden Times—Evening,* also unlocated.

revived in the 1850s by artists including Durand, Cropsey, Church, George Inness, Sanford Gifford, Homer Martin, Christopher Cranch, William Sonntag, Benjamin Bellows Grant Stone, and Thomas Hill.[2] This fascination with Colean wilderness was limited in scope, however, and was eventually eclipsed by the more pastoral style of the National Academy artists.[3]

Cole's greatest allegory was also the one that left the profoundest mark on later American painting. Yet *The Course of Empire*, with its vast historical sweep and artistic ambition, offered a bleak prognosis for the future, thus challenging the succeeding generation to answer Cole with visions of a republican millennium. In *Progress*, Durand fused the two halves of Cole's legacy, endowing a naturalistic landscape with allegorical content in an influential synthesis. (The legacy of *The Course of Empire*, and its fusion with naturalism, are the subject of Chapter 4.)

Beginning with Cole's *Oxbow*, the unconcealed American landscape, without explicit allegory or narrative content, had occasioned some of the deepest reflections on America's unfulfilled millennial promise. The belief that this was a providentially blessed nation readied by history to realize the biblical prophecy of a thousand-year reign of peace originated with the founding of the republic.[4] From this time forward, millennialism had furnished a ready discourse with which to understand the wavering progress of the nation. It gave a religious basis to American exceptionalism. As the heir of the ages, America held the possibility of transcending the historical cycles that had guaranteed the cultural defeat of all previous

2. Sanford Gifford's pendant pair *Sunrise in the Adirondacks* and *Sunset in the Catskills* may have been an updating of Cole's allegorical pendants of the 1830s, *Departure* and *Return*, and *Past* and *Present*. Gifford also completed pendants titled *The Past* and *The Present* in 1848; see Ila Weiss, *Poetic Landscape: The Art and Experience of Sanford R. Gifford* (Newark: University of Delaware Press, 1987), pp. 67, 172. Jervis McEntee painted a pendant pair titled *Past* and *Present*. Other instances of the revival of interest in the Colean sublime are Jasper Cropsey's *Catskill Creek, Autumn* (ca. 1850, Saint Louis Art Museum), and his *Storm in the Wilderness* (1851, Cleveland Museum); Frederic Church's *Storm in the Mountains (Blasted Tree)* (1847, Cleveland Museum), although it may be as much a continuation of the teacher's style as a revival; and Thomas Hill's late *Crawford Notch* (1872, Collection of New Hampshire Historical Society).

3. Cole's influence persisted, however, for provincial painters, for whom he was a native "Old Master." John Bradley Hudson, Jr., recorded the impact that Cole's *Course of Empire* had on him when he viewed it at the Boston Atheneum in 1859, and Charles Codman, Maine's "leading resident landscapist," also painted imaginary scenes influenced by Cole. Elizabeth Wilder and Gertrud Mellon, eds., *Maine and Its Role in American Art, 1740–1963* (New York: Viking, 1963), pp. 75, 82.

4. On millennialism in the American context, see Ernest Lee Tuveson, *Redeemer Nation: The Idea of America's Millennial Role* (Chicago: University of Chicago Press, 1968); F. C. Harrison, *The Second Coming: Popular Millenarianism, 1780–1850* (New Brunswick, N.J.: Rutgers University Press, 1979); Timothy L. Smith, "Righteousness and Hope: Christian Holiness and the Millennial Vision in America, 1800–1900," *American Quarterly* 31 (Spring 1979): 21–45.

republics. Yet millennial thinking turned on an unanswered question central to national identity: Where was the country headed, and where was it situated in the millennial timetable? American painters turned to the landscape as the arena within which collective destiny would be tested. Since they did not know when—and what—the concluding act would be, their landscape meditations assumed a characteristic structure of ambiguity, in which a dramatic moment in nature expressed rival versions of national destiny: an escape from history and into an earthly millennium, or a painful fall back into history's complex dynamics.[5]

In this chapter I analyze a series of landscapes painted between the Mexican-American War and the close of the Civil War which embody in compositional or narrative terms the uncertainty at the heart of America's "enterprise sublime." The changing historical circumstances of each decade continually reanimated millennial habits of thought and contributed a variety of new historical contexts within which to frame the great national question. These changing contexts gave a topical meaning, generally overlooked, to landscapes dealing with natural crises. During these decades a landscape mode emerged which expressed the nation's millennial hopes and apocalyptic fears. Later painters borrowed from Cole's bifurcated compositions of the 1820s and 1830s, both biblical and American, for subjects that explored moments of national reckoning. Typology replaced allegory as current events came to be interpreted in the light of Bible history, and Americans emerged as God's chosen. In the most radical instances of the millennialist landscape, history collapses into nature, and nature becomes one with nation. This final identification realized the essence of the nationalist painter's mission: to convince his audiences that nationhood was rooted in land, sky, and water, and governed by Providence.

With the decline of older republican explanations for historical process, a new language and understanding of causality was slow to evolve. The nationalist myth—that the physical environment itself produced national character—was readily available to a generation seeking to root difficult social and political choices in a natural landscape they claimed as incontestable. Landscape was more than metaphor; it was also the site of tensions within national identity. I have already noted the dramatic underpinnings of Cole's art, his tendency to see nature and culture as actors in an unfolding drama. This propensity persisted into the next generation somewhat altered, however, with the contest now more fully naturalized. The

5. Smith, "Righteousness and Hope," p. 22, points out that the decade of the 1830s in particular "witnessed the flowering of [a] millennial vision." David Bjelajac, *Millennial Desire and the Apocalyptic Vision of Washington Allston* (Washington, D.C.: Smithsonian Institution Press, 1988), p. 153, argues that millennial eschatology made for "a spiritually dynamic form of nationalism . . . like membership in the Christian elect, [nationalism in America] was not an established, certain fact but rather an evolving process and a persistent cause for enormous anxiety."

drama no longer pitted the wilderness of the New World against the human agents of settlement. Instead it set natural forces—meteorological or volcanic tumult—against one another. The fuller identification of nature and nation allowed the artists who followed Cole to use nature, often devoid of human presence, as a symbolic substitute for the republic. At the same time, however, landscape was not history painting. It lacked human actors and an explicit human economy of motivation. Landscape, or "scenery," as the word implies, was only the backdrop, or the stage, for meaningful action. Through the exclusion (or disguised presence) of the human actor from the stage of action, nature displaced history in a fulfillment of the fantasy that underlay the myth of exceptionalism.

One result of this rhetoric of natural conflict was to blunt any notion of historical causality, and to substitute compelling natural dramas for human and social agency. This change reveals another level at which later landscape artists differed from Cole, for Cole never removed the human social actor from his scenarios; he remained indebted to older Protestant and republican assumptions that held the individual morally accountable. The major figure in the naturalization of the national allegory was Frederic Church. Complementing his efforts, however, were a variety of other artists working along parallel lines. They provide a fuller picture of this dimension of American landscape art.

The unfinished character of the national identity left a large and ever-present element of doubt in all imaginative grapplings with the future. Cole's sense that this future rested in the balance generated a logic of uncertainty not unlike that faced by the individual in the Protestant scenario of salvation. Despite important differences in religious culture, Cole held such attitudes in common with many other Americans. On the most literal level the logic of uncertainty involved the timing of the millennium: Would the thousand-year reign of peace come before or after the day of judgment? Those who, like the apocalyptic Millerite sect of the 1840s, saw history as a mere prelude to the actual work of salvation, and who viewed the society of saints as a purely heavenly corporation, were premillennialists. Christ's imminent arrival on earth was the concluding act of history and the opening act of the heavenly millennium. Those who believed in America's redemptive mission and in the vision of collective salvation looked to postmillennialism, the fulfillment of the scheme of salvation *within* history. The thousand-year reign of peace would occur in time, realizing the dreams of contemporary reformers. Pre- and postmillennialists shared a common set of assumptions about history. Yet they also held very different views about the relationship between the secular and the sacred.[6] They

6. On the distinction, see Ernest Sandeen, *The Roots of Fundamentalism: British and American Millennialism, 1800–1930* (Chicago: University of Chicago Press, 1970), esp. pp. 4–5, 42–58, and 90–102.

also foresaw vastly different prospects for the nation in time. The dialogue between pre- and postmillennialists was not always confined to distinct parties. The polarities evident within the dramatic structure of individual paintings express the unfinished nature of the great national picture and the uncertainty over the possibility of a republican millennium.

In periods of national crisis such as the Mexican-American War or the sectional feuding of the 1850s, subjects such as Church's *Plague of Darkness* and his *Deluge,* or Durand's *God's Judgement upon Gog* (ca. 1851, figure 20), assumed topical relevance.[7] In addition, alongside these theatrical biblical themes there emerged a different but related imagery. The clashing armies that had appeared in the popular gift books and biblical paintings of the 1830s, 1840s, and early 1850s appeared during periods of war and national strife in a new, naturalized form as a storm engulfing the landscape in turbulent darkness.[8]

Meteorological symbols, in which the heavens bore evidence of God's witness, derived ultimately from Revelation and the prophetic books of the Old Testament. Puritan jeremiads pointed to the signs of collective guilt in the collision of the natural and the supernatural. Such imagery found new life in the types of nineteenth-century natural theology. In moments of collective reckoning natural events assumed portentous significance. From the comet's appearance in Hawthorne's *Scarlet Letter*—witness to the guilt of the sinning couple—to Church's *Our Banner in the Sky* (1861) and Melville's poem "Commemorative of the Dissolution of Armies at Peace," in which the play of the northern lights symbolizes the cessation of war between North and South in 1865, the 1850s and 1860s saw numerous instances of natural events read as portents. Melville's poem, dated May 1865, may have been inspired by Frederic Church's painting *Aurora Borealis* of 1865

7. Frederic Church treated the subject of the Deluge in a work that is now missing. Nonetheless, a study for the painting, dated 1850, does exist at Church's home, Olana. This is reproduced as figure 25 in Franklin Kelly and Gerald L. Carr, *The Early Landscapes of Frederic Edwin Church, 1845–1854* (Fort Worth: Amon Carter Museum, 1987). On the significance of apocalyptic themes, see Gail Husch, "'Something Coming': Prophecy and American Painting, 1848–1854" (Ph.D. diss., University of Delaware, 1992). That Durand, primarily identified with pastoral landscapes, would undertake a commission from Jonathan Sturges for a dramatic subject such as *God's Judgement upon Gog* (ca. 1851), taken from Ezekiel 39:17, indicates how widespread was the interest in apocalyptic imagery. The significance of the subject has not yet been fully explored. By the 1850s this sort of theatricality was generally considered more appropriate to popular art forms such as panoramas and cycloramas. See "Our Private Collections: No. 11," *The Crayon* 3 (February 1856): 58.

8. An example of such symbolism is found in George Caleb Bingham's 1856 letter to his friend James Rollins about the sectional strife in the wake of the Kansas-Nebraska Act: "A storm of popular fury, surpassing even that which succeeded the immediate passage of the Nebraska bill is darkening the Northern horizon." C. B. Rollins, ed., "Letters of George Caleb Bingham to James S. Rollins," *Missouri Historical Review* 32 (October 1937–July 1938): 195 (letter of June 2, 1856).

Figure 20. Asher B. Durand, *God's Judgement upon Gog*, ca. 1851. Oil on canvas; 60¾″ x 50½″. The Chrysler Museum, Norfolk, Virginia.

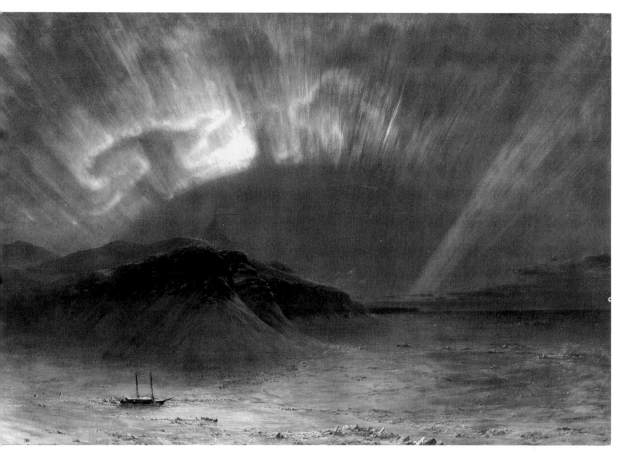

Figure 21. Frederic Edwin Church, *Aurora Borealis*, 1865. Oil on canvas; 56⅛″ x 83½″. National Museum of American Art, Smithsonian Institution. Gift of Eleanor Blodgett.

(figure 21), suggesting that the phenomenon of the northern lights carried a political as well as a national symbolism for the painter.[9]

Another instance of this prophetic use of meteorology is George Inness's *Sign of*

9. Herman Melville, *Battle-Pieces and Aspects of the War* (1866; reprint, Gainesville, Fla.: Scholars' Facsimiles and Reprints, 1960), pp. 148–49. Melville employed the image of the meteor to describe John Brown in "The Portent," a poem that opened *Battle-Pieces*. David Huntington, *The Landscapes of Frederic Edwin Church: Vision of an American Era* (New York: Braziller, 1966), p. 61, and Weiss, *Poetic Landscape*, pp. 95–96, have also observed the relevance of Church's meteorological symbols. William Truettner, "The Genesis of Frederic Edwin Church's *Aurora Borealis*," *Art Quarterly* 31 (Autumn 1968): 267–83, argues, however, that Church's work had its genesis in an earlier display of northern lights (January 1861) than that which inspired Melville's poem, and consequently downplays the nationalist significance of the subject for Church.

Promise, completed in 1862 and exhibited in 1863. The *New York Evening Post* described it as "a comingling [*sic*] of vaporous clouds and azure sky, murmuring stream and quiet meadow, field and forest, hills and mountains, and over all the rainbow of hope, following the storm, giv[ing] glorious promise of peace and joy to come." Henry Tuckerman quoted an anonymous source to demonstrate the impact of the work: "The picture has a moral in its subject and a moral in its treatment. It expresses hopefulness, the promise of good; it implies a divine purpose." In a pointed symbolic gesture, Inness subsequently painted over *The Sign of Promise* with his *Peace and Plenty* in 1865 (figure 22), celebrating the conclusion of the war. He also painted another landscape in 1862 whose pious title, given by the well-known minister Henry Ward Beecher—*The Light Triumphant* (unlocated)—once again demonstrates the allegorical uses to which northern artists put nature in their efforts to spiritualize their cause.[10] At the conclusion of the war, Thomas Moran drew an explicit association between natural and national conflict in a charcoal drawing, perhaps a preparation for a painting, titled *Track of the Storm: An Allegory of the War for the Republic.*[11]

Not only unusual but ordinary moments of nature served as natural types of moral truths.[12] George Caleb Bingham, in a familiar war-time image, wrote to his close friend James Rollins: "I hope, with me, that you see beyond the shadow of the cloud immediately in the fore-ground to the glorious sunlight upon the distant hills."[13] In this tradition is an 1856 landscape by Durand titled simply *A Symbol* (private collection). Daniel Huntington, in his memorial address to the artist,

10. Quoted in Nicolai Cikovsky, Jr., *George Inness* (New York: Praeger, 1971), 34, see also pp. 36–38; Henry T. Tuckerman, *Book of the Artists* (1867; reprint, New York: James F. Carr, 1966), p. 529; LeRoy Ireland, *The Works of George Inness: An Illustrated Catalogue Raisonné* (Austin: University of Texas Press, 1965), pp. 53, 78. Other notices include " 'The Sign of Promise.' By George Inness. Now on Exhibition at Snedecor's Gallery" (New York, n.d.); James Jackson Jarves, *The Art-Idea,* ed. Benjamin Rowland, Jr. (Cambridge: Belknap Press of Harvard University Press, 1960), p. 196; and "Pictures on Exhibition: George Inness' *The Sign of Promise,* Snedecor's Gallery," *New Path* 1 (December 1863): 99–101.

11. The painting, dated February 1866, is listed in Moran's "Old Book of Lists, 1863–1909," a manuscript transcribed by Anne Roberts Morand of the Gilcrease Institute, in "The Early Career of Thomas Moran, 1853–1870" (M.A. thesis, Washington University, 1991).

12. This moralization of nature was an important aspect of the moral picturesque in landscape representation. See Richard S. Moore, " 'That Cunning Alphabet': Melville's Aesthetics of Nature," *Costerus* 35 (Amsterdam, 1982): 26–30. The best contemporary statement is John Ruskin, "Of the Turnerian Picturesque," in volume 4 of *Modern Painters;* see *The Works of John Ruskin,* ed. E. T. Cook and Alexander Wedderburn, 39 vols. (London: George Allen, 1903–1912), 6:9–26.

13. "Letters of Bingham to Rollins, June 5, 1861," *Missouri Historical Review* 33 (October 1937–July 1938): 518.

Figure 22. George Inness, *Peace and Plenty*, 1865. Oil on canvas; 77⅝″ x 112⅜″. All rights reserved, The Metropolitan Museum of Art.

described it as "an ominous storm . . . gathering and blackening around a mountain; a giant peak rises high above the murky confusion below, catching a golden flush of sunlight through a rift in the clouds." The description concludes that "the hopeful glow on the granite peak reflects more of the artist's cheerful temper than the dismal strife of the whirling clouds."[14] Here the separation between the depths and the upper reaches of the landscape allegorize the trials of vision, the mountain serving as an emblem of transcendent knowledge.

14. Daniel Huntington, *Memorial Address* (New York, 1887), p. 36, quoted in David B. Lawall, *Asher B. Durand: A Documentary Catalogue of the Narrative and Landscape Paintings* (New York: Garland, 1978), pp. 114–15, no. 203. See also John Durand, *The Life and Times of Asher B. Durand* (1894; reprint, New York: Da Capo Press, 1970), p. 176; Tuckerman, *Book of the Artists*, p. 189. Compare this passage to Starbuck's symbolic reading of the doubloon in Herman Melville, *Moby-Dick,* ed. Harrison Hayford and Hershel Parker (New York: W. W. Norton, 1967), p. 360: "A dark valley between three mighty, heaven-abiding peaks, that almost seem the Trinity, in some faint earthly symbol. So in this vale of Death, God girds us round; and over all our gloom, the sun of Righteousness still shines a beacon and a hope. If we bend down our eyes, the dark vale shows her mouldy soil; but if we lift them, the bright sun meets our glance half way, to cheer."

Durand's symbolic storm-engulfed landscape at once suggests a moral, spiritual, and national condition.[15] Such charged moments gave social conflict a natural stage. American artists from Durand to Church and Inness, by framing social and historical processes as natural events, lifted contemporary developments out of the present and translated the contingent and unstable into timeless absolutes. The outcome of the elemental conflict occurred safely beyond the unsteady fortunes of society, the responsibility of a higher power directing America's predestined mission.

The storm theme, metaphorical of the nation's spiritual condition, furnishes an instance of how the generation of more nationally oriented artists transformed Cole's romantic preoccupations. Cole's *Tornado* of 1831 (figure 23), painted and exhibited in London during his first trip to Europe, was an exercise in the American sublime, complete with storm-riven trees and a frightened witness exposed to nature's awesome energy. Cole's painting evokes a feeling for wilderness and its biblical resonances with the wrathful power of God.[16] By midcentury, however, nationalist typology had supplanted romantic allegories concerned with the individual's moral pilgrimage. Nature's moods expressed the changing relationship between God and the larger commonwealth.[17]

In the late 1840s Church exhibited two paintings dealing with the storm theme in a biblical context. His large *Plague of Darkness* (unlocated) was shown at the National Academy of Design and the American Art-Union in 1849. A description of the work evokes the apocalyptic paintings of John Martin, to whom an earlier notice had compared Church: "In the foreground is a lofty crag, upon which Moses is standing, being the only figure which catches the light. Thick black clouds are rising, which nearly cover the sky. Below are long lines of Egyptian architecture, seen by reflected light."[18] In the biblical theme, as in the storm subject, the drama

15. Weiss, *Poetic Landscape*, p. 103, suggests that Sanford Gifford's painting *The Coming Storm* (1865) had a more general significance, carrying the "Civil War period theme of foreboding" into the final year of the war. See also ibid., pp. 95–96, on the symbolism of landscape imagery during the Civil War.

16. On the popular reception of this painting, see Ellwood Parry, *The Art of Thomas Cole: Ambition and Imagination* (Newark: University of Delaware Press, 1988), p. 114.

17. For more on this transition, see David C. Huntington, "Church and Luminism: Light for America's Elect," in *American Light: The Luminist Movement, 1850–1875* (Washington, D.C.: National Gallery of Art, 1980), pp. 155–90. On typology, see Sacvan Bercovitch, *The American Jeremiad* (Madison: University of Wisconsin Press, 1978). For a specific instance of how Puritan typology remained vital and applicable to American landscape imagery, see David C. Huntington, "Frederic Church's *Niagara:* Nature and the Nation's Type," *The Puritan Imagination in Nineteenth-Century America: Texas Studies in Literature and Language* 25 (Spring 1983): 100–138, and Huntington, *The Landscapes of Church,* which has influenced all subsequent readings of Church's work.

18. "Catalogue of Works of Art," *Bulletin of the American Art-Union* 2 (July 1849): 32, no. 151. The

Figure 23. Thomas Cole, *Tornado*, 1831. Oil on canvas; 46⅜″ x 64⅝″. In the collection of The Corcoran Gallery of Art, Museum Purchase.

lies in the implicit confrontation between opposing forces of light and dark, or more literally between those enjoying God's favor and those who, like the Egyptians, are guilty of thwarting his divine plan and causing, in the words of Isaiah (34:8), "the controversy of Zion."

During Church's years of study with Cole, which began in 1844, the nation went

painting was purchased by the American Art-Union. Church took as his source passages from Exodus 10:21 and 10:22, reproduced in the catalogue entry for the work: "And the Lord said unto Moses: Stretch out thine hand toward heaven, that there may be darkness over the land of Egypt, even darkness which may be felt. And Moses stretched forth his hand toward heaven, and there was a thick darkness in all the land of Egypt three days." See also the lengthy description of the painting in "The National Academy of Design," *Bulletin of the American Art-Union* 2 (May 1849): 14; Franklin Kelly, "The Legacy of Thomas Cole," in Kelly and Carr, *Early Landscapes of Church*, p. 45.

to war with Mexico. Although Church's response to the Mexican-American War is unrecorded, his teacher was less reticent, decrying what he referred to as "this *vile* Mexican War."[19] Church was born and raised in Hartford, long a socially and religiously conservative center of both federalism and Congregationalism. Dissent from "Polk's war," and more generally from the Democratic administration's aggressively expansionist policies, was strong in New England.[20] Like the storm paintings he did during these war years and immediately after, Church's *Plague of Darkness* may register the artist's muted protest against Polk and his party, the "Egyptians" whose actions placed them at cross-purposes with national destiny.[21]

An urgent, almost feverish quality evident in condemnations of the Mexican-American War links the natural and biblical themes of conflict in painting to the anti-imperialist rhetoric of those who protested the nation's territorial ambitions. Theodore Parker's "Sermon of War," preached on June 7, 1846, captures this quality of prophetic intensity. Parker summons the voices of past history—the "Genius of the Old Civilization"—whose children are "Assyria, Egypt, Tyre, Carthage, Troy, Etruria, Corinth, Athens, Rome." His younger brother, the "Genius of the New Civilization," presides over a splendid young empire. In imagery reminiscent of Revelation, he is described as wearing "a crown of stars . . . some glorious with flashing, many-colored light, some bloody red." He shouts: "My feet are red with the Indians' blood; my hand has forged the negro's chain. I am strong; who dares assail me? I will drink his blood, for I have made my covenant of lies and leagued with hell for my support. There is no Right, no Truth; Christianity is false, and God

19. Cole to Robert Cooke, July 19, 1846, Archives of American Art, Reel ALC1.

20. See Frederick Merk, Samuel Eliot Morison, and Frank Freidel, *Dissent in Three American Wars* (Cambridge: Harvard University Press, 1970).

21. Another example of the storm theme that may be related to political events is Robert Walter Weir's painting *The Coming Storm,* listed as no. 39 at the American Art-Union in 1850 and described as "a broad, well-wooded country, indistinctly seen through the misty air. In the middle distance, a Gothic church, with its tower and adjoining plantations, which receive a few rays of sun. Beyond, a long line of mountains, hardly perceptible through the storm clouds." Also relevant here is Thomas Rossiter's *Return of the Dove to the Ark* (1849), painted the year after the conclusion of the Mexican-American War. The painting, listed as no. 38, was exhibited at the Gallery of the Philadelphia Art Union, as noted in the *Bulletin of the American Art-Union* 2 (January–June 1849): 219. According to the description, Rossiter's work depicted a sunset view with beautiful atmospheric effects, a dove bearing an olive branch, "and a world of hope to the eager watchers before us." J. W. Glass painted *Preparing for the Strife—"The Sword of the Lord and of Gideon,"* listed as no. 338 in the American Art-Union exhibition of 1850. Glass specialized in Cromwellian and other themes from English history, whose relevance for the 1850s is examined in Wendy Greenhouse, "Reformation to Restoration: Daniel Huntington and His Contemporaries as Portrayers of British History, 1830–1860" (Ph.D. diss., Yale University, 1989).

a name." The Genius of the Old World can only reply that "the wicked shall not prosper," to which "the hollow tomb of Egypt, Athens, Rome, of every ancient State, with all their wandering ghosts, replies, 'Amen.' "[22]

Such apocalyptic imagery of reckoning relates to Church's choice of subject in 1848, two years after Parker's speech. It would have been entirely in keeping with Church's typological mind-set to respond to the Mexican-American War by casting historical events in biblical terms. He interpreted such events, however, not as the sinful excesses of a corrupt people but as the travails of God's chosen. His nation was not Babylon but Zion.

A year later, at the conclusion of the war, Church exhibited *New England Landscape (Evening after a Storm)* (ca. 1849, figure 24), a composite scene of idyllic rural beauty organized around recessional bands of light and dark which culminate in a luminous distance. Overhead a perspective of foreshortened sky moves from the dark, rain-laden clouds in the foreground plane to those in the distance, which catch the rays of the setting sun. This painting was described in the *Bulletin of the American Art-Union* under a different title, *Lifting of a Storm-Cloud*, "in which the thick murky veil of vapor is lifting up like a huge curtain in the heavens, while from below the setting sun is pouring its glowing rays upon the landscape, casting forward the long shadows of intervening objects."[23] Coming on the heels of his *Plague of Darkness*, Church's *Evening after a Storm* naturalizes the theme of divinely instigated turmoil in the painting of a year before. The subject may refer obliquely to the crisis in the moral conscience of the nation caused by the Mexican-American War, brought to a conclusion that year. The storm cloud would allude, in this context, to the imperialistic behavior of those leading the nation astray in pursuit of empire as well as to the dissension over the war policy.[24]

22. Theodore Parker, *A Sermon of War, Preached at the Melodeon on Sunday, June 7, 1846* (Boston: I. R. Butts, 1846), p. 42. The description in Parker's sermon resembles Jasper Cropsey's projected series celebrating American liberties, *Genius of the Republic*, discussed in Chapter 4. Thomas Corwin, "On the Mexican War. In the Senate of the United States, Feb. 11th, 1847," reproduced in Daniel Walker Howe, ed., *The American Whigs: An Anthology* (New York: Wiley, 1973), p. 215, criticizes the Democratic expansionism of the war in related imagery.

23. *Bulletin of the American Art-Union* 2 (June 1849): 27, cited in Kelly and Carr, *Early Landscapes of Church*, p. 103. Kelly and Carr (pp. 99–107) offer evidence that this painting is the same as the work (ca. 1849) now in the collection of the Amon Carter Museum titled *New England Landscape (Evening after a Storm)*. Franklin Kelly, *Frederic Church and the National Landscape* (Washington, D.C.: Smithsonian Institution Press, 1988), p. 33, further links Church's 1850 *Twilight, Short Arbiter 'Twixt Day and Night*, to the political and social mood of the nation.

24. Like Church, George Caleb Bingham also painted a *Pleague [sic] of Darkness* (n.d., unlocated), a highly unusual choice of subject for the artist. Bingham was a committed Whig. Although the work is not dated, it may have been painted in the 1840s, raising the possibility that such imagery formed part

Figure 24. Frederic Edwin Church, *New England Landscape (Evening after a Storm)*, ca. 1849. Oil on canvas; 25⅛″ x 36¼″. Amon Carter Museum, Fort Worth, 1971.11.

In contrast to landscape painters, history painters responded to the war in the language of Grand Manner allegory with works such as *The Apple of Discord* (unlocated) and *The Wages of War* (figure 25), both painted by Henry Peters Gray in 1849 and highly praised by contemporary reviewers.[25] Gray's academic allegories

of a covert language of Whig dissent from the Mexican-American War. This suggestion carries further credibility given the prevalence of both explicit and veiled political imagery in Bingham's art. See Nancy Rash, *The Painting and Politics of George Caleb Bingham* (New Haven: Yale University Press, 1991). It is listed as no. 432 in E. Maurice Bloch, *The Paintings of George Caleb Bingham: A Catalogue Raisonné* (Columbia: University of Missouri Press, 1986).

25. See "The Gallery," *Bulletin of the American Art-Union* 2 (April 1849): 13. *The Apple of Discord* is listed as no. 23 in *Bulletin of the American Art-Union* 2 (May 1849): 22.

Figure 25. Henry Peters Gray, *The Wages of War*, 1849. Oil on canvas; 48¼″ x 76¼″. All rights reserved, The Metropolitan Museum of Art. Gift of Several Gentlemen, 1872 (73.5).

employed the remote language of the antique world to keep at arm's length the mire of partisan controversy that the Mexican-American War itself inspired. Both landscape and history painters, however, shared a preference for symbolism or allegory over realistic representation of the war, directing their talents away from the specific historical content of contemporary events. There is nothing in American easel painting that corresponds to the topical and reportorial works of French academic realism inspired by the events of 1848 and later by the Paris Commune and the Franco-Prussian War.[26]

26. Robert Rosenblum and H. W. Janson, *19th-Century Art* (Englewood Cliffs, N.J./New York: Prentice-Hall/Abrams, 1984), pp. 186–90, 218–19, 326–31. Jarves, *The Art-Idea*, p. 197, makes a similar observation, commenting that "rarely have our artists sought to give even the realistic scenes of strife"

The tendency of American artists to embed topical references in allegory and natural metaphor characterized the artistic response not only to the Mexican-American War but also to other occasions of militancy and national self-doubt. Such works incited their audiences to confront, generally in a disguised manner, the afflictions that war brought in its train. In 1848 Inness exhibited a painting titled *Peace and War,* which, like related themes during these years, universalized the social costs of war while recalling the recently concluded conflict with Mexico.[27] Inness's allegory was repeated by Jasper Cropsey in a pendant pair of 1851, *The Spirit of War* (figure 26) and *The Spirit of Peace* (figure 27).[28] The precedent for these works, noted by contemporary critics, was Cole's "epico-allegorical style."[29] Cropsey's pair synthesized Cole's contrasting themes—medievalizing and classical, sublime and beautiful, Rosaesque and Claudean.[30] The *New York Herald* reported in 1852 that Cropsey's pendant pair was considered by his fellow artists to be his greatest production. They were exhibited every year between 1852 and 1857.[31] A description published in the catalogue of the National Academy of Design exhibition in 1852 emphasized the social and material costs of war—"the evils and

in the recently fought Civil War, and speculates that this may have to do with their weakness in portraying "strong passions and heroic action." An exception is Jasper Cropsey's *Battle-Field at Gettysburg,* described in the *New-York Home Journal,* January 31, 1866.

27. This painting was listed as no. 201 in the *Bulletin of the American Art-Union* 1 (November 1848): 12, and is currently in a private collection. A decade earlier (1836–1840), Robert Walter Weir also painted an allegorical mural, *War and Peace,* at the United States Military Academy at West Point, where he was teaching.

28. The history of the *War* and *Peace* pendants is given in William Talbot, *Jasper F. Cropsey, 1823–1900* (New York: Garland, 1977), pp. 106–10, 112–14, 365–67, 375–76; Talbot, *Jasper F. Cropsey, 1823–1900* (Washington, D.C.: National Collection of Fine Arts, 1970), pp. 28–29, 73–76; Peter Bermingham, *Jasper Cropsey, 1823–1900: A Retrospective View of America's Painter of Autumn* (College Park: University of Maryland Press, 1968), pp. 14–15.

29. "Art and Artists in America," *Bulletin of the American Art-Union* 4 (December 1851): 149. Unlike Cole's pendants, Cropsey's change locations between canvases.

30. In certain cases, figures in Cropsey's *Spirit of Peace* seem to derive directly from *The Pastoral State* of Cole's *Course of Empire:* in the left foreground, the figure of the woman with distaff and the small child next to her; on the right, the seated, bearded old man who gestures toward a tomb; and the group of merrymakers dancing in a nearby grove. Cropsey may have had Cole's arcadian and pastoral landscapes in mind when he conceived his own work, as well as older allegories of war and peace in European art of the seventeenth century, celebrating the diplomatic resolution of an impending conflict or the virtues and benefits of peace.

31. *New York Herald,* February 7, 1852. The pair was also extensively reviewed for the *New York Daily Tribune,* April 24, 1852 (unsigned article probably by George William Curtis). Curatorial files, National Gallery of Art. For further information on the exhibition history of the pair, see Talbot, *Jasper F. Cropsey* (1977), p. 367.

Figure 26. Jasper Francis Cropsey, *The Spirit of War*, 1851. Oil on canvas; 43⅝″ x 67⅝″. National Gallery of Art, Washington, D.C., Avalon Fund.

sorrows, domestic and pastoral, industrial and commercial, that cluster about war"—and the contrasting benefits of peace to domestic life, commerce, industry, and learning.[32] *The Spirit of War* was placed in the Middle Ages, while *The Spirit of Peace* was a pastoral Mediterranean landscape recalling the classical republics on which Americans modeled their own culture, and combining prophecies from both

32. National Academy of Design exhibition catalogue for 1852, as quoted in Talbot, *Jasper F. Cropsey* (1977), p. 366. The immediate source for *The Spirit of War* was a poem by Walter Scott, with its attendant association between war and the feudal culture of the Old World. Cropsey exhibited the pendants with verses from Scott's poem. Curatorial files, National Gallery of Art. "The Desire of 'Place,'" *American Magazine* 1 (August 1841): 47, evokes the costs of national ambition in terms that parallel Cropsey's series: "The warrior gazes through the vista of many battles, and beholds a diadem and happiness and renown. He rushes forth to the crimson field of war. The warm blood of millions flows. Mothers and maidens weep seas of sorrow. The earth is clothed in mourning. The harp of nations is hung upon the willows. . . . The heavens become one vast gallery of woe."

Figure 27. Jasper Francis Cropsey, *The Spirit of Peace*, 1851. Oil on canvas; 44″ x 67″. Courtesy, The Woodmere Art Museum, Philadelphia. Bequest of Charles Knox Smith.

Isaiah and Revelation.[33] Scattered throughout the painting are various symbols of the new Christian dispensation—palm and olive trees, a Temple of Peace, signs of "domestic and pastoral happiness," "cultivated fields and growing city." A sculptural group of a lion, lamb, and child is supported by a pedestal containing reliefs of swords being turned into ploughshares. The moon that rose in Cole's *Desolation* upon a scene destitute of any living human presence here "renew[s] by night the tale of happy and perpetual change that has followed the stern and desolate times of

33. These verses are from Isaiah 11:4 and 11:6. Cropsey's use of the verses from Isaiah recalls Edward Hicks's series of paintings on the theme of "the Peaceable Kingdom." On the connection between the two, see Bermingham, *Jasper Cropsey*, p. 14, n. 15.

human strife. Man's peace is made with man and his Creator and from the altar of his heart assends [*sic*] unceasing and acceptable incense to Him who came to proclaim peace on Earth."[34]

A look at the circumstances of 1851 reveals that, once again, events left their mark on such biblically inspired allegories. The Mexican-American War created new territories and intensified the debate over the extension of slavery into the West, an issue addressed by the Compromise of 1850. Although proabolitionists were incensed by the measure, moderate and conservative northerners and westerners welcomed its passage as a respite from a highly charged political climate, promising the possibility of a political resolution to the antagonisms between the sections.[35] "The lovers of peace," wrote Philip Hone, "the friends of the Union, good men, conservatives, have sacrificed sectional prejudices, given up personal predilections, given up everything, for Union and peace; and for this sacrifice the Lord be good to them."[36] Referring to the abolitionist William Seward "and his gang of incendiaries," George Templeton Strong noted that "extreme people on both sides [are] much disgusted with the result [of the Compromise], but the great majority [are] satisfied and relieved." It was apparently among this "majority" that Cropsey placed his sympathies.[37]

If *The Spirit of War* spoke to the growing fears of a fratricidal conflict threatening the Union, *The Spirit of Peace* lauded the efforts of compromise through which

34. Cropsey papers (Miscellaneous Letters, Diaries, Sketches, and Memorandums), Newington-Cropsey Foundation, Archives of American Art, Reel 336. This passage occurs in a letter to Cropsey's patron "M," May 12, 1852. *Jasper F. Cropsey, Artist and Architect: Paintings, Drawings, and Photographs from the Collections of the Newington-Cropsey Foundation and the New-York Historical Society* (New York: New-York Historical Society, 1987), p. 29, n. 17, identifies "M" as either E. P. Mitchell or George McGrath. See also "Art and Artists in America," *Bulletin of the American Art-Union* 4 (December 1851): 149, for a lengthy description. Cole anticipated Cropsey's theme in an undated verse fragment, Archives of American Art, Reel ALC3: "Peace nurses nations—War destroys and plague/And famine—Earthquake fire—and all the beauty/All the blessedness man knows—/Empires proud rise out of gloom and silence/towering high/Oer shadowing earth/Like to a sun-girt/Exhalation consumed/By that which glorifies—."

35. The Compromise of 1850 was actually a series of half-measures forged into a single act of legislation following months of heated congressional debate. These included the admission of California as a free state with the provision that other new territories would be allowed to decide by popular vote whether to permit slavery; the reinforcement of the Fugitive Slave Law; and the banning of slave sales within the District of Columbia.

36. Entry of September 9, 1850, in *Diary of Philip Hone, 1828–1851*, ed. Allan Nevins, 2 vols. (New York: Dodd, Mead, 1936), 2:902.

37. Entry of September 9, 1850, in *Diary of George Templeton Strong*, ed. Allan Nevins, 4 vols. (New York: Macmillan, 1942), 2:19. Hone expressed similar contempt for Seward; see *Diary*, March 12, 1850, 2:904–5.

disunion would be averted. The symbolism of the lion and the lamb in *The Spirit of Peace* may thus allude to the reconciliation of opposing social systems and to the necessity of laying aside sectional conflict in order to embrace a higher principle of national harmony. Admiring supporters dubbed Henry Clay, architect of the Compromise bill, "the great Pacificator."[38] The realization of the republican dream of global redemption, as Cropsey and his contemporaries well knew, depended on averting the national crisis portended by recent events. During a period of intense political strife and polarization, audiences of his pendant pair would have read them in terms of the starkly posed alternatives of feudal war or Christian millennium.

Like so many landscapes in the opening years of the 1850s, Cropsey's *Spirit of Peace* and his *Millennial Age* (1854) echoed the tranquil pastoralism of the second canvas of *The Course of Empire*.[39] With the appearance of greater militancy in both the North and the South, however, such subjects appeared increasingly nostalgic or irrelevant.

Northeastern artists occasionally sounded a note of preparedness prior to the onset of the Civil War itself. An example was A. F. Bellows's *Home-Side View of the War* (1859), described as "an extended view through a valley. In the distance arises the smoke of battle; upon a bluff stands a group of villagers watching the progress of the engagement—old men, women and children, driven from their homes. It is a work of feeling."[40] Following the outbreak of war, Henry Livingston Hillyer (1840–1886) in 1863 exhibited a now unlocated pendant pair titled *War* and *Peace,* an allegory that combined the imagery of agrarian cycles, the disruption of pastoral

38. "The North and the South," *Western Journal and Civilian* 8 (July 1852): 224. See also in the same volume "Dirge for Henry Clay," p. 295.

39. Cropsey's *Millennial Age,* containing the same prophetic iconography as *The Spirit of Peace,* has no pendant depicting war. His fascination with the millennial theme was reiterated in a poem titled "The Age" and published in the gift book *Forget-Me-Not* (New York, 1855), pp. 60–64. Coming within a year of Cropsey's painting, the poem makes explicit the utopian hopes that also characterized his allegorical landscapes.

40. Listed in the "Catalogue of Premiums," *Cosmopolitan Art Journal* 3 (December 1859): 247. Other paintings suggesting public preparedness for war included *Young America, or, Military Education* (listed among the works acquired by the *Cosmopolitan Art Journal* 1 [July 1856]: 24); and an allegorical figure of America by Horatio Greenough reexhibited in 1859 "with olive leaves in outstretched hand, while the drawn sword behind her in the right indicates the readiness for war if it becomes necessary." *Cosmopolitan Art Journal* 3 (March 1859): 87. Also evident is a new tone of wistful melancholy suited to portraying national anxieties in the personal, domestic terms of sentimental allegory and portraiture. An example by Lilly Martin Spencer, titled *Il Penseroso,* no. 98 in *Cosmopolitan Art Journal* (Supplement) 2 (December 1857): 60, was described as a "serious, subjective delineation. It is a lady 'robed in grey,' wrapped in deep and sad meditation, and gazing fixedly upon the crimson-streaked sky, where her thoughts seem to dwell."

life, and the meteorological symbolism of the storm. The catalogue entry for *War* described a "tumultuous, stormy picture" that was "a mirror of the times. The warring of the elements is a common figure of conflicting human passions"; masses of rolling clouds, heavens thundering like artillery, lightning, "the ruined homestead, the turbulent stream, . . . the burned bridge and the forsaken implements of husbandry . . . grown o'er with weeds and vines," all told a story "but too truly of this trying hour of our country." *Peace* dwelt on equally familiar if contrasting imagery: a "quiet, sunny valley," immobile clouds that "form and vanish," seemingly without motion, "the rich harvest, and the quiet placid stream that reflects the whole without a ripple ruffling its surface," all telling "a story of peace, plenty and happiness."[41] Such descriptions reveal how standard, indeed hackneyed, the symbolism of the storm had become for conveying themes of national crisis.

Around the middle of the 1850s bleak if disguised predictions of the nation's future began to appear, coinciding with the deterioration of compromise efforts. To artists searching for images with which to evoke a prospective sense of loss and cultural ruin, Cole's *Desolation* (figure 6) summed up a generation's fears.[42] Orators across the land evoked images strikingly resembling the last painting in Cole's series, as in this speech mockingly quoted as an example of rhetorical excess by the *Cosmopolitan Art Journal*: "If the time shall unhappily come when this mighty fabric shall yield to the parricidal attacks of civil discord, I pray God that its fate may be oblivion, that no wreck or vestige of its existence may remain to attest its former greatness or incite the story of its fall. Let the Atlantic and the Pacific meet in a mournful embrace over its ruins, and their commingled waves sing its requiem."[43] Such highly colored visions answered the threat to the union in apocalyptic language that matched disappointed millennial expectations. Millennium and apocalypse remained in these years, as three decades earlier when Cole had first explored the alternatives, two sides of the same coin. In the late 1850s, however, apocalypse carried the greater probability.[44]

Artistic responses to *Desolation* ranged from the literal to the metaphoric. The

41. "Catalogue of the Fourth Annual Exhibition of American and Foreign Paintings, Summer Season," Derby Galleries, New York, 1863, Archives of American Art, Reel N438.

42. See, for instance, the praise *Desolation* received in an 1853 review of Cole's series, "The Fine Arts. The Washington Exhibition. Second Article," *Albion*, March 19, 1853, p. 141, for which reference I am indebted to Franklin Kelly; see also G. W. Sheldon, *American Painters* (1881; reprint, New York: Benjamin Blom, 1972), p. 105, on Daniel Huntington's high opinion of *Desolation*.

43. *Cosmopolitan Art Journal* 3 (September 1859): 186.

44. Sandeen, *The Roots of Fundamentalism*, pp. 92–93, notes an increase in millenarian activity in the 1850s and 1860s, measured by growing interest in the premillennial (Apocalyptic) advent of Christ. On p. 97 he points to the Civil War as one source of revived millenarian (premillennial) interest.

description of an 1857 painting listed in the *Cosmopolitan Art Journal* seems to be a direct reworking of the earlier painting: "The ruins of a city which once had been mighty. Palaces are in ruins, pillars are prostrate and broken, the grass is over all the ways—no life there but a few wretched Gypsies, who seem all of mankind that remain." The description ends admiringly: "This is a powerful composition."[45]

On a deeper level Franklin Kelly has argued that Frederic Church's *Twilight in the Wilderness,* painted on the eve of the Civil War, registers his own transmutation of *Desolation,* demonstrating the younger artist's habit of thematically reworking earlier compositions by his teacher and thereby transforming their meaning internally.[46] Church was particularly indebted to what he called Cole's "noble series of landscapes." His *Composition,* engraved in 1879, was closely inspired by *Desolation,* and as late as 1883 Church claimed that *Desolation* was the work he preferred above all others by Cole.[47] Although Church renounced the biblical-allegorical mode of his teacher in favor of a form of natural typology, he had not renounced his effort to make landscape serve national meaning. *Twilight in the Wilderness* introduced a new complexity beyond Cole's emblematic if poetic treatment, allowing Church to explore levels of meaning that Cole closed off through the very finality of his concluding note. The apocalyptic intensity of Church's wilderness sunset may be seen either as an end or as a new beginning.[48] In this duality *Twilight* is a recasting not only of Cole's *Desolation,* a work of resounding doom, but also of his *Oxbow.*

Church, like other artists who came of age in the middle of the century, transformed Cole's renunciatory and pessimistic vision into one replete with national promise. In place of Cole's allegorical landscapes, Church imagined nature in the typological terms of a crusading Protestantism. He saw nature as the essential medium of a unifying nationalism. He was, as David Huntington has clarified, far more concerned with collective experience and its biblical types than with individual spiritual redemption.[49] As an artist Church was thoroughly comfortable with

45. "Catalogue of Premiums," no. 101 in *Cosmopolitan Art Journal* (Supplement) 2 (December 1857): 60.

46. On the relationship of *Twilight* to *Desolation* and to *The Course of Empire* as a whole, see Kelly, *Church and the National Landscape,* pp. 117, 155.

47. The engraving appeared in *Harper's Magazine* 59 (September 1879) at the head of an article titled "Fifty Years of American Art, 1828–1878." On September 11, 1883, Church wrote to John D. Champlin: "Thomas Cole was an artist for whom I had and have the profoundest admiration—If I were permitted to select three from among all the landscapes I have ever seen I should certainly choose for one of them "Desolation" the last of the five pictures by Cole. . . . Wretchedly lighted but even at such disadvantage it is a striking picture, possessing as much poetic feeling as I ever saw in Landscape Art." Archives of American Art, Albert Duveen Collection, Reel DDU1, frames 115–16. See also Kelly, *Church and the National Landscape,* pp. 64–65.

48. My analysis here is indebted to Kelly, *Church and the National Landscape,* p. 107 and passim.

49. See Huntington, "Church and Luminism," pp. 155–90.

his public role as image maker, his personality a transparent medium that left few if any traces of private convictions apart from his grandiose productions in paint. Although he extended Cole's legacy of using the landscape to explore issues of national destiny, the human actor as an agent of history is now absent.

Church's wilderness apocalypse is a baptism through violence into a redeemed sense of nationhood. Such was the manner in which northerners frequently justified the social and human costs of war, interpreting its advent as the first act of the millennium.[50] A more troubling alternative was that the war, by defeating America's republican experiment, heralded nature's final triumph—perhaps through divine intervention—in an apocalyptic blaze, ending the centuries-long struggle of the European for control of the continent. The millennium, when it came, would occur beyond time and history. Two distinctly different interpretations of the painting, and of present events, were thus possible. Church's image preserves the ambiguity between a pre- and a postmillennialist reading of the war that inhered in contemporary commentary. His apocalypse is an implicit tribute to Cole's *Course of Empire,* but it retains the ambiguity of his *Oxbow,* as well as its naturalistic language. *Desolation* anticipates the resurgence of culture—its eventual reappearance in yet another round of the historical cycle. Church's *Twilight* renders into natural terms this elision of end and beginning. Their conflation at the point of contact between two cycles of history—revealed at the moment of sunset—gave Church's landscape a complexity of meaning appropriate to the war years.[51] As both the origin and end of the American republic, nature, Church's painting asserts, is the answer to the political problems of nationalism. If Cole's *Oxbow* was an admonition, Church's *Twilight* was a prayer, summoning not to action but to silent witness. In place of Cole's engagement of the spectator as an actor implicated in the transformations of nature is a nature that has erased culture's wounds.

Perhaps the greatest image of the war as a struggle of cosmic proportions is Church's *Cotopaxi* (plate 4), painted in 1862. *Cotopaxi,* like Cole's *Subsiding of the Waters,* represents a world evolving out of the simultaneous processes of creation and destruction. In both, the sun rising in the East is an emblem of hope qualified by deep ambivalence.

For critics writing about *Cotopaxi,* Church's genius was in creating a landscape

50. See James H. Moorhead, *American Apocalypse: Yankee Protestants and the Civil War, 1860–1869* (New Haven: Yale University Press, 1978), esp. pp. 42–81.

51. Church's *Twilight* resulted in a vogue for paintings on the theme, many of which play upon the national symbolism of this elegiac subject. The topic is explored in Franklin Kelly, "Frederic Edwin Church and the North American Landscape, 1845–1860" (Ph.D. diss., University of Delaware, 1985). Church's probable allusion to the coming war is echoed, for instance, by George Inness's *Twilight* (1859), listed in the *Cosmopolitan Art Journal* 4 (June 1860): 82.

that merged antinomies—"power, beauty, sublimity and pathos."[52] The awesome immensity of nature in *Cotopaxi,* along with the enormous destructive power it depicts, was the keynote of the critical response to the painting: "The superb disdain which the equator hurls at high civilization and human mastery and progress, are subtly reproduced in this painting, leaving in the spectator's mind a feeling of the profound sadness, which the sight or the story of the Tropics always inspires."[53] But only a few years earlier, between 1853 and 1859, when Church had exhibited a series of brilliant South American landscapes, the story of the tropics had inspired not profound sadness but an expansive new sense of spiritual and national possibilities. No longer evoking a New World Eden, *Cotopaxi* dramatized a nature that was, like the nation, at war with itself. Once again the metaphor of a natural conflict embodied the artistic response to contemporary events.

Cotopaxi returned to an older "theatrical sublime" of volcanoes and earth-shaking tumult, in a manner that echoed the confrontational rhetoric of the early Civil War period. Henry Tuckerman compared Church to an orator seeking "a theme fitted to give ample scope to rhetoric." Church was inclined not to love of effect so much as to "an instinctive interest in such scenes and objects in nature as are exceptional and impressive."[54] *Cotopaxi* contrasts with Church's earlier South American paintings, characterized by a very different imagery of silent earth-generating forces irreducible to specific local agencies. In luminous paintings such as the 1855 *Andes of Ecuador* (figure 28), Church was inspired not by fascination with elemental conflict but by organic unity.

Not long after the firing on Fort Sumter, even pacifist northerners turned away from accommodation to embrace armed conflict. "It is a great thing," wrote the poet William Cullen Bryant, looking back in 1865 over four years of warfare, "to have lived long enough to see this mighty evil [of slavery] wrenched up from our soil by the roots and thrown into the flames."[55] Church's companion Theodore Winthrop, one of the earliest casualties of the war, "saw clearly the inevitable necessity of arms." A memorial article about Winthrop, probably written by George William Curtis, recalled how "we all talked of it [the imminent war] constantly,—watching the news,—chafing at the sad necessity of delay." In his image of a "war-

52. Unidentified newspaper clipping, "Art and Artists: Church's Cotopaxi," from "American Landscape Painters," Artists' Scrapbook, New York Public Library.

53. Unidentified newspaper clipping dated April 4, 1864, from "American Landscape Painters," Artists' Scrapbook, New York Public Library.

54. Tuckerman, *Book of the Artists,* p. 371.

55. Bryant to Catherine Maria Sedgwick, reproduced in Parke Godwin, *A Biography of William Cullen Bryant* (New York: D. Appleton, 1883), 2:228.

Figure 28. Frederic Edwin Church, *The Andes of Ecuador*, 1855. Oil on canvas; 48″ x 75″.
Reynolda House, Museum of American Art, Winston-Salem, North Carolina.

cloud" rolling up "thicker and blacker" with each passing day, Curtis returned to
the earlier imagery of the coming storm and anticipated Church's own culminating
statement of the theme in *Cotopaxi*.[56]

Along with many of his fellow painters, Church found his creative energies
commandeered for the Union cause. As a flyer for Church's 1861 *Our Banner in the
Sky* (figure 29) enthusiastically proclaimed, a "sudden and simultaneous outburst
of patriotism . . . electrified the entire North, West, and East of America," finding
"no more hearty or instant response among any class of our citizens than the
Artists." A small work which became the basis of a chromolithograph, *Our Banner
in the Sky* demonstrates the literal extremes to which he went in forging a unionist

56. "Theodore Winthrop," *Atlantic Monthly* 8 (August 1861): 245.

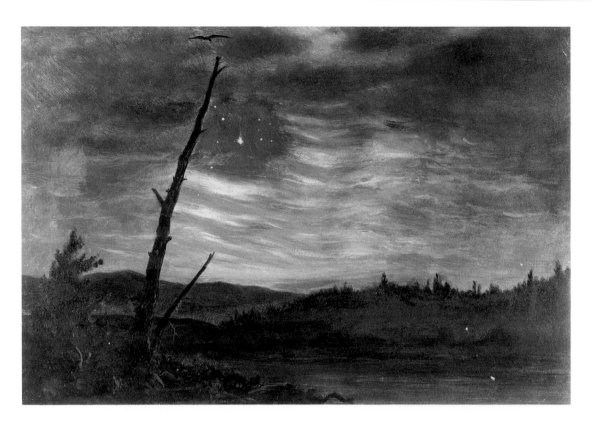

Figure 29. Frederic Edwin Church, *Our Banner in the Sky*, 1861. Oil on paper; 7½″ x 11¼″. New York State, Office of Parks, Recreation and Historic Preservation, Olana State Historic Site.

rhetoric out of the materials of landscape. The painting's title may have been taken from Oliver Wendell Holmes's patriotic poem "Old Constitution."[57]

Cotopaxi was perhaps his greatest effort to establish landscape on a par with history painting by endowing it with public symbolism.[58] Every element in *Coto-*

57. "Our Banner in the Sky," flyer, ca. 1861, from "American Landscape Painters," Artists' Scrapbook, New York Public Library. In 1861 and 1864 Church exhibited three of his major landscapes—*Icebergs, Heart of the Andes,* and *Niagara*—to contribute to the Patriotic Fund. On *Our Banner* and the chromolithograph published within three months of it by Goupil and Company, see Doreen Bolger Burke, "Frederic Edwin Church and *The Banner of Dawn*," *American Art Journal* 14 (Spring 1982): 39–46, who draws the parallels between Church's painting and a sermon of Henry Ward Beecher's on the occasion of the firing on Fort Sumter, but does not cite Holmes's poem.

58. See Kelly and Carr, *Early Landscapes of Church,* p. 50. Church found a precedent for endowing natural events with moral and political significance in Ruskin. The best example of this is Ruskin's

paxi carries a particular moral valence. The volcanic eruption that obscures the light of the sun is a new, naturalized version of Church's 1849 *Plague of Darkness.* The confrontation between these two natural forces resonates with allusions to the social, moral, and military confrontation of North and South on the stage of the nation. From the early nineteenth century on, volcanic explosions had been compared to bombs and heavy discharges of artillery, while their smoke and fire recalled the horrors of battle.[59] Yet despite such references to national events, there are reassuring signs of renewal and a return of peace. The sun's eclipse promises to be temporary; its light burns through the surrounding gloom, casting its luminous reflection on the lake in the middle ground. The green of the landscape testifies to its vivifying power. *Cotopaxi* visually echoes the grand epic histories of the New England historians Francis Parkman and George Bancroft, which were collectively informed by a Hegelian sense of dialectical process.[60] Church's vision of the landscape as the ground of contending geological forces reenacts Parkman's and Bancroft's violent contest between individuals and nations.[61]

Nature in *Cotopaxi* is a vast stage set where good and evil meet in a final Armageddon. The glow of the sun piercing the dense veil of smoke and ash promises both a moral and a national renewal. The curious bend of the landscape reflects the arc of the earth, suggesting enormous distances and substituting panoramic scope for the delimited space of one-point perspective. In this new form of geographic immensity are intimations of a world not yet mapped or understood. The effect of this realism is to shorten the distance between the viewer and the background by telescoping or folding the intervening space. The volcano looms up suddenly from the horizon, at once threatening and strangely remote. Dominating the left side of the painting, the erupting volcano violently intrudes into the still world of nature, a black, ugly fissure in the once inviolate envelope of light and air

moving passage on Turner's *Slavers Throwing Overboard the Dead and Dying* from volume 1 of *Modern Painters,* in Cook and Wedderburn, *The Works of John Ruskin:* 3:571–73.

59. Church's announcement for a proposed print of *Cotopaxi,* "Cotopaxi: Painted by Frederic Edwin Church. From Studies Made in the Summer of 1857" (ca. 1863, Goupil's Gallery), quoted the *American Cyclopaedia*'s description of "occasional discharges, like those of bombs," issuing from the volcano. The widely read Alexander von Humboldt employed similar imagery; see Tuckerman, *Book of the Artists,* p. 379.

60. On Parkman and Bancroft, see Ann Douglas, *The Feminization of American Culture* (New York: Avon Books, 1977), pp. 202–15. Church's comprehensive reach, if not his rhetoric, was likened to the literary powers of Milton, Macaulay, and Carlyle in "Church's 'Heart of the Andes,'" *Cosmopolitan Art Journal* 3 (June 1859): 133.

61. See Tuveson, *Redeemer Nation,* chap. 1, on the related Christian vision of history.

that was the subject of much midcentury landscape art. As natural history, its trace is evident in the landscape. One writer identified the "fifty-mile" foreground of *Cotopaxi*, "with all its strange peculiarities growing out of the surrounding volcanic agencies," as "the true subject of the picture."[62] We can imagine that the great chasm in the center of the picture was caused by the same earth movements that gave rise to the volcano in the background. This emphasis on the historic dimension of the landscape—literally on the groundwork of events—is still teleologically directed, for all interest in the painting leads ultimately to the central contest of light and dark.[63]

Out of reach of the sun's rays, in the lower right corner of the landscape, is a dark gulf suggesting spiritual death. The white birds that fly across this chasm allude, as in Cole's *Subsiding,* to the dove of Genesis which heralds the return of light following the Deluge, just as the sun, whose light will eventually dissipate the gloom, promises resurrection. A great expanse of reflective water fills the middle distance, bifurcated by the horizon. This passage recalls the placidly expansive wells of space characteristic of luminism, a contemporaneous nonnarrative mode of landscape art remote from the rhetoric of the older sublime. With the exception of the white-winged birds in the lower right, this space is without motion and action, hanging suspended on a breath. One perceives it not in the sequential terms of dramatic landscape but removed from historical process and substituting in its place the perpetual rhythms of nature. The grand geological narrative of the left side is balanced by the timeless space on the right. Yet the impalpable elements of air, light, and water ultimately triumph over the bombast of the volcano. Its jet of angry black smoke and brimstone seems the appropriate climax to a rugged, impassable landscape referring to a tradition of moral allegory epitomized in John Bunyan, where faith is tested through a series of trials that prepare one for salvation.

"When I think of this great conflict, and its great issues," wrote Bryant,

62. *Journal of Commerce,* March 17, 1863; see also "Fine Arts. Mr. Church's *Cotopaxi,*" *New York Herald,* March 16, 1863; both clippings from "American Landscape Painters," Artists' Scrapbook, New York Public Library.

63. In its Humboldtian fascination with natural history, Church's painting of 1862 anticipates Thomas Moran's grand postwar trilogy—*The Grand Canyon of the Yellowstone, The Grand Canyon of the Colorado,* and *The Mount of the Holy Cross*—paintings that, in meditating on the geological past, likewise offered clues to the nation's uncertain future. On the subject, see Joni L. Kinsey, *Creating a Sense of Place: Thomas Moran and the Surveying of the American West* (Washington, D.C.: Smithsonian Institution Press, 1992). The *New York Times*'s declaration (March 17, 1863) that Church was "the artistic Humboldt of the new world" was a common perception; see also "Mr. Church's Pictures," *Art Journal* (London), September 1, 1865.

my mind reverts to the grand imagery of the Apocalypse—to the visions in which the messengers of God came down to do his bidding among the nations, to reap the earth, ripe for the harvest, and gather the spoil of the vineyards; to tread the wine-press, till it flows over far and wide with blood; to pour out the phials of God's judgements upon the earth, and turn its rivers into blood; and, finally, to bind the dragon, and thrust him down into the bottomless pit.[64]

That Bryant, whose earlier meditations on death were rooted in the regenerative cycles of nature, could so readily employ the apocalyptic rhetoric of his contemporaries demonstrates that natural religion coexisted with a very different form of prophetic and revelatory discourse evident in *Cotopaxi*.

A critic for the *New York Times* wrote that *Cotopaxi*, "throbbing with fire and tremulous with life," "admirably subordinated" detail to "the main idea of the landscape, which impresses itself more and more vividly upon the mind as the spectator familiarizes himself with the separate passages—one might almost say the successive stanzas—of the picture-poem."[65] *Cotopaxi* offered a lesson to Church's generation in how to compose the details of the present into a meaningful whole connected to both past and future, each segment part of a readable moral landscape. It served as a symbolic arena in which to explore issues fundamental to citizenship in an embattled republic: issues of historical process, of secular to redemptive history, of earthly to heavenly, or, in Melville's terms, of horologicals to chronometricals.[66] Church's success in subordinating the competing data of empirical reality to a single overarching moral vision paralleled the process through which a new corporate identity subsumed the claims of individuality as northerners summoned the moral conviction needed to wage war with the South.[67]

Church's *Rainy Season in the Tropics*, painted a year after the end of the Civil War (1866, figure 30), is a South American analogue to George Inness's *Peace and Plenty* of the same year. Each work celebrates the miraculous healing of the nation's war wounds in the language of nature. Yet of the two artists Inness better captures the elegiac mood of the nation in the years following the war. Church's natural pyrotechnics deny that any fundamental change has occurred in the historical

64. Bryant to Richard H. Dana (1865), in Godwin, *Biography of Bryant*, 2:228.
65. "Church's Cotopaxi," *New York Times*, March 17, 1863, p. 4.
66. Herman Melville, "The Journey and the Pamphlet," in *Pierre, or, The Ambiguities* (New York: Grove Press, 1957), pp. 293–300.
67. See George M. Fredrickson, *The Inner Civil War: Northern Intellectuals and the Crisis of the Union* (New York: Harper Torchbooks, 1965).

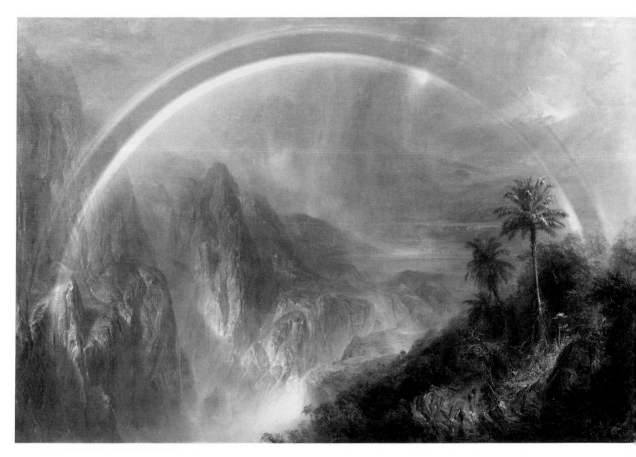

Figure 30. Frederic Edwin Church, *Rainy Season in the Tropics,* 1866. Oil on canvas; 56¼″ x 84³⁄₁₆″. The Fine Arts Museums of San Francisco, Mildred Anna Williams Collection.

consciousness of the nation. The rainbow vaulting across his plunging spaces remains a symbol of national rebirth rooted in the prewar symbolism of virgin wilderness cleansed of history's sins and corruptions. This postwar ritual of renewing the covenant occurred within a fundamentally new context that made such imagery appear histrionic. The terms of collective redemption that had shaped the rhetoric of prewar landscape gave way gradually to a more personal engagement with nature. Many Americans welcomed the war as a fall *into* history, bringing with it transformations in how nature was perceived—a deflation of the imperialist ambitions of the 1850s and the birth of a new mood of introspective self-awareness. Such cultural shifts set the stage for Church's own subsiding fame in the 1870s and his movement toward a style infused by nostalgia for his own more heroic convictions.

4 / The Imperial Republic

Rewriting *The Course of Empire*

Westward the Course of Empire takes its way,
The first four acts already past,
The fifth shall close the drama of the day,
Time's noblest offspring is the last.
—Reverend George Berkeley, "Verses on the Prospect
of Planting Arts and Learning in America," 1752

They may go their way to their manifest destiny which
I trust is not mine.
—Thoreau on his contemporaries, letter to
Harrison Blake, February 27, 1853

If Cole offered the succeeding generation an example to be followed, many of these artists largely ignored his criticism of American society. Instead they chose to appropriate his authority as founder of a national school in order to bolster their own claims to an artistic patrimony for their work. The landscapes of William Sonntag, Jasper Cropsey, Asher B. Durand, and others projected a pious belief in wilderness as the basis of national culture. But unlike Cole's, their engagement with nature lacked the edge of uncertainty, the moral and physical drama that energized his canvases. In their most programmatic works wilderness served as the blank slate ready to receive culture's imprint.

Cole's *Course of Empire* remained on public view throughout these years, its artistic influence assured.[1] The series presented a specific challenge that had to be met by those who followed. Later artists turned the bleak forecast of the series on its head. These artists—Sonntag, Cropsey, and Durand in particular—expressed a new vision of empire purged of its associations with the imperial history of the Old World and linked instead with the extension of northern industrial and urbanized democracy to the West. Expansion came to mean the enlargement of America's

1. After its first public exhibition the series was returned to Luman Reed's gallery. Purchased in his memory by a group of merchants, it became the seed of the New York Gallery of Fine Arts in 1844, changing locations until 1858, when it was absorbed into the New-York Historical Society. See Maybelle Mann, "The New York Gallery of Fine Arts: 'A Source of Refinement,'" *American Art Journal* 11 (January 1979): 76–86. *The Course of Empire*, unlike Cole's later series *The Voyage of Life*, was never engraved.

"dominion over inanimate nature" rather than the conquest and subjugation of other people.[2] Nature sanctified material ambitions by associating them with faith in America's civilizing mission of moral uplift and its efforts to transcend the historical patterns embodied in ancient Rome, the subject of Cole's 1836 allegory.

William Sonntag's now lost series *Progress of Civilization* (1847) encapsulates the substance of the intellectual and cultural shift from Cole's pessimistic cycles of empire to the celebratory vision of republican destiny.[3] Following Cole's lead, Sonntag apparently maintained a consistent perspective through the presence of a river in each canvas.[4] The later series, however, ends with a scene that parallels Cole's *Consummation,* exemplifying "the highest state of civilization. The river, narrow and solitary in the first picture, is here in all its full majesty, covered with the flotillas of commerce; the banks are of the richest landscape; spires and towers cut the clear distance; the grand temple of Liberty crowns an eminence overlooking the whole scene, as some guardian spirit."[5]

The shift in thinking from Cole's bleak vision to Sonntag's midcentury faith in physical and moral improvement is evident in two descriptions of *The Progress of Civilization* published in 1858 and 1864. The former, an article on Sonntag that appeared in the *Cosmopolitan Art Journal,* described the first canvas of the series as a view of "Nature in her primitive grandeur," citing Bryant's poem of 1821 "The Ages" as Sonntag's source for the series, and in particular a stanza evoking a "youthful paradise," "broad and boundless."[6]

Contrasting with this is an 1864 description of the first canvas as a "dismal waste," utterly bereft of human or divine influences:

2. Francis Grund, quoted in *Speech of Mr. [Caleb] Cushing, of Massachusetts, on the Bill Granting Pre-Emption Rights to Settlers on the Public Lands* (Washington, D.C., 1838), p. 14. Americans exempted themselves from the charge of subjugating other people only by denying the plight of the Native American.

3. *The Progress of Civilization* resembles a projected series by Cole, a contrast between an American scene "in its primeval wildness—with Indians" and "the same under the hand of civilization." In the finished pendants, *The Past* and *The Present,* Cole transformed his original idea from an optimistic forecast into a melancholy image of loss. See no. 90 in Cole's list of subjects, in Howard Merritt, ed., *Studies on Thomas Cole: An American Romanticist* (Baltimore: Baltimore Museum of Art, 1967), p. 92.

4. This river as a thematic device resembles Cole's *Voyage of Life,* suggesting an intriguing parallel Sonntag may have had in mind between the life course of the individual and the nation.

5. "William Louis Sonntag," *Cosmopolitan Art Journal* 3 (December 1858): 27. Related imagery appears in the frontispiece to David Moore, *The Age of Progress; or, a Panorama of Time: In Four Visions* (New York: Sheldon, Blakeman, 1856).

6. "William Louis Sonntag," p. 27. The article matched each canvas of Sonntag's series with stanzas from Bryant's poem.

In the first [painting] we have a vast, wild mountain, steep and trackless, over which hover flocks of birds, and among whose rocks "the wild fox digs his hole unscared"; while, perched on the extreme verge of a high cliff, on a dead limb, sits a solitary owl, contemplating the dismal waste about him. The second shows a group of Indians, scattered in their single shabby tent, some indolently basking in the sunshine, and others seeking a precarious livelihood by catching the fish of an adjoining river. In the third, a party of pioneers are pressing westward, through a country which is gemmed on all sides by countless, thriving log-cabins; and, lastly, we have a palatial private residence, in the suburbs of a great city, teeming with manyhanded activity, and sending out on all sides streams of trade and travel.[7]

The two descriptions of Sonntag's series paradigmatically express the alternative meanings of wilderness during the ascendancy of the national school. The earlier one reflects not only Sonntag's poetic source in Bryant, but an entire tradition of Edenic imagery familiar to American audiences of romantic landscape. Yet Bryant (and perhaps Sonntag as well) is clearly describing a nature that is poised for the appearance of the American settler, "another race" than the Indian, bringing "towns . . . fertile realms . . . harvests and green meads."[8] The 1864 review, by contrast, reflects an iconographic tradition rooted in Genesis and in the prophetic books of the Old Testament: the mandate to transform the landscape into a fruitful garden through human labor, "to adorn [the] land, and make it bud and blossom as the rose." What was once a howling wilderness would thus become productive nature, its bounty touched into life by the hand of man.[9] This transformation is in fact the tale told by this later description of Sonntag's series, with its enumeration of the successive stages in the nation's passage from desolation to plenitude.

Although these two readings give different aesthetic values to wilderness, in each case nature is merely the first stage in a preordained and benevolent process culminating in the full urban flowering of American civilization. Neither description laments the subordination of nature's "primitive grandeur" to the kingdom of the human. However Sonntag intended his series to be read, it is clear that it reinforced the contemporary confidence in America's mission of wilderness conquest.

7. *History of the Great Western Sanitary Fair* (Cincinnati: C. F. Vent, 1864), p. 143.

8. William Cullen Bryant, "The Ages," in *Poetical Works of William Cullen Bryant* (1903; reprint, New York: AMS Press, 1969), p. 21.

9. See Genesis 1:28 and Isaiah 35:1–2 for examples. For a related analysis of the dual attitudes toward wilderness, see James Moore, "The Storm and the Harvest: The Image of Nature in Mid-Nineteenth-Century American Landscape Painting" (Ph.D. diss., Indiana University, 1974), p. 204.

Credit for inspiring the series belonged to E. L. Magoon, who visited the artist in 1845 and encouraged him to paint *The Progress of Civilization*.[10] Magoon was a man of broad talents: Baptist minister, patron of American painters, contributor of prose essays on American scenery, vigorous national apologist, and author of a global history, *Westward Empire, or the Great Drama of Human Progress* (1856).[11] Although *Westward Empire* was not published until nine years after Sonntag had completed his series, the two works share a common conception of history. Magoon replaced the cyclical theories dominant in much eighteenth-century historical thought with the progressive linear march of culture that characterized nineteenth-century ideologies of progress, in which each event fit within a continuous and sequential narrative:

> An immense future lies before . . . the unbounded West; where . . . the most exalted sphere is reserved for the indefinite expansion of her ameliorating spirit. It is the destiny of this mighty moral agent to make the tour of the world. . . . Having arrived at this ultimate centre of earth's fermentation and fruitfulness, philosophy, with all subordinate elements of civilization, will prosecute the last stage of her journey, and return upon the mountains whence she originally descended, permitted at last to contemplate thence a world redeemed.[12]

Magoon's sweeping vision of a spiritual "passage to India" was sustained by the economic dream of a trade empire with Asia. Most forcibly expressed by western Democrats such as Thomas Hart Benton and William Gilpin, this dream exercised a continuing hold on the American imagination, transformed into a fabled vision of human unity by Walt Whitman in his 1868 poem "Passage to India." In each case America was the agent of redemption, and its historical advance part of a universal

10. "William Louis Sonntag," p. 27.

11. On Magoon as a collector, see the exhibition catalogue by Ella M. Foshay and Sally Mills, *All Seasons and Every Light: Nineteenth-Century American Landscapes from the Collection of Elias Lyman Magoon* (Poughkeepsie, N.Y.: Vassar College Art Gallery, 1983); "Sketchings: Our Private Collections," *The Crayon* 6 (December 1856): 374. Magoon, according to Foshay and Mills, actually did purchase a work by Sonntag—*Sunset in Western Virginia* (1859)—some years later, when he had become a well-known collector of American landscapes. Benjamin McConkey, a student of Cole's during these years, mentioned Sonntag's series *The Course of Civilization* in a letter from Cincinnati written to Cole on May 10, 1847, which clearly linked the series to *The Course of Empire*. I am indebted to Joseph Ketner for a copy of this letter from the Archives of American Art; also quoted in Merritt, *Studies on Thomas Cole*, p. 39.

12. E. L. Magoon, *Westward Empire; or, The Great Drama of Human Society* (New York, 1856), p. 414.

plan.[13] Sonntag's *Progress of Civilization* localized Magoon's majestic scenario in the burgeoning growth of the Mississippi Valley.

Conceivably Magoon, well versed in American art and undoubtedly familiar with Cole's *Course of Empire*, challenged Sonntag to recast Cole's pessimistic prophecy in terms more suited to the historical mission of his own generation. Both Cole's series and Magoon's *Westward Empire* make deliberate use of George Berkeley's oft-quoted phrase "Westward the Course of Empire takes its way," from "Verses on the Prospect of Planting Arts and Learning in America," albeit in opposing contexts. Cole's series moralizes on the dangers of ambition and the cyclical nature of history; Magoon's text glorifies the rising culture of the New World. Indeed Magoon, in his role as a patron encouraging the progress of the arts in the maturing republic, seems to have identified with the English divine who had introduced the fine arts to the New World and shared his missionary zeal for the possibilities of New World culture. Magoon commissioned J. F. Kensett in 1856 to paint a work recalling Berkeley's stay in Newport from 1729 to 1731 while awaiting his trip to Bermuda.[14]

If Magoon furnished Sonntag with the immediate idea for his series, the typology of cultural stages in which it was cast was nonetheless thoroughly conventional by the 1840s. Sonntag's series demonstrates the debt that new landscape iconography owed the cultural apologetics of expansion, closely based upon the contemporary "stage theory" of historical development. Born in Pittsburgh, Sonntag spent his early years as an artist in Cincinnati, the growing metropolis on the Ohio River. A journey in the early 1840s to the Wisconsin Territory took him quite literally through the stages of social development on the frontier.[15] Such a trip could be experienced either as a passage from civilization back to wilderness or as a voyage

13. The literature on the theme of the passage to India is considerable. See Albert K. Weinberg, *Manifest Destiny: A Study of Nationalist Expansionism in American History* (Baltimore: Johns Hopkins University Press, 1935); Henry Nash Smith, *Virgin Land: The American West as Symbol and Myth* (Cambridge: Harvard University Press, 1950); Howard Mumford Jones, *O Strange New World: American Culture, The Formative Years* (New York: Viking, 1964); John Seelye, *Prophetic Waters: The River in Early American Life and Literature* (New York: Oxford University Press, 1977).

14. On Magoon's commission to Kensett, see Foshay and Mills, *All Seasons and Every Light*, p. 70. On Berkeley's relevance to Kensett's contemporaries, see Sadayoshi Omoto, "Berkeley and Whittredge at Newport," *Art Quarterly* 27 (Winter 1964): 42–56. Worthington Whittredge and James Augustus Suydam also painted the Newport site associated with Berkeley; see *American Paradise: The World of the Hudson River School* (New York: Metropolitan Museum of Art, 1987), pp. 191–93.

15. I am grateful to Dr. Charles Sarnoff of Great Neck, New York, for allowing me to see his research on Sonntag's career. See also Nancy Dustin Wall Moure, *William Louis Sonntag: Artist of the Ideal, 1822–1900* (Los Angeles: Goldfield Galleries, 1980).

from wilderness to civilization. Sonntag's series, however, reversed Cole's romantic, primitivist fascination with a return to the origins of the social order and substituted a scenario of progressive urbanization.

Sonntag's typology in *The Progress of Civilization* parallels a description of the four stages of social development in an article by John Quincy Adams published in the *American Review* in 1845, the year he began his series. The former president analyzed social development in terms of an ascending scale reaching from the "Savage" to the "Pastoral" (by which he meant nomadic), "Agrarian," and "Civilized, or Urban."[16] The similarity between Sonntag and Adams underlines the shared assumptions that drew landscapists together with others committed to a massive transformation of wilderness into domesticated nature.[17] Adams's vision of social order overtaking nature's nonproductive regions was also at the heart of his Whig political program.

Adams shared his vision of culture as a sequence of stages with another former president of a very different political persuasion: Thomas Jefferson. In 1826, the year of his death, Jefferson graphically applied the stage theory to American society in a letter to William Ludlow written from Monticello. The passage illuminates how an older, eighteenth-century stage theory of civilization could serve as a crucial support for a newer ideology of expansionism. Steeped in republican theory and anxieties of social declension, by the end of his career Jefferson seems to have closed the gulf between his own skeptical generation and the more sanguine expansionists who came after him. Like them, he envisioned a steady march of national institutions across the country. Nonetheless, there remains in his final query a sense of lingering doubt. Traveling from west to east took one on a journey through the stages of human culture:

> Let a philosophic observer commence a journey from the savages of the Rocky Mountains, eastwardly towards our seacoast. These he would observe in the earliest stage of association living under no law but that of nature, subsisting and covering themselves with the flesh and skins of wild beasts. He would next find those on our

16. John Quincy Adams, "Society and Civilization," *American Review* 2 (July 1845): 80–89. The distinction between the pastoral and the nomadic is largely lost in contemporary usage; see Leo Marx, "Pastoralism in America," in Sacvan Bercovitch and Myra Jehlen, *Ideology and Classic American Literature* (New York: Cambridge University Press, 1986), pp. 36–69, esp. 42–44.

17. Sonntag's vision of progress, however, may have come more directly from his childhood tutor, Alexander Kinmont, the author of *Twelve Lectures on the Natural History of Man and the Rise and Progress of Philosophy,* the first American edition of which appeared in Cincinnati in 1839. See "William Louis Sonntag," p. 26. The work is an extended argument for general progress, despite the rise and fall of particular nations and races.

frontiers in the pastoral state, raising domestic animals to supply the defects of hunting. Then succeed our own semi-barbarous citizens, the pioneers of the advance of civilization, and so in his progress he would meet the gradual shades of improving man until he would reach his, as yet, most improved state in our seaport towns. This, in fact, is equivalent to a survey, in time, of the progress of man from the infancy of creation to the present day. I am eighty-one years of age, born where I now live, in the first range of mountains in the interior of our country. And I have observed this march of civilization advancing from the seacoast, passing over us like a cloud of light, increasing our knowledge and improving our condition, insomuch as that we are at this time more advanced in civilization here than the seaports when I was a boy. And where this progress will stop no one can say.

Jefferson then strikes a note that was to become an insistent chord over the next half century: "Barbarism has, in the meantime, been receding before the steady step of amelioration; and will in time, I trust, disappear from the earth."[18] The theme of the retreat of "barbarism" in the face of civilization became the predominant, perhaps the exclusive, concept shaping American attitudes toward the Indian for nearly a century. Jefferson's description is symptomatic of a powerful nineteenth-century insistence on a progressive and unidirectional concept of history that consigned non-European cultures to marginality or oblivion.[19]

Through Jefferson's conversion of temporal into spatial dimensions, a process of social evolution that had occurred over centuries was telescoped into three or four generations, each representing a progressive step toward civilization. Jefferson's prognosis anticipated by a quarter century the optimistic vision of republican empire that by the 1850s had replaced Cole's version of imperial decline.

Jefferson's letter to Ludlow merely translated into spatial and geographical terms the temporal development of human society as it had been described by Adam Ferguson, an influential philosopher of the Scottish Enlightenment, whose *Essay on the History of Civil Society,* first published in 1767, enjoyed great currency in

18. Quoted in *The Portable Thomas Jefferson,* ed. Merrill Peterson (New York: Viking, 1975), p. 583.

19. The background of such attitudes has been widely investigated. See Roy Harvey Pearce, *The Savages of America: A Study of the Indian and the Idea of Civilization* (Baltimore: Johns Hopkins University Press, 1953); Ronald L. Meek, *Social Science and the Ignoble Savage* (Cambridge: Cambridge University Press, 1976); Robert F. Berkhofer, *The White Man's Indian: The History of an Idea from Columbus to the Present* (New York: Knopf, 1978), esp. pp. 44–49; Richard Drinnon, *Facing West: The Metaphysics of Indian Hating* (Minneapolis: University of Minnesota Press, 1980); Reginald Horsman, *Race and Manifest Destiny: The Origins of Racial Anglo-Saxonism* (Cambridge: Harvard University Press, 1981).

America.[20] No doubt this currency was due in part to Ferguson's proposal to regulate the unstable cycles of history through political guidance and education. But Jefferson's striking image also drew on a standard Anglo-American topos of classical origin—*translatio imperii,* or the progressive westward movement of civilization. Unlike Ferguson, Jefferson ignored the cyclical dimension of the stage theory, anticipating the later American use of the progressive model to undergird westward expansion. As each civilization in succession rose to its apogee, a new one was dawning that would eventually eclipse its predecessor.[21] The stage theory of social development transformed the global context of *translatio imperii* into a single nation's progressive evolution from wilderness through each stage of settlement. The logical result of Jefferson's fusion of the stage theory and the course-of-empire theme was that the West would emerge as the new center of American civilization at the very moment when the East, having reached maturity, was sinking into old age. If the new flame of empire was in fact moving continually westward, it could do so only at the risk of leaving America's older eastern states in the dark. Lingering within the progressive vision of the next generation was the ever-present reminder of a prior cyclical history of migrating empire.

Two short decades after Jefferson's letter to Ludlow, westerners indeed assumed as a matter of course that their region would eventually eclipse the East as the seat of empire. Primitive frontier conditions were merely the first stage in the glorious apotheosis of the West. But what they failed to acknowledge was that the historical logic that marked them for imperial ascendancy would also ensure their eventual eclipse as the light of civilization moved ever westward.

Sonntag's and Magoon's celebration of progress was repeated in a related series by the American artist John R. Johnston. The work, also titled *Progress,* was described in an article on Johnston that appeared in the *Cosmopolitan Art Journal:*

> The first three of the series are composed of studies from western scenery. One
> presents a view of a wild glen, with untutored savages in the foreground and "la

20. For more on the stage theory of social development and on Ferguson's impact in America, see Pearce, *The Savages of America;* Gladys Bryson, *Man and Society: The Scottish Inquiry of the Eighteenth Century* (Princeton: Princeton University Press, 1945); Drew R. McCoy, *The Elusive Republic: Political Economy in Jeffersonian America* (Chapel Hill: University of North Carolina Press for the Institute of Early American History and Culture, 1980), pp. 18–20, and 22.

21. On the history of the idea, see Loren Baritz, "The Idea of the West," *American Historical Review* 66 (April 1961): 618–40; Robert Nisbet, *The History of the Idea of Progress* (New York: Basic Books, 1985); J. G. A. Pocock, *The Machiavellian Moment: Florentine Political Thought and the Atlantic Republican Tradition* (Princeton: Princeton University Press, 1975); Sacvan Bercovitch, *The Puritan Origins of the American Self* (New Haven: Yale University Press, 1975), pp. 145–46.

belle rivere [*sic*]," the Ohio, . . . in the distance. Another shows the emigrant en route for the wide prairies of the West, which form the background of the picture, and the third is a scene of agricultural life. The fourth of the series represents "Civilization;" a vast city, with its domes and steeples, its courts and churches, and the steamboats and the white sails of commerce are seen in the distance, while the railroad, the canal, and the telegraph, are aptly introduced in the foreground. . . . Col. J[ohnston] has succeeded in transferring upon the canvas, in four brief but comprehensive volumes, the whole history of the progress of the civilization of our country.[22]

The series, now lost, failed to bring Johnston the notoriety that the review promised him.

Jasper Cropsey was another midcentury artist fascinated by epic allegories of national destiny. Cropsey conceived, although he never executed, his own contemporary recasting of Cole's *Course of Empire*.[23] Eight years before the Civil War he projected a four-part series, *The Genius of the Republic*, which traced the movement of empire from the Old World to the New in millennial terms. The series was to open with a composite scene of Egyptian, Greek, Roman, and medieval ruins. This was to be followed by a great deluge, destroying the despotic governments of the Old World while sweeping the young Genius of the Republic to transatlantic shores, the subject of the next scene.[24] The final scene was to be a form of republican triumph, complete with a pantheon of national heroes, monumental Liberty column, and statue of Washington.[25]

The Genius of the Republic was in effect to be a continuation of *The Course of Empire*, picking up the tale where Cole ended it, with the wreck of empire. Cropsey's projected work systematically reversed the stages of the earlier series.[26]

22. "John R. Johnston," *Cosmopolitan Art Journal* 3 (September 1859): 178.

23. On Cropsey's attitude toward allegory, see William Talbot, *Jasper F. Cropsey, 1823–1900* (New York: Garland, 1977), pp. 108–9.

24. This background resembles that found in William Allen Wall's *Nativity of Truth* (*terminus ante quem* 1853). On this painting, see Angela Miller, "*The Nativity of Truth:* William Allen Wall and Universal Allegory," *New England Quarterly* 63 (Fall 1990): 446–67.

25. Cropsey described the entire series in a letter to his patron "Mr. M.," dated May 12, 1854, Archives of American Art, Reel 336.

26. A series by the artist Jesse Talbot bears an interesting relationship to Cropsey's. Described in the *Cosmopolitan Art Journal* 2 (March and June 1858): 148, the series, identified as *The Division of the Earth among the Sons of Noah*, taken from the tenth chapter of Genesis, is yet another excuse for treating the theme of *translatio imperii*, the westward transit of empire. This time, however, civilization moves from Asia to Egypt and Greece, "at a time when Greece had attained to her highest state of

The opening scene of ruin corresponded to *Desolation*. The great destroying flood of the second canvas formed a counterpart to *Destruction*, serving as a prelude to the rebirth of culture in the New World, the subject of the third canvas. By invoking the biblical Deluge to mark the transition between epochs, Cropsey invested the beginnings of republicanism in the New World with the overtones of a postdiluvian second chance for humanity. The fourth canvas, with its elaborate monuments, statuary, and shrines, would have reworked *Consummation* by celebrating the chaste achievements of the republic as Cole's earlier work had represented the corrupt forms of empire.[27]

Cropsey conceived *The Genius of the Republic* when he was thirty-one years old, nearly the same age as Thomas Cole when he began work on his own serial composition. Like Cole, Cropsey prepared for his ambitious undertaking with several years of study in Europe, during part of which time he occupied Cole's former studio in Rome.[28] Like Cole, Cropsey was a religious man. But whereas Cole's religiosity was renunciatory and otherworldly, Cropsey's supported his millennial vision of national culture in which personal and collective salvation were bound to each other.[29] His projected work is difficult to imagine without the example of the American master of epic allegory behind it. But Cropsey deliberately refashioned Cole's allegory for his own generation, assuming Cole's mantle by redoing his master. He substituted a figure of the artist as impersonal mouthpiece of collective prophecy in place of the Colean figure of the artist as Cassandra-like doomsayer, morally removed from his subject. Furthermore, Cropsey was creating a specifically national drama. Cole's scenario, by contrast, purported to be rooted in universal truths, pitting humanity's fallen state against a natural paradise lost through sin.

civilization and refinement." The progress of Talbot's series was eagerly noted by the *Cosmopolitan*. What distinguishes it from the work of Sonntag and Cropsey is its Old World setting. It differs as well from earlier interest in historical cycles, placing its emphasis not on the inevitable decline of individual nations but on the overall progressive transit of civilization.

27. Cropsey's projected series closely paralleled another never-executed series by Cole, to be called *The Future Course of Empire*. Archives of American Art, Reel ALC3. It is unclear whether Cropsey knew about Cole's planned series, which anticipates Cropsey's millennial themes and probably dates from the latter part of Cole's career. For other examples of Cole's influence on Cropsey, see Talbot, *Jasper Cropsey*, p. 114.

28. Talbot, *Jasper Cropsey*, p. 50. Cole in turn occupied the former studio of Claude Lorrain; see William Dunlap, *History of the Rise and Progress of the Arts of Design in the United States*, 2 vols. (1834; facsimile reprint, New York: Dover Publications, 1969), 1:149.

29. This identification of personal with national destiny as a particular version of American redemptive history is analyzed in Bercovitch, *Puritan Origins of the American Self*, pp. 88–89, 146, 172–73.

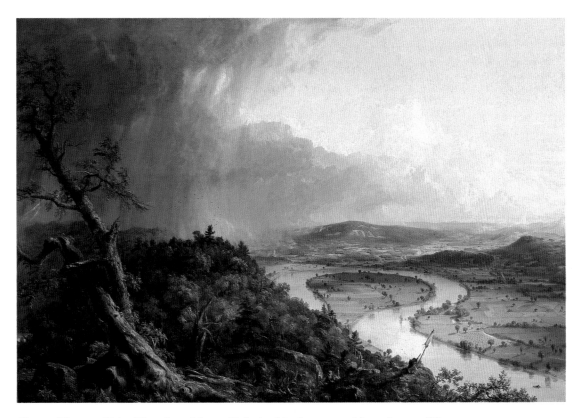

Plate 1. Thomas Cole, *View from Mount Holyoke, Northampton, Massachusetts (The Oxbow)*, 1836. Oil on canvas; 51½″ x 76″.

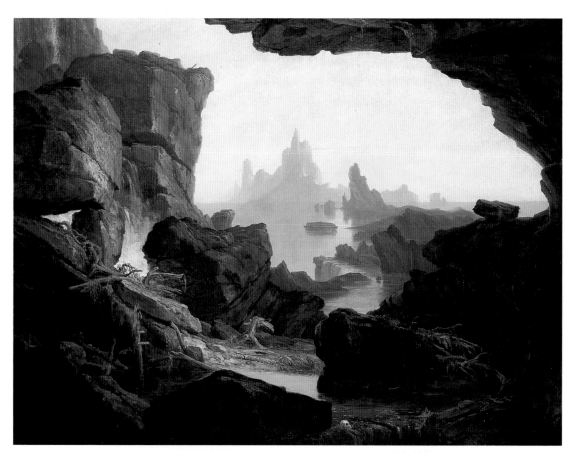

Plate 2. Thomas Cole, *Subsiding of the Waters of the Deluge,* 1829. Oil on canvas; 36″ x 48″. The National Museum of American Art, Smithsonian Institution. Gift of Mrs. Katie Dean in memory of Minnibel and James W. Dean and Museum Purchase through SI Collections Acquisitions Program.

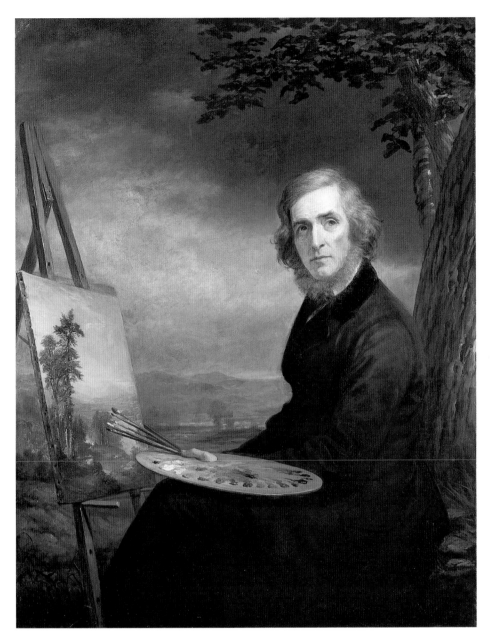

Plate 3. Daniel Huntington, *Asher B. Durand*, 1857. Oil on canvas; 56½″ x 44″. The Century Association, New York City.

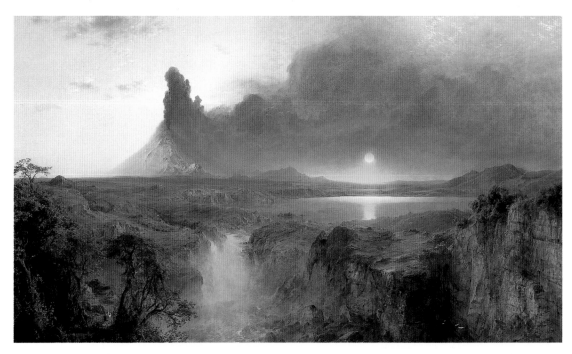

Plate 4. Frederic Edwin Church, *Cotopaxi*, 1862. Oil on canvas; 48″ x 85″. © The Detroit Institute of Arts, Founders Society Purchase with funds from Mr. and Mrs. Richard A. Manoogian, Robert H. Tannahill Foundation Fund, Gibbs-Williams Fund, Dexter M. Ferry, Jr., Fund, Merrill Fund, and Beatrice W. Rogers Fund, 76.89.

Plate 5. Asher B. Durand, *Progress (The Advance of Civilization)*, 1853. Oil on canvas; 48″ x 71¹⁵⁄₁₆″. The Warner Collection of Gulf States Paper Corporation, Tuscaloosa, Alabama.

Plate 6. Frederic Edwin Church, *New England Scenery,* 1851. Oil on canvas; 36″ x 53″. George Walter Vincent Smith Art Museum, Springfield, Massachusetts.

Plate 7. John Frederick Kensett, *The White Mountains—Mount Washington*, 1851. Oil on canvas; 41″ x 63⅜″. Collection of the Wellesley College Museum, Wellesley, Massachusetts. Gift of Mr. and Mrs. James B. Munn (Ruth C. Hanford, Class of 1909) in the name of the Class of 1909.

Plate 8. Sanford Robinson Gifford, *Kauterskill Clove*, 1862. Oil on canvas; 48″ x 39⅞″. All rights reserved, The Metropolitan Museum of Art. Bequest of Maria De Witt Jesup, 1915.

The desire to retell Cole's great national story issued not only in executed and proposed series by Sonntag, Johnson, and Cropsey, but also in landscapes whose nationalistic content was fully integrated within a naturalistic matrix. Art in the service of nationalism, wrote a contributor to the *Bulletin of the American Art-Union*, was envisioned as "a record of the progress of humanity and the race. Thus are marked indelibly the characteristics of the world, age by age; and we read on that mighty page, the progress of civilization—the movings of the spirit that animated the nations in the course of empire."[30] The transformation in the meaning of empire was part and parcel of a broader move during the midcentury decades into the totalizing panoramic reach of the universal histories written by E. L. Magoon and others.

Insofar as a consistent social vision emerges out of the nationalistic narratives of Sonntag, Cropsey, and their contemporaries in the New York and White Mountain schools, it is based on a proprietary aesthetic—a vision of nature transformed by human activity. Wilderness was valued primarily as a foil to the pastoral, and as a historical artifact worthy of documentation if not necessarily of preservation. Wilderness set into relief the divinely inspired progress Americans had made toward a stable, civilized society.[31] Thomas Starr King found in the early history of the White Mountains and in the "movements of population, carrying the threads of civilization to new districts," evidence "of an Intellect that works through human folly as through human wisdom for generous ends."[32] But the message of the midcentury sequential landscape was one not only of divine but also of human and social stewardship. Travelers to the wilderness regions of the Northeast were experiencing a nature no longer inviolable but compartmentalized into manageable aesthetic categories. Such familiarity eased the absence of historical associations so often lacking in the American landscape. The visual experience of a painted landscape reenacted the manner in which one physically oriented oneself in nature, locating major landmarks, establishing a sense of controlling scale, using the intellectual power of vision not simply to record but to condense and formalize the

30. "Development of Nationality in American Art," *Bulletin of the American Art-Union* 4 (December 1851): 138.

31. According to Richard Moore, "'That Cunning Alphabet': Melville's Aesthetics of Nature," *Costerus* 35 (Amsterdam, 1982): 20–21: "Background sublimities could image the promise of the nation's special covenant with God, while pastoral foreground could body forth fulfillment of the covenant." This compositional program conflated "the moral picturesque and the moral sublime in a politically expressive aesthetic vision" (p. 29).

32. Thomas Starr King, *The White Hills: Their Legends, Landscape, and Poetry* (Boston: Crosby, Nichols, Lee, 1860), p. 216.

relative relationship of human to nonhuman, prospect to refuge, improved to unimproved nature. To gaze upon a painted scene with a prepared sensibility was to rehearse the process of taking actual possession of the landscape.

Academic landscape painting of the northeastern United States characteristically sublimated economic ownership and property into aesthetic proprietorship. In doing so, however, it based its appeal on the democratic availability and "common possession" of "universal and unmonopolized nature," in the rhapsodic words of Henry Ward Beecher.[33] As a set of visual conventions, the middle landscape lightly sidestepped the issue of private ownership and the inexorable parceling of the land into private lots. Westward expansion was accompanied by the gridding of the common land in a system established by the Jeffersonian Land Ordinance of 1785 regulating the disposition of the western territories. From that time on expansion, in its most literal economic sense, was the substitution of private or local for federal ownership.[34]

Inevitably the language of economic possession crept into discussions of landscape art. A pointed example appeared in the 1849 *Bulletin of the American Art-Union*. Complaining that landscape paintings commonly placed all the interest in the distance, neglecting the foreground, it concluded: "The eye will not consent to overlook the foreground and rest in a vague horizon, howsoever beautiful it may be; it sees first a point of repose in that which is near and definite—*a base line, as it were, from which to extend its surveys*" (emphasis added). Successful composition required "a middle foreground an open space on which the vision may *rest*—a patch of lawn or broad surface of rock" that would afford "a feeling of pleasure in being there; for *there is the place where we must be,* or else the picture is so much dead wall." Such an open place allowed the spectator to stand and survey the scene. "Whatever be the character of the picture, this rule is of the first consequence."[35] Much antebellum landscape visually insisted that the viewer belonged *in* the

33. Henry Ward Beecher, *Star Papers: Experiences of Art and Nature* (New York: J. C. Derby, 1855), p. 304. See also Donald B. Kuspit, "Nineteenth-Century Landscape: Poetry and Property," *Art in America* (January–February 1976): 64–71; Albert Ten Eyck Gardner, "Scientific Sources of the Full-Length Landscape: 1850," *Bulletin of the Metropolitan Museum* (October 1945): 65; Michael Gilmore, *American Romanticism and the Marketplace* (Chicago: University of Chicago Press, 1985), pp. 18–34; David C. Miller, *Dark Eden: The Swamp in Nineteenth-Century American Culture* (New York: Cambridge University Press, 1990), pp. 133–35.

34. John R. Stilgoe, *Common Landscape of America, 1580 to 1845* (New Haven: Yale University Press, 1982), pp. 99–107.

35. "Some Remarks on Landscape Painting," *Bulletin of the American Art-Union* 2 (November 1849): 23.

landscape, as part of it. The viewer's aesthetic experience reenacted the actual experience of standing before the landscape of nature itself, preparing to move physically through it. Here the eye takes on the quality of an animate force. It becomes a commanding gaze, personified in terms of the surveyor preparing to measure off the surrounding countryside.

The purposes of surveying were multifold in the nineteenth century: to prepare the land for settlement; to create clear, manageable divisions between privately owned properties; and to master a knowledge of topography for the purposes of military conquest. To survey was to measure, to translate a complex, constantly varying terrain into the abstractions of boundary lines and property divisions, converting scenery into measured lots and grade variants. Surveying implied that an understanding of the land was preliminary to conquering it. The intrusion of the term "survey" and its attendant images ("base line") belies the carefully maintained fiction of nature as communal resource.[36] The passage revolves as well around the opposition of near and far, the stasis of the foreground and the dynamic pull of the distance. The structure of landscapes expressed polarities common to democratic culture—the tension between containment and freedom—grounding them in the experience of space itself.

The relationship between mental knowledge of the land and aesthetic control, with its unstated corollary of economic and social possession, is implicit throughout Timothy Dwight's account of the difficulties of aesthetically colonizing a virgin landscape, in a passage inspired by the White Mountains:

> In the first view of a new region, the mind, from its absolute want of knowledge concerning everything within its grasp, finds not a little difficulty in settling upon certain capital points as stations from which it may proceed in all its inquiries, and to which everything of inferior importance might be reduced in order to fix the proportions and relations of the subordinate parts, and thus correctly adjust the situation of the whole. In this case, the imagination is equally at a loss with the intellect, and until it has fixed its own stations, drawn its outline, and referred its

36. A "base" or "baseline" is defined in a military context as "the line or place . . . from which the operations of a campaign are conducted"; as a surveying term, "baseline" is "a line on the earth's surface or in space . . . which is used as a base for trigonometrical observations and computations" (*Oxford English Dictionary*). In addition, certain scenic areas also carried associations with the actual contest over control of the land. Describing his painting *Gates of the Hudson*, Cropsey noted that it was well known for its strategic position commanding a view of the upper Hudson during the Revolutionary War. Cropsey to John W. Kitchell, May 20, 1892/7[?], Archives of American Art, Reel 336. On the association of the panoramic gaze with power, see Michel Foucault, *Discipline and Punish: The Birth of the Prison*, trans. Alan Sheridan (New York: Vintage, 1977), pp. 195–228, 317, n. 4.

inferior images to this scheme will find all its succeeding efforts to form the perfect picture for which it labors in vain.[37]

Here aesthetic order is realized by the act of imposing a hierarchy of value, "subordinat[ing] parts" to a unified whole. Imagination and intellect labor together to relegate "inferior images" to a larger "scheme." In aesthetic terms this entails the suppression of specific details—spatial obstacles, sudden discontinuities, or troubling discrepancies of scale—that disturb the search for "proportion" and "relation." These intransigent natural facts were as disturbing to aesthetic mastery as they were to agrarian and economic appropriation. Dwight's conservative preference for the aesthetically controlled landscape is informed by his vision of a nature regulated by a social hierarchy in which everything and everyone had "fixed its own stations" and accepted its relative position. Yet the struggle involved in establishing this hierarchy is evident in the difficult and hesitant syntax of his writing, in which an accumulation of qualifying clauses embodies the conceptual difficulty that is his subject.

Despite efforts to sublimate economic or extractive motives, the representation of nature, in words or in paint, embodied many of the same assumptions that guided Americans as they established economic and social control over nature. It did so in the displaced language of visual mastery—a metaphor for other types of control—in which the eye was the stand-in for the actual human presence, vicariously enacting the rituals of power, property, and custodianship by which Americans defined their relationship to the natural world.

The somewhat predatory character of visual experience is suggested by that most benign and symptomatic of midcentury figures, Henry Ward Beecher, who sighed to readers of his popular *Star Papers:* "Of gazing there can not be enough. The hunger of the eye grows by feeding."[38] Another New Yorker approached the painted

37. Timothy Dwight, *Travels in New England and New York,* ed. Barbara Miller Solomon (Cambridge: Belknap Press of Harvard University Press, 1969), 2:93–94; the passage was inspired by Dwight's 1797 trip. Quoted in Peter M. Briggs, "Timothy Dwight 'Composes' a Landscape for New England," *American Quarterly* 40 (September 1980): 363.

38. Beecher, "Mid-October Days," in *Star Papers,* p. 327. Thomas Starr King also employed the image of landscape viewing as a form of alimentary ingestion, criticizing the tendency of summer travelers to the White Mountains to "bolt the scenery, as a man, driven by work, bolts his dinner at a restaurant. Sometimes . . . they will *gobble* some of the superb views between two trains, with as little consciousness of any flavor or artistic relish, as a turkey has in swallowing corn." *The White Hills,* p. 17. The alimentary image appeared again in "Art and Artists," *New-York Home Journal,* June 21, 1851, which noted that New York artists were leaving for the mountain and valley regions of New England and "setting their *palettes* in order for a *bonne bouche* at Dame Nature's table." See also E. L. Magoon's lament that to the "gross" utilitarian mind, "nature is made to present herself . . . not as a quiet and

landscape in images of sexual possession. In 1850 George Templeton Strong, in a journal entry, drew a revealing connection between the ownership of nature in the form of art and the covetous desire to possess the actual landscape. Stopping at the New York atelier of a painter friend, Strong "saw two lovely little cabinet-size landscapes," one of which he "did covet most criminally."

> I am tempted to the sin of covetous longing and "inordinate desire" by nothing more strongly than by a really lovely landscape. Even a *natural* landscape inspires me with the feeling. I never can see, for example, a beautiful summer sunset with its soft horizontal light streaming among the trees, or poured over green fields, or blended with cool shadow as it falls among the slopes and swellings of any commonplace tract of uneven ground, without coveting what I see, wishing to go to somebody's shop and buy that very thing. And the consciousness that I *can't* always dashes a little subdued annoyance into the pleasure of the sight. Lucky that people can't buy such things. How some of our Fifth Avenue people would monopolize the brightness of the earth if they could, to add splendor to their soirees and to decorate their supper tables.[39]

Strong's repetition of the biblically charged word "covet," used three times in this passage, and his "inordinate desire," a phrase usually applied in the nineteenth century to the pursuit of gain, here suggests the impious, even sacrilegious nature of his aesthetic craving, sullied by its too close association with the desire for ownership and possession of God's own nature. Added to these is the sexual innuendo that runs throughout the passage. Nature, in all her virginal innocence, provokes the lustful desire of man the despoiler. To possess nature is to contribute to her fall, and her subsequent appearance in the drawing rooms of the wealthy. It is refreshing to find Strong, a highly principled and religious man remarkably clear-sighted about his own motives, refusing to take refuge in the usual exalted language his contemporaries so frequently reserved for discussing art. He freely admitted what few others would recognize—that the taste for landscape was associated in no small measure with the desire for possession, in all its ambiguous allusions.[40] A few

awful temple, but as a plenteous kitchen, or voluptuous banqueting-hall," in *The Home Book of the Picturesque: or, American Scenery, Art, and Literature* (1852; reprint, Gainesville, Fla.: Scholars' Facsimiles and Reprints, 1967), p. 6. On alimentary metaphors for describing Americans' relationship to nature and to one another in the American West, see Ann Norton, *Alternative Americas: A Reading of Antebellum Political Culture* (Chicago: University of Chicago Press, 1986), pp. 203–18.

39. Entry of March 20, 1850, in *Diary of George Templeton Strong*, ed. Allan Nevins, 4 vols. (New York: Macmillan, 1942), 2:10.

40. See Carol Fabricant, "Binding and Dressing Nature's Loose Tresses: The Ideology of Augustan Landscape Design," in *Studies in Eighteenth-Century Culture*, vol. 8 (Madison: University of Wisconsin

years later the Reverend Samuel Osgood explicitly linked the eye, one of the "imperial senses," to Eros.[41]

Only in the vernacular tradition of topographical village and rural views does one find a more direct and unfiltered expression of ownership as pride of place. Here, in works such as James Hope's 1855 *Bird Mountain, Castleton, Vermont,* the economic and social forces transforming the rural landscape are shown with an explicitness ruled out by the conventions of eastern academic practice—conventions that served the fiction of the stable middle landscape.[42] All the same, scholarship has perhaps overemphasized the distance between vernacular and academic practice. A work such as Jasper Cropsey's *American Harvesting* (1851, figure 31) is centrally concerned with demarcating the boundary between the agricultural or human landscape of labor and the wilderness that lies beyond. While the issue of property here is indirect, the general theme of carving a freehold out of the wilderness, so current in eastern painting beginning in the 1840s, was also about wresting ownership from an undifferentiated nature.[43]

There were times, however, when nature disputed Americans' presence on the land. Although these moments ultimately found a safe and unthreatening position within the legendary history of a region, they made a deep and lasting impression on collective memory. Episodes such as the great White Mountain rock slide that destroyed the Willey family in Crawford Notch consecrated the settlement of the region with a tragic history that cast into relief the achievements of the present. The episode enjoyed enormous currency in the literature on the White Mountains up to the middle of the century. Not only did it lend itself to sensationalized accounts,

Press, 1979), for the common associations eighteenth-century gardeners drew between landscape gardening and the social and sexual containment of women. John Berger, "Past Seen from a Possible Future," in *Selected Essays and Articles: The Look of Things* (New York: Penguin, 1972), pp. 211–21, links aesthetic and social experience, taste and ownership.

41. Samuel Osgood, "The Fellowship of the Arts," in *The Bryant Festival at The Century* (New York: D. Appleton and Co., 1865), p. 53. On the Renaissance origins of the association between space and Eros (body), time and Psyche (soul), see W. T. J. Mitchell, "Spatial Form in Literature: Toward a General Theory," in *The Language of Images* (Chicago: University of Chicago Press, 1974), pp. 276–77.

42. Jay Cantor, *The Landscape of Change: Views of Rural New England, 1790–1865* (Sturbridge, Mass.: Old Sturbridge Village, 1976); Cantor, "The New England Landscape of Change," *Art in America* 64 (January–February 1976): 51–54.

43. Relevant in this connection are numerous paintings on the theme of the "Home in the Wilderness" by Cole, Church, Cropsey, Sonntag, Worthington Whittredge, Frederick Rondel, T. Addison Richards, Asher B. Durand, and others. On Cropsey's interest in the theme, see Richard H. Saunders's essay in *American Paintings from the Manoogian Collection* (Washington, D.C.: National Gallery of Art, 1989), pp. 12–15.

Figure 31. Jasper Francis Cropsey, *American Harvesting*, 1851. Oil on canvas; 35½″ x 52¾″. Indiana University Art Museum, Bloomington. Gift of Mrs. Nicholas Noyes. Photo: Michael Cavanagh/Kevin Montague.

furnishing a wild region with human incident, but it also contained a tragic irony that could be moralized. Fleeing their cabin, the Willeys, a family of early settlers, were engulfed in the slide, while the cabin itself was miraculously preserved from destruction, the avalanche of rock and earth dividing around it like the Red Sea parting before Moses. Had the Willeys only remained within, they would have escaped their terrible fate. Property, in this instance as in others, seems to have been marked by a divine seal of approval, preserved from the "wreck of matter" by some higher law. The Willey house continued to stand in the lonely isolation of the Crawford Notch, giving cover to the wayfarer, a melancholy memorial to the

tragedy but also a reminder of its larger lesson: that nature itself respects the rights of property.[44]

No painting better exemplifies the narrativity, confidently nationalistic message, and proprietary gaze that characterized the national style of the 1850s than Asher B. Durand's *Progress (The Advance of Civilization)* (1853, plate 5). And no painting more compellingly rewrote *The Course of Empire* for its own generation. A virtual catalogue of expansionist themes, it offered a model of how to integrate narrative detail into a synthetic but naturalistic whole. *Progress* telescoped the discrete stages of America's movement from wilderness to civilization into one image.[45] Durand's synthetic, temporally condensed view differs in this respect from Sonntag's 1847 exploded view, in which each stage of development is accorded an entire canvas.

The "plot trail" of the painting begins in the left foreground, where a group of Indians gaze out from a raised wilderness prospect upon an extended landscape bearing the signposts of development. These figures are both spatially and historically removed from the main body of the landscape, and Durand identifies them with the passive nature that is the raw material of a national culture. A diagonal recession into the middle distance points to cattle grazing amidst telegraph wires and sparse settlement. A canal parallels the road. Winding down from the foreground to a wide river is a dirt road carrying a wagon. The sweep of the river defines the next stage of technological and social progress, the train crossing it by

44. The rock slide in Crawford Notch inspired varied retellings, from Theodore Dwight's *Sketches of Scenery and Manners in the United States* (1829; reprint, Delmar, N.Y.: Scholars' Facsimiles and Reprints, 1983), p. 68, to Thomas Starr King's dramatic version in *The White Hills*, pp. 185–229, as well as fictionalized versions such as Hawthorne's short story "The Ambitious Guest." Thomas Cole, "Sketch of my tour to the White Mountains with Mr Pratt" (1828, Detroit Institute of Arts, 39.559), published in the *Bulletin of the Detroit Institute of Arts* 66 (1990): 27–33, recorded the tremendous impact that the memory of the event had on him during his visit to Crawford Notch in 1828. Years later, in 1839, he painted his *Notch of the White Mountains* (National Gallery of Art), which indirectly recalls the rock slide. Charles Lyell commented on the slide in *A Second Visit to the United States of North America* (London: John Murray, 1849), 1:67. Robert L. McGrath, "The Real and the Ideal: Popular Images of the White Mountains," in Donald Keyes et al., *The White Mountains: Place and Perceptions* (Hanover, N.H.: University Art Galleries, 1980), lists numerous other artistic and written records of the event. See also Curtis Dahl, "The American School of Catastrophe," *American Quarterly* 11 (Fall 1959): 390, for a further discussion of the impact of the event. A late expression of interest is Melville's epic poem "Clarel," published in 1876, in a section titled "Nathan," where the slide serves as an image of impermanence.

45. The second part of the title was used for the engraving of the work. For more on this painting, see Kenneth Maddox, "Asher B. Durand's *Progress:* The Advance of Civilization and the Vanishing American," in Susan Danly and Leo Marx, eds., *The Railroad in American Art: Representations of Technological Change* (Cambridge: MIT Press, 1988), pp. 51–69.

aqueduct, signaled only by the plume of steam whose forms echo the clouds, mist, and smoke rising from a settlement in the distance, where steamboats cluster around a wharf on the water.

Progress encompasses the history of American transportation, from the primitive wagon to the locomotive. Narrative details, however, disappear amidst the broader contours of the landscape, drawing the spectator back toward a luminous horizon. The well of light at the virtual center of the painting sucks the eye in across space, establishing an instantaneous visual link in which the mire of the landscape, and by implication the narrative drag of historical process, is transcended. The fulfillment of Durand's nationalist program in *Progress* rests ultimately on the promise of the future. The journey through the landscape, spatially enacting the nationalist plot of progressive historical development, culminates in the transcendence of historical process implied in the imagery of the rising sun.

In Durand's studied inversion of Cole's *Course of Empire,* the stages of progress—defined by planes within the landscape—visually parallel the accumulating clauses of nationalist oratory. Despite Durand's role as arbiter of the new Ruskin-influenced naturalism of the 1850s, his *Progress* is firmly rooted in the plot-based constructions of space which characterized the mediated sequential mode of the first New York school. In place of Cole's cautionary cycle Durand substituted the sequential phases of the transportation revolution, defining a broader path of social progress and wilderness settlement. Cole's vision of history fueled by imperial pride is transformed into a technological millennium.

Progress is as much a formal and aesthetic reworking of Claudean devices as it is a thematic reworking of Cole. Unlike Claude's historical-biblical landscapes, suffused with a sense of belatedness, Durand's composition faces a light-filled future. Stable Claudean coulisses create the appearance of containment, as if gently to prompt the vision, and by extension the imagination, along a prescribed course. Space in Durand's canvas fulfills its temporal functions. The movement from shadowy foreground to sunlit distance implies a progression from "primitive" origins through a transitional present toward a future filled with light. Such an effort to encapsulate in a single image the sweep of national history gave rise to a readable spatial iconography that was, however, in subtle tension with the powerful pull of vision and imagination toward the horizon.[46]

46. For a related discussion of the spatial-temporal parallels in *Progress,* see Moore, "The Storm and the Harvest," pp. 207–9. Roger Stein, *Susquehanna: Images of the Settled Landscape* (Binghamton, N.Y.: Roberson Center for the Arts and Sciences, 1981), p. 40, observes that "spatial movement . . . as a language for movement in time, from the wild and savage to the beautiful," was a device common to the pictorial treatment of the Susquehanna in the nineteenth century. For a theoretical analysis of how space may be perceived in temporal terms, see Rudolph Arnheim, "Space as an Image of Time," in Karl

By the 1850s Durand was the recognized dean of New York landscape painters and a respected spokesman for their interests. Aspiring to the same programmatic scope as Cole, Durand answered Cole's *Course of Empire* in terms meaningful to his contemporaries. The shift from Colean high allegory to new forms of historical narrative embedded in naturalistic landscape paralleled a similar movement in literature away from derivative themes toward native concerns and local subject matter, enunciated by writers as diverse as Emerson, Cornelius Mathews, and Henry Tuckerman.[47] Steamboats, telegraph poles, cut tree stumps, and cleared fields are the actors in his drama. According to a contemporary review of the painting, "[*Progress*] is purely AMERICAN. It tells an American story out of American facts, portrayed with true American feeling, by a devoted and earnest student of Nature."[48] The language of the ideal or heroic landscape had to be brought back down to the realm of everyday associations, purged of its learned references, localized and updated. In accordance with this view, Cole was criticized for painting "a medley, destitute of individual, local character; such as might be expected from a man who spent his best years abroad." Cole's "early pictures gave promise of a strong nationality, destroyed in his later idealisms, but returning again in his last few years." Critics praised instead those works inspired by American scenery, for example, *The Oxbow* and *The Mountain Ford*.[49]

This shift to a new pictorial language was better suited to the nonpatrician, middle-class tastes of a growing public audience for landscape. Art such as Cole's, wrote one reviewer,

> is a species . . . which our people can never amply sympathize with, because it is an idle thing, aimless, and without root or permanence. The art which they will have, and in which, therefore, they will be benefited is that which arises from a genuine feeling for the things with which the people have sympathy. It hardly matters whether or no the materialism of the times is an error. So long as it is the spirit of the age, Art, to be in any way successful, must carry it out. Rhapsodies, dreams, and studio vagaries will not satisfy a public sentiment accustomed to find in all

Kroeber and William Walling, eds., *Images of Romanticism: Verbal and Visual Affinities* (New Haven: Yale University Press, 1978), pp. 1–12.

47. See, for instance, Ralph Waldo Emerson, "Art," in *Essays, Second Series* (Columbus, Ohio: Charles E. Merrill, 1969); Cornelius Mathews, "Americanism: An Address Delivered before the Eucleian Society of the New York University" (New York, 1845). This is also a theme of F. O. Matthiessen's *American Renaissance: Art and Expression in the Age of Emerson and Whitman* (New York: Oxford University Press, 1941).

48. "Exhibition of the National Academy of Design," *Knickerbocker Magazine* 42 (July 1853): 95.

49. "Development of Nationality in American Art," p. 139.

other things some substantial, positive truth, something which the mind, grasping, holds ever after.[50]

Durand's combination of native subject matter, elevated style, and optimistic national forecast echoed a certain sector of public opinion given to glowing forecasts of the nation's future. Such forecasts supported efforts to promote industry and development while naturalizing both their social processes and their results. The bombastic self-promotionalism of such interests led one commentator to complain: "We hear so much, in Presidents' messages, speeches in Congress, and Fourth of July orations, about our 'unexampled progress,' our 'wonderful prosperity,' and the 'success of our free institutions,' that these topics have become trite and tiresome, and are regarded as the peculiar property of professional patriots and orators of the stump."[51] The sentiment reveals the extent to which Durand, in painting *Progress*, identified himself with these "professional patriots."

The new, more comfortable relationship that midcentury artists enjoyed with their public, however, did not mean in every case that academic artists wished to narrow the distance between high art and popular forms of expression. Despite the fact that Durand's *Progress* shared its view of American history with "orators of the stump," it disguised the full impact of the new technological order within an elevated aesthetic rhetoric. Durand's painting was both accessible and studiously self-conscious. Naturalism authenticated the historical message couched in the landscape.

Durand painted *Progress* for Charles Gould, the broker and later treasurer of the Ohio and Mississippi Railroad.[52] Gould actively encouraged American art, not only through patronage and collecting but also through activities that conveniently promoted his own business interests. Although it is unclear what role Gould himself played in Durand's choice of theme, the artist clearly read his patron's mixed (and contradictory) involvements. *Progress* shrewdly reconciled Gould's

50. "The National Academy," *Putnam's* 5 (May 1855): 506. This point of view is far removed, however, from the culturally conservative view propounded in "The American School of Art," *American Whig Review*, o.s., 15 (n.s., 9) (August 1852): 138–48, which took a universalist (i.e., antinationalist) position that American art was part of a broader current that originated in Europe. The currency of the debate emerges in Henry Wadsworth Longfellow's polemical novel of 1849, *Kavanagh* (Boston: Houghton Mifflin, 1893), pp. 114–20.

51. "Art: Its Meaning and Method: Review of *Scenery and Philosophy in Europe*. Being Fragments from the Portfolio of Horace Binney Wallace," *North American Review* 169 (July 1855): 212.

52. According to Maddox, "Durand's *Progress*," p. 53, the correspondence between Gould and Durand in the New York Public Library suggests that Gould probably played no direct part in determining Durand's choice of theme.

Figure 32. John Frederick Kensett, *Rocky Landscape*, 1853. Oil on canvas; 48″ x 72½″.
Henry E. Huntington Library and Art Gallery, San Marino, California.

interests in the American wilderness as a subject for a native artistic tradition with
his professional activities in transportation. When it was exhibited at the National
Academy of Design in 1853, *Progress* was shown with a pendant, *Rocky Landscape*
(figure 32), painted by John Frederick Kensett and also commissioned by Gould in
1853. The pairing may have been intended to contrast the differing landscape styles
of two of the nation's leading painters, and perhaps to associate the contrasting
aesthetic modes of the picturesque and the beautiful with the transition from
wilderness to settled landscape.[53]

In 1858, five years after he commissioned *Progress*, Gould helped select the New

53. On this painting, see *The Illustrated News*, July 2, 1853, p. 16, which described it as "simply a wild
scene in nature, showing no traces of civilization—a bold mountain sketch." Quoted in Maddox,
"Durand's *Progress*," p. 53.

York artists who participated in the highly touted Artists' Excursion on the Baltimore and Ohio Railroad. As publicity the excursion was an effective idea, directly addressing American fears that with the advent of the railroad the wilderness would succumb to utilitarian pressures. Railroad entrepreneurs such as Gould were quick to reassure the public that the new transportation technology would bring more Americans into elevating contact with nature. Increasingly by the middle of the century railroads were facilitating painters' access to their wilderness workshop, even as they brought growing numbers of tourists with them.[54] Here, as on other occasions, American artists wedded their talents to the cause of commerce and technology.

Gould's commission confirmed Durand's allegiance to his commercial patrons, the men who indirectly empowered landscape art with a nationalistic doctrine of progress. The commission also acknowledged Durand's artistic and institutional ascendancy within the small but nationally influential world of New York arts and letters. The stature of the landscape genre in the 1850s depended to no small extent on its adaptation to the ideological requirements of patrons who were sponsoring a program of economic and technological expansion. The proclaimed function of this economic program—to unify space through new transportation technology—resembled in no small measure the ideological program of the sequential landscape as developed by the National Academy artists. At a time when the contradictions embedded in the nation's progressive republican nationalism were increasingly apparent, *Progress* epitomized the main strategies of a landscape of accommodation.

Durand deliberately minimized the destructive and invasive aspects of the train.[55] Likewise the conflict of Indian and white cultures is neutralized through the spatial displacement of the Indian to a position safely removed from the landscape of development.[56] *Progress* subtly deflated the high romantic conception of nature with a posture characteristic of midcentury landscape art. While New York artists continued to pay lip service to the belief in nature as the origin of cultural values, their nature was frequently tamed, its roughness smoothed, its mountains lowered. Increasingly, in their work it acted as the measure of human achievement, serving

54. On the Artists' Excursion and other details of Gould's activities as a patron, see Kenneth Maddox, "The Railroad in the Eastern Landscape, 1850–1900," in Susan Danly Walthers, ed., *The Railroad in the American Landscape, 1850–1950* (Wellesley, Mass.: Wellesley College Art Museum, 1981), pp. 17–36.

55. John Kasson, *Civilizing the Machine: Technology and Republican Values in America, 1776–1900* (New York: Penguin, 1977), discusses how Americans reconciled republican values with technology.

56. Stein, *Susquehanna*, pp. 48, 50, 56, points out how Claudean devices resolved the dynamic political and historical tensions within the ideology of an expanding nation.

moral, national, and social ends and suppressing the cruder results of the American quest for mastery over the land.[57]

Engraved and published in 1853 and 1855, *Progress* proved influential on later landscapists.[58] The narrative structure of Durand's landscape was echoed in an equally ambitious painting of 1860, Jasper Cropsey's *Autumn—On the Hudson River* (figure 33). Like *Progress,* it proceeds from a roughly picturesque wilderness foreground to a more settled and undulant middle ground to a light-filled distance harboring towns and riverside ports. *Autumn—on the Hudson,* according to the *Illustrated London News,* "possesses a grand wildness, mixed with indications of advancing civilization and industry." As another newspaper observed, it combined "complete life and thorough repose" in a characteristic sleight of hand that permitted Americans to indulge both their faith in material progress and their longing for stasis.[59]

Durand and his audience were conditioned by the utopian promise of technological change, abetted by nationalist rhetoric and popular images, to view technology, working in tandem with natural features, as the agent that would draw together the republic. They made the entire program of expansion possible by integrating the local landscape into a vast web of space.[60] Such icons of progress

57. See Angela Miller, "Nature's Transformations: The Meaning of the Picnic Theme in Nineteenth-Century American Art," *Winterthur Portfolio* 24 (Autumn 1989): 113–38.

58. Maddox, "Durand's *Progress,*" p. 61, claims *Progress* as perhaps the first major American painting to illustrate the clash of cultures in the settlement of the continent, noting that the theme of the advance of civilization had been popular since the 1840s. Durand's theme, however, was anticipated by DeWitt Clinton Boutelle's *Indian Hunter* of 1846 (Chrysler Museum, Norfolk), which contains many of the same elements while focusing on the plight of the Indians dispossessed of their lands. Boutelle's painting, which predates Durand's by seven years, was exhibited at the National Academy of Design (no. 285), and conceivably influenced Durand's formulation. What makes this possibility even more intriguing is what Durand did with Boutelle's painting, turning a wistful meditation on the fate of the Indian before the tide of white migration into a celebration. On this painting, see Patricia Anderson, *The Course of Empire: The Erie Canal and the New York Landscape, 1825–1875* (Rochester: Memorial Art Gallery, University of Rochester, 1984), pp. 46–48.

The engraving of *Progress* gave rise to numerous reworkings of the theme, among them Andrew Melrose's virtual copy, *The March of American Civilization,* and a work attributed to Thomas Chambers, reproduced in *Antiques Magazine* 93 (April 1968). Other examples are Boutelle's *Indian Surveying a Landscape* (1855), Samuel Seymour's *Indians, Salmon Falls* (n.d.), and O. Rodier's *View of Ottowa, Illinois, from Starved Rock* (1876). In several instances the formula is employed to sentimentalize the plight of the Indian rather than to celebrate frontier progress.

59. *Illustrated London News,* June 16, 1860; *Spectator,* May 20, 1860, in Archives of American Art, Reel 336. Franklin Kelly, *Frederic Edwin Church and the National Landscape* (Washington, D.C.: Smithsonian Institution Press, 1988), discusses this painting (pp. 128–29).

60. See John Durand, *The Life and Times of Asher B. Durand* (1894; reprint, New York: Da Capo

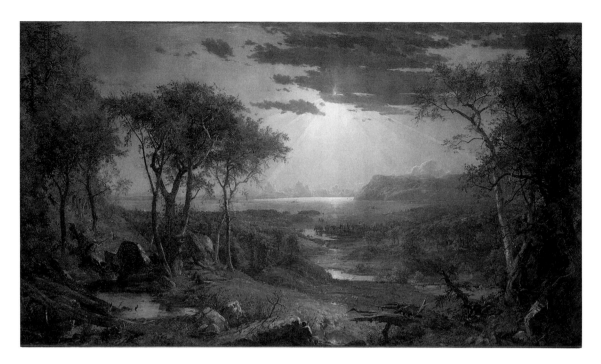

Figure 33. Jasper Francis Cropsey, *Autumn—On the Hudson River,* 1860. Oil on canvas; 60″ x 108″. National Gallery of Art, Washington, D.C. Gift of the Avalon Foundation.

symbolized America's triumph over physical limitations. American technology—a gift from Providence—would overcome the formidable geographic barrier that threatened to weaken "the sense of oneness, the preservation of national feeling, and of true social and political union."[61] Perry Miller has noted a double impulse in American science toward belief in "a static order and within it growth and

Press, 1970), p. 175. Related to the iconography of empire in *Progress* is the frontispiece to George Harvey's *Scenes of the Primitive Forest of America, at the Four Seasons of the Year, Spring, Summer, Autumn, and Winter,* originally intended as the first part of an eight-part series to be titled *Superb Royal Folio Work of American Scenery.* The composite scene moves from the axe-wielding men hewing timber to the distant landscape of ships, steamboats, and trains situated before a view of the United States Capitol, clearly recapitulating the stages-of-empire theme. The scene represented, in Harvey's words, "an epitome of the historic progression of the United States." On Harvey's series, see Walter Karp, "The American Land as It Was," *American Heritage* 21 (December 1969): 16; Gloria Gilda Deak, *Picturing America, 1497–1899,* 2 vols. (Princeton: Princeton University Press, 1988), 1:315–16.

61. "California," *American Whig Review* 9 (April 1849): 332. See also "The Destiny of Our Country," *American Whig Review,* o.s., 5 (March 1847): 234–35, and "The Mississippi River," *Putnam's Magazine,* n.s., 1 (May 1868): 600, which also identifies "cheap and rapid communication" as an element of successful union.

change."[62] By suggesting that technological development paralleled the social evolution from wild to pastoral and urban, Durand's painting contained historical change within structured and stable boundaries.

Such assertions, however, tell us little about the popular response to the transportation revolution. Americans, as Leo Marx has long since demonstrated, were highly ambivalent about technology. The celebration of the train as an agent of nationalism was only one point along a spectrum extending to Thoreau's far more ambiguous image of a fire-breathing, earthbound monster. If nationalists insisted that trains unified communities, the new technology also imposed on small rural communities a regimented schedule determined by metropolitan timetables which interrupted their sense of organic time adjusted to the natural rhythms of work and community life. Thoreau wrote in acknowledgment of this fact: "We have constructed a fate, an *Atropos,* that never turns aside. . . . Men are advertised that at a certain hour and a minute these bolts will be shot toward particular points of the compass."[63] Trains likewise fragmented the visual space and perceptual and experiential continuity enjoyed by farsighted pedestrian travelers. Gazing toward the profile of a familiar mountain, Thoreau described the cheering effect of looking across space and of being reminded of the "invisible towns and communities, for the most part also unremembered, which lie in the further and deeper hollows" between himself and the hills, "towns of sturdy uplandish fame, where some of the morning and primal vigor still lingers, I trust . . . it is cheering to think that it is with such communities that we survive or perish."[64] It was precisely such communities whose "sturdy" localism was being undermined by the newer translocal linkages established by the railroad which reordered space in radically new ways. By endangering the rural order, the train was an unwitting cause of its sentimentalization. Yet Americans could afford to be sentimental about their rural origins from the vantage point of the urban prosperity which railroads helped to bring into being. They adjusted to its iron laws.

The ability of the imagination to travel across and inhabit space, and the imaginative dialogue between the distant or remote and the intimate, were changed by the appearance of the train. Travel on iron tracks brought the far near, condensing certain distances and expanding others, creating new spatial relations determined by impersonal factors in which the journey came to seem of far less

62. Perry Miller, *The Life of the Mind in America from the Revolution to the Civil War* (New York: Harcourt, Brace and World, 1965), p. 317.

63. Henry David Thoreau, "Sounds," in *Walden* (New York: Random House, 1981), p. 107.

64. Entry of August 2, 1852, in *The Journal of Henry Thoreau*, ed. Bradford Torrey and Francis H. Allen, 14 vols. (Boston: Houghton Mifflin, 1949), 4:273–74.

importance than the destination. On foot the landscape was something to be experienced part by part. Travel was a dialectic between destination and process, the events of the journey actively transforming the meaning of the end point. In a train the social microcosm of the interior assumed far greater significance than the external landscape, which became scenic backdrop rather than primary environment, a displaced dimension of experience. Bayard Taylor described the course of the Erie Railroad as "a rapidly unrolling panorama. . . . We sped along . . . in a warm and richly furnished chamber, lounging on soft seats, half arm-chair and half couch, apparently as disconnected from the landscape as a loose leaf blown over it by the winds. In that pleasant climate of our own we heard the keen air whistle without, and the light patter of the snow against the windows, with a sense of comfort rendered doubly palpable by the contrast."[65] With the advent of the train, travel became "not an experience so much as a suspension of experience."[66]

Progress includes epitomes of both the pedestrian and the technologically mediated landscape. The scenery of the steamboat and the train on the right is defined by a series of diagonally receding land formations occupying the middle ground and distance, and bathed in light. This is balanced by the wilderness on the left side of the painting, which takes up most of the foreground with a richly picturesque topography of cascading water and storm-blasted trees. The wilderness landscape is as visually involving as the landscape on the right is formulaic and generalized. On this side the terrain presents difficulties—rifts and clifflike drops into space, steep and densely forested mountainsides, and rocky obstacles. The wilderness is also living nature, in contrast to a nature rendered into abstractly schematic flattened forms. The arbitrary spatial condensation of *Progress,* in which elements of a nationally extended landscape are juxtaposed in quasi-emblematic fashion, reconstitutes in visual terms the experience of the landscape from the train window, in which abstract relations supplant physical involvement. This landscape, occupying

65. Bayard Taylor, "The Erie Railroad," in *Home Book of the Picturesque,* pp. 147, 149.

66. Howard Gossage, "Understanding Marshall McLuhan," *Ramparts Magazine* 4 (April 1966), as quoted in Roland Van Zandt, *Chronicles of the Hudson: Three Centuries of Travelers' Accounts* (New Brunswick, N.J.: Rutgers University Press, 1971), p. 272. Van Zandt also reproduces Jacques Offenbach's 1876 account (p. 286), as well as Washington Irving's remark that "before steamboats and railroads had annihilated time and space," a voyage to Albany "was equal to a voyage to Europe at present, and took almost as much time. We enjoyed the beauties of the river in those days; the features of nature were not all jumbled together, nor the towns and villages huddled one into the other by railroad speed as they are now" (p. 272). Also relevant are Wolfgang Schivelbusch, *The Railway Journey: Trains and Travel in the Nineteenth Century* (New York: Urizen, 1979), and Robert H. Wiebe, *The Opening of American Society from the Adoption of the Constitution to the Eve of Disunion* (New York: Knopf, 1984), pp. 260–61, on the limits of mechanized time and travel.

the middle and far distance, is remote and stylized, a sophisticated version of the popular prints of Currier and Ives and of currency bills, with their stock assemblages of motifs symbolizing the commercial, agricultural, and technological constituents of national wealth.[67] With its inventory of technological advances, landscape here serves as national symbol rather than as apprehended reality.

This observation points toward what is perhaps the most curious feature of the painting, the position of the spectator vis-à-vis the bifurcated landscape. The structure of *Progress* encourages identification not with the subject but with the object of the transforming program of nationalism—the Indians themselves. Sheltered within the cleft landscape, they gaze out upon the scene in the spectatorial role of the viewer gazing upon Durand's painting. In this moment of identification both viewer and Indians find themselves distanced from the landscape of technological progress, which achieves an identity separate from the spectators within and without, who witness the scene as spectacle. The landscape that is most emotionally and visually compelling proves to be that which is also defined as historically marginal within the painting's symbolic program. The observer status of the viewer, which the awed Indians act out, betokens a sense of alienation from the actual historical processes that transform nature into a kind of pasteboard stage scenery in contrast to the varied and convincing topography of the foreground. Here the proprietary force of the spectator's gaze—the urbane northeastern audience implicated in Durand's construction—is displaced by the absorbed wonderment of the Indians.

This covert identification with the observer figure undermines Durand's program by placing emotional allegiances at odds with nationalistic symbols. *Progress* constitutes national identity through difference with the native Indian population, whose presence in the landscape marks the point of origin beyond which the landscape of progress has advanced. The program implied in the painting's title furthermore asks the viewer to identify with technology as a key historical actor or plot element animating the landscape. Yet this programmatic requirement is belied by the visually and emotionally charged triangle of landscape in the left foreground, a wilderness refuge from which the relatively barren prospect of advancing industry and technology appears all the less inviting. Durand's wilderness here is nurturing and maternal, appealing to the atavistic desire to see without being

67. Maddox, "Durand's *Progress*," suggests that Durand's work as an engraver between 1824 and 1834 may have allowed him to experiment with the pictorial ideas that led eventually to *Progress*. Durand's pen-and-ink designs for bank notes are now in the New York Public Library. The figure of the Indian was an important element of bank-note iconography, serving as both national emblem, *genius loci*, and contrast to the agrarian life of white settlers. See D. C. Wismer, *New York Descriptive List of Obsolete Paper Money* (Federalsburg, Md.: J. W. Stowell Printing Company, 1931).

seen.[68] It is associated with the "childlike" Indian and with the regressively nostalgic phases of the adult imagination—phases which must be overcome on the way to full maturity. This maturity is symbolized in the distanced, alienated encounter with the landscape of national forecast. *Progress* epitomizes the powerful undertow of nostalgia running beneath the progressive current of national life in these years.

68. For an application of these terms to landscape painting, see Jay Appleton, *The Experience of Landscape* (London: John Wiley and Sons, 1975), esp. pp. 68–74.

5 / Nationalism as Place and Process
Frederic Church's *New England Scenery*

*In copying nature, we have attained a nationality by
the reproduction of scenes appertaining to our climate,
and of beauties familiar to every eye. . . . From
admiration of locality, the mind of every reflective
being passes to appreciation of nationality, and from
the enthusiasm of nationality, is but a step to the
grandeur of universality.*
> —*Cosmopolitan Art Journal*, June 1857

*My brother is determined that you shall paint a picture
for him of this village. . . . We have settled that the
subject is without doubt the finest in creation, to say
nothing of the additional interest of its being our native
place.*
> —Patron of Asher B. Durand

Although Frederic Church was Cole's student, he came of age in the 1850s and identified with the mission of his generation: to give to nationalism an organic basis, to root it in the geography of the continent. Like other contemporaries Church was concerned with defining a representative national landscape. Yet the possibilities for imaging nationalism at midcentury were multifold, for it was both a synthetic abstraction and a form of localism writ large. It was alternatively something to be progressively realized through time—embattled though ultimately triumphant—and a reified value to be preserved, reliclike, against the competing claims of politics and history. Construed as the child of history, nationalism implied a temporal realization; as a treasured icon of past struggle, however, it was best realized in static images that resisted narrative ambiguities.

As a student of Cole's, Church would have grasped on some level these interpretive dilemmas created by competing definitions of national identity. This much he had learned from the older man. Yet reaching artistic maturity in the 1850s, he would also have grasped the beleaguered status of nationalism, the power of rhetorical affirmation, and the role of the artist in fostering unity of sentiment. The tension between nationalism as a process evolving through time and nationalism as a thing already realized, to be preserved from the assaults of history, left its trace in Church's art. Furthermore, alternate versions of nationalism dictated very different and competing pictorial strategies.

In *New England Scenery* (1851, plate 6), Church took for his model his own region, attempting to transmute the local into the national. For the regional landscape to realize its national meaning it had to be interpreted synecdochically, as a physical part representing a larger symbolic whole. But this whole would be intimated in the parts. As an effort to capture the essential features of a geographical and cultural region that served as a prototype for the nation, *New England Scenery* condenses several landscape modes, moving from the picturesquely rugged foreground and rocky landscape on the left to the pastoral, sloping meadows and village in the distance, hinting at the sublime in the background mountains. It includes a variety of representative topography—wooded, lake, mountainous, and, in an earlier study, marine—within a single frame.[1]

In 1850 Church completed an oil study for *New England Scenery* (figure 34) which differs from the final version at several key points. The study, a more compressed, crowded composition painted in a richer chiaroscuro with more dramatic cloud effects, reveals in one particular detail Church's ambition to create a truly synthetic and inclusive image. Visible in the gap between the distant mountains is the horizon of the ocean. In painting the final version, Church must have realized that this passage of marine landscape, perhaps included in a bid to compete with Cole's *Course of Empire,* a compendium of landscape types, would tax credibility by placing the entire middle and foreground of the painting below sea level. In any case he eliminated it from the final version.

Church's effort of synthesis was rewarded when in 1851 the American Art-Union chose the work as one of six to be engraved for distribution among its members. Explaining their choices, the *Bulletin of the American Art-Union* stressed that all were "national in their character."[2] Yet the declaration—and Church's efforts to synthesize a whole out of parts—must have seemed curiously hollow, as readers confronted the increasing political, social, and economic divisions that ran through the unitary concept of nationhood at the time.

In the first half of the nineteenth century, however, there existed a body of theory that supported Church's pictorial argument for the workable association between the particular and the general, the local and the national. In seeking to visualize the

1. David Huntington, *The Landscapes of Frederic Edwin Church: Vision of an American Era* (New York: Braziller, 1966), p. 35, points out that *New England Scenery* contains a number of discrete vignettes loosely inspired by scenery in western New York, Maine, and the Green and White mountains. To this list I would add the Catskills, an obvious source for Church as a student of Cole's. For further analysis of this painting, see Franklin Kelly, *Frederic Edwin Church and the National Landscape* (Washington, D.C.: Smithsonian Institution Press, 1988), pp. 53–58.

2. The choices are discussed in Chapter 4.

Figure 34. Frederic Edwin Church, oil study for *New England Scenery,* 1850. Oil on canvas; 12″ x 15″. The Lyman Allyn Art Museum, New London, Connecticut.

relationship of part to whole, Americans found assistance in landscapes that could be read as types of the national through a simple extension of the local. There is much in Church's painting to suggest this kind of locally inflected nationalism. This reliance on symbolization in prompting his audiences to connect very different levels of experience—the local and the national—resembles educational methods being promulgated in his hometown of Hartford during his childhood.

When Church first attended school in the early 1830s, educational reform centered on the application of Scottish common sense principles, according to which learning proceeded from the specific to the general, from concrete sensory data to

more abstract or universal principles. Scottish common sense assumptions were the very lingua franca of the educated classes in America before the Civil War.[3] Such theories were fully domesticated in both the religious and the academic-intellectual environments of the New England elite. A prominent manifestation of these educational reforms was the infant school movement, which put into pedagogical practice common sense ideas about learning. Inspired by the theories of the British reformer Samuel Wilderspin, the movement, from its beginnings in 1826 through 1837, found a sympathetic audience among conservative New Englanders such as Theodore Dwight.[4] In the early national period educational reforms called for a gradual movement in focus from the concrete local landscape to the more remote, abstract concept of the nation, and from the visible environment to its invisible extension beyond the child's immediate sensory reach. Any idea of nationalism, according to common sense precepts, was thus a form of localism writ large. Relying on a mechanistic model of the mind, the common sense version of nationalism was as the extension of a specific landscape that the individual knew and experienced.

According to his biographer Charles Dudley Warner, Church attended an infant school.[5] He may also have received such ideas through directly visual means in the popular geographies of S. W. Goodrich, whose *First Book of History for Children and Youth* (1831) and similar works were widely used in New England schools during the second quarter of the nineteenth century. In a new visual pedagogy illustrated textbooks employed images as the primary mode of access to more abstract ideas, and therefore as an effective tool of instruction. Goodrich's *Child's Book of American Geography* (1831) began with the child's immediate environment as a foundation for learning about more distant locales. These pedagogical devices were consistent with the common sense belief in the ladder of thought as a movement from the concrete to the more abstract. W. C. Woodbridge, a theorist of the infant school movement, explained that the function of association was "to compel the

3. See William Charvat, *The Origins of American Critical Thought* (1936; reprint, New York: Russell and Russell, 1966); D. H. Meyer, *The Instructed Conscience: The Shaping of the American National Ethic* (Philadelphia: University of Pennsylvania Press, 1972); Wilson Smith, *Professors and Public Ethics: Studies of Northern Moral Philosophers before the Civil War* (Ithaca: Cornell University Press, 1956).

4. See Theodore Dwight, Jr., *Sketches of Scenery and Manners in the United States* (1829; reprint, Delmar, N.Y.: Scholars' Facsimiles and Reprints, 1983), introduction by John F. Sears, pp. 3–14, for a brief analysis of the movement and its impact on how Dwight responded to and wrote about the scenery of New England.

5. Warner's unfinished biography of Church is reprinted in Franklin Kelly, *Frederic Edwin Church* (Washington, D.C.: National Gallery of Art, 1989), pp. 174–99. The reference appears on p. 177. See also p. 179 on Church's early education.

pupil as far as possible to attach each characteristic of a nation to the spot on which they [*sic*] reside." Toward this end, Woodbridge explained, "I have been led to resort to the use of emblems."[6] Nationalism was a sentiment instilled in the young mind through analogy with attachment to the local environment, and pictorial emblems, or "types," served to connect the two levels of knowledge and experience.

Theodore Dwight's train of thought on gazing at the White Mountains in New Hampshire illustrates the conditioned movement from part to whole, visible to invisible, which guided the cultivated New England sensibility in the early nineteenth century. As Dwight explained the process, "Objects are to be scrutinized in detail; and as each mountain can be referred to its appropriate place, while the memory of this sight is preserved, and each be regarded according to its comparative importance in the general scale, what is seen will be constantly reminding us of what is unseen, which must necessarily be the greater part of the whole."[7] In the words of John Sears, Dwight's *Sketches of Scenery* was "a fascinating attempt to project the values of a culture into a landscape, and thereby make the landscape into a school of citizenship."[8] The same claim could be made for *New England Scenery*, which prompted its audience to move ladderlike from the known scenery of place to the national landscape. It offered a model of how to project the local as a type of the national.

Buttressed by such theories, *New England Scenery* proposed a solution to a key problem confronting midcentury landscape painters: how to use the local landscape as a vehicle of nationalist sentiment. Yet these common sense theories of knowledge left unresolved the persistent problem of how to assimilate narrative, with its historical and temporal dimension, into the static representation of the landscape.[9]

Asher B. Durand's *Progress* had furnished another resolution to the competing programmatic demands of nationalist landscape. In it he had given up both

6. Quoted in intro. to Dwight, *Sketches of Scenery and Manners,* p. 7.

7. Ibid., p. 60.

8. Ibid., p. 14.

9. Church's *New England Scenery* influenced a number of other paintings in the 1850s. Cropsey's *View near Sherburne, Chenango County, New York* (1853, Thyssen-Bornemisza Collection), an imaginary composite landscape, is an especially interesting example of Church's influence. An American flag on a boat plays a role similar to that of the Conestoga wagon in *New England Scenery,* reaffirming, according to Kenneth W. Maddox in Barbara Novak et al., *The Thyssen-Bornemisza Collection: Nineteenth-Century American Painting* (New York: Vendome Press, 1986), p. 76, Cropsey's "intense patriotism within the conventions of the pastoral landscape." On the influence of *New England Scenery,* see Franklin Kelly and Gerald Carr, *The Early Landscapes of Frederic Edwin Church, 1845–1854* (Fort Worth: Amon Carter Museum, 1987), pp. 118–19.

allusions to specific place and, despite its naturalism, any concern with topographical accuracy. Nationalism appears here as a process driven by technology, and fully naturalized in the landscape. Yet, as we have seen, Durand's resolution contains its own internal tensions between the dynamic unfolding of history and the static present of a mythic Arcadia. Such were the ideological dilemmas of the 1850s that pictorial solutions claiming any degree of ambition acted them out in their very structure. The assertion of programmatic unity is consistently countered by the incomplete and uneasy ordering of compositional parts.

Church's *New England Scenery* was completed two years before Durand's *Progress.* He substituted the local and specific for the general; the narrative organization so evident in *Progress* here competes with the iconic power of place. Yet both paintings suggest, in their different ways, the dilemmas of representation faced by the painters of the national landscape. Historic agency in *New England Scenery,* in the form of a westward-moving Conestoga wagon, is overwhelmed by the sheer immobility of place. Instead of a dynamically evolving nationalism, the painting presents only its scenic context.

In its own terms *New England Scenery* rivaled and reformulated the comprehensive scope of Cole's *Course of Empire:* both series and painting combined a variety of landscape types and modes. *New England Scenery,* however, like the paintings explored in Chapter 4, transformed the allegory of the earlier series, updating and localizing the second landscape, *The Pastoral State,* and by implication arresting the cycles of history with an iconic image of arcadian equilibrium.[10]

In selecting New England themes and history for so many of his early paintings, Church was answering a call for "representative" subjects, involving a region that combined national and familial identity.[11] The deep imprint that Cole's moral and didactic art had left on Church, along with the younger man's sense of New England's critical role in national culture, all influenced the early drift of Church's art toward subjects that tapped the region's national significance.[12] Through dis-

10. Kelly, *Church and the National Landscape,* pp. 57–58; Huntington, *Landscapes of Church,* p. 36, hints at something similar.

11. An example of this personal meaning is his *West Rock, New Haven* (1849); see Christopher Wilson, "The Landscape of Democracy: Frederic Church's *West Rock, New Haven, American Art Journal* 18 (1986): 20–39. While a student of Cole's he also painted Catskill scenes; yet this region of New York was still powerfully linked to his teacher. See Kelly and Carr, *Early Landscapes of Church,* pp. 84–85.

12. A useful summary of these New England themes is found in Franklin Kelly, "Visions of New England," in Kelly and Carr, *Early Landscapes of Church,* pp. 53–76; David Huntington, "Church and Luminism: Light for America's Elect," in *American Light: The Luminist Movement, 1850–1875* (Wash-

tillation and synthesis Church was able to extend the limits of topographic painting to achieve representativeness on his own terms. In the 1850s composite representations began to appear alongside topographically specific, recognizable portraits of place such as his *View near Stockbridge, Massachusetts* (1847, figure 35). Such practice was in keeping with the tradition of the grand composed landscape, sanctioned by academic theory in Joshua Reynolds's *Discourses,* which called for the selection and recombination of natural particulars in the creation of an ideal artistic order. Church absorbed this approach to landscape through Cole, whose academic bias was reinforced by his own organic theory of the role imagination and memory played in transfiguring topographical data.

Added to this, however, were the ideas of the influential German geographer and scientist Alexander von Humboldt, in particular the concept of typical nature. Coupled with the new emphasis on precisely rendered atmospheric and other natural phenomena, influences of this sort gave a strong naturalistic foundation to Church's broad symbolic program.[13] For Church's generation, landscape subjects acquired universal meaning through their typicality—the fusion of the scientific, the aesthetic, and the social into a single whole rooted in the physical geography of the continent. By grounding cultural development in the conditions of environment, Humboldt endowed factors such as climate with new scientific authority as determinants of culture. His theories of isothermal zones may have offered Church an alternative to economically and historically based explanations of sectional divisions. By focusing on the natural rather than the social, Humboldt redirected the content of landscape images away from their political subtext and back toward a more innocent, scientifically informed embrace of nature as the unitary framework within which the United States—both North and South—developed. Humboldt's concept of the typical, with its belief in the structural unity underlying the diversity of natural phenomena, also gave a scientific rationale to Church's typology—his vision of New World nature and history as an antitype or latter-day figuration of the biblical narrative.[14] The physical pattern within nature harmonized variety with

ington, D.C.: National Gallery of Art, 1980), p. 159, has discerned a program of typological meaning unifying Church's Old Testament with his New World subjects—including *Hooker and Company Journeying through the Wilderness from Plymouth to Hartford, in 1636* (1846), *The Charter Oak* (1846), and *West Rock, New Haven* (1849)—whose historical significance locates them within a larger providential pattern of meaning.

13. On Humboldt's influence, see Huntington, *Landscapes of Church,* pp. 41–42; Kelly, *Church and the National Landscape,* pp. 54–55, 74–75; Kelly and Carr, *Early Landscapes of Church,* pp. 65, 75.

14. A large measure of Humboldt's appeal in the 1850s was that, as one writer put it, *Cosmos* furnished an "argument for the unity of nature" which he called upon artists to match. "Literary Notices," *New-York Home Journal,* July 12, 1851, n.p. Emerson called him "a universal man," proclaim-

Figure 35. Frederic Edwin Church, *View near Stockbridge, Massachusetts,* 1847. Oil on canvas; 27¼" x 40". Private collection.

underlying order. The typical and the typological—science and religion—reinforced each other within this pre-Darwinian universe. Church's Humboldtian faith in the ability of the landscape painter to subordinate the detail of natural observation to a unifying vision was another instance of how the discourse of nationalism was translated into the terms of art and nature. Church's effort to place New England materials in the service of nationalism, however—to imbue the place-specific landscape with the force of the typical—brought with it a host of unresolved problems.

Born and raised in Hartford, Church came from a wealthy family with deep roots in New England history. Charles Dudley Warner, also a native of Connecticut and a

ing his faculties "all united, one electric chain, so that a university, a whole French Academy, travelled in his shoes." Ralph Waldo Emerson, "Humboldt," in *Miscellanies* (1878; Boston: Houghton Mifflin, 1904), p. 457.

Figure 36. Frederic Edwin Church, *Hooker and Company Journeying through the Wilderness from Plymouth to Hartford, in 1636*, 1846. Oil on canvas; 40¼″ x 60³⁄₁₆″. Wadsworth Atheneum, Hartford. Photo: Joseph Szaszfai.

friend of the artist, described him in an unfinished biography as "a nineteenth century type of the old Puritan." Jervis McEntee satirized Church's restrained manner by expressing surprise that Church and his wife attended the theater: "I thought they only went to prayer meetings."[15] In works such as *Hooker and Company Journeying through the Wilderness from Plymouth to Hartford, in 1636* (1846, figure 36) Church was doing more than illustrating New England history.[16]

15. Warner, in Kelly, *Frederic Edwin Church,* p. 197; Garnett McCoy, "Jervis McEntee's Diary," *Archives of American Art Journal* 8 (July–October 1968): 18.

16. In "The Importance of Illustrating New England History by a Series of Romances like the Waverly Novels" (1833), in Daniel Walker Howe, *The American Whigs: An Anthology* (New York: Wiley, 1973), p. 160, Rufus Choate called for "a vast, comprehensive, and vivid panorama of our old New-England lifetimes, from its sublimest moments to its minutest manners."

He was exploring the significance of Hooker's seventeenth-century journey into the wilderness for his own generation's westward migration. Five years later, in 1851, *New England Scenery* explored the national significance of the New England landscape itself. Despite its title, the painting takes all of America as its subject, boldly projecting from the specifics of place to a larger historical identity.[17] The westward-moving Conestoga wagon in the foreground of his painting evoked the literal fulfillment in the present of the original Puritan migration which had given rise to a new epoch in history. But like nearly everything else in the painting, its narrative power remains secondary to its role as an element of scene.

Another work of 1851, *Beacon, off Mount Desert Island* (figure 37), turned from New England's providential history and present to its prophetic role in the life of the republic.[18] Exhibited at the American Art-Union the same year as his *New England Scenery, Beacon, off Mount Desert* fuses the naturalist vision of Church's mature style—evident in the vividly observed sunrise as well as in the panoramic organization of the composition—with his early tendency to see landscape in typological terms. His image evokes the post-Puritan rhetoric of New World redemption, spelled out explicitly in an 1839 tribute to the region's exalted role in the destiny of the nation: "[These were] the means, and these the men, through which not New Plymouth only was to be planted, not New England only to be founded, not our whole Country only to be formed and moulded, but the whole Hemisphere to be shaped and the whole world shaken . . . it was the bright and shining wake they left upon the waves, *it was the clear and brilliant beacon they lighted upon the shores,* that caused them to have any followers."[19]

Evident in these varied New England subjects is a form of regional imperialism which claimed for itself a privileged role in the genesis and makeup of national identity.[20] In *New England Scenery* in particular this message of regional apologetics countered its communal appeal. To understand the painting's underlying disunities, we must analyze the contradictions in the image of New England itself for Church and his generation.

17. Huntington, *Landscapes of Church*, pp. 35, 61, relates *Hooker and Company* thematically to *New England Scenery.*

18. This painting is noted in "Affairs of the Association," *Bulletin of the American Art-Union* 4 (December 1851): 153; see also Kelly, "Visions of New England," pp. 60–64, 115–17, and Kelly, *Frederic Church and the National Landscape,* pp. 38–42.

19. Robert C. Winthrop, "Address" (1839), in Cephas Brainerd, ed., *New England Society Orations,* 2 vols. (New York: Century Society, 1901), 1:227–28; emphasis added.

20. Although Church came to New York to paint, he remained, according to Warner, "none the less a New Englander; the fact that he lived elsewhere did not affect his native sympathies . . . all through his life he took a keen interest in the affairs of his native State." In Kelly, *Frederic Edwin Church,* p. 190.

Figure 37. Frederic Edwin Church, *Beacon, off Mount Desert Island*, 1851. Oil on canvas; 31″ x 46″. Private collection.

Much of the New England myth rests on a powerful and persistent image of place: a rural haven of pristine villages; a richly communal society made intimate by the hardships of weather; a tidy landscape of well-tilled fields and orchards, quaint wooden churches and covered bridges, where extended families gather beneath one roof for seasonal celebrations. This popular calendar image of New England has not changed substantially from the idealizations of Currier and Ives. The economic deterioration of New England in the twentieth century and the demographic revolution it has witnessed with the arrival of French Canadian, Irish, Italian and other immigrants have done little to blunt its vigor as a symbol of traditional American life—agrarian, pious, and virtuous.

New England, however, has long denoted not only a place but also a historic legacy of beliefs and attitudes associated with the region's role as the birthplace of the republic. Although the origins of a privileged New England consciousness

predate the Revolutionary War, both the image of New England and its historic definition developed most fully during the antebellum decades, when New Englanders, threatened by developments both within and without, set about promoting their own region as the source of the nation's sustaining values, a seedbed of enormous literary, intellectual, and historical importance.[21] For Harriet Beecher Stowe the history of the New England colonies foreshadowed "the glorious future of the United States of America . . . commissioned to bear the light of liberty and religion through all the earth and to bring in the great millennial day."[22] Her husband, the Reverend Calvin Stowe, concisely expressed the substance of the region's claims: "From the family and the school, from the church and the state, as they existed in New England, originated most of that which is really valuable in the social and political condition of the United States." Stowe also sounded the critical corollary that New England furnished the best model for national culture as it migrated westward: "We should be very glad to see, rising in our beautiful West, such villages as rose in the place of the forests of our fatherland, with their white steeples, their school-houses, their clean, comfortable farm-houses, reposing under the shade of fatherly old trees, and inhabited by men and women as industrious, moral, thrifty, and God-fearing as the pilgrims."[23]

Apologists for the region located the fullest realization of its historic values and cultural institutions in the future of the expanding West, where they would be implanted by Yankee farmers. While fellow northerners from George Templeton Strong to Rebecca Harding Davis, James Russell Lowell, and Nathaniel Hawthorne satirized the excesses of New England's nineteenth-century moral and spiritual reformers, their movements flourished on the conviction that the region was in

21. On the persistence of the New England myth as a central element in the definition of American cultural identity, see George Wilson Pierson, "The Obstinate Concept of New England: A Study in Denudation," *New England Quarterly* 28 (1955): 3–17; Laurence Veysey, "Myth and Reality in Approaching American Regionalism," *American Quarterly* 12 (1960): 31–43; Lawrence Buell, "The New England Renaissance and American Literary Ethnocentrism," *Prospects* 10 (1985): 409–22.

22. Harriet Beecher Stowe, quoted in Sacvan Bercovitch, *The Puritan Origins of the American Self* (New Haven: Yale University Press, 1975), p. 88. Bercovitch notes the popularity of Cotton Mather's *Magnalia Christi Americana* in the mid-nineteenth century, registering the fascination with the present as a fulfillment of seventeenth-century prophecies.

23. Calvin Stowe, "The New England Forefathers' Day," *Godey's Lady's Magazine* 39 (December 1849): 458. Ruth Miller Elson, *Guardians of Tradition: American Schoolbooks of the Nineteenth Century* (Lincoln: University of Nebraska Press, 1964), pp. 169–85, points out that over the course of the nineteenth century, schoolbooks, many written by New Englanders, perpetuated the notion of the region's primacy in the formation of national character. See "Our School Books," an article in *De Bow's Review* 28 (April 1860): 434–40, esp. 438–39, a journal published in the South, decrying northern schoolbooks for their bias.

some sense the guiding spirit, the historic pith of the nation. The Conestoga wagon moving laterally across the foreground of *New England Scenery* toward the western sun was carrying Yankee values to the West.[24] In a period of agrarian decline and depopulation, New Englanders would enlarge the arena of their cultural and moral influence.

In the decade before the war this sense of mission assumed a new polemical force. Well before the mid-nineteenth century Plymouth Rock, marking the establishment of the first North American commonwealth, had emerged not only as an organizing myth central to New England's identity but also, through the tireless campaigning of New Englanders themselves, as a more general myth of national origins. Efforts to monopolize the birthright of nationhood did not go undisputed. Southerners responded to the myth of Plymouth Plantation with their own countermyth, centering on Jamestown, Virginia.[25] The countermyth, however, played right into the hands of those wishing to advance the New England cause. Robert Winthrop conceded that Virginia deserved some credit for its contribution to national character, but turned to the French traveler Michel Chevalier for his conclusion: "If we wished to form a single type, representing the American character of the present moment as a single whole, it would be necessary to take at least three-fourths of the Yankee race and to mix it with hardly one-fourth of the Virginian."[26] Even more devastating a thrust at Virginia's pretensions to being the birthplace of American liberties was the comparison between the human cargo of the Mayflower and that of the Dutch man-of-war that landed at Jamestown filled with Africans, laying "the foundations of domestic slavery in North America. . . . And American Liberty, like the Victor of ancient Rome, is doomed, let us hope not

24. The oil study for the painting depicted an uncovered flatbed wagon employed for local transport. The fact that Church substituted the more symbolically resonant Conestoga wagon in the final version suggests its narrative significance as an emblem of western emigration. The Conestoga wagon appeared in this role in an 1847 print titled "Elements of National Thrift and Empire," by J. G. Bruff, an imaginary view of the Mall in Washington, D.C., including various symbols of trade, agriculture, mercantilism, and expansion (Prints and Photographs Division, Library of Congress).

25. I am indebted to a talk on the historic myth of Plymouth Rock given by Professor John Seelye of the University of Florida at Washington University in 1987 for first alerting me to its nineteenth-century symbolism. On the significance for southerners of Pocahontas, one of the main figures of the Jamestown drama, see Anne Norton, *Alternative Americas: A Reading of Antebellum Political Culture* (Chicago: University of Chicago Press, 1986), p. 183. Prior to the heightening of sectional antagonism William Gilmore Simms was promoting "national" subjects associated with the South, as in his "Pocahontas: A Subject for the Historical Painter," in C. Hugh Holman, ed., *Views and Reviews in American Literature, History, and Fiction* (Cambridge: Belknap Press of Harvard University Press, 1962), pp. 112–27.

26. Winthrop, "Address," 1:256.

for ever, to endure the presence of a fettered captive as a companion in her Car of Triumph."[27]

Before New Englanders could establish their claim to being the historic guardians of national values, however, they had to overcome the prejudicial view of many other Americans that they were narrowly provincial. The New Yorker George Templeton Strong frequently poked fun at New Englanders, decrying the "dingy rat-holes that are the thoroughfares of those unhappy little people who live in Boston," and referring to that city as "the Yankee metropolis."[28] New England's history of localism, episodes such as the Hartford Convention, and, more recently, Dorr's Rebellion, along with the image of the self-interested, avaricious, and wily Yankee, undermined its claims to loyalty to the Union. Unsympathetic northerners viewed its appeals to a transcendent nationalism (with some justice) as a disguised form of self-promoting regional apologetics.[29] A critic of Robert Weir's *Embarkation of the Pilgrims,* painted for the United States Capitol, objected to what he termed "the complacent fluency with which New England writers and speakers dwell upon home themes. . . . It is not quite just to accept without reserve the motto which partial eulogists have recognized in behalf of that stern little band of dissenters, 'with these men came the germ of the republic.'" Insisting that "the urbane conservatism of the New York colonists and the frank enthusiasm of the Virginia cavaliers, are at least requisite contrasts in the moral picture," the author

27. Ibid., 1:256–57. The invidious comparison between New England and Virginia was made again by Charles Brickett Hadduck, "The Elements of National Greatness" (1841), in *New England Society Orations,* 1:272–73. Conceding the original role of Virginia in the settlement of the continent, the author then draws out the differences that distinguish them, concluding that "the Virginian belongs more to the Old World. His solitary manor, his feudal hospitality, his chivalrous honor and frankness . . . all associate him with the knights and cavaliers of England." New Englanders such as John Quincy Adams drew the lines between North and South with uncompromising severity: "There are two facts which have a great influence on our character: in the North, the religious and political doctrines of the first founders of New England; in the South, slavery." Quoted in George W. Pierson, *Tocqueville and Beaumont in America* (New York: Oxford University Press, 1938), p. 418.

28. Entry of August 9, 1853, in *Diary of George Templeton Strong,* ed. Allan Nevins, 4 vols. (New York: Macmillan, 1942), 2:127, 187.

29. Not all northerners accepted the designation "liberty-loving" as an accurate description of the Pilgrim fathers. Strong, a devout Episcopalian, debunked New England's historical pretensions; see ibid., 1:119–20 (December 31, 1839), and 1:157 (January 17, 1841). In a similar spirit Thoreau's study of the French colonization, *The Journal of Henry Thoreau,* ed. Bradford Torrey and Francis H. Allen, 14 vols. (Boston: Houghton Mifflin, 1906), 4:227, 232, led him to the conclusion that "the Englishman's history of New England commences only when it ceases to be New France." Quoted in Robert D. Richardson, Jr., *Henry Thoreau: A Life of the Mind* (Berkeley: University of California Press, 1986), pp. 218, 289–90.

grudgingly conceded the contribution of Puritan character "as an element of civilization and national growth."[30] In 1856 Peter Oliver could refer to "that worst of all cant, the cant of New Englandism." Yet New England's success in establishing its identity with the republic was such that a South American cleric, intending no jest, termed the United States "the Boston republic."[31]

Such accusations provoked a defensive reaction. Referring to New England, Calvin Stowe asked querulously: "Does she conduct herself like a selfish or mean member of this great confederacy? I should think the selfishness and meanness belonged somewhere else."[32] Yet Stowe followed his sustained tribute to the virtues of the New England way by disclaiming any narrow self-interest: "All local prejudices and jealousies in our nation are . . . the extreme of folly. . . . If there is any honor or advantage in being a native of any particular section of the Union, the honor and advantage of being a member of the Union itself, are still greater."[33] The historian Samuel Lorenzo Knapp protested that New Englanders were "born for others as well as themselves. . . . Educated for no particular place," they belonged rather "to society and mankind."[34] New Englanders' love of place in this context appeared a positive virtue, casting the western emigrant into the role of a self-sacrificing missionary. "The New-England emigrant is every where an active being, deeply interested in every thing around him, making arrangements for the present, and calculations for unborn ages; but still if you search his heart you will find the love of his birthplace deeply engraven on it; follow the wandering of his imagination, and you will discover that he revisits the scenes of his childhood, and even in his dreams returns to his kindred and friends with true delight."[35]

As Lawrence Buell has argued, the provincial element in New England's cultural

30. "Our Artists," *Godey's Lady's Magazine* 34 (February 1847): 70. A similar complaint appeared in "American Literature," *Western Monthly Magazine* 1 (April 1833): 184–85, which lists the contributions of nationalities other than the English to American culture and rejects the claim of English paternity for the nation.

31. Peter Oliver, *The Puritan Commonwealth* (Boston: Little, Brown, 1856), quoted in Buell, "New England Renaissance," p. 409; the unnamed cleric is quoted in Bernard Moses, *The Intellectual Background of the Revolution in South America, 1810–1824* (New York: Hispanic Society of America, 1926), p. 39, cited in Richard Lyle Power, "A Crusade to Extend Yankee Culture, 1820–1865," *New England Quarterly* 13 (December 1940): 643.

32. Stowe, "The New England Forefathers' Day," p. 459. See also William R. Taylor, *Cavalier and Yankee: The Old South and American National Character* (New York: Harper and Row, 1969), pp. 95–96, 101–41.

33. Stowe, "The New England Forefathers' Day," p. 460.

34. Samuel Lorenzo Knapp, "Address" (1829), in *New England Society Orations*, 1:163–64.

35. Ibid., 1:163–64.

legacy "becomes legitimated in proportion to its ability to transcend itself" by assuming national status.[36] Yet throughout the drive to disseminate New England values, apologists, including Church, strove to keep alive the original sentiment of place. The evolution of a regional image had to resolve these two competing definitions, the one place-centered, the other expansionist, involving the diffusion of those spiritual, moral, and social beliefs that have critically shaped the self-image of Americans.[37]

New England nationalists and their sympathizers viewed the migration westward as the perfect antidote to the formation of entrenched sectional sympathies and provincial isolation. The German Francis Grund pointed out that emigration would "serve in no small degree to eradicate from their minds certain prejudices and illiberalities with which they have but too commonly been reproached by their brethren of the south. . . . I know of no better specimen of human character than a New Englander transferred to the western states."[38] Admitting that "local influences and associations" could militate against a broader nationalism, apologists argued that emigration would "tend always to the production of a uniform national character."[39]

Growing ties of sentiment and political loyalty bound together East and West, accounting for Thoreau's observation in the 1850s that "sympathies in Massachusetts [are] not confined to New England; though we may be estranged from the South, we sympathize with the West."[40] As its loyalties with the West deepened, so

36. Buell, "The New England Renaissance," p. 411. His argument is made in connection with the manner in which New England authors have defined the nation's literary canon. Playing on the paradox of a nationalism compounded of provincial elements, Buell cites "New England's readiness to equate itself with the national spirit" as a mark of its provincialism (p. 413).

37. These two impulses are evident in the anonymous "Lines Inscribed to a Friend," *New England Offering* 2 (September 1849): 209, which recall "New England's rude/And rocky coasts, high hills, and happy homes" to those wandering in "the scalding tropics and the frigid poles"; also Lucy Larcom, "Farewell to New England," *New England Offering,* n.s., 1 (September 1848): 126: "O, spirits of the Pilgrims!/Suns, beaming from the Past!/Upon your wandering daughter/A warm reflection cast!"

38. Francis Grund, *The Americans in Their Moral, Social, and Political Relations,* 2 vols. (London: Longman, Rees, Orme, Brown, Green, and Longman, 1837), 2:42–43.

39. C. R. Hadduck, "The Elements of National Greatness," in *New England Society Orations,* 1:273.

40. Henry David Thoreau, "Walking," in *Excursions* (1863), ed. Leo Marx (Gloucester, Mass.: Peter Smith, 1975), p. 183. On the realignment of regional sympathies in the antebellum years, see Carl Degler, "Northern and Southern Ways of Life and the Civil War," in Stanley Coben and Lorman Ratner, eds., *The Development of an American Culture* (New York: St. Martin's, 1983), p. 114. Degler notes that East and West "were divided by little except time. The West's cultural values and economy were modeled after those of the East. By the 1850s, there were only two sections, culturally speaking, the North and the South."

did New England's alienation from the South. The consolidation of the Northeast and the Northwest into an economically integrated section in the 1850s and the absence of transportation lines connecting North and South reinforced this deeper moral and social division between the two sections.[41] In 1856 George Templeton Strong committed to his diary what many Americans must already have felt: "This alienation between North and South is an unquestionable fact and a grave one."[42]

In the charged atmosphere of the 1850s, trade with the South and the economic and material prosperity it brought appeared to many New Englanders a form of moral collusion with slavery. Commerce, which had provided an economic guarantee of mutual reliance and interdependence between the regions and the basis of political consensus, now seemed a "fell Upas" tree whose fruits would poison the moral soil of the nation.[43] In an effort to resolve the conflict between New England's economic welfare and its moral revulsion toward slavery, an institution indirectly supported by northern manufacturers, New Englanders such as John Greenleaf Whittier appealed to local production and to the figure of the virtuous, self-sufficient yeoman. Such images served a double nostalgia, addressing not only the longing for a simpler past but also the desire for an escape from the moral complexities that followed in the wake of economic progress. Church's flourishing pastoral republic of small villages and well-tended fields takes on a different resonance against this backdrop.

Embedded within the imagery of autonomous agrarian communities and emigrants carrying New England values to the West was the counterimage of southern slaveholders claiming the new lands for their peculiar institution. The debate as to which social order would inherit the West was further kindled by the Kansas-Nebraska Act of 1854, which left each new state free to determine its own future—slave or free.[44] Against this backdrop the frequency of paintings, prints, and poetry dwelling on characteristically New England landscapes and activities assumes new significance. A pronounced New England voice emerged in oratory, while a regional satire and humor developed around native dialect.[45] New England subjects—

41. Ray Allen Billington, *Westward Expansion: A History of the American Frontier* (New York: Macmillan, 1964), pp. 387–402.

42. Strong, *Diary*, 2:284 (July 8, 1856).

43. The term is John Greenleaf Whittier's, from his abolitionist poem "The Panorama," in *The Works of John Greenleaf Whittier*, 7 vols. (Boston: Houghton Mifflin, 1892), 3:201.

44. On the Kansas-Nebraska bill and its repercussions, see Major L. Wilson, *Space, Time, and Freedom: The Quest for Nationality and the Irrepressible Conflict, 1815–1861* (Westport, Conn.: Greenwood Press, 1974), pp. 178–84.

45. The best known of these satires were the *Biglow Papers* of James Russell Lowell, whose Hosea Biglow issued scathing denunciations in Yankee dialect of the southern slave power and northern

Figure 38. George H. Durrie, *Going to Church*, 1853. Oil on canvas; 22″ x 30⅛″. White House Collection.

depictions of rural winter landscapes such as George Henry Durrie's 1853 *Going to Church* (figure 38), maple sugaring such as Arthur F. Tait's "American Forest Scene: Maple Sugaring" (1856, Currier and Ives, figure 39) and comparable scenes by Tompkins Harrison Matteson and Eastman Johnson, or apple picking and autumn harvests painted by Jerome B. Thompson—all bore the common impress of a northern cultural identity brought into focus through an implicit but ever-present contrast with the South. "Representative" American scenes by Currier and Ives—farm, homestead, and winter subjects—were invariably northern in both locale and associations.[46]

collaborators. Seba Smith's Major Jack Downing was another such invention. See John H. Schroeder, "Major Jack Downing and American Expansionism: Seba Smith's Political Satire, 1847–1856," *New England Quarterly* 50 (June 1977): 214–33.

46. On the polemical undercurrent of such subjects, see Larzar Ziff, *Literary Democracy: The*

Figure 39. Arthur F. Tait, "American Forest Scene: Maple Sugaring," 1856. Color lithograph, Currier and Ives. The Harry T. Peters Collection, Museum of the City of New York.

Such visual imagery paralleled the growing literary consciousness of the region in the work of the "fireside" poets—Whittier, Lowell, Holmes, and Longfellow— who sounded the intimacies of northern domesticity throughout the cold winter

Declaration of Cultural Independence in America (New York: Penguin, 1981), pp. 51–55. In works such as *Going to Church* (1853, White House Collection) and *Red School House, Winter* (1858, private collection) Durrie combined the imagery of New England winters with an interest in its most characteristic institutions. Currier and Ives produced ten lithographs based on his paintings between 1861 and 1867. On Durrie, see Martha Young Hutson, *George Henry Durrie (1820–1863), American Winter Landscapist: Renowned through Currier and Ives* (Santa Barbara: Santa Barbara Museum of Art, 1977). Alan Gowans, "Painting and Sculpture," in *The Arts in America: The Nineteenth Century* (New York: Charles Scribner and Sons, 1969), p. 228, notes the new meaning Durrie's New England paintings acquired once the region emerged as a center of abolitionism and champion of the Union. On Eastman Johnson's paintings of maple sugaring, see Patricia Hills, *Eastman Johnson* (New York:

months and during seasonal holidays. These literary subjects were often coupled with an explicit message of northern freedom which makes clear the political subtext in visual images. In 1857 the *Atlantic Monthly* contrasted the agrarian landscape of free labor with the counterimage of slavery: "On one side . . . thrift and comfort and gathering wealth, growing villages, smiling farms, convenient habitations, school-houses, and churches . . . on the other, slovenly husbandry, dilapidated mansions, sordid huts, perilous wastes, horrible roads, the rare spire, and rarer village school betray all the nakedness of the land." The source of the striking contrast was "the magic of motive": "willing and intelligent" labor calls forth "wealth and beauty to bless the most sterile soil," while its reverse "scatters squalor and poverty and misery over lands endowed by Nature with the highest fertility."[47]

Decay and opulence were the two poles northeasterners most often associated with southern landscape and culture, and these almost inevitably carried moral associations with the perceived undisciplined sensualism of southern character.[48] Fatally associated with slavery, the southern landscape was beyond the reach of northeastern sympathies. Southern nature, even when it approximated northeastern scenery and mimicked the artful conventions of the sublime and the beautiful, nevertheless seemed tainted. "The scenery this side the Blue Ridge is beautiful," wrote a Lowell mill girl visiting Virginia, "the climate delightful, and everything looks as if *it might have been so Eden-like* had not a blight rested upon all. But here among the mountains, where we have pure air, good water, and such

C. N. Potter in conjunction with Whitney Museum of American Art, 1972), pp. 63–67. Matteson's treatment of the subject dates slightly earlier, to 1845, and expresses a regional appreciation for New England that is without distinct sectional overtones.

47. "Where Will It End?" *Atlantic Monthly* 1 (December 1857): 241. Whittier's poem "The Panorama," *Works*, 3:196–99, draws a similar contrast. References to the decay of the southern landscape in Whittier's writing are numerous. In "Justice and Expediency," in *Works*, 7:32–33, Whittier describes "the baneful and deteriorating influences of slave labor, . . . of grass-grown streets, of crumbling mansions, of beggared planters and barren plantations," concluding that "a moral mildew mingles with and blasts the economy of nature" in the South. In "The Abolitionists and Their Sentiments and Objects," in *Works*, 7:81, 83–84, he contrasts New England's agrarian landscape with that of the South: "For more than two centuries the cold and rocky soil of New England has yielded its annual tribute, and it still lies green and luxuriant beneath the sun of our brief summer. The nerved and ever-exercised arm of free labor has changed a landscape wild and savage as the night scenery of Salvator Rosa into one of pastoral beauty,—the abode of independence and happiness. Under a similar system of economy and industry how would Virginia, rich with Nature's prodigal blessings, have worn . . . the smiles of plenty, the charms of rewarded industry!"

48. David Miller, *Dark Eden: The Swamp in Nineteenth-Century American Culture* (New York: Cambridge University Press, 1989), pp. 82–83.

glorious thunder-storms, even here Indolence, Slavery's oldest daughter, hath many worshippers."[49] These seemingly ingenuous observations were conditioned. Like so many of the mill girls who contributed to *New England Offering*, the young author, chaste symbol of the virtues of northern industry, served as a convenient mouthpiece for the social and moral polarities represented by North and South. Northeasterners drew conditioned associations between the physical and the moral landscape of the South. By the 1850s these were part of a growing sectional antagonism.

Although slavery was the root issue shaping the formation of southern landscape stereotypes in the North, there were other contributing factors, among which was a growing distrust of southern nationalism and the awareness of the extent to which loyalty to the South implied disloyalty to the Union. Such concerns carried implications for the interpretation of landscape themes. A double standard developed in which northeastern views taught lessons in cultural nationalism that were denied to southern landscapes under suspicion of encouraging southern sympathies.

Church, careful to avoid polemical references to the divisive issue of slavery, could nonetheless count on its presence in the minds of his viewers.[50] Prior to the open declaration of hostilities, sectional apologetics were conducted in veiled terms. Cultural products came to play an important role in the impending crisis, casting North and South not only as social and political but also as moral and spiritual antagonists.[51] Faced with New England's aggressively promoted agrarian image, southerners answered with counterclaims to being the nation's only genuine agrarian society, turning back upon the North some of the very terms with which it disparaged the South.[52]

49. "Virginia and New England," *New England Offering*, n.s., 1 (September 1848): 139.

50. The attitude of Church, who lived and worked in New York, toward the South was more than likely a relatively moderate one. More extreme and uncompromising expressions of northern antagonism were concentrated in New England. The subject is explored in Robert C. Albrecht, "The New England Transcendentalists' Response to the Civil War" (Ph.D. diss., University of Minnesota, 1962).

51. Sarah Burns, *Pastoral Inventions: Rural Life in Nineteenth-Century American Art and Culture* (Philadelphia: Temple University Press, 1989), p. 78, has made a similar argument about the "political subtext" of farm imagery as "the rightness of the northern capitalist system of freehold property and free labor"; see esp. pp. 77–89. Appreciation of the regional New England landscape was enhanced not only through contrast with the South but against the backdrop of modernization. James Russell Lowell, reviewing Whittier's "Snowbound," in *The Function of the Poet and Other Essays* (Boston: Houghton Mifflin, 1920), p. 139, wrote that "already are the railroads displacing the companionable cheer of crackling walnut with the dogged self-complacency and sullen virtue of anthracite."

52. An example is "How the South Is Affected by Her Slave Institutions," *De Bow's Review*, o.s., 11 (October 1851): 354, which hypothesizes about the impact of the abolition of slavery on the northern way of life and laments the decline of a rural gentry as the flower of American society. Numerous

Other historical contexts shaped the received meaning of *New England Scenery.* Church's painting projected its image of abundance in the midst of an unprecedented agricultural crisis.[53] The physical deterioration of the New England countryside in a period of agrarian depression had no place in regional apologetics, which overcompensated with a rosy image of lush prosperity.

From the early nineteenth century on, New England's predominantly rural economy was beset by a series of agricultural depressions precipitated by poor farming methods, soil exhaustion, overpopulation, and the steady increase of competition from fertile new farmlands in New York State and later in the Ohio and Mississippi valleys. By the 1830s commercial fertilizers and a system of crop rotation were being widely advocated in both the North and the South in an effort to restore the lost productivity of the land. In 1852 Thoreau described a countryside where "the apple trees are decayed, and the cellar holes are more numerous than the houses, and the rails are covered with lichens, and the old maids wish to sell out and move into the village. . . . I say, standing there and seeing these things, I cannot realize that this is that hopeful young America which is famous throughout the world for its activity and enterprise, and this is the most thickly settled and Yankee part of it."[54] Articles in both northern and southern journals lamented the sterility of the soil and the impoverished and rude quality of rural life. The image of farmers migrating west bearing the venerable New England way belied historical reality, for the westward flow of New England's sons was also a flight from exhausted farmlands and economic collapse.[55]

An 1846 painting by Church offers a poignant image of New England's agrarian

articles and books on the topic of rural beauty, upkeep, and improvement published in the North in these decades suggest that in a region dominated by manufacturing, the rural landscape, frequently disheveled and aesthetically barren, was a sensitive topic. An example is R. Morris Copeland, *Country Life* (Boston, 1859), reviewed in *Atlantic Monthly* 4 (September 1859): 384–85.

53. On the farm crisis that began in the 1820s, see Clarence H. Danhof, *Change in Agriculture: The Northern United States, 1820–1870* (Cambridge: Harvard University Press, 1969), pp. 51, 108–14, 253–54; Jonathan Prude and Steven Hahn, *The Coutryside in the Age of Capitalist Transformation* (Chapel Hill: University of North Carolina Press, 1985); and Raymond O'Brien, *American Sublime: Landscape and Scenery of the Lower Hudson Valley* (New York: Columbia University Press, 1981), pp. 131–33.

54. Thoreau, *Journal*, 3:237–38; cited in Richardson, *Henry Thoreau*, p. 289.

55. Southerners shared the alarm over soil depletion; see "Necessity of Agricultural Reform," *De Bow's Review* 25 (August 1858): 144–64; "Southern Agricultural Exhaustion and Its Remedy," *De Bow's Review* 14 (January 1853): 34–46; "Improved Agriculture for the Southern States," *De Bow's Review* 25 (October 1858): 395–404. On the agricultural crisis in New England, and on the role internal economic distress played in the fomentation of sectional antagonism, see Avery Craven, "The Northern Attack on Slavery," in David Brion Davis, ed., *Antebellum Reform* (New York: Harper and Row, 1967), pp. 19–38.

decline: *New England Landscape with Ruined Chimney.* The chimney—symbol of the patriarchal New England household—is now the isolated relic of a once prosperous farm.[56] "Rising out of a grassy and weed-grown cellar," it becomes an emblem of "Time's vicissitude" and a melancholy vestige of loss in Hawthorne's "Old Manse."[57]

Migration to the West in one sense ensured the perpetuity of New England values and institutions. In another sense, however, it depleted the population of the region and with it the level of political representation New England carried in Congress.[58] The steady outmigration of its farmers indicated as well a more general decline in the political and cultural hegemony of New England. Although proud of their role in siring the lion of the West, New Englanders were not prepared to give up their position of moral leadership—a position challenged by the growing political and economic might of their offspring.[59]

The regional imperialism of Church's *New England Scenery* was ironically promulgated by a print issued and disseminated by the New York–based American Art-Union. It appeared in the context of images that recalled the Revolutionary War, a historic past shared by all Americans, or others such as Cropsey's *American Harvesting* (see figure 31), which pictured a generically northern agrarian mission to subdue the wilderness and bring it under cultivation. Why would the American Art-Union have been willing to distribute a print dedicated to celebrating the cultural and historical priority of New York's rival cultural region? Without under-

56. The painting is reproduced in Kelly and Carr, *The New England Landscapes of Church*, p. 78. Another example of related symbolism is in Melville's short story "I and My Chimney," analyzed in Chapter 7.

57. In Nathaniel Hawthorne, *Mosses from an Old Manse* (Boston: Houghton Mifflin, 1883), p. 21.

58. Hal S. Barron, *Those Who Stayed Behind: Rural Society in Nineteenth-Century New England* (New York: Cambridge University Press, 1984), p. 33, points out that outmigration and depopulation were a continuous feature of New England rural society, yet not until the mid-nineteenth century did they become a serious object of concern, in the form of the "western craze," or "Genessee fever." New England agriculturalists criticized the speculative craze that drove people west, lured by the promise of "unsurpassed fertility." See S. C. Charles, "New England Emigration," *American Agriculturalist* 4 (May 1845): 145–46. Criticism of those who had deserted New England could be scathing. George Perkins Marsh, speaking before the Agricultural Society of Rutland, Vermont, denounced emigrants as deserters "who abandoned the blessings of a well-ordered home in New England amidst rural beauty . . . to live among the miry sloughs, the puny groves, the slimy streams which alone diversify the dead uniformity of Wisconsin or Illinois." Cited in Barron, *Those Who Stayed Behind*, p. 35. How one judged the landscape was, here as elsewhere, relative to one's situation.

59. Buell, "The New England Renaissance," interprets John Quincy Adams's assertion that New England was the prototype for the North American confederacy of 1774 as a way of compensating for the actual decline of New England.

standing more about the politics of the Art-Union and the makeup of its board, one finds this question difficult to answer.[60] But there are possible answers to this puzzle.

By 1851 Church was firmly identified as a New York artist, a reputation that neutralized his New England loyalties and endowed the AAU board with a kind of noblesse oblige as patrons of an enormously talented artist paying homage to his first home. More important, throughout the nineteenth century New York was indebted to New England émigrés for its cultural character and contributions—men such as William Cullen Bryant in literature, Church and John Frederick Kensett in painting, Cyrus Field, Luman Reed, and Samuel Ward in business and patronage. As Emerson pointed out to his New York contemporaries, "Your great metropolis is always, by some immense attraction of gravity, drawing to itself our best men."[61] Despite the tone of good-humored if slightly sharp rivalry with New England so often expressed by New York intellectuals such as George Templeton Strong and Centurions such as John Durand, many of the leading spirits of New York art life still had strong natal or family ties with New England. If New York possessed the machinery and institutions of cultural production, it remained rooted in the intellectual climate of New England. Moving to New York City for its unrivaled artistic and literary opportunities, artistic immigrants, as the case of Church makes so clear, did not give up their loyalties to New England or their strong sense of its formative role in the national culture. The relationship between New England and New York was symbiotic: New England writers and artists required institutions such as the AAU, the NAD, the great publishing houses, audiences, patrons, and critics of New York in order to garner a national reputation. New York was in its turn greatly enriched by the arrival of New England talent. The situation would become more familiar in the postwar years as the city's cultural and economic power swelled to new proportions. But already by the 1850s New England was furnishing a vital ingredient in the cultural amalgam of New York.

To understand fully the construction of meaning in *New England Scenery*, we must consider not only how historical context illuminates Church's symbolic program but also how this program was compromised by its own internal contradictions. *New England Scenery* is a generic composition, assembled from passages

60. Possibly a number of the board members of the AAU, responsible for choosing which paintings to engrave, were themselves New Englanders who continued to identify with the region. Perhaps, too, they felt the print would appeal to their western if not their southern subscribers, by offering a nostalgic vision of the region from which so many emigrants hailed.

61. Ralph Waldo Emerson, in *The Bryant Festival at "The Century"* (New York: D. Appleton, 1865), pp. 16–17.

of remembered scenery woven together into a deceptive unity.[62] Its compositional approach is additive. A wooden bridge fills the foreground, establishing a strong horizontal axis. This bridge is framed on the right by a severely undercut embankment supporting ancient trees, one of which seems on the verge of toppling over. Portions of the shadowed foreground are illuminated by the warm, rich light of the sun, which sets just beyond the right-hand frame of the picture. In the middle distance the glassy surface of a lake contrasts with the rocky, wooded topography surrounding its borders. A mill, situated on the steeply sloping eastern bank of the lake, divides a river into a series of waterfalls that cascade down into it. Beyond its border the land flattens out into an upland meadow punctuated by groves of trees which cast long shadows in the late afternoon light, and by a small village, identified by a white church spire, another beacon in the New England landscape. Just slightly off center from the axis that bisects the canvas vertically is a mountain peak whose rocky summit presents a sheer and shadowed eastern face, sloping down more gradually to the west. In the background other peaks recede toward the horizon, their outlines muted by the glow of the setting sun.

Church's composite or additive method, however, fails to produce a seamless whole, and the painting remains an assemblage of parts. The perspective shifts as one moves through the composition, the effect being to distance the image from its topographical sources.[63] Without such distortions in perspective Church simply would not have been able to fit everything into one frame. These manipulations, however, are disguised within a projected unity. Through its aesthetic disjunctions *New England Scenery* inadvertently demonstrates that the sense of any place larger than the eye can take in necessarily involves a condensation, a mental fabrication, of reality.

The additive method of composition used by Church was put to somewhat different ends in an engraving titled "View of the Progress of Civilization in New England" (figure 40), which offers a compressed panorama of the region's economic, social, and institutional life.[64] In this respect it did for the human history of

62. The painting was praised for its "great breadth of effect, with wonderful excellence in details." Quoted in Kelly, *Church and the National Landscape*, pp. 53–54.

63. The painting's lower half is organized according to a two-point perspective system, with the horizon situated at the further border of the lake. This perspective does not include the rocky, wooded hillside with mill on the left, forming part of another perspective system which dominates the upper portion of the painting, and which is also two-point. Here, however, the vanishing points are situated along a higher horizon line which divides the painting roughly at its midpoint, rather than two thirds of the way down.

64. The engraving served as a frontispiece to volume 1 of A. J. Coolidge and J. B. Mansfield, *A History and Description of New England, General and Local* (Boston: Austin J. Coolidge, 1859), a

Figure 40. "View of the Progress of Civilization in New England." Frontispiece, A. J. Coolidge and J. B. Mansfield, *A History and Description of New England, General and Local,* volume 1 (Boston, 1859).

the region what Church attempted to do for its natural scenery, collapsing agriculture, trade and commerce, shipping and industry, various forms of transportation, and representative institutions—church, schoolhouse, and factory—into one scene, even including the ubiquitous *genius loci,* a group of Indians who survey the progress of civilization from a safe remove.

Such an additive method of composition was also used in popular prints and currency design as a means of condensing an expanse of time and space into a single frame.[65] Unburdened by the formulas of European landscape art, this

detailed place-by-place compendium covering both natural and economic history, as well as furnishing a record of settlement and a description of geographic particulars.

65. Numerous American painters, including Durand, Casilear, and Kensett, received their initial training as engravers, in many instances designing currency.

popular tradition freely combined landscape backgrounds with emblems of economic progress—Conestoga wagons, ploughs, trains, steamboats—and with allegorical attributes of republican government. These popular or commercial prints dispensed with high-art considerations such as consistency of scale and perspective or visual unity. Church's *New England Scenery* retains traces of the additive quality of its popular prototypes.

There is one other structural element of the painting that furnishes evidence of its unresolved motives. Its two major axes—one parallel to the picture plane and one at right angles to it—compete for dominance. Church eliminated the immediate foreground in a manner that characterized much of his later work. The object closest to the viewer is the wooden bridge, its directional character emphasized by the Conestoga wagon which moves left to right across it toward the setting sun. The spit of land that projects into the lake and its distant wooded bank reiterate this horizontal element, along with the upper horizon demarcated by the background mountains. The dimensions of the painting (36″ × 54″) further emphasize its horizontality, as does the direction of the light, which shines from west to east, that is, from right to left. This horizontal organization is far more pronounced in the final composition than in the oil study.[66]

The sense of lateral movement implied by this strongly horizontal arrangement is undercut, however, by the peak in the distance. The visual pull of this majestic form is further heightened by the fact that it commands its own horizon line, seeming to establish a direct visual relationship with the viewer across the intervening space.[67] The peak both anchors the composition and dramatically culminates its deep spatial recession. Like the spire that embodies the ancestral faith, it is a powerful symbol of place. "Clad with local associations, . . . consecrated by a particular name," mountain peaks were the markers of home, recalling for New England's restless sons their earliest and fondest memories: "The mariner or other

66. Compositionally the painting is closely related to Cole's Catskill views of the late 1830s and 1840s, a correlation which suggests that at some point between painting the two versions Church looked carefully at this series. Cole's *View on the Catskill, Early Autumn* (1837, Metropolitan Museum of Art) parallels *New England Scenery* in a number of respects: the raised vantage point of the viewer, the body of water in the middle distance, and the background peak. A related work is Cole's *River in the Catskills* (1843, Museum of Fine Arts, Boston). Church's composite composition may also have been influenced by works such as Cole's *New England Scenery* (1839, Art Institute, Chicago), with which it shares not only a title but several narrative elements as well, including a bridge with wagon and a steepled church. In addition, Church may have learned from Cole's later work such as *Schroon Lake* (ca. 1846, Adirondack Museum, Blue Lake, New York), which, despite its title, is a composite in which nostalgia and the remembered image of a place takes precedence over direct observation.

67. I am indebted to Kathleen E. Diffley of the Department of English, University of Iowa, for first making this observation to me.

traveler across the ocean holds them in his last aching gaze as long as he can; and thitherward his heart aims its last adieu." Such peaks were also symbols of national greatness, "mantled all over and beautified with a national interest."[68]

These two major organizational axes in *New England Scenery*—one across the canvas, the other deep in its illusionistic space—manifest this dualism within the region's identity. New England was both a process and a place, struggling to maintain its hold on the present order even as it insisted on its leading role as an agent of the future. If the wagon signifies New England as process, the realization in time and history of its meaning for the nation, the background peak symbolizes a place-centered ideal. As an artist and a loyal son of New England, Church closely identified with its historic sense of mission, inextricably bound up with its physical geography. The dynamic lateral pull of the missionizing spirit connecting East to West and the mountain as a symbol of place, powerful in its unmoving presence, present alternate forms of national experience.

Church's conflicting motives are further evident in a detail that has been overlooked in earlier scholarship: the Conestoga wagon that crosses the bridge toward the setting sun is heading straight into the embankment on the right. In place of the open road is a shadowy, tangled topography that threatens to sabotage all future movement.[69]

The painting's composite composition, perspectival disunities, and unresolved organization all point to the incomplete character of its fiction: that autonomous stretches of scenery could be melded into an aesthetic unity, and by extension that local polities could be assimilated into a unified nation. The artifacted, assembled character of the painting further betrays its natural appearance.

The spatial and compositional ambiguities apparent in *New England Scenery* were faults in Church's work that received persistent criticism throughout the 1850s. In the painting of 1851 these faults may have been exacerbated by his relative youth (Church was only in his mid-twenties at the time), and his tendency to overshoot artistic means and experience. If *New England Scenery* does not entirely succeed in uniting its independent parts under a common banner, however, the reason goes beyond age, and may be found in both the aesthetic dilemmas of landscape painting in the 1850s and Church's own divided allegiances.

Landscape in this period was, on one key level, an art of the particular—the

68. Warren Burton, "Scenery-Showing, in Word-Paintings," in *The District School as It Was: Scenery-Showing, and Other Essays* (Boston: T. R. Marvin, 1852), pp. 280–81.

69. This curious breakdown in the narrative logic of Church's painting has gone unobserved by scholars, perhaps because most of Church's audience, then and now, are used to reading the space of the landscape from foreground to background rather than as a laterally extended narrative. In this case the narrative is intended to be read in both directions, creating some confusion for both the painter and the viewer.

particular place or seasonal or atmospheric moment—and particularity was clearly a precondition of all convincingly American landscapes. Yet Church, more than any of his contemporaries, took seriously the Humboldtian call for a synthesis of aesthetics and science, for artistic unity and detailed naturalism. The called-for unity of highly localized, precise observation and aesthetic breadth was frequently difficult to achieve in practice, at least to the satisfaction of Church's critics.[70] Lacking Cole's conviction that imagination should remain the primary agent of pictorialization, Church assumed a posture of artistic transparency that left him vulnerable to charges that he was not fully in control of his compositions. Despite the emphasis on naturalism of detail, for the critics of the New York school composition remained a preeminent value.

Repeatedly calling for a record of particular places, critics and theorists of landscape art also insisted on the infusion of sentiment and imagination into the meticulous rendering of nature. The careful transcription of natural detail served as a disciplinary stage prior to the realization of an artistic unity in which individual elements were reshaped by their collective context.[71] Accordingly a recurrent aesthetic debate in the 1850s centered on the relative virtues of local, place-specific views versus "compositions." As a reviewer wrote for the *New-York Home Journal* in 1851: "We too often find [American artists] engaged on 'composition.' . . . We have yet to see the country which abounds with fairer subjects for the artist's pencil than our own. . . . Yet it is a rare thing indeed to see a faithful American picture from the pencil of the most renowned. 'Composition' seems all the rage—as though the pencillings of God, or Nature, if you please, were of too 'commonplace' a character for our artists."[72] Church, Durand, Cropsey, and others combined observation of particular places in synthetic landscapes whose associational reach was not bounded by what Heinrich Fuseli a few generations earlier had contemptuously referred to as "Views" or "map-work," primarily of interest to "the inhabitants of the spot."[73] Although the identity of separate parts was retained, these parts were anchored

70. This was the substance of the most probing discussions of landscape art in the 1850s. Pre-Raphaelite critics (discussed further in Chapter 7) tended to emphasize the particulars, while the most complete statement of landscape aesthetics from these years, Asher Durand's "Letters on Landscape Painting," argued for plein-air studies as a stage on the way toward fully developed "compositions."

71. This principle is most fully articulated in Durand's "Letters on Landscape," published in *The Crayon* in 1855, and elsewhere in that journal.

72. "Art and Artists," *New-York Home Journal*, August 9, 1851. The reviewer praised the English school for avoiding this tendency.

73. Quoted in John Barrell, *The Political Theory of Painting from Reynolds to Hazlitt: "The Body of the Public"* (New Haven: Yale University Press, 1986), p. 285. An example of the midcentury critical attitude is one Professor Hart's "Lectures on Painting," *The Crayon*, March 28, 1855, pp. 197–99, which lauds synthesis as opposed to analysis or "mere fac-simile."

within a larger compositional unity.[74] In Church's case, however, critics complained that the parts were overly assertive.

The problem of the proper relationship of detail or part to whole was one with which Church wrestled throughout the early and middle period of his career. Time and again he was charged with the same fault: that the visual insistence of his detailed passages of painting interrupted the overall harmony and management of the aesthetic impression. Seen in the context of *New England Scenery,* this observation originated in both a conceptual and an aesthetic dilemma: Church's effort to satisfy the naturalistic (Humboldtian) requirements of midcentury landscape, with its call for a finely discriminated portrait of place, while at the same time attempting to transcend the hold of particulars through synthetic composition. "Church's great want is that of breadth," wrote a critic for *Putnam's* in 1855. "His details too often start out of their place, and, unsought, claim our attention. His compositions too often lack the unity and singleness of interest proper to Nature."[75] Benjamin Champney complained that the triumphant *Heart of the Andes,* exhibited in 1859, was "too literal a rendering of facts, and wanting in higher poetic treatment," although he conceded it was "a beautiful and interesting picture all the same."[76] *The Heart of the Andes,* like *New England Scenery,* was a composite composition; yet by the late 1850s Church was more successful at hiding the seams, and the later painting more suavely orchestrates its parts into a visual unity. As with his earlier painting, Church was attempting to create a geographical summary of an entire region, although his new interest in South America vastly expanded his imaginative

74. Invention, however, is defined as "to find out, not to contrive," in "The Academy Exhibition—No. 1," *The Crayon,* March 28, 1855, p. 203.

75. Review of National Academy exhibition, *Putnam's Monthly* 5 (May 1855): 508. A similar complaint about Church was made in "The Fine Arts; Exhibition at the National Academy of Design—No. III," *Literary World,* May 8, 1852, p. 332, which called on the artist to discipline his faculties: "The individual parts of his pictures are full of the qualities of nature; but as wholes they lack breadth and system, not giving a single and united impression." "Some Remarks on Landscape Painting," *Bulletin of the American Art-Union* 2 (November 1849): 22, describes a painting by Church as "a perfect daguerreotype . . . admirably finished," but continues with the criticism that "the scene itself perhaps hardly affords a reason for the labor that has been bestowed upon it." Church's faults, according to G. W. Sheldon in 1881, *American Painters* (New York: Benjamin Blom, 1972), p. 13, were "recognized by almost every intelligent American lover of art," and consisted "in the elaboration of details at the expense of the unity and force of sentiment."

76. Benjamin Champney, *Sixty Years' Memories of Art and Artists* (1900), ed. H. Barbara Weinberg (New York: Garland, 1977), pp. 141–42. Henry Tuckerman, writing about *Heart of the Andes* in *Book of the Artists* (1867; reprint, New York: James F. Carr, 1966), p. 375, noted that "four or five pictures might easily be cut out of this one," but also acknowledged Church's advance "from the faithful rendition of details, to a comprehensive realism in general effect" in his later work (p. 371).

field. Yet despite the growth of his artistic skills, Church faced the same dilemma in the later work as in *New England Scenery* eight years before: how to create an aesthetic and visual experience that was greater than the sum of its parts.

The problem was most acutely identified by the critic and collector James Jackson Jarves, a man who maintained a reserved distance from the nationalist painters of the New York school, and who was, perhaps as a result, one of its most apt critics. Church and his archrival Albert Bierstadt, Jarves complained, were "as laborious as they are ambitious," carefully reproducing detail from field sketches in an effort "to render the general truths and spirit of the localities of their landscapes, though often departing from the literal features of the view." Attempting to satisfy two different sets of requirements, they painted with the precise naturalism demanded of them by critics and audiences without tying the associations narrowly to one place. The result was that "with singular inconsistency of mind, they idealize in composition and materialize in execution, so that, though the details of the scenery are substantially correct, the scene as a whole often is false." For Jarves, part and whole in these works were aesthetically irreconcilable.[77] Few critics were as direct in isolating the aesthetic dilemmas of midcentury landscape. But the problem of how to reconcile specificity with compositional breadth persisted, offering a symbolic arena in which to test the relationship of the local to the national landscape.

On one revealing occasion this key aesthetic dilemma of the day was formulated in the political discourse of nationalism, exposing a major ideological ingredient embedded within the ostensibly neutral language of form. The context was an 1849 review of Church's *Evening after a Storm*. Describing at some length certain problems with the foreground, whose details, the writer complained, were poorly assimilated with the rest of the landscape, the review concluded by urging the artist to keep ever in mind "the production of great harmonious wholes, where each part is in perfect *keeping* with all the rest, and the result is a single irresistible impression, formed out of many—*e pluribus unum*—if such an application of words be admissible."[78] The sudden intrusion of a political motto into an art review reveals the reciprocity of aesthetic and political language in these years. Both turned on the question of unity. Aesthetic issues of composition were understood in terms

77. James Jackson Jarves, *The Art-Idea* (1864), ed. Benjamin Rowland, Jr. (Cambridge: Belknap Press of Harvard University Press, 1960), p. 191. The remark contains the germ of Jarves's critique of academic landscape art in America. See also his comment in *Art-Hints: Architecture, Sculpture, and Painting* (New York: Harper Bros., 1855), p. 294, concerning "the obtrusive realism and superficiality of thought" of "popular painters" in America; also "The Representative Art," *Atlantic Monthly* 5 (June 1860): 687: "This spirit of our age, this mixed materialistic and imaginative spirit . . ."

78. "Some Remarks on the Landscape Art," *Bulletin of the American Art-Union* 2 (November 1849): 16.

directly applicable to the major problems of nation building. Conversely, the fusion of parts into wholes which was a critical process in nation building offered a ready analogy with the art-making process. Political nationalists, perhaps influenced by the language of art, envisioned nation building as a form of picture making—a synthesis of parts in which individual elements would give up their refractory local character in exchange for participation in a larger community, although the nature of this community often remained frustratingly vague. Nationalism was described as a panorama or a composition that required, like any good painting, the proper relationship between part and whole, detail and broader narrative, in which local experience provided the raw material for a synthesis larger than the sum of its parts. This use of artistic and compositional terms to describe the project of nationalism placed a controlling conceptual framework around an issue that was notoriously open-ended. It also offered a vision of higher unity in place of a mere accumulation of individual elements. It assumed that every American must to some extent possess the intuitive apprehension of an artist—or else rely on images created by artists—in order to move beyond the mere mechanical extension of the known which often made do for a deeper kind of national sentiment.[79]

Such an organic and intuitive, as opposed to additive, approach to nationalism did well to turn to image-making analogies, for images were relatively free from the temporal conditions of language, with its dependence on sequence. Of course, images carried their own inherent limitations. They could make their appeal to an organic nationalism only through metaphor, analogy, or emblem. Indeed, the very integrity of the concept of nationalism resided in its lack of referential specificity. Paintings such as *New England Scenery* offered a hypostatized image for a dynamic and elusive process that continually redefined its object from moment to moment.

The aesthetic dilemmas Church inherited as a member of his generation go a long way toward explaining the compositional disunities of *New England Scenery*.

79. The difference between additive and organic approaches to nationalism recalls Coleridge's influential distinction between fancy, a purely mechanical faculty, and imagination, capable of original new creations. See M. H. Abrams, *The Mirror and the Lamp: Romantic Theory and the Critical Tradition* (New York: Oxford University Press, 1953), pp. 161–62, 168–69, 175–76. In his biography of the artist, Warner, in Kelly, *Frederic Edwin Church*, p. 188, clearly sensitive to such issues, brought the machine and organic images together in explaining Church's technique: "Having completely familiarized himself with the nature, the individuality, of the greatest possible variety of the elements that make up a scene, having acquired the skill to reproduce them faithfully, his own intuitions showed him how to bring them together, as the maker of a machine knows how to assemble the parts in an organic whole." Warner addresses here the major critical issue raised by Church's painting for his own contemporaries: the relationship of part to whole.

But Church's inexperience as a painter, and the problems with which he and his contemporaries were grappling, accentuated the deeper programmatic dilemmas he faced as he attempted to paint a regional landscape with a national appeal, a composite composition that transcended its parts, and a work that simultaneously envisioned New England as a physical place and as a cultural blueprint for the entire nation. Any nationalist program in the 1850s was premised on the assumption that regional loyalties would be subsumed by national ones, yet Church appeared reluctant to let go of the specifics of place in favor of an abstraction. In addition, in the decade before the war loyalty to the Union was shaped by a specifically northern form of nationalism indebted to the historic values for which New England stood, and which specifically precluded the South. To be a nationalist in the 1850s meant embracing a concept of nationalism that was no longer inclusive. *New England Scenery* appears in retrospect a highly unresolved and problematic solution to the challenge of national image making.

The unstable coupling of narrative and icon, history and stasis, is evident in the formal disjunctions and compositional disunities of the painting. The tension between the assertiveness of individual components and the fiction of a larger organic unity parallels the very problem the artist attempted to address: how to reconcile attachment to place with a larger abstract nationalism. The missionary venture that appears as the motivating force of the "New England way" is frustrated by topography itself. Expansive movement battles with the magnetism of place, and dynamic process confronts stable identity in a work that never resolves these polarities.

In calling his painting *New England Scenery,* Church tacitly acknowledged his inability to represent a dramatic process whose final outcome more than ever before rested in the balance. Cole's *Oxbow* translates dramatic natural events into narrative terms, a translation Church never successfully made. What he painted was the scenic backdrop of an untransacted destiny—not an image of American nationalism and its discontents, but the desire for it. The representation of the thing stood in place of the contested thing itself. As the title suggests, it is a stage without action. The painting reveals the effort, and ultimate failure, to represent nationalism. In place of a process realized in time, it offers a static vision of a mythic republic, too brittle to adjust to the complexities of history. It represents a retreat from the difficult challenges of national identity.

The final polarity raised by this work is that between a transcriptive theory of representation and one that is constitutive. To transcribe was to image a form of nationalism already materialized in nature, a very different undertaking from an approach to representation that acknowledged the inventive, synthetic character of

nationalism and the artifacted quality of its representations.[80] In *New England Scenery* Church remained poised uncomfortably between rhetorical transparency and manipulation, between his role as a nationalist taking his lead from nature and merely reassembling to reveal a higher order, and as a moral visionary using art to mediate the challenge of American identity, in the manner of Cole. Identifying with the scene of American nationalism—its context—he succeeded in evoking only its elusive quest.

In 1853, two years after painting *New England Scenery,* Church made the first of two trips to South America. His travels furnished him with a rich and virtually untapped body of landscape subjects ripe for cultural exploitation (see, for example, *Tamaca Palms,* 1854, figure 41).[81] Perhaps no other artist of his generation was better prepared to grasp the pictorial possibilities of the South American landscape; no other artist was as technically capable of mastering its visual intricacies and submitting them to an encompassing symbolic program, as Church was able to do in *The Andes of Ecuador* (1855, figure 28). Church's contemporaries quickly identified him with South American scenery. Three decades later he was still painting South American subjects such as *Sierra Nevada de Santa Marta* (1883, figure 42). Lacking the edge of fresh discovery, however, these landscapes suggest the static quality of frequently rehearsed, remembered images. Their original symbolic content reduced by history to irrelevance, they are diminished to exotica, comfortably occupying a place on the wall beside the academic orientalists of the later nineteenth century, surrounded by the bric-a-brac of the cultivated traveler, the shawls and ottomans, the stereoscopic views of the Holy Land and the Far East.

Yet when Church first began to extend his landscape range from the northeastern United States to the southern hemisphere, his choice of subject was charged with meaning. His art developed from subjects such as *Hooker and Company* (1846, see figure 36), imbued with place-specific historical associations, to *New England Scenery,* in which regional identity became one component within an emergent struggle of sectional loyalties. Nonetheless, his search for nationally representative landscapes had moved by the late 1850s to embrace the hemisphere. This movement from the place-specific to the hemispheric was one solution to the problems he first encountered in painting the New England landscape for a national audience.

80. Warner, in Kelly, *Frederic Edwin Church,* p. 185, claimed for Church "the spirituality that made him an interpreter of nature rather than a transcriber, and enabled him to reveal her soul through its manifestations in form." See also p. 187, where Warner defends Church against the charge of literalism.

81. *Tamaca Palms* was one of four paintings based on Church's 1853 trip which he exhibited at the 1855 exhibition of the National Academy of Design. On Church's first voyage to South America, see Kelly, *Frederic Edwin Church,* pp. 48–50.

Figure 41. Frederic Edwin Church, *Tamaca Palms*, 1854. Oil on canvas; 27¾″ x 36½″. In the collection of The Corcoran Gallery of Art. Gift of William Wilson Corcoran.

Humboldt's global vision lay behind the midcentury fascination with South America as a natural laboratory of geological processes that furnished clues to the origins of the earth itself. In addition to Humboldt's scientific and artistic stimulus, political and commercial ties between the two hemispheres also prompted interest in South America.[82] Possessively referred to in periodical literature as "our southern

82. On the North American fascination with South America during this period, see Katherine Emma Manthorne, *Tropical Renaissance: North American Artists Exploring Latin America, 1839–1879* (Washington, D.C.: Smithsonian Institution Press, 1989).

Figure 42. Frederic Edwin Church, *Sierra Nevada de Santa Marta,* 1883. Oil on canvas; 40″ x 60½″. Washington University Gallery of Art, St. Louis. Gift of Charles Parsons, 1905.

continent," South America seemed a new land of promise ripe for the reception of North American social and political values.[83] Americans cast an avuncular gaze toward their political protégés, the youthful republics formed by the colonial revolutions of the early nineteenth century. North American cultural patronage of these new republics, however, became increasingly proprietary with developing interest in commercial and trade relations and, among southern slave interests at least, in outright colonization.[84] To these familiar intellectual, scientific, political,

83. Katherine Manthorne, *Creation and Renewal: Views of Cotopaxi by Frederic Edwin Church* (Washington, D.C.: Smithsonian Institution Press, 1985), p. 56.

84. One such instance was the scheme promoted by Matthew Fontaine Maury, director of the U.S. Naval Observatory up to the outbreak of the Civil War. A vocal southern apologist, Maury advocated the colonization of the Amazon Valley by southerners, a scheme that would vastly enlarge the

and commercial interests in South America one may add Church's personal ambition as an artist, his desire not only to extend the technical achievements of his art through fresh challenges, but also to adapt the landscape genre to the new requirements of an increasingly embattled national identity.[85]

Following his 1853 trip to South America, Church focused his interest in the North American landscape on the wilderness areas of Maine, and slightly later on the far northern reaches of Labrador.[86] Turning away from the more settled areas of southern New England, he was drawn to largely uninhabited regions, producing landscapes that were fitting pendants to his growing concern with South America. He chose subjects removed from the reach of sectional associations and attuned instead to the generically American qualities of pure wilderness. Titles such as *Autumn, Sunset,* and *Twilight* underline the permanence of nature's cycles.[87] By emphasizing the wilderness attributes of American scenery, Church shifted his covert dialogue with audiences from a concern with sectional differences to a concern with the larger distinction between America and the Old World. By unifying North and South America through a comprehensive hemispheric portrait, he reinforced the myth of American exceptionalism—a vision of cultural uniqueness shared by all Americans, northerners, southerners, and westerners.[88] His move to South America, like his move into pure wilderness subjects, deflected internal rivalries between slave and free states onto a shared sense of cultural difference from Europe.

Interpreted by Church, the Andean scenery of Ecuador was a landscape of

geographical arena of the slave-based plantation system and solve some of the looming problems of economic sectionalism. See John P. Harrison, "Science and Politics: Origins and Objectives of Mid-Nineteenth-Century Expeditions to Latin America," *Hispanic American Historical Review* 35 (May 1955): 175–202; Gordon Connell-Smith, *The United States and Latin America: An Historical Analysis of Inter-American Relations* (London: Heinemann Educational Books, 1974), pp. 49–56; Manthorne, *Tropical Renaissance,* pp. 51–53. Also of relevance is Angela Miller, "American Expansionism and Universal Allegory: William Allen Wall's *Nativity of Truth,*" *New England Quarterly* 63 (Fall 1990): 446–67.

85. For a somewhat different interpretation of Church's interest in South America, see Kelly, *Church and the National Landscape,* pp. 77–79.

86. See Kelly and Carr, *The Early Landscapes of Church,* pp. 75–76. Kelly, *Church and the National Landscape,* p. 79, dates Church's turn away from New England pastoral subjects to 1855, after which date he focused on wilderness views.

87. Kelly, *Frederic Edwin Church,* lists eight paintings, two of them sketches, carrying the title *Autumn* or some variant; the first of these was painted in 1853.

88. Kelly, *Church and the National Landscape,* p. 114, describes Church's *Heart of the Andes, Twilight in the Wilderness,* and *Icebergs* as a "landscape trilogy that spanned the entire north-south axis of the New World."

Figure 43. Frederic Edwin Church, *The Heart of the Andes*, 1857. Oil on canvas; 66⅛" x 119¼". The Metropolitan Museum of Art. Bequest of Mrs. David Dows, 1909.

breathtaking scale, millennial promise, and lush Edenic abundance synthesized in his great Humboldtian *summa, The Heart of the Andes* (1857, figure 43). Such scenery was at the same time symbolically open to new interpretations, unbounded by limiting references to a specific historical experience. His South American landscapes, for example *View of Cotopaxi* (1857, figure 44), were grounded in an older tradition of paradisal New World images. Too great an associational specificity imposed boundaries on a concept of nationalism that demanded infinite elasticity to accommodate the considerable social, economic, and political divisions of the 1850s. It was still possible in the opening years of the decade to dress an appeal to unifying nationalism in the homespun garb of New England; the political polarization of the mid-fifties, however, increasingly burdened regional imagery with sectional associations. For a painter who had built his reputation on New England subjects, and who remained dedicated to the preservation of the Union,

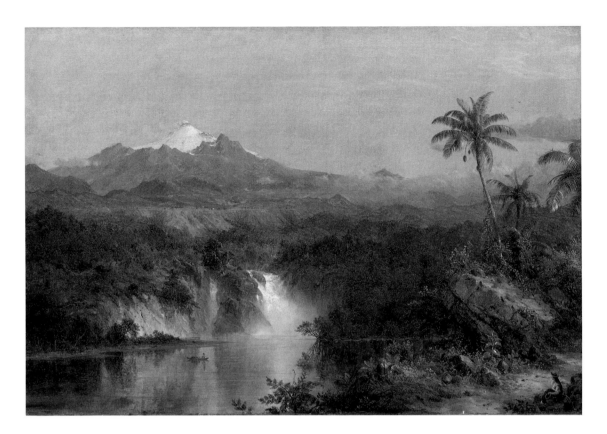

Figure 44. Frederic Edwin Church, *View of Cotopaxi*, 1857. Oil on canvas; 24½″ x 36½″.
Gift of Jennette Hamlin in memory of Mr. and Mrs. Louis Dana Webster, 1919.753.
Photograph © 1991, The Art Institute of Chicago, All rights reserved.

this intensification of sectional feeling raised serious questions about his chosen subject matter. When Church answered Humboldt's scientific and aesthetic summons to paint the landscape of South America, he was also answering a call for unity of sentiment by painting a landscape that in theory carried more or less the same meaning for all Americans. Images of South America avoided the divisive political realities inscribed in their own landscape.

The Far West served a similar function, promising a renewal of national hopes with landscapes of heroic and unfamiliar dimensions such as Bierstadt's numerous operatic views of Yosemite Valley (see, for example, *In the Mountains*, 1867, figure 45) and Thomas Moran's of the Yellowstone and the Grand Canyon.[89] In light of the

89. Bierstadt's first western paintings predate the war, dating to his trip with the Lander expedition in 1859.

Figure 45. Albert Bierstadt, *In the Mountains*, 1867. Oil on canvas; 36³⁄₁₆″ x 50¼″.
Wadsworth Atheneum, Hartford. Gift of John J. Morgan in memory of his mother, Juliet
Pierpont Morgan.

complex forces already transforming the West from a mythical Eden into an
industrial Atlantis, Bierstadt and Moran approached this landscape with consider-
able conviction.[90] One can only wonder why Church himself never traveled to the
West, why his wanderings were measured by latitude rather than longitude.

Church's effort to avoid the inherent imaginative limits of the familiar by
removing his nationalistic subject matter to a politically and associatively uncon-
taminated and distant realm resembles the introduction of *mirabilia*—marvelous,
strange, and unfamiliar detail such as American Indians—into eighteenth-century

90. Alan Trachtenberg, *The Incorporation of America: Culture and Society in the Gilded Age* (New
York: Hill and Wang, 1982), pp. 11–37.

history painting. The effect of these additions to the academic language of the genre was to achieve universality by appealing to the exotically distant, transcending the modern or local.[91]

Despite their visual complexity, Church's paintings of the Andes may have posed fewer intellectual demands on his contemporaries than *New England Scenery,* for even while he taxed their eyes with a vision that appeared as inexhaustible as nature itself, he saved them the difficulty of adjusting local to national sympathies. In South America he could sublimate the political debate over nationalism into an exalted image of nature close enough for Americans to claim as their own yet far enough away not to aggravate divisive political tensions.

In light of such a possibility, it is ironic that in the decade before the war South America, like the West, had also been drawn into the sectional dispute. If its vast river basins promised new markets for the commercial North, its unpopulated and fertile Amazonian wilds offered a new lease on life for a slaveholding economy that needed to expand in order to remain viable. Church's own trip to Ecuador in 1853 was underwritten by his friend and companion on the journey Cyrus Field, who was drawn there by the promise of mineral wealth. As with the more recent case of Antarctica, the promise of a land free from economic, commercial, or political rivalries proved to be delusory. Yet for a few years at least the artistic illusion created by Church was a resounding success, immediately compelling in its scientific and visual authority, its exoticism, and its summons to a fresh new natural paradise untouched by politics.

91. Edgar Wind, "The Revolution of History Painting," *Journal of the Warburg Institute* 2 (October 1938): 116–18; Charles Mitchell, "Benjamin West's 'Death of Wolfe' and the Popular History Piece," *Journal of the Warburg and Courtauld Institutes* 7 (1944): 21; and Mitchell, "Zoffany's Death of Cook," *Burlington Magazine* 84 (March 1944): 56–62.

6 / The Sectional Conflict in the 1850s
Fissures in the National Landscape

*One who was not large enough, both in mind and in
heart, to embrace the whole, was not fit to be intrusted
with the interest of any part. . . . When my eyes shall
be turned to behold for the last time the sun in heaven,
may I not see him shining on the broken and
dishonored fragments of a once glorious Union.*
—Daniel Webster, "Second Speech on Foot's
Resolution"

The claims to representing a national school made by the landscape painters of the
National Academy of Design did not go unchallenged. By the late 1850s the very
concept of a national art seemed hedged about with qualifications. Should it speak
for and represent the South and the West? Given the existence of distinct values and
social systems in different regions of the country, upon whose values and tastes
should a national art be modeled? As we have seen, local subject matter was
susceptible to sectional loyalties that cut across its nationalist claims. This chapter
maps the rift that opened up in the topography of antebellum art, dividing from
within the unitary and unifying enterprise of the national landscape.

As we have seen in the case of Frederic Church's *New England Scenery,* at critical
periods landscape imagery enhanced an awareness of locality and of section that
countered nationalist claims.[1] Its symbolic power was compromised, or at least
scaled down and redefined, to fit within nationalism's newer and pointedly north-
ern contours. Through increasingly more fully developed institutions of cultural
production—publishing and book distribution, exhibition, criticism, and other

1. Ann Norton, *Alternative Americas: A Reading of Antebellum Political Culture* (Chicago: University
of Chicago Press, 1986), rethinks scholarly assumptions about a unified nationalism growing out of a
northeastern, Puritan-centered tradition by exploring the political and cultural implications of
southern attitudes toward nature and other areas of experience. Also useful is John M. Murrin, "A
Roof without Walls: The Dilemma of American National Identity," in Richard Beeman, Stephen
Botein, and Edward Carter, eds., *Beyond Confederation: Origins of the Constitution and American
National Identity* (Chapel Hill: University of North Carolina Press, 1987), pp. 333–48.

forms of promotion—northeasterners actively shaped the definition of nationalism. These institutions and their members melded refractory elements of national life into a formal unity that recognized the principle of diversity while policing it through aesthetic norms and conventions of propriety. They offered the promise of a complete and unitary landscape in place of a discontinuous and fragmented body politic. The unity of the natural landscape, composed through art, served as a metaphor or symbolic substitute for other, more elusive forms of social and cultural unity. Eastern institutions organized and controlled the variety of competing regional characteristics.

One sign that a normative perspective was tacitly operating was the tincture of condescension that crept into New York writers' discussions of western types, or the defensively didactic tone that typified lofty declarations of the representative character of certain landscapes. This point of view was firmly entrenched in New York by the 1850s, by which time the city was engaged in an effective cultural campaign to recast the raw materials of a national culture into identifiable and palatable forms. These raw materials gained national status through acknowledgment by major cultural figures such as Henry Tuckerman, and through their translation from the popular culture of almanacs, local lore, and rough wood engravings into the middlebrow and high culture of oil painting, gift-book and literary journals, and engravings. Tuckerman struck the proper attitude when he wrote of popular culture:

> The caricatures in *Punch,* the rude "counterfeit presentment" of a popular
> statesman, the wooden filagree of an anomalous villa, the coarsely "illustrated"
> paper delineating an event or a personage about which the town is occupied, bank-
> bill vignettes, Ethiopian minstrels, and "the portrait of a gentleman," form the
> staple art-language for the masses; and, in all this, there is little to kindle aspiration,
> to refine the judgement, or to hint the infinite possibilities of Art.[2]

Tuckerman's language here reveals his own anxieties about other forms in which the counterfeit or meretricious paraded as the real. In his damning vision of popular culture the demagogue poses as the statesman, caricature is presented as character, white is presented as black, and paper money is presented as real. The value of art vis-à-vis more popular forms of representation thus emerges as a type of authentication, underwritten by a class that held the monopoly to authorize

2. Henry Tuckerman, "Art in America: Its History, Condition, and Prospects," *Cosmopolitan Art Journal* 3 (December 1858): 7.

what was "true," and to control the carnivalesque inversions of regional and social subcultures for which "truth" was only a pretext.[3]

Before analyzing the dilemmas that rising sectionalism posed to the concept of a national landscape, I want to consider the political rationale for a nationalism grounded in place. This nationalism would become increasingly problematic as regional loyalties hardened into sectional antagonisms. Throughout much of the antebellum period regional identity was the lens through which nationalism was filtered and took shape. An embrace of local diversity, a sometimes truculent but good-humored pride of place, was the cultural expression of political confederation, widely celebrated by Americans and Europeans alike as the key to America's success in combining physical expansion with democratic liberties and local rights. As an article in the *Atlantic Monthly* stated the problem in 1861: "The fundamental idea of the American system is local self-government for local purposes, and national unity for national purposes."[4] By means of the federative principle, Americans maintained a just balance between the rights of the locality and the imperatives of the central government, thus finding a solution to one of the key dangers faced by the new imperial republic: how to maintain political cohesion and union in a time of expanding boundaries that threatened, as in the example of ancient Rome, the collapse of the republic under its own weight.

According to the federative model, nationalism was the abstraction and enlargement of local attachments, the product of a synthetic faculty that transformed personal experience into shared associations. It was not necessary to resort to a mystical imperative in the call for national sentiment; Americans would substantiate the call through their own experience of place. Nationalism was localism writ large.[5] Despite the erosion of local autonomy over the course of the nineteenth century, the fact remained that in the 1850s communities in the Mississippi Valley,

3. The relationship between high culture and popular forms is discussed further in Angela Miller, "The Mechanisms of the Market and the Invention of Western Regionalism: The Example of George Caleb Bingham," *Oxford Art Journal* 15 (1992): 3–20. This essay will be republished in David Miller, ed., *American Iconology: Situating the Image in Nineteenth-Century Culture* (New Haven: Yale University Press, 1993). On the relationship of the normative language of a dominant class to a multiplicity of other languages whose meanings are determined by social contexts, see Mikhail Bakhtin, "Discourse in the Novel," in *The Dialogic Imagination: Four Essays,* ed. Michael Holquist (Austin: University of Texas Press, 1981). The term "carnivalesque" is likewise Bakhtin's.

4. "Where Will the Rebellion Leave Us?" *Atlantic Monthly* 8 (August 1861): 238.

5. John McCardell, *The Idea of a Southern Nation: Southern Nationalists and Southern Nationalism, 1830–1860* (New York: W. W. Norton, 1979), pp. 143–54.

along the Ohio Valley, throughout New England and the central Atlantic states, and in the South all defined daily life primarily around the qualities of the immediate environment. Geographical distance ensured de facto community autonomy and countered the tendency toward political centralization, but the counterdanger was that of atomization. Federation avoided these twin shoals of republican government—centralization and dispersion—furnishing guarantees that republican forms could be indefinitely multiplied across the frontier.[6]

Tocqueville articulated the principle to a southern planter during his 1831 journey through the United States: "What still singularly favours the Republic with you is the fact that you form a number of small and almost entirely separated nations." The planter took the principle even further: "Not only does each State form a nation, but each town of the State is a small nation, each ward of a town is a small nation, has its particular interests, its government, its representation, its political life in a word."[7] Implicit in the planter's explanation, however, was the danger of a regression toward ever smaller units ending with the individual, a situation that portended the atomization of the republic.

George Bethune identified the principle of federation—variety within unity—as both a political and a cultural agency of central importance: "How far beyond the conception of European statesmanship is the simple law by which the very multiplicity of our well-guarded state sovereignties best secures our national union!" History furnished the precedent for America's current course. Overlooking the implications of the imperial analogy with ancient Rome, Bethune praised the latter's "successive engorgements of neighboring people" as an example of cultural and national heterogeneity. A commonality of purpose ensured unity within diversity. Emigration enriched rather than diluted the great national enterprise, whose unity clearly resided for Bethune in ideological consensus rather than in any

6. Major Wilson, *Space, Time, and Freedom: The Quest for Nationality and the Irrepressible Conflict, 1815–1861* (Westport, Conn.: Greenwood Press, 1974), pp. 30–32.

7. Alexis de Tocqueville, quoted in George Pierson, *Tocqueville and Beaumont in America* (New York: Oxford University Press, 1938), pp. 424–25; see also pp. 121–22, 185, 383, 413, 776. Francis J. Grund, *The Americans in Their Moral, Social, and Political Relations,* 2 vols. (London: Longman, Rees, Orme, Brown, Green, and Longman, 1837), 2:13–18, gives a closely related analysis of the relationship of local to national culture. Also relevant are Michel Chevalier, *Society, Manners, and Politics in the United States,* ed. John William Ward (Ithaca: Cornell University Press, 1961), p. 88; John C. Calhoun, "Speech in reply to Mr. Webster, on the Resolutions respecting the Rights of the States, delivered in the Senate, Feb. 26th, 1833," and his "Speech on his proposition to cede the Public Lands to the new States . . . delivered in the Senate February 7, 1837," in *Works of John C. Calhoun,* ed. Richard K. Cralle, 6 vols. (New York: D. Appleton, 1881), 2:262–309; 634–52, esp. 637–38, 645.

equivalence of parts. He was arguing for the important role of art in extending American cultural values across the continent. Is it presumptuous, he asked, "to hope that, as empire marches westward, Art may here attain the lustre reserved for her destined acquisition of universal sway?" What distinguished the civilized from the noncivilized nations of the world was the existence of a physical record of a culture's self-image. Art was one such record. Art would help shape the consensus of beliefs that would counteract the centrifugal force of westward migration and help ensure a binding nationalism.[8]

Faith in the federative principle, however, was at least matched by anxiety that the pull of distance would diffuse commitments to more abstract values. In response to the perceived danger that national sentiment would not withstand the migratory habits of Americans, nationalists put greater stock in symbols of nationhood: the dome arching to the sky expressed democratic aspirations, the obelisk of the Washington Monument recalled a common ancestry, the sublime waterfall with its rainbow arc expressed the nation's proud natural patrimony and special covenant with God. Yet for such national symbols to work, the public audience for them had to be able to shift easily between local realities and translocal abstractions. This process was vastly facilitated by the rise of a national market for images of the landscape.[9] As a writer for the *Atlantic Monthly* put it in 1858: "The greatest benefit . . . we owe to the artist, whether painter, poet, or novelist, is the *extension of our sympathies*. Art is the nearest thing to life; it is a mode of amplifying our experience and extending our contact with our fellow-creatures beyond the bounds of our personal lot."[10]

This extension of sympathies occurred through shared ideological allegiances among those whose lives were increasingly defined by a new spatial and associative mobility. Mechanized travel played its part. Nonetheless, the emergent landscape of national meaning constituted by train travel, interregional markets, and cultural organizations with national distribution such as the American Art-Union proved at times to be poor compensation for the weakening of secure local attachments grounded in a continuous family history, in oral communication, and in a knowl-

8. George Bethune, "Art in the United States," in *Home Book of the Picturesque; or, American Scenery, Art, and Literature* (1852; reprint, Gainesville, Fla.: Scholars' Facsimiles and Reprints, 1967), pp. 168, 170, 182.

9. Landscape images worked, in this sense, very much in the manner of what Benedict Anderson has called "print languages," crucial factors in the formation of the "imagined communities" that constitute a sense of nationalism. See Anderson, *Imagined Communities: Reflections on the Origin and Spread of Nationalism* (London: Verso, 1983), esp. pp. 41–49, 66–77.

10. "Something about Pictures," *Atlantic Monthly* 1 (February 1858): 403.

edge and experience that was place-specific. The advent of train travel heightened awareness and appreciation of certain picturesque or quaint features of the landscape. As James Fenimore Cooper wrote in *The Home Book of the Picturesque:*

> The graceful winding curvatures of the old highways, the acclivities and declivities, the copses, meadows and woods, the half-hidden church, nestling among the leaves of its elms and pines, the neat and secluded hamlet, the farm-house, with all its comforts and sober arrangements, so disposed as to greet the eye of the passenger, will long be hopelessly looked for by him who flies through these scenes, which, like a picture placed in a false light, no longer reflects the genius and skill of the artist.[11]

Nathaniel Hawthorne sketched the impact of a national market and print culture on an insular New England community in an early short story, "The Bald Eagle." He describes a small Connecticut Valley town frantically preparing for the rumored arrival of the Marquis de Lafayette on his triumphal tour of the nation. The year must therefore be 1824, and the signs of an emerging national order and market are evident on the walls of the local tavern in advertisements for "new invented machines, patent medicines, toll gate and turnpike companies, and coarse prints of steam boats, stage coaches, opposition lines, and Fortune's home forever."[12] The old order and the new—oral and print culture—meet and converse in familiar terms here as villagers discuss the latest political news. Communal sociability, gossip, and popular lore persist within the newer pace set by the periodic arrival of the daily stage, bringing news and information from the outside world. The carrier of change in this community is the turnpike, not only the avenue for travel, as well as news and information, but also emblematically the conduit of patriotic feeling, bringing heroes from abroad, placing the local environment into contact with the landscape of national symbols and meanings. The sudden and total reorientation of the town following news of the "Gin'ral's" arrival is symptomatic of the impact produced by national events upon the traditional fabric of local life. All normal activity ceases as the talents of townspeople—tailor, schoolmaster, lawyer-orator, militiamen, cooks, tavernkeepers, and schoolchildren—are redirected toward the reception of Lafayette at noon the next day. Yet the heralded event never transpires. Lafayette, it is announced after hours of tense waiting, has taken another road.

Hawthorne's sketch manages to convey how the nonevent, in the name of an

11. *The Home Book of the Picturesque,* p. 66.
12. Nathaniel Hawthorne, "The Bald Eagle," in S. G. Goodrich, ed., *The Token and Atlantic Souvenir* (Boston: Gray, 1883), pp. 74–89; quote on p. 76.

essentially abstract nationalism, furnishes the occasion for a reaffirmation of local community. He suggests that symbols of nationalism—and Lafayette remains at best a distant one—rely on local experience. Indeed, the newer economic and spatial order of turnpikes and steamboats in the end deludes and disappoints the patriotism of the villagers rather than serving it. The actual space of community, centering on hearth, tavern, and school, coexists with a newer space abstractly organized around the intervals of the timetable, the distance between stage stops and cities. Yet eventually, as Hawthorne's readers probably sensed, the old preindustrial patterns would find themselves displaced, as well as the experience of localism that defined communal life.

Localism and nationalism remained compatible in a context that recognized the complementarity of regional and national interests. In the early 1850s the Whig party most consistently articulated the ideal of a nationalism that acted to regulate and moderate the play of regional identities. Shunning partisan sentiment, Whig ideology advocated programs rooted in the broadest vision of American life. Daniel Webster and Henry Clay—twin pillars of the party—both made their careers by successfully accommodating their regional concerns to a broad national agenda. Webster supported compromise and played down the separate nature of his own region's economic and political concerns. Clay advocated a strong central government and supported internal improvements. Yet by the end of 1851 both statesmen were dead. The Whig spirit of compromise they represented was breaking down, and with it an all-inclusive version of nationalism that transcended sectional interests.[13]

Drawing on attachment to a particular place and an identifiable landscape, regionalism as a basis of nationalism acknowledged the claims of economic and political interdependence and shared history that bound separate regions into a whole. Regionalism was compatible with nationalism, construed not as a mosaic of separate and distinct localities but as a partnership of equals enjoying the benefits of a strong central government. By contrast, sectionalism negated any sense of shared culture, placing loyalty to a particular place above allegiance to the Union.[14] By midcentury this older version of nationalism rooted in the specifics of the local

13. Paul C. Nagel, *This Sacred Trust: American Nationality, 1798–1898* (New York: Oxford University Press, 1971), pp. 47–94. See also George B. Forgie, *Patricide in the House Divided: A Psychological Interpretation of Lincoln and his Age* (New York: W. W. Norton, 1979), pp. 159–60.

14. William B. Hesseltine, "Regions, Classes and Sections in American History," in *Sections and Politics: Selected Essays* (Madison: State Historical Society of Wisconsin, 1968), p. 110, gives a definition: "Sectionalism is the combination of comparable dominant groups in contiguous regions in order to exploit other regions or the nation as a whole. . . . Sectionalism is competitive rather than cooperative; it is directed toward particularistic rather than national ends."

and regional landscape had been discredited by its new association with sectional apologetics.[15]

Nature, a resource possessed, in theory, by all Americans, presented a solution to regional and later sectional disunities by offering a nonspecific and expansive symbol of nationalism. Landscape art provided refuge from the combative loyalties of place in images of a natural vineyard where the covenant would be renewed through the timeless and persistent agency of nature itself.[16] Such symbols of unity served the crucial function of rhetorically constituting a shared identity in place of the thing itself.

Yet during the 1850s the sheer pressure of public events assumed precedence over mental habits, eventually effecting a reorganization of symbolic paradigms and undermining the explanatory power carried by the cultural myth of "nature's nation."[17] Insofar as depictions of American nature inevitably bore the impress of certain cultural regions, they could also be enlisted in the shadow play of sectional loyalties being enacted before the war. Nature itself became covertly politicized.[18] Images of nature had at one time worked to gloss over political contradictions. They did so by projecting the vision of a reified space whose status as "nature" disguised its role in the production of cultural rhetoric and in the consolidation of northeastern identity. In the years before the war these contradictions broke through the surface, clamoring for recognition.

As problems of nationalism made their appearance on the political front, they

15. Benjamin Spencer, *Quest for Nationality: An American Literary Campaign* (Syracuse: Syracuse University Press, 1957), pp. 253–58.

16. Nagel, *This Sacred Trust*, chap. 3, contends that the crisis of the 1850s overwhelmed geopolitical arguments for national unity, which meant that nature's appeal now needed to rely less on physical conditions and more on sentimental attachment. This shift may help explain the movement toward more domesticated, settled landscapes and away from an older nationalist rhetoric of sublime nature as the stage of cultural self-definition.

17. In a curiously inverted sense the myth may have shaped the reality, for its persistence perhaps delayed the effort to find political solutions to the sectional crisis. On the relationship between history, myth, and ideology, see Richard Slotkin, "Myth and the Production of History," in Sacvan Bercovitch and Myra Jehlen, eds., *Ideology and Classic American Literature* (New York: Cambridge University Press, 1986), pp. 70–90.

18. The quandary of a "national" art in a decade characterized by strong sectional loyalties would seem more immediate in the realm of genre, explicitly preoccupied as it was with the portrayal of local character types readily identifiable as Yankee or frontier, eastern or western. Yet, as Elizabeth Johns has argued in her study *American Genre Painting: The Politics of Everyday Life* (New Haven: Yale University Press, 1991), one primary function of genre painting was to consolidate a sense of one's social position relative to members of other social groups. Since such loyalties ran across sectional and regional lines, the argument I am making about the specifically northern form of nationalism contained in landscape images is less relevant to genre.

also surfaced in the arena of cultural politics, most evidently in the 1850s. The dilemma focused on the dominance of New York City in the production of a national art. If political federalism was a venerated Whig principle, no corresponding principle of artistic federalism—pluralism of local expression combined with the support and promotion of nationwide objectives—was ever articulated. Instead, a single institution, the National Academy of Design (founded in 1826), became the self-appointed mouthpiece of a national artistic culture. The NAD, though not the oldest art academy in the nation, was the most successful and the first of its kind to be run by artists with the primary purpose of encouraging public appreciation of the arts.[19] The English model of a central academy for the training and support of artists remained an important and relatively undisputed element in the promotion of a national art in the United States. From its origins in the 1820s until the fourth quarter of the nineteenth century, the National Academy went from being the youthful bearer of artistic culture in the new republic to an entrenched elite with what some considered a stranglehold on artistic expression. Its virtual monopoly on the definition of artistic culture in the United States hampered the development of alternative definitions and expressions. It acted hegemonically.

If the challenge for nationalists was to engender a vivid and engaging sense of national community by overcoming the inertial pull of distance, local habit, and custom, the problem remained that the power to create such symbols belonged to those who possessed the instruments of cultural production. The importance of Niagara Falls as a national icon suggests how dependent the creation of cultural symbols was on the instruments of economic hegemony. With the opening of the Erie Canal, the falls became accessible to thousands of tourists each year.[20] As a natural feature Niagara attained its aesthetic preeminence not only through economic factors but also through associative qualities—size, sublimity, and power—that linked it to the republic. Adam Badeau explicitly drew the association between American nature and nation that imbued icons such as Niagara with cultural authority. American art, he wrote in 1859, "will be turbulent and impassioned," its artists "emotional, brimful of earnestness, perhaps even stormy" like American nature, "wild and ungovernable, mad at times."[21]

19. On the National Academy, see Lillian B. Miller, *Patrons and Patriotism: The Encouragement of the Fine Arts in the United States, 1790–1860* (Chicago: University of Chicago Press, 1966), pp. 100–102, 282, 283 passim.

20. On the relationship between the Erie Canal and New York's dominance as a literary market, see William Charvat, *Literary Publishing in America, 1790–1850* (Philadelphia: University of Pennsylvania Press, 1959), pp. 18–20.

21. Adam Badeau, "American Art," in *The Vagabond* (New York: Rudd and Carleton, 1859), pp. 122–23.

These icons, however, occupied the somewhat paradoxical position of celebrating not only wilderness but the will to subdue it. This "wild and ungovernable" spirit, represented for Badeau by Frederic Church's *Niagara* (1857, figure 46),

> is a true development of American mind; the result of democracy, of individuality, of the expansion of each, . . . inspired not only by the irresistible cataract but by the mighty forest, by the thousand miles of river, by the broad continent we call our own, by the onward march of civilization, by the conquering of savage areas; characteristic alike of the western backwoodsman, of the Arctic explorer, the southern fillibuster, and the northern merchant. So, of course it gets expression in our art.[22]

By evoking the power and energy of New World nature, *Niagara* drew its nationalistic lesson from an implicit contrast with the puniness of European nature. It redirected rivalry between the sections into a rivalry with Europe that was more generally shared by all regions of the country.[23] It appealed to America's cultural commonalities rather than to its growing internal divisions.

The uses of *Niagara* demonstrated one way around the problem of competition between cultural institutions and regions of the nation: through an imagery that deflected internal rivalries onto external foes. Much of the discussion concerning the character of a national art was shaped by what Robert Lawson-Peebles has termed "a rhetoric of negation," defined less by innate values than through an inversion of European values.[24] A democratic art was first and foremost anti-aristocratic, prepared, in the words of a writer for the *Bulletin of the American Art-Union,* to enlist "the intelligent masses" and to exploit "the popular theme." Other calls followed for an art that would express "the aspirations and sympathies of a nation," illustrating "a distinct national character."[25]

External challenges in the 1840s—the standoff with England over the Oregon boundary dispute and the war with Mexico—stimulated nationalist feeling.[26] The

22. Ibid., pp. 123–24.

23. Church sent *Niagara* abroad to England and Scotland, where it was widely admired and commented upon, fully realizing its role in representing American nature to Europe. See Elizabeth McKinsey, *Niagara Falls: Icon of the American Sublime* (New York: Cambridge University Press, 1985), pp. 243–47.

24. Robert Lawson-Peebles, *Landscape and Written Expression in Revolutionary America: The World Turned Upside Down* (New York: Cambridge University Press, 1988), p. 11.

25. "Development of Nationality in American Art," *Bulletin of the American Art-Union* 4 (December 1851): 139, 138.

26. Wilson, *Space, Time, and Freedom,* p. 112. See also Louis Hartz et al., *The Founding of New Societies* (New York: Harcourt, Brace and World, 1964), p. 93, on the intensifying sense of national

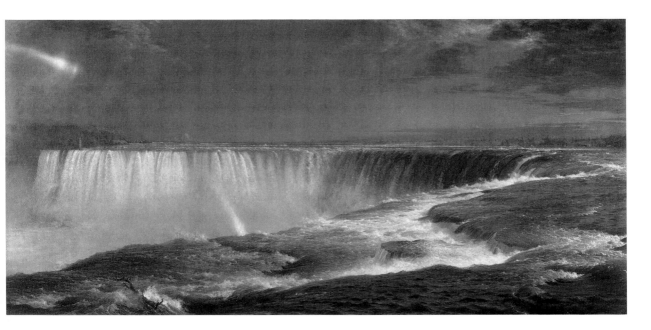

Figure 46. Frederic Edwin Church, *Niagara*, 1857. Oil on canvas; 42½″ x 90½″. In the collection of The Corcoran Gallery of Art, Museum Purchase.

territorial gains of the late 1840s, however, issued during the 1850s in the increasingly heated sectional disputes over the future of these regions as slave or free, disputes that could no longer be deflected onto external enemies.[27] The 1840s rhetoric of nationalism was fueled by a Democratic administration whose support came from intersectional alliances that spanned North and South, East and West. The national concerns that loomed largest in the 1850s, by contrast, were internal. The demise of the Whig party resulted in political realignments around issues that, by the end of the 1850s, had produced a virtual polarization along ideological lines. In the face of these growing internal tensions, apologists for a national art retreated to vague generality.

How well the displacement of internal antagonisms actually worked is difficult to

community that results from the triumph of democratic ideology, partly defined in opposition to minority groups.

27. The shift from external enemies to internal sectional divisions is revealed in volume 2 of *The Diary of George Templeton Strong*, ed. Allan Nevins, 4 vols. (New York: Macmillan, 1942), which is taken up heavily by the question of external disputes during the 1840s, while in the succeeding decade the diarist was absorbed to a greater degree in sectional, partisan commentary. Nagel, *This Sacred Trust*, p. 49, suggests that the nation's focus in the 1840s on physical expansion was a means of deflecting internal tensions. By the next decade these tensions had become too insistent to be denied.

gauge. Yet the fissures that opened up in the pan-national symbol of Niagara are apparent in its sectionalization during the war. At least one artist of strongly antisouthern sentiment identified the power of Niagara with the military and industrial might of a North prepared to crush the insurgents in the name of freedom. Celebrating "the freemen of the North," John Frankenstein, in his hysterically shrill epic in verse *American Art: A Satire,* used Niagara as an image of unquenchable northern power: "Like their Niagara, men, means still pour,/From out the mighty Northern reservoir,/Like their Niagara most truly great,/Most glorious while in that transition-state,/That bounding leaping toward the broader field/Their ocean-future only full can yield."[28]

Landscape painters would find it increasingly difficult to escape the politicized web of loyalties that organized national sentiments in the 1850s. New York–based landscape painters were implicated in discussions about the extent to which their choice of subject, their workplace, and their institutions were representatively national. The dominance of northeastern scenery, of New York as an art center, and of the National Academy of Design was each tentatively questioned. A sense of fatigue and boredom that anticipated the decline of the first New York School in the 1870s was already voiced from time to time in these early years. Underlying these vague expressions of malaise was the perception that the "national" school of landscape was in fact parochial and local. Increased sensitivity to the nationalist *claims* of landscape art ironically called forth the realization that the landscape genre did not always live up to them.

New York artists, publishers, and art institutions had three identifiable responses to these charges, each of which is explored in the ensuing discussion. First, and most revealingly, they defensively insisted on their political neutrality vis-à-vis the sectional polemics of the 1850s. Second, they redefined the issue of nationalism in exclusively northeastern terms, at times taking refuge in a covert language of sectional apologetics. Third, artists began exploring landscape subjects outside the Northeast, filling out the picture of the national landscape with scenes of the South and other regions they had neglected.

One indication of how far the issue of sectionalism had seeped into discussions of art and literature was the insistence on the nonpartisan interests of those who promoted an American art. The problem was stated in an article in the *United States Magazine and Democratic Review* of 1851, which identified one of the most incendiary beliefs fueling disunion, what the author referred to as "geographical discrimination—*northern* and *southern*,—*Atlantic* and *western;* whence designing

28. John Frankenstein, *American Art: Its Awful Altitude; A Satire,* ed. William Coyle (1864; reprint, Bowling Green: Bowling Green University Popular Press, 1972), p. 66.

men may excite a belief that there is a real difference of local interests and views." Playing upon fabricated regional differences is "one of the expedients of party"— misrepresenting "the opinions and aims of other districts." The resultant jealousies "tend to render alien to each other those who ought to be bound together by fraternal affection."[29] Journals promoting an American art accordingly played down sectional interests. In their eyes, to encourage local loyalties amounted to a form of national treason. Given the frequency with which northern politicians charged the South with promoting its sectional interests, many northern institutions took their stand on the higher ground of principle. In 1851 an article in the *Bulletin of the American Art-Union* praised the organization for its "national character. It has no sectional views, no local interests."[30] These sentiments were repeated in an article addressed "To the Friends of the Art-Union": "More strongly than ever . . . may the Art-Union appeal to the public, in this season of political agitation. It presents a field of work in which all may unite like brethren. It belongs to the *whole* people. It disregards all sectional differences. It is attached to no parties. It addresses the South as well as the North, the poor as well as the rich."[31] A notice for *The Flag of Our Union,* "a family miscellany," proclaimed that "in politics, and on all sectarian questions, it is strictly neutral."[32] Such decrees of political and economic neutrality were not always made in a disinterested spirit, however. Numerous New York journals, many of whose readers were southerners, not only desisted from antisouthern statements but frequently showed an exaggerated deference to southern feelings.[33]

Three years before the war, in an apparent effort to avert the coming crisis

29. "Northern Democracy and the Union," *United States Magazine and Democratic Review* 28 (May 1851): 474–75.

30. "Affairs of the Association," *Bulletin of the American Art-Union* 4 (October 1851): 117.

31. *Bulletin of the American Art-Union* 3 (April 1850): 2. See also "Nationality in Art," *Cosmopolitan Art Journal* 1 (March 1857): 77: "The name 'Cosmopolitan' was assumed . . . when it was decided to give the Institution truly world-wide sympathies and brotherhoods. It aims at no sectionality, and shall in no way minister to prejudices or assumptions which would narrow its labors, or circumscribe its influences."

32. *Gleason's Pictorial Drawing Room Companion,* July 5, 1851, p. 15. Neutrality was a more common concern in New York than in New England, and the reasons were not only ones of expediency. H. P. Floan, *The South in Northern Eyes, 1831–1861* (Austin: University of Texas Press, 1958), p. 112, states that Washington Irving and other northern writers "resented both Northern and Southern forces which aggravated sectional opposition." Such neutrality was more difficult for New Englanders, who tended to abstract an image of the South. Melville, Bryant, and Whitman, by contrast, "knew the South in all its variety and particularity."

33. See Philip Foner, *Business and Slavery: The New York Merchants and the Irrepressible Conflict* (Chapel Hill: University of North Carolina Press, 1941).

through rhetoric alone, the *Cosmopolitan Art Journal* evoked science and technology to bolster its appeal to nationalism:

> Disregarding all sectional controversies; cultivating an enlarged and liberal patriotism, which looks with equal favor and affection upon every portion of the Republic, and extending its list of memberships, like an endless net-work of electric wires, to every city and village and hamlet in the nation, our institution, if as we fondly trust, it shall, in due time, reach the glorious consummation designed by its founders, is destined to flash its light over every hill and valley; to stud the whole land with gems of art: and, by a simultaneous and impartial dissemination of its favors, through successive years, to inspire that unity of interest—that community of intelligence—that co-partnership of enterprise—that sympathy of purpose—and that fraternity of hope, which cannot fail to consecrate and give perpetuity to the Union, and to render our country as truly eminent in art and knowledge, "as she has already proved herself invincible in arms."[34]

The monotonous repetition of words signifying unity and continuity—"enlargement," "community," "co-partnership," "sympathy," "fraternity," "perpetuity"—has the cumulative effect of creating through language the kinds of organic bonds between regions that were increasingly lacking in fact. Such rhetorical flights were most necessary when the thing so constituted by language was most threatened in reality. The technological analogy that underlies the quotation gives the lie to the writer's insistence on the natural, geographically and divinely ordained unity of the elements making up the republic. Art appears here not as a natural force but as a man-made device for drawing together that which is sundered by space and by politics.

The writer for the *Cosmopolitan* thus betrayed two contradictory levels of meaning. The first was cast in an older rhetoric of a nationalism endowed by nature, the second in a rhetoric that prefigures a postwar industrial society in which nationalism is literally manufactured, and in which political union emerges as the most efficient form for the developing economies of scale peculiar to advanced industrialism. Already evident in the language of cultural nationalism before the war were intimations of this unified postwar order that would supplant the earlier model grounded on nature and God. Yet caught within the coils of their own logic, those who employed the sentimental appeal to both nature and technology as foundations of nationalism were unable to consider the possibility of other forms of nationalism dependent neither on nature nor on Providence. They clung to

34. "Address to Members of the Cosmopolitan Association," *Cosmopolitan Art Journal* 1 (March 1857): 95.

nature as the ground of their belief that political union was legislated by a power higher than the human or the social.

Again in 1857 the *Cosmopolitan*, setting out to correct misperceptions about the relationship between art and nationality, spoke on behalf of an older idea of art's universality, arguing that art in America transcended national interests. Yet the journal continued to pay tribute to the concept of a national art, calling on the one hand for a "purely national painter," an art that could rival America's "eminent historians," writers, and sculptors, and that would "transmit to our children the grandeur of our fathers," and on the other hand declaring in the same volume that the development of art in America was part of world history. "The various sections of the Union are fostering such opposite passion and feeling, that it would be strange if the literature of these sections should not become dissimilar in many features. We already have clamors for a Western and Southern literature, contra-distinguished from trans-Alleghany [*sic*] letters. But what art-critic will hazard the possibility of such a sub-division of 'American Art'?" This author at least was willing to cancel decades of insistence on a purely American art in order to avoid what was by the 1850s the more serious challenge of an art mired in sectional special pleading. His alternative was a largely irrelevant call for an art that was adorned by "features brought from other lands, and other ages."[35]

In its self-contradictory call for a national art safely removed from topical or local associations, an art at once universal and peculiar to its age and place, the *Cosmopolitan Art Journal* betrayed the characteristic confusions of the 1850s. The editors proclaimed their allegiance to a nonsectional vision of art's role: "We hope to have Maine and Texas, California and New Jersey, Utah, Minnesota, Canada, and 'the rest of mankind' meet and shake hands in these pages."[36] Art offered a refuge from politics: "Stunned with the political din of bluster, ending only in defeat, when a great principle is involved . . . a work devoted to the beautiful in art and literature is like the soft green of a pleasant oasis in a wilderness of brambles and quicksands."[37] Yet the wilderness unavoidably encroached on the oasis of art, and artists in turn reacted by denying their complicity with political interests and symbolically asserting the higher law of nature. "While a large portion of the world

35. "American Painters. Their Errors as Regards Nationality," *Cosmopolitan Art Journal* 1 (June 1857): 119; "Nationality in Art," *Cosmopolitan Art Journal* 1 (March 1857): 76.

36. "Editorial Etchings," *Cosmopolitan Art Journal* 1 (November 1856): 72.

37. "Expressions of Our Contemporaries," *Cosmopolitan Art Journal* 1 (June 1857): 138. Compare this with Henry Schoolcraft, "An Address, delivered before the Was-Ah Ho-De-No-Son-Ne, or New Confederacy of the Iroquois . . . August 14, 1846" (Rochester, N.Y., 1846), p. 6: "No people can bear a true nationality, which does not exfoliate . . . something that expreses [*sic*] the peculiarities of its own soil and climate."

has been convulsed by devastating wars, and while our own country even is shaken to its center by sectional agitation, the march of intellectual culture and the progress of the fine arts have been onward and upward!"[38]

It was against this treacherous polemical backdrop that apologists for American art tentatively offered various solutions to the problem, yet they too proved elusive. One strategy was to transform local into national subjects. This strategy, however, like others, came under suspicion as a disguised form of northern promotionalism. The suspicion was justified. On the very eve of the Civil War a writer for the *Cosmopolitan,* in reference to Eastman Johnson's *Washington's Kitchen at Mount Vernon* (ca. 1857–58, figure 47), exhibited at the National Academy in 1860, declared that such "local subjects almost assume the air of nationality under his cunning hand."[39] Given the subject of the painting—a black female seated next to a huge fireplace in one of the decrepit slave quarters of Mount Vernon—and its undeniable political symbolism on the eve of the war, the comment of the *Cosmopolitan* critic has an ironic ring. Mount Vernon, by then a powerful symbol of the nation's founding father and a summons to unity, had fallen into a dereliction that served as an apt visual metaphor for the plight of the Union. The black—free or slave—in the house of the Union was hardly an image calculated to inspire unity of sentiment across North-South lines. The word "cunning" was commonly associated with the wiles of politicians, most frequently southern, in their efforts to pass programs favorable to their particular sectional interests. By the 1850s many northerners were convinced that southerners were masquerading slave interests behind other motives, and northern anxieties over a slaveholders' conspiracy were widespread. The *Cosmopolitan* author inverted the term's usual associations: Johnson's "cunning" was his disguised appeal to northern nationalism. This statement reveals the deception at the heart of a nationalist theory of art in the 1850s—its pointed exclusion of the South from its cultural and political program.[40]

38. "Transactions for the Cosmopolitan Art Association. Address by Eleutheros Cooke, Annual Distribution of the Cosmopolitan Art Association," *Cosmopolitan Art Journal* 1 (July 1856): 20.

39. "Academy of Design Exhibition," *Cosmopolitan Art Journal* 4 (June 1860): 81. Also included in this judgment was another work by Johnson titled *Mating. Kitchen at Mount Vernon* was listed as no. 316 in the exhibition record of the NAD. The same year he exhibited *The Freedom Ring* (no. 449). The antislavery undercurrent of these two works contrasts with Johnson's highly popular painting of the previous year, *Negro Life at the South* (no. 321), whose stance toward slavery remained ambivalent. Patricia Hills, *Eastman Johnson* (New York: Whitney Museum of American Art, 1972), mentions this painting (p. 32) and other Mount Vernon subjects by Johnson (pp. 21–22). Later, during the war, Johnson painted a *New England Kitchen* (ca. 1863), and it is tempting to see these two works as thematically linked. See also Hugh Honour, *The Image of the Black in Western Art*, vol. 4, pt. 1, *From the American Revolution to World War I: Slaves and Liberators* (Houston: Menil Foundation, 1989), p. 220.

40. Donald Scott, "The Popular Lecture and the Creation of a Public in Mid-Nineteenth-Century America," *Journal of American History* 66 (March 1980): 791–809, has argued a similar point with

Figure 47. Eastman Johnson, *Washington's Kitchen at Mount Vernon,* ca. 1857–58. Oil on cradled panel; 12½″ x 20½″. Cummer Gallery of Art, Jacksonville, Florida.

The strongly northern bias of the appeal to nationalism in the 1850s is apparent in the fact that by midcentury, New York City had monopolized the artistic and publishing institutions that disseminated American art and shaped its political content.[41] The emergence of a "national" artistic culture paralleled the rise of New York as an artistic capital. Through the agency of magazines such as the *Cosmopolitan Art Journal* (1856–1860), *The Knickerbocker* (1833–1864), and the *Bulletin of the American Art-Union* (1848–1851), New York–based artists enjoyed by far the greatest share of critical attention. Conversely, working through these journals New York critics and writers enjoyed the power of defining the artistic forms of national culture. In short, the definition of a national landscape was being produced in the Northeast.

respect to the lyceum movement directed toward the diffusion of learning. The public for both painting and lyceums was predominantly northern, Protestant, and middle class, excluding large sectors of the American population while insisting on its representative character; see esp. pp. 808–9. Miller, *Patrons and Patriotism,* p. 228, similarly assesses the specifically northern content of the call for a national art.

41. On this monopoly, see Charvat, *Literary Publishing in America,* pp. 17–37.

The situation in the field of literary publishing, which was likewise monopolized by New York City up to the 1850s, offers a suggestive contrast. William Charvat has argued the importance of the "reciprocity between writer and reader . . . [which] has been the essence in our literary history," and counters the notion that "the reader is merely passive and receptive, just as the province is supposed to have a merely passive relation with the metropolis." Accordingly he defines the cultural center as "the place or places in which reciprocal influences are explicitly and crucially operative; where the publisher not only accepts or rejects but influences literary work through his knowledge of taste in the country as a whole."[42] Charvat's argument suggests a far more dynamic role on the part of the noneastern public in shaping the character of literary publications from New York. The other side, of course, is the role of publishers in shaping popular taste by influencing the character of a writer's own literary product. The years during which the American Art-Union was active were undoubtedly those in which this mutuality between public and producers most closely approximated the situation in book publishing. Because National Academy exhibitions did not travel, their audiences were predominantly local. The shift from the exclusive and singular nature of the art object to its commodification through print reproductions circulated to a national public is a critical one, for it carried at least the possibility for the kind of dynamic interaction between producers and consumers that Charvat posits for the publishing business. It is unclear just how responsive the governing board of the American Art-Union was to popular taste. The relatively brief life of the AAU also may have prevented the development of a more reciprocal relationship with its public. In any case, the governing board of the AAU saw itself as shaping rather than accommodating public taste.

The National Academy of Design set a pattern for public attendance, critical notice, and artistic quality which, though at times acknowledged to be deficient, nonetheless became a primary measure for the rest of the country. A correspondent of the London Art Union, reviewing the National Academy's exhibition, wrote that "New York is fast becoming the metropolitan city of the New World and artists already crowd thither, to obtain recognition, from all parts of the country." Taking note of exhibitions held in Philadelphia and Boston, he nonetheless gave precedence to the National Academy: "The most eminent artists in the United States," he concluded, "reside in New York, and by far the greater number of them are natives of this state."[43]

Institutions such as the NAD staked their *raison d'être* on their national status,

42. Ibid., p. 22.
43. "The Fine Arts," *Literary World*, July 3, 1846, p. 517.

claiming to serve America's cultural call for an art that expressed the country's historical uniqueness. Although these organizations may have risen to prominence on such rhetorical summonses, they nonetheless fell short of the full regional representation that some demanded of a national institution. Their selection of artists, as a handful of observers duly noted, was far from national in its reach. Indeed, the NAD's claim to its title had been disputed since its origins in 1826.[44] Its membership was restricted to artists resident in New York, a rule that was changed in 1859, partially in response to the earlier charges leveled by the AAU that it was too exclusive.[45] As the *Bulletin of the American Art-Union* stated in 1850 with respect to the NAD: "All the genius of the land is not shut up within its walls. All the taste and connoisseurship are not confined to its immediate circle of friends."[46] An 1859 article in the *Cosmopolitan Art Journal* called for a truly "national" National Academy, the one currently so named being "a local affair."[47]

By contrast, the American Art-Union's official claim to represent the entire nation was uncontested. Like the NAD, the American Art-Union (1837–1853) furnished a prototype for similar organizations elsewhere in the country. The catalogue for an 1848 exhibition at the AAU asserted that the 231 works of art bought by the union had been "painted by . . . artists residing in fifty towns in sixteen states and territories, from Maine to Louisiana, [and] in Rome, Florence, Dusseldorf, Paris, and London." Yet the actual breakdown of representation reveals a somewhat different picture: 145 of the artists chosen were from New York (many of these doubtless artists from elsewhere who had taken up residence in the nation's artistic capital), 27 were from Pennsylvania, 10 from Massachusetts, 7 from Ohio, 5

44. One example is a review of Samuel F. B. Morse's "Academies of Arts" lecture, given on the first anniversary of the founding of the academy. Published in *North American Review* 24 (January 1828): 207–24, reprinted in Thomas Seir Cummings, *Historic Annals of the National Academy of Design* (New York: Da Capo Press, 1969), pp. 45–54, the review charged that the academy did not merit its name, for it was neither "founded and supported by the nation" nor "a private association of the first artists of a country" but "simply a society of artists in the City of New-York, organized for the purposes of exhibition and instruction" (p. 45). Morse rejoined by demanding " 'by what right' does the *Review* to which he has contributed, bear the name of *North American*? 'It means, in the common use of language, the great *Review of North America*;' not of the United States only, but of *Canada* and *Mexico* too; yet who objects to its name, or thinks it worth while to write a page to prove that, because it is published in Boston, it should have a more limited title?" Cummings, *Historic Annals*, pp. 56–57.

45. See Charles E. Baker, "The American Art-Union," in Mary Bartlett Cowdrey, *The American Academy of Fine Arts and American Art-Union, Introduction: 1816–1852* (New York: New-York Historical Society, 1953), p. 198; Cummings, *Historic Annals*, pp. 228, 248, 274.

46. Quoted in Baker, "The American Art-Union," p. 190.

47. The Editor, "Plea for American Art. A National Academy a National Want," *Cosmopolitan Art Journal* 3 (December 1859): 218.

from New Jersey, and 4 from the District of Columbia. The remaining 33 were from six or so other states.[48] The disproportionately large number of works from New York no doubt reflects the far greater production of art in that city than elsewhere, and this production was itself related to the high level of patronage and consumption in New York. The question, however, remains as to the extent to which both the National Academy and the American Art-Union promulgated a tacit aesthetic norm whose long-range effect was to codify artistic practice within certain boundaries. Despite its national circulation, the AAU was in other respects a local institution. Its board consisted of prominent members of New York's merchant elite. John Durand, son of the landscape painter Asher B. Durand, stated matter-of-factly that the AAU was run by "commercial men."[49] The choice of what paintings to buy and to engrave for circulation among members reflected the cultural values of the northeastern merchants who served on the board as the self-appointed executors of a democratic art that appealed across class and sectional lines.[50]

National political events surrounding the Compromise of 1850 sensitized artists to divisions within their own community, a kind of nation writ small in which commonalities were often lost sight of in the contentions of the moment. In 1850 several heated exchanges took place between the NAD and the AAU over what each institution felt to be usurpations of its proper functions by the other. In September of that year Abraham Cozzens, president of the AAU and honorary member of the NAD, made a conciliatory call for "Union and Harmony among all the friends of Art."[51] What is noteworthy is the extent to which both the language and the behavior that accompanied the incident paralleled the events being enacted on the national stage—the pattern of confrontation and reconciliation that culminated in Clay's Compromise. The rift over which organization would capture the title of the nation's premier art institution was subsequently bridged by the sentimental rhetoric of family unity, cooperation, and dedication to the welfare of the whole, which was heard in the aftermath of the falling out. Asher B. Durand, president of the NAD, made a toast in May 1851 following the formal reconciliation between the two institutions, to "union and harmony of action and compromise, if necessary, among all institutions devoted to the cause of art."[52]

48. Baker, "The American Art-Union," p. 151; see also David Shapiro, "William Cullen Bryant and the American Art-Union," in *William Cullen Bryant and His America: Centennial Conference Proceedings, 1878–1978*, Hofstra University Cultural and Intercultural Studies, no. 4 (New York: AMS Press, 1983), pp. 85–95.

49. John Durand, *The Life and Times of Asher B. Durand* (1894; reprint, New York: Da Capo Press, 1970), p. 169. See also Miller, *Patrons and Patriotism*, pp. 160–72, esp. 170.

50. Baker, "The American Art-Union," pp. 152–53, 164.

51. Ibid., p. 192.

52. Quoted ibid., p. 194.

The short-lived Artists' Association also raised issues that had plagued relations between the NAD and the AAU. Echoing the resolution of the earlier controversy, members of the Artists' Association dedicated themselves from the start to the principle of cooperation: "It is highly desirable to the success of Art and Artists, that a *parle mente* should be held and measures taken, having in view the *solidarity* of the whole. The remark that 'a House divided against itself cannot stand,' is pertinent and merited."[53] The use of Webster's phrase later made famous by Lincoln, with its imagery of familial unity and harmony, reveals the infiltration of a nationalist political agenda into the discussion about a national art and its institutional forms.

Choices about what constituted the representatively American depended on point of view and unexamined assumptions. The nation's revolutionary history furnished a rallying point safely removed from a divisive present.[54] In 1851 a writer for the *Bulletin of the American Art-Union*, citing Jasper Cropsey's *American Harvesting* as "a thorough American landscape," added that "one peculiarity in the engravings of the present year . . . [is that] they are all national in their character." Elsewhere the *Bulletin* stated that the choices were "*American* in subject, being illustrations either of the scenery, manners, or history of the country." The choices made by the AAU are revealing: Church's *New England Scenery*, Richard Caton Woodville's *Mexican News* and *Old '76 and Young '48*, John Frederick Kensett's *Mount Washington*, William Sidney Mount's *Bargaining for a Horse*, and William Tylee Ranney's *Marion Crossing the Pedee*.[55] Each selection appealed implicitly to the undisputed values of the revolutionary generation, locating present-day controversy within a stable historical matrix. The divisive Mexican-American War is linked with the War for American Independence and the values of the founders (*Old '76 and Young '48*). A northeastern, identifiably "Yankee" subject—*Bargaining for a Horse*—is counterbalanced by a subject commemorating the southern states' role in the revolutionary struggle, in *Marion Crossing the Pedee*. Kensett's *Mount Washington* and Church's *New England Scenery* both appealed to national begin-

53. *New-York Home Journal*, March 1, 1851, n.p.

54. Mark Edward Thistlethwaite, *The Image of George Washington: Studies in Mid-Nineteenth-Century American History Painting* (New York: Garland, 1979), p. 28, has commented on Washington's crucial unifying symbolic role in a period of sectional conflict.

55. "Affairs of the Association," *Bulletin of the American Art-Union* 4 (November 1851): 135. The selection seems to have striven for a balance—two landscapes, two genre works, and one historical piece. The growing emphasis on national symbols in the AAU's choice is evident if one compares the 1851 selection with the previous year's: Thomas Cole's *Dream of Arcadia*, Asher B. Durand's *Dover Plains*, Emanuel Leutze's *Image Breaker*, Francis Edmonds's *New Scholar*, and Richard Caton Woodville's *Card Players*. See "Affairs of the Association," *Bulletin of the American Art-Union* 3 (September 1850): 87.

nings, the first by invoking the name of Washington, the second by means of an image associated with the origins of the rural and godly republic. Such subjects appeared to transcend sectional politics.

If the AAU strove for at least token southern representation, other promoters of a national art were less scrupulous. The common argument that scenery shaped national character was used to promote an exclusively northeastern subject matter. With curiously circular reasoning E. L. Magoon explained that "the literature of a country is truly national, just so far as it bears upon it the stamp of national character." This he defined as "an exalted type of individuality." Natural scenery and climate contributed to produce men such as Milton, Shakespeare, Sir Walter Scott, and Edmund Burke: "The minds of these great men were the transcripts of the first scenes they loved; and it is most pertinent to this theme to remind the reader that one, perhaps greater than they, the master statesman and orator of his age, was cradled in the rugged bosom of Alpine New Hampshire, where all is cool, colossal, sublime."[56] It is fitting that Magoon should invoke Daniel Webster, the granite-browed New Englander and prophet of union, in discussing the relationship between scenery and nationalism. "Godlike Dan," master of a rhetoric as sweeping and majestic as the continent itself, had been shaped by the rigors of New Hampshire winters, and untainted by the "mephitic breeze" that undermined the moral vision of southerners.[57] For Magoon, to choose such a representative of nationalism was to define the issue in specifically northeastern terms. Climatic determinism conveniently reinforced political belief.

Southerners' resentment over their status as an economic and cultural colony of the North rose to counter northern fears of southern nationalism:

At present, the North fattens and grows rich upon the South. We depend upon it for our entire supplies. We purchase all our luxuries and necessaries from the North . . . every branch and pursuit in life, every trade, profession, and occupation, is dependent upon the North. . . . The slaveholder dresses in Northern goods, rides in a Northern saddle, sports his Northern carriage, patronizes Northern newspapers, drinks Northern liquors, reads Northern books, spends his money at Northern watering places.[58]

56. E. L. Magoon, "Scenery and Mind," in *The Home Book of the Picturesque,* p. 43.

57. The phrase is Melville's, from chapter 23 of *The Confidence-Man,* ed. H. Bruce Franklin (Indianapolis: Bobbs-Merrill, 1967), p. 181.

58. Quoted in F. A. P. Barnard, *An Oration Delivered before the Citizens of Tuscaloosa, Alabama, July 4, 1851,* cited in Robert Russel, *Critical Studies in Antebellum Sectionalism: Essays in American Political and Economic History* (Westport, Conn.: Greenwood Press, 1972), pp. 80–81. See also p. 84; and see McCardell, *The Idea of a Southern Nation,* pp. 91–140, 177–226. Journals such as *De Bow's* promoted the economic independence of the South.

The author might well have added that southerners bought northern art and subscribed to the northern-based American Art-Union, ironically intent on promoting an American art that left them largely unrepresented. A reader of the *Cosmopolitan Art Journal* complained that "the people of the South, generally, are very little interested in any thing that pertains to either Art or Literature. The 'Almighty Dollar' is the ruling deity—the Trinity, the negro, the mule, and land. The wealthy, intelligent planter is an exception. All others are in eager pursuit of the dollar, looking neither to the right nor to the left." The *Cosmopolitan* editors replied by defending the South against charges that it was uninterested in supporting a national art: "Our Southern lists are *very* large, and the good word that comes to us from many sections of the Southern States, proves that there is no want of Art appreciation throughout that rich and commercially great portion of this Union. *Dollar-worship*, certainly, is not wanting in the Northern States." Here as elsewhere the *Cosmopolitan* was upholding its self-appointed mission to dissolve political tensions through the ministry of art.[59]

Northeasterners' moral and aesthetic unreceptiveness to the South is apparent from the selection of subject matter in the popular lithographs of Currier and Ives. Southern subjects were rare in the prewar period, and were limited by and large to scenes of Mississippi boating, or to images that accorded with the moral stereotyping of the South, such as "The Lake of the Dismal Swamp."[60] A survey of Currier and Ives in the decades preceding the war makes clear the reason for this virtual exclusion: the firm was strongly pro-Union and antislavery, issuing images such as the 1845 "Branding Slaves: On the Coast of Africa—Previous to Embarkation," and prints supporting Charles Francis Adams, "Free Soil Candidate for Vice President" in 1848 and other Free Soil candidates.[61] No comparable prints for southern political figures are listed in the catalogue raisonné of the firm. During the war years it issued "The Dis-United States: Or the Southern Confederacy," "The Folly of Secession" (1861), and "Confederacy—The Secession Movement."[62] Only after the war did Currier and Ives turn to a broader range of southern subjects by artists such as William Aiken Walker ("A Cotton Plantation on the Mississippi," 1884, figure 48), yet these were nostalgic in character, treating local color or evoking a picturesque but dying plantation South.

One could argue that western or frontier scenes were equally rare in the work of

59. "Cosmopolitan Correspondence," *Cosmopolitan Art Journal* 1 (November 1856): 69 (both quotes).

60. Nos. 3683 and 3684 in *Currier and Ives: A Catalogue Raisonné*, 2 vols. (Detroit: Gale Research, 1984). Many of the Mississippi boating scenes were executed by Frances Palmer without benefit of a trip down the Mississippi.

61. "Branding Slaves" is no. 0723 in *Catalogue Raisonné*, ibid.

62. These are listed as nos. 1730, 2256, 1356, and 622 in *Catalogue Raisonné*, ibid.

Figure 48. William Aiken Walker, "A Cotton Plantation on the Mississippi," 1884. Color lithograph, Currier and Ives. The Harry T. Peters Collection, Museum of the City of New York.

Currier and Ives, and that no particular weight should be attached to the relative absence of southern subjects. Yet it is evident from Currier and Ives's handful of western themes, such as "The Western Farmers Home" (1871, figure 49), in the years immediately before and after the war, that the West was presented in terms of the freehold agrarian ideal still central to northern identity.[63] The West also served as a more general symbol of national values. Melville's *Israel Potter* identified the West with America as a whole: "His spirit was essentially Western; and herein is his peculiar Americanism; for the Western spirit is, or will yet be (for no other is, or can

63. Other examples of western themes include "The Pioneer's Home: On the Western Frontier" (1867, no. 5189); "Across the Continent: 'Westward the Course of Empire Takes Its Way'" (1868, no. 0039); "Through to the Pacific" (1870, no. 6527); and "Western Farmers Home" (1871, no. 7150); see ibid. On the West's alliance with the North, see Miller, *Patrons and Patriotism*, p. 175 and passim.

Figure 49. Currier and Ives, "The Western Farmers Home," 1871. Color lithograph. The Harry T. Peters Collection, Museum of the City of New York.

be), the true American one."[64] Southern culture, by contrast, failed notably to find a place in the landscape of northern loyalties.

There were alternatives to the "representative" landscape of northern nationalism, with its growing burden of sectional content. Instead of relying on the ladder of association to carry viewers from the local to the national, landscape artists could strive for geographical inclusiveness. But this goal failed to materialize in practice. In the most conspicuous instance, northeastern artists consistently slighted southern subjects until after the Civil War.

The majority of the leading landscape painters in the prewar years practiced their

64. Cited in George E. Probst, ed., *The Happy Republic: A Reader in Tocqueville's America* (New York: Harper, 1962), p. 138.

art in the Northeast. Those who were southern-born were drawn to New York by training, patronage, and exhibition opportunities. Only a few artists suggested that the South might offer possibilities for the landscapist. Yet they frequently did so in terms that implicitly held up northeastern scenery as the standard by which the aesthetic merit of other landscapes was to be measured. In addition, the leading publications dealing with American scenery dwelt almost exclusively on northeastern subjects. Characteristic of this neglect were the thirteen engraved views in *The Home Book of the Picturesque,* a collection of essays published in 1852, of which only one was southern, a view of the Alleghenies of North Carolina painted by T. Addison Richards, an artist with personal attachments to the South.[65] Northeastern artists rarely traveled south for subject matter. Somewhat earlier, Nathaniel Willis and William Bartlett's influential book *American Scenery* (1840) limited itself to the Northeast, going no farther south than the Natural Bridge in Virginia.[66]

The most frequently painted landscapes south of the Mason-Dixon line in the antebellum period were those that carried associations with the Revolution and the ensuing federal period: the Great Falls of the Potomac, one of the earliest landscape subjects in American art, linked to the nation's capital; the Pedee River in North and South Carolina, associated with the revolutionary hero Francis Marion; the Natural Bridge in Virginia, made famous by Jefferson's description in *Notes on the State of Virginia;* and the Allegheny, Blue Ridge, and Cumberland mountains, crossed by the nation's first western emigrants.

There were compelling reasons for northeastern landscape painters to "branch out." By the late 1850s the landscape genre as it was practiced by academic New York painters had become somewhat tame and predictable. Among the middling ranks of landscapists certain stretches of northeastern scenery had become overworked. As one old-timer reputedly advised a younger artist, "Do, for heaven's sake, paint a field, a meadow, a flat, a swamp—anything without that everlasting stream, and that inevitable hill."[67] James Jackson Jarves, goading American artists to ever higher

65. On Richards's residence in the South and his interest in southern landscape see Mary Koch, "The Romance of American Landscape: The Art of Thomas Addison Richards," *Georgia Museum of Art Bulletin* 8 (1983): 5–36.

66. Nathaniel Parker Willis and William Bartlett, *American Scenery; or, Land, Lake, and River Illustrations of Transatlantic Nature,* 2 vols. (London: George Virtue, 1840). In 1840, when the book was first published, places such as Harper's Ferry, the valley of the Shenandoah, and Washington and Baltimore were still considered part of the Northeast. A map of the region thus labeled is included in *American Scenery.*

67. The Editor [O. J. Victor], "Character in Scenery: Its Relation to the National Mind," *Cosmopolitan Art Journal* 3 (December 1858): 11.

efforts, wrote that the "new men" carrying European influence brought "an infusion of fresh life into the old academic routine of conventional dulness and weakness" which placed artistic America "much into the condition of the good people of Sleepy Hollow, reducing our aesthetic condition to a level of the understanding required to appreciate the Peter Parley style of literature."[68] In an effort to spur America's landscape painters to more creative efforts that would retain a national audience for native subjects, the editor of the *Cosmopolitan Art Journal* enumerated the country's underexploited scenic areas. Having concentrated on the "White Mountains, the Hudson, Lake George, the Catskills, the St. Lawrence, and, to a limited degree, the Alleganies [*sic*], the Ohio, and the Upper Mississippi," American artists, he advised, should turn their sights to the

> Northern Lakes, with all their majesty of flood and shore—the vast prairies, with their matchless beauties of vegetation, their grand perspectives, their ever-changing horizons—the forests of depths and graces surpassing aught the "Old World" has known—the "hills" of Tennessee, South Carolina, Virginia, and Ohio— . . . all these remain almost strangers to us, chiefly because our painters have not made them subjects of pious study, and our authors have not sung their praises. We shall not know our country until these recognized interpreters reveal to us the excellence of our native possessions.[69]

The author's inclusion of southern scenery is noteworthy in a period when the South was largely beyond the cultural pale of northeastern painters.

The call was out for landscape artists to help Americans lay claim to their continental birthright. By 1860, however, the neglect of the varieties of landscape in the United States was combined with a fascination for the more distant reaches of the hemisphere. A writer for the *Cosmopolitan* noted a general flight from the boredom with northeastern subjects:

> Our artists are quite generally "out of town"—which means gone to the antipodes, or anywhere else that a good sketch can be had. The hope of *that* great picture, of which every artist dreams, sends them into every imaginable locality in quest of *the* sketch. They straddle mountains, ford rivers, explore plains, dive into caves, gaze inquisitively into the clouds . . . sail seas, run into icebergs, scald themselves in Amazonian valleys—always returning safely home in the golden October, with a

68. James Jackson Jarves, *Art-Thoughts* (1869), ed. H. Barbara Weinberg (New York: Garland, 1976), p. 298.

69. "Character in Scenery: Its Relation to the National Mind," *Cosmopolitan Art Journal* 3 (December 1858): 9.

lean pocket and plethoric portfolio, ready for commissions *and* praise. The Hegira, this season, is quite general; the studios are ticketed "closed," and all is as silent around their precincts.[70]

Jarves appraised the motives of this artistic hegira in somewhat more cynical terms: "Partaking of the enterprise of commerce, [the American landscape school] sends its sons to Brazil, to the Amazon, to the Andes, beyond the Rocky Mountains; it orders them in pursuit of icebergs off frozen Labrador; it pauses at no difficulties, distance, expense or hardship in its search of the new and striking."[71]

Occasionally in the prewar period northern artists turned to landscapes that departed from the traditional aesthetics informing the taste for northeastern land-scapes. As David Miller has shown in his study of the iconology of the swamp, during the antebellum period artists such as Henry Inman initially approached the swamp landscape of the southern states through the veil of literary and emblematic associations which obscured its specific qualities in favor of conventionalized motifs. With the extension of travel and the growing taste for exotic, psychologi-cally regenerative landscapes, northerners became increasingly receptive to these new settings so antithetical to the pastoral ideals of northeastern academic art.[72] Louis Remy Mignot (himself a southerner), Thomas Addison Richards, who actively promoted southern subjects after a six-year residency in the South, Henry Inman, and others painted swamps, bayous, and coastal marshes.[73] David Hunter Strother, known as "Porte Crayon," a southern-born, European-trained artist for *Harper's*, likewise explored southern subjects.[74] By contrast, another group of northeastern landscape painters who treated southern subjects before the war—

70. "Art Gossip," *Cosmopolitan Art Journal* 4 (September 1860): 126.

71. James Jackson Jarves, *The Art-Idea*, ed. Benjamin Rowland, Jr. (Cambridge: Belknap Press of Harvard University Press, 1960), pp. 194–95.

72. David C. Miller, *Dark Eden: The Swamp in Nineteenth-Century American Culture* (New York: Cambridge University Press, 1990), esp. pp. 47–76, 118–31.

73. Examples are Mignot's *Carolina Coastal Marsh with Deer* (ca. 1860) and Richards's *Encountering an Alligator* (ca. 1860). Henry Tuckerman, *Book of the Artists* (1867; reprint, New York: James F. Carr, 1966), pp. 563–64, wrote that Mignot "is Southern not only in color and subjects, but in sympathy." Both artists were based in New York. On Richards, see Louis T. Griffith, "T. Addison Richards: Georgia Scenes by a Nineteenth-Century Artist and Tourist," *Georgia Museum of Art Bulletin* 1 (Fall 1974): 9–16; Koch, "Romance of the American Landscape." Mignot was also drawn to South America; see Katherine Emma Manthorne, *Tropical Renaissance: North American Artists Exploring Latin America, 1839–1879* (Washington, D.C.: Smithsonian Institution Press, 1989), pp. 133–57, 185–86.

74. On "Porte Crayon," see Miller, *Dark Eden*, pp. 23–46. Tuckerman, *Book of the Artists*, p. 557, also mentions that John Bunyan Bristol traveled to Florida in 1859 to gather material "for a number of semi-tropical pictures." The American painter and journalist William Stillman also went to Florida in

Figure 50. Alexander Wyant, *Tennessee*, 1866. Oil on canvas; 34¾″ x 53¾″. All rights reserved, The Metropolitan Museum of Art. Gift of Mrs. George E. Schanck, in memory of her brother Arthur Hoppock Hearn, 1913 (13.53).

Alexander Wyant, William Sonntag, Frederick Rondel, and Andrew Melrose—generally avoided the Deep South, preferring by and large those subjects that most closely approximated the mountain wilderness or pastoral scenes they chose to paint in the North: the James River valley, the banks of the Potomac, the Harper's Ferry river gorge, the valley of the Shenandoah, the Cumberland and Blue Ridge mountains, and the Kanawha River Falls. A good example is Wyant's *Tennessee* (1866, figure 50), a wilderness river view only incidentally situated in the South.[75]

the 1850s to recuperate from pneumonia in what would become a frequent reason for southern travel. Much of the appeal of the postwar South lay in its therapeutic and recreational value, ironically, given its prewar reputation as a dangerously unhealthy climate.

75. Katherine Manthorne, in " 'Forty Acres and a Mule' ": Land, Race, and Power in the Art of the Reconstruction," paper presented to American Studies Association meeting, Baltimore, 1991, argued that Wyant's choice of subject matter may have carried references to the Civil War, since the setting lies

Northern artists had two obvious reasons for avoiding the South—a possible distaste for southern slavery and an undeveloped market for southern views in the North. There were other reasons why painters overlooked southern landscapes. The South was economically underdeveloped and physically isolated from the North. Good roads were a rarity, and accommodations were poor. Artists in the generation after Cole's had access to comfortable farmhouses during their annual sketching trips to the mountains of the Northeast—the Adirondacks, the Catskills, and the wilderness of New Hampshire and Maine. During these trips they enjoyed the invigorating life of the woods, the companionship of other artists, and the harvest of sketches done from the motif, ready to be synthesized into exhibition paintings during the winter's work in the studio. Yet the same adventurers who joyously embraced travel to the northeastern wilderness could react squeamishly to the lack of physical amenities in the rural South. Descriptions of southern lodgings and the coarseness of southern fare dwelt on the miseries of a protracted stay. The "Northern voyager," wrote Thomas Addison Richards, "will sadly miss the superior conveniences and comforts of his own more traveled and better ordered routes; the by-ways are miserable, the people ignorant, the fare scant and wretched, the expense of travel disproportionately great."[76] Richards also sounded a familiar warning about mosquitoes and "miasmas" exhaled from the fetid environment of the swamps, bayous, and banks of the Mississippi. With such descriptions from the self-proclaimed promoters of southern scenery, it is not surprising that more painters did not flock to the region.[77] Richards's assessment was only slightly more appealing than that delivered by the patrician *North American Review*, which described the South as a "region of miasms, musquitoes [*sic*], congestive fevers, cholera morbus, dyspepsia, [and] blue devils!"[78]

Foreign-born artists, less burdened by northern animus against southern subjects, responded more consistently to the artistic possibilities of the region. Those

on the course of Sherman's southern campaign and was documented in George Barnard's Civil War album. See also *American Paradise: The World of the Hudson River School* (New York: Metropolitan Museum of Art, 1987), p. 322.

76. Thomas Addison Richards, "The Landscape of the South," *Harper's New Monthly Magazine* 6 (May 1853): 721–33; quote on p. 732. In Richards, *The Romance of the American Landscape* (New York: Leavitt and Allen, 1854), pp. 113–14, the author's complaints are coupled with humorous condescension in his description of a conversation between a supercilious northerner and a southern backwoods woman.

77. Richards, "Landscape of the South," pp. 730–31. Bruce Chambers, *Art and Artists of the South: The Robert P. Coggins Collection* (Columbia: University of South Carolina Press, 1984), p. 13, argues that Richards's stories, travel accounts, and paintings of the South made an important contribution to raising awareness of the region. See also Miller, *Dark Eden*.

78. "Northern Lakes and Southern Invalids," *North American Review* 57 (1843): 119.

who worked in the South before the war included George Harvey, an English émigré who traveled and painted in Florida after 1850;[79] Edward Beyer, a German landscape and panorama painter whose American career spanned the years from 1848 to 1857 and who produced an *Album of Virginia* published in Richmond in 1858; and William Charles Anthony Frerichs, a Belgian artist who painted the Smoky Mountains. The English-born artist John Antrobus (1837–1907) also called for equal representation of the South, announcing a plan to paint a series of twelve pictures of "Southern life and nature" in 1859.[80] Antrobus arrived in the United States from England in 1850 "impelled," in his own words,

> to this immense undertaking by the determination to vindicate the claims of the scenery of the South to the consideration of artists. Hither to it has formed no portion of the subjects of the brushes, and the general idea was that there is nothing in the South worth painting. Artists roam the country of the North, turning out pictures of its scenes and scenery by the hundred yearly, but none come to glean the treasures with which the grand and beautiful country of the South and its peculiar life abound.[81]

Richards, another apologist for the southern landscape, had emigrated to the United States from England at the age of eleven. This prevalence of British artists among those who painted the southern landscape before the war suggests the close cultural ties between the South and England, resulting perhaps from vital economic and trade contacts between English manufacturers and the southern states.[82]

In his *Romance of the American Landscape,* Richards questions why Virginia "has won so little of the attention of our landscapists. Despite the extent and variety of her scenery, from the alluvial plains of the eastern division, through the picturesque hills and dales of the middle region, onward to the noble summits of the Blue Ridge, with their intervening valleys and mountain streams and waterfalls, the white-cotton umbrella of the artist has scarcely ever been seen to temper its sunshine." Richards mentions the Natural Bridge and Harper's Ferry as exceptions to the general rule. By way of explanation he cites the easier access of New York–

79. In "The Fine Arts. Our Landscape Painters," *New-York Mirror,* July 18, 1840, Harvey was named as one of the nation's leading landscapists, along with Cole, Huntington, Doughty, and Durand. His name was incorrectly given as George Horn, however. One such southern view is his *White Pelicans in Florida* (1853/73 [? date unclear], Museum of Fine Arts, Boston).

80. Ella-Prince Knox et al., *Painting in the South: 1564–1980* (Richmond: Virginia Museum of Art, 1983), pp. 82–83.

81. John Antrobus, quoted in Honour, *The Image of the Black in Western Art,* p. 215. Antrobus apparently completed only two of the twelve projected works. According to Honour, p. 215, Antrobus's "attitude seems to have been that of a disinterested spectator."

82. See William J. Stillman, *Autobiography of a Journalist* (London: Grant Richards, 1901), 1:284–86.

based painters to northeastern scenery, concluding that "in due time the forests and fields of Virginia, as of all the land, will find fitting record."[83]

A young artist of twenty-two, Richards evidently hoped to benefit from the neglect of southern landscape subjects when he issued a book titled *Georgia Illustrated* (1842), from which he expected commissions for "cabinet pictures" and "exquisite home views" based on the steel engravings included in the volume. Southerners applauded his interest in their landscape, noting the overlooked possibilities furnished by "this rich storehouse of nature." Yet it was the older rhetoric of eighteenth-century aesthetics that shaped Richards's response to the South, and that dictated his choice of subject. Describing Tallulah Falls and the valley of the Nacoochee, he spoke of an "exquisite beauty, blended with fearful sublimity." His apologia for the southern landscape was grounded not on those features distinct to the region but rather on a favorable comparison of southern with more famous northeastern scenes: "Proud mountain heights lift their voice of praise to Heaven; the thunders of Niagara are echoed by Tallulah." Kaaterskill and Trenton Falls found their counterpart in Ammicalolah and Toccoa (see figure 51, "Cascade of Toccoa, Georgia"): "For the verdant meadows of the North, dotted with cottages and grazing herds, the South has her broad savannas, calm in the shadow of the palmetto and the magnolia; for the magnificence of the Hudson, the Delaware and the Susquehanna, are her mystic lagunes, in whose stately arcades of cypress, fancy floats at will through all the wilds of past and future."[84] The South, for Richards, was an exotic and regionally inflected version of the North; the primary defense of southern scenes as a subject for landscape painters was the opportunity for greater variety *within* the established and predictable aesthetics of the beautiful, the sublime, and the picturesque.[85]

In the decades after the war, when the failed search for a comprehensive nationalism gave way to a literary and artistic exploration of the varieties of local experience, the South emerged in a different light, as one region among others. Its past assumed a romantic coloration that denied the ravages of the Reconstruction present. Painters began to explore features of the South that were appealing

83. Richards, *Romance of the American Landscape,* pp. 48–49. The point is repeated pp. 102–4, where Richards's characters evoke the peculiar features of the southern landscape.

84. Quoted in Knox, *Painting in the South,* p. 79; Richards, "Landscape of the South," p. 721. The favorable comparison of southern and northern views was also made by Charles Lanman, *Letters from the Allegheny Mountains* (New York: George P. Putnam, 1849), p. 36, where the falls of Tallulah take their place beside Niagara.

85. Chambers, *Art and Artists of the South,* p. 43, points out that "in the prewar years, images of Southern landscape had tended to parallel images of landscape elsewhere—the Blue Ridge could be portrayed in terms applicable to the Adirondacks or Catskills."

Figure 51. Thomas Addison Richards, "Cascade of Toccoa, Georgia." Wood engraving, *Harper's New Monthly Magazine* 6 (May 1853).

precisely because they had not been colonized or appropriated by the imperialistic reach of Anglo-American landscape aesthetics.[86] By the 1860s this latter tradition appeared badly enervated. American audiences met the South with new curiosity. As they responded to its peculiar qualities as a region, they measured it by less exclusive standards.

86. After the Civil War, northern artists such as Thomas Moran, Winslow Homer, and Martin Johnson Heade spent extensive periods of time in the South, particularly in Florida.

7 / Domesticating the Sublime
The Feminized Landscape
of Light, Space, and Air

*KENSETT has left a legacy of light to us all— . . .
instinct with feeling, all alive with love.*
—Charles Osgood, meeting of the Century
Association, 1872

New York landscape painting in the 1850s and 1860s had several distinct representational modes. It was not exclusively defined by visual forms that translated expansionist ideology into the structured experience of a humanly ordered nature. Painters of this generation, notably Sanford Robinson Gifford and John Frederick Kensett, produced landscapes that answered the frequent critical call for breadth of treatment guided by a unifying emotion.[1] Resonant, light-suffused atmosphere melded topographic divisions into a visually seamless whole. Space appeared as an undifferentiated continuum, a vessel or container, encouraging a sustained absorption in the image in place of an active movement through it. Writing of Gifford's *Twilight in the Adirondacks* (1864), a critic remarked on this seamless spatial quality achieved through delicate modulations of color: "[Gifford] always seems to have felt all his scene at once; not by bits, like a Chinese puzzle. There are few artistic qualities higher than this."[2] Such a spatial unity demanded a new kind of involvement on the part of the viewer, no longer engaged in reading details of the scene or in pondering, as more acute critics did, the relationship of parts to whole. The new landscape mode expressed—and in turn shaped—a growing midcentury appreciation for nature as a complex organic realm surrounding the human world. These

1. It was on this basis that Adam Badeau complained bitterly about the Pre-Raphaelite obsession with detail in his essay "Pre-Raphaelitism," in *The Vagabond* (New York: Rudd and Carleton, 1859), pp. 235–41.

2. "The National Academy of Design," *New York Evening Post,* May 21, 1864. Quoted in *Sanford Robinson Gifford* (Austin: University of Texas Art Museum, 1970), p. 26.

developments represent an effort to reinfuse nature with a primal authority compromised by the colonizing aesthetic of the middle and sequential landscape explored in the preceding chapters.

Kensett's *View on the Hudson* (1865, figure 52), for instance, inverts the earlier compositional emphasis on natural mass and shape. Light fuses the elements of the landscape, breaking down the spatial syntax of foreground, middle ground, and distance. *View on the Hudson* optically insists on instantaneous apprehension of the image as a whole, picking out random details here and there but in no particular sequence. Atmospheric luminism, the term I use to denote this alternative spatial mode, characteristically eliminated the foreground, the physical stage for the visual survey of the landscape, as well as the metaphoric stage for human activity.[3] Without this spatial anteroom, the precise boundary between viewer and image was vitiated. This blurring had been a feature of earlier sublime landscapes as well. The difference, however, was that paintings such as Cole's *Kaaterskill Falls* dramatized the sense of physical confrontation with the landscape and the vicarious feeling of danger. The aesthetic of atmospheric luminism was grounded by contrast in an identification with nature rather than an insistence on one's physical separateness from it—a separateness confirmed by the organism's revulsion to danger. Instead of temporalizing space through planar divisions, atmospheric luminism spatialized time. In doing so it freed landscape art from its loyalties to a narrative or literary meaning.[4] The landscape of atmospheric luminism was difficult to survey and

3. James Moore, "The Storm and the Harvest: The Image of Nature in Mid-Nineteenth-Century American Landscape Painting" (Ph.D. diss., Indiana University, 1974), p. 48, emphasizes the function of the foreground as a " 'viewing' space for the operation of human activity" not only in painting but in tourism, gardening, and poetry as well. Moore also notes the later shift in emphasis toward a less mediated encounter with nature in which "man is not simply an onlooker in the landscape but is an actor in its drama." The tendency of both Gifford and Kensett to slight the foreground occurred in the face of a contrary impulse among the American Pre-Raphaelite painters to emphasize the foreground through close delineation—a tendency, however, that flew in the face of earlier practice.

4. The term "luminism" itself has engendered more confusion than clarification. I use it here in a purely descriptive sense, as distinct from the conceptually loaded usage it has acquired since John Baur first coined the term in the 1940s. For an overview of its changing definition, see Ila Weiss, *Poetic Landscape: The Art and Experience of Sanford R. Gifford* (Newark: University of Delaware Press, 1987), pp. 13–20. My use of the term comes closest to Weiss's own descriptive term "aerial-luminism," which she specifically distinguishes from the Emersonian "transcendental luminism" defined by Barbara Novak in reference to Fitz Hugh Lane. Weiss locates the poetic qualities of light in Gifford's art with reference to his own New York intellectual circle, avoiding cultural generalities and assumed parallels between artists, writers, and intellectuals which characterized earlier discussions of luminism. Oswaldo Rodriguez Roque uses the term "atmospheric luminism" in *American Paradise: The World of the Hudson River School* (New York: Metropolitan Museum of Art, 1987), p. 47.

Figure 52. John Frederick Kensett, *View on the Hudson*, 1865. Oil on canvas; 28″ x 45″. The Baltimore Museum of Art. Gift of Mrs. Paul H. Miller, BMA 1942.4.

mentally organize. Its appearance marked not only a stylistic and aesthetic shift but also a basic transformation in the ideological content of landscape art.

Kensett's *View from Cozzens' Hotel near West Point* (1863, figure 53) only glancingly portrays the world of labor, of tourism and transportation, of land divisions and ownership. Given no particular order of importance, human actors, like motes in the light, drift imperceptibly into the frame and beyond it, leaving little or no trail. The quasi-military quality of visual command, the landscape as seen, ordered, and ultimately possessed by human vision, gives way here to a dreamlike absorption that confuses the boundaries between the viewing subject and the objects of sight. These boundaries, though never lost, are blurred, while individual forms maintain the clarity and precise delineation that was a hallmark of virtually all American landscape until the later paintings of George Inness in the 1870s and 1880s.

Figure 53. John Frederick Kensett, *View from Cozzens' Hotel near West Point*, 1863. Oil on canvas; 20″ x 34″. Courtesy of the New-York Historical Society, N.Y.C., The Robert L. Stuart Collection, on permanent loan from the New York Public Library, 1944.

Kensett's 1869 *Lake George* (figure 54) starkly reduces both detail and spatial effects. In place of the serpentine transition from plane to plane of his stylistically conservative *White Mountains—Mount Washington* of 1851 (see plate 7) is a watery rupture between foreground and distance, softened and bridged by an infinitely fine gradation of value and an almost monochromatic restriction of hue.[5] Rather

5. Kensett did another version of *Lake George,* ca. 1860s, now in the Thyssen-Bornemisza Collection. John Paul Driscoll and John K. Howat, *John Frederick Kensett: An American Master* (New York: W. W. Norton, 1985), p. 63, note the dramatic transformation in Kensett's style from "the stagelike, narrative composition" of his earlier work to "the simplified, almost abstract design" in works such as his 1856 *Shrewsbury River*. On Kensett's style, see Henry T. Tuckerman, *Book of the Artists* (1867; reprint, New York: James F. Carr, 1966), p. 512. James Jackson Jarves, *The Art-Idea,* ed. Benjamin Rowland (Cambridge, Mass.: Belknap Press of Harvard University Press, 1960), pp. 192–93, describes the quality of "phantom-like lightness and coldness of touch and tint" which gave Kensett's paintings "a somewhat unreal aspect. . . . they take all the more hold on the fancy for their lyrical qualities."

Figure 54. John Frederick Kensett, *Lake George*, 1869. Oil on canvas; 44⅛″ x 66⅜″. All rights reserved, The Metropolitan Museum of Art. Bequest of Maria DeWitt Jesup, from the collection of her husband, Morris K. Jesup, 1914 (15.30.61).

than creating a graduated progression of planes, Kensett tautly opposes the meticulously painted foreground to a remote, veiled distance. Discrete motifs and narrative incidents are minimal. The framing of *Lake George* seems arbitrary, and the careful overall weighting of shapes is dictated by formal concerns rather than by any play of external associations.[6] Atmospheric luminist landscapes did not rely upon associational psychology, with its dependence on historical and literary references. Their power over the viewer could not be translated into any nonvisual, programmatic form.

The difference between the stagelike narrative or plot-based landscape and the integrated space of atmospheric luminism expressed distinct artistic choices. Ken-

6. In his *History of American Painting* (New York: Macmillan, 1927), p. 248, Samuel Isham wrote that Gifford was "the first to base the whole interest of a picture on purely artistic problems, such as the exact values of sunlit sails against an evening sky."

sett, for example, was able to shift back and forth between the two modes according to the tastes of a patron, a situation illustrated by a commission he received from the Century Association, of which he was a member. Kensett's *Mount Chocorua* (1864–1866), painted after the artist had already explored a more visually unified approach, reverted to the conservative style associated with the Sister Arts tradition, to which the intellectual and artistic elite of the association still swore allegiance.[7] Discussing this painting, John Driscoll concluded that Kensett's choice of an older style paid tribute to the preceding generation of landscape painters and revealed his abiding optimism, epitomized in his early integrated and harmonious vision of a domesticated nature.[8] Kensett's manipulation of landscape style to suit a patron's tastes demonstrates the often explicit loyalties such choices carried at the height of the New York academic manner.

The growing aesthetic resonance of light and the move from temporal narrative to spatial image in the mid- to late 1850s was linked to changes that had accompanied the emergence of sentimental culture in the second quarter of the century. The "sentimental revolution" left its mark on fundamental ways of imagining space itself. But atmospheric luminism also anticipated the cultural movement later in the century away from faith in nature as the source of national self-definition toward a more introverted, personal, and reflective relationship with the natural world.[9]

The shift from the strenuous masculine associations of the romantic mountain sublime to an interest in space as a container of colored air marks a fundamental change in cultural preferences. The sublime as a category of experience did not disappear, but it was reformulated and extended. This redefinition emphasized subtle passages of feeling and mood associated with secondary attributes such as finely graded color rather than with the primary attributes of form. It coincided with, and was a part of, the appearance of a new language that couched social and moral formation in natural analogies, framing both in the language of gender. The new emphasis on feminine agency, signaled by the growing cultural potency of sentimental language, had important repercussions for imaging both nature and society.

7. Kensett employed the domesticating formula of the mediated landscape on a subject that Thoreau described in a journal entry as "in some respects the wildest and most imposing of all White Mountain peaks." Quoted in Richard Schneider, "Thoreau and Nineteenth-Century American Landscape Painting," *ESQ* 31 (1985): 78.

8. In Driscoll and Howat, *Kensett*, pp. 96–98. The painting was commissioned for $5,000 and donated to the Century Association in 1867. See also Hyatt A. Mayor and Mark Davis, *American Art at the Century* (New York: Century Association, 1977), p. 28.

9. This is a central theme in David C. Miller, *Dark Eden: The Swamp in Nineteenth-Century American Culture* (New York: Cambridge University Press, 1989).

Earlier theories of the sublime, chiefly Edmund Burke's, took as their point of departure the pleasurable physiological response of the subject to the proximity of danger, witnessed from a safe remove. This theory, with its emphasis on sensation, was applied to landscape subjects for the first time in the late eighteenth and early nineteenth centuries, finding its most characteristic visual expression not in America but in England, in the early and middle career of J. M. W. Turner. Paintings such as *Snowstorm: Hannibal Crossing the Alps, Vesuvius in Eruption,* and *The Fifth Plague of Egypt* (1800, figure 55), translated Burkean precepts into visual terms. As Andrew Wilton has made clear, however, these works by Turner fulfilled a limited definition of the sublime. Emphasizing the external manifestations of natural process—storms and volcanoes—they were not-so-distant cousins of the eighteenth-century theatrical sublime, widely distrusted in America (if widely enjoyed) for its amoral sensationalism and its dependence on mechanical contrivances. The theatrical sublime found an enduring place, however, in the popular taste for spectacle, and in the engravings of John Martin, well known in both America and England despite his snubbing within higher art circles and his association with cockney vulgarity.[10]

By midcentury this reaction against the material in favor of the moral sublime had reached its fullest expression. Too much visible motion in nature was considered to be in poor taste, like speaking too loudly in public.[11] The fear of imminent annihilation which had occasioned Jefferson's not-so-pleasurable headache as he gazed down from the vertiginous heights of Virginia's Natural Bridge had defined the older sublime.[12] Two generations later sublimity was redefined as a voluntary and entirely painless subjection to nature's majestic forces. The sublime now found its highest meaning in nature's generative potential. No longer threatening annihilation, nature appealed through a deeper identification with the expansive soul of life itself.[13] Nature's most profound meaning was to be found not in moments of

10. See, for instance, the Martin-like engraving in the background of *Rev'd. John Atwood and His Family* by Henry F. Darby (1845, M. and M. Karolik Collection, Museum of Fine Arts, Boston).

11. The term "material sublime" is Charles Lamb's. See Martin Meisel, "The Material Sublime: John Martin, Byron, Turner, and the Theater," in Karl Kroeber and William Walling, eds., *Images of Romanticism: Verbal and Visual Affinities* (New Haven: Yale University Press, 1978), pp. 211–32, esp. 212–13.

12. The passage appears in Jefferson's 1787 *Notes on the State of Virginia,* ed. William Peden (New York: W. W. Norton, 1972), pp. 24–25.

13. The romantic sublime, as Marjorie Hope Nicolson has demonstrated in *Mountain Gloom and Mountain Glory: The Development of the Aesthetics of the Infinite* (Ithaca: Cornell University Press, 1959), pp. 384–85, was epitomized in the two contrasting instances of Byron and Shelley. Byron's *Manfred* and *Childe Harold* include their share of earthquakes, lightning and hurricanes, volcanoes, and avalanches, although quieter, more meditative moods occasionally appear in which "all heaven

Figure 55. J. M. W. Turner, *The Fifth Plague of Egypt*, 1800. Oil on canvas; 48″ x 72″.
© 1991 Indianapolis Museum of Art. Gift in memory of Evan F. Lilly.

destructive, elemental violence but in its invisible power. Geologically active moun-tains such as the erupting volcano of Church's *Cotopaxi* could still symbolize civil discord. The more general withdrawal from this symbolism, however, suggests a retreat from the intensified rhetoric of war, which drew its power from hyperbolic natural images.

The waning interest in the older sublime is widely evident in both the art and the criticism of the 1850s. The new sublime was as far removed from the old as the force of gravity from the thunder of the heavens, to use another frequent analogy. Imperceptible and sustained operations of natural law now carried a far more pro-

and earth are still." The "false" or sensationalistic sublime was occasionally referred to as the "Byronic" sublime. The quieter mood, however, is fully characteristic of Shelley. Wordsworth's related "tranquil sublimity" also appealed to Americans' concern with the moral underpinnings of the sublime. Such images anticipate the development of the American midcentury sublime.

found significance than the momentary if dramatic interruptions in the rhythms of nature which had constituted the Burkean sublime.[14] The newer interest in atmosphere was, according to a writer for *The Crayon,* grounded in "a revelation of Nature's repose, of her permanent moods rather than . . . her fitful phenomenal display." Such scenes offered consolation and refuge from "the abortive tests of politics and commerce."[15] The most successful landscapes were those that renounced the "Ossianic quality," referring to the dramatic, literary sublime conventionally associated with the remote, inhospitable, mountainous terrain of northern Europe.[16]

This new response to nature was eloquently expressed by John Ruskin, the most influential voice of Anglo-American aesthetics at the time: "It is not in the broad and fierce manifestations of the elemental energies, not in the clash of the hail, nor the drift of the whirlwind, that the highest characters of the sublime are developed. God is not in the earthquake, nor in the fire, but in the still small voice."[17] The sentiment was widespread. Henry Ward Beecher gave it a homier expression relevant to the transformation in landscape sensibilities when he insisted that enjoyment of nature rested not in the traditional excitements of "august mountains, wide panoramas, awful gorges, nor from any thing that runs in upon you with strong stimulations." Such things were "occasional" pleasures. They "come in as the mighty undertone upon which soft and various melodies float. A thousand

14. See Richard Moore, " 'That Cunning Alphabet': Melville's Aesthetics of Nature," *Costerus,* n.s., 35 (1982): 20, 25, on the American distrust for the sensationalistic sublime of Burke. Moore also notes the moralization of the sublime in nineteenth-century America, and the rejection of its Gothic or Byronic associations. The sublime "had for Americans a distinctly moral and communal semantic emphasis" (pp. 14–15).

15. "Sketchings. The National Academy of Design," *The Crayon* 8, pt. 4 (April 1861): 95. A related evaluation was given to the paintings of Sanford Gifford in the *Cyclopedia of American Biography* (New York: Appleton's, 1887): "His pictures are the interpretation of the profounder sentiments of nature rather than of her superficial aspects" (p. 643). In 1880 a reviewer drew an invidious contrast between Gifford and the showier, more commercially minded tactics of Church: "The last thing that he thought of was the mercantile aspect of his profession. He never made merchandise of his art." Obituary for Gifford, *Art Journal* 6 (1880): 320.

16. "Some Remarks on Landscape Painting," *Bulletin of the American Art-Union* 2 (November 1849): 22. Such landscapes furnished the setting of the apocryphal Nordic epic poems of Ossian, translated by James MacPherson (1736–1796), which enjoyed considerable currency among artists and writers in the late eighteenth century. For other references to the "Ossianic sublime," see Theodore Dwight, Jr., *Sketches of Scenery and Manners in the United States* (1829; reprint, Delmar, N.Y.: Scholars' Facsimiles and Reprints, 1983), p. 71.

17. John Ruskin, *Modern Painters,* vol. 1, in *The Works of John Ruskin,* ed. E. T. Cook and Alexander Wedderburn (London: George Allen, 1903), 3:345. Ruskin's characteristically biblical image derives from 1 Kings 19:11–12.

daily little things make their offering of pleasure to those who know how to be pleased."[18] Elsewhere Beecher wrote of standing on the crown of a hill, meditating on nature's "gigantic powers . . . silently working" with a force infinitely surpassing the power stored in the Crystal Palace. In a revealing passage he contrasted the industrial might of hammers to "the stroke of the dew," which noiselessly reduced stone to powder, and great "rattling engines" to the pumping force of trees drawing moisture from the soil. "This farm," concluded Beecher, in an image that denied the terrible displacements of a new industrial order, "is a vast shop, full of noiseless machinists."[19]

Since the late eighteenth century natural convulsions had offered a convenient image for human and social revolution.[20] Earthquakes, fiery volcanoes, storms, avalanches, and landslides, which formed the subject of the pictorial sublime, also furnished vivid and horrific images of social cataclysm for those drawing parallels between the inexorable operation of natural and social forces.[21] The eighteenth-century sublime suited the imaginative needs of a generation embroiled in revolutionary change. Burke's 1756 theory of the sublime, written three decades before his conservative attack on the French Revolution, was both a synthesis of older developments and a prophecy of a new world in which the aesthetic and the social

18. Henry Ward Beecher, *Star Papers; or, Experiences of Art and Nature* (New York: J. C. Derby, 1855), p. 308.

19. Ibid., p. 265.

20. Ronald Paulson, *Representations of Revolution, 1789–1820* (New Haven: Yale University Press, 1983).

21. Marx also used geological imagery to characterize social forces: "The so-called revolutions of 1848 were but poor incidents, small fractures and fissures in the dry crust of European society. But . . . beneath the apparently solid surface, they betrayed oceans of liquid matter, only needing expansion to rend into fragments continents of hard rock." Quoted in Marshall Berman, *All That Is Solid Melts into Air* (New York: Simon and Schuster, 1982), p. 19. Abysses, earthquakes, and volcanic eruptions were all used at various times to describe revolutionary social forces. American conservatives likewise employed the volcano as an image of social revolution. See, for example, *Letters and Journals of James Fenimore Cooper,* ed. James Franklin Beard (Cambridge: Harvard University Press, 1960–1964), 2:240. The Reverend Richard Storrs, in a sermon of 1855, warned: "If, even now, we be not sleeping on the crater's edge, whose fiery floods threaten an overflow of our civil and religious liberties more terrible than was felt by Pompeii or Herculaneum, the signs of the times and the interpretations of prophecy deceive us!" Cited in Douglas Miller, *The Birth of Modern America, 1820–1850* (New York: Pegasus, 1970), p. 64. Volcanic imagery was also employed to describe the social impact of the depression of 1837; see Samuel Rezneck, "The Social History of an American Depression, 1837–1843," *American Historical Review* 40 (July 1935): 665. A popular use of the volcano as an image of social unrest is found in a political cartoon, "The Mountain in Labor," which featured the "Volcano of Loco Focoism" in eruption (Prints and Photographs Division, Library of Congress).

would uncannily reflect each other.[22] The mid-nineteenth-century sublime was also associated with social developments, as Americans reacted to the events of 1848 in Europe with a new suspicion of revolutionary energies. Social changes brought forth a preference for nature's quieter moods. The silent sublime affirmed that change—whether in the social or the natural world—could occur without the histrionics of revolution or violent cataclysm. In place of nature in upheaval appeared a new paradigm of evolutionary development.

Art, mirroring this new appreciation, furnished a form of social instruction. An editorial in the American Art-Union, written in the banner year 1848, lauded the "sweet lessons breathed in all the works of Nature, when we are taught to understand and love them by the pictured canvass." In a characteristic call for men and women to adjust their lives to the eternal rhythms of nature, the editorial continued, "Thousands have been taught lessons of beauty, of gentleness, of hope, of effort, and of endurance, by like silent but certain monitors."[23]

Many Americans, repeatedly faced with the dilemma of redefining the legitimate basis of social and political authority, turned for guidance to the natural order. Nature's laws furnished metaphors—and ultimately physical models—for the invisible operation of those moral influences that ultimately shaped the character of the social world. As traditional habits of deference and hierarchy were eroded by decades of economic and material expansion, those concerned with maintaining the status quo looked to natural law to confirm that the bonds of social and moral cohesion operated as inevitably as the stately movement of the heavens or the rhythms of the tides. Just as revolutionary turmoil had been imaged in terms of violent natural forces, so now the tumult within nature's established hierarchies came to be associated with the overthrow of traditional restraints. The prospect of both was equally disturbing.

The metaphoric association between natural and social process was explicitly drawn by a writer in the revolutionary year 1848. His terms reveal the political subtext that helped propel the changing imagery of the sublime. Commenting on the meaning for Americans of the revolutionary forces at work in European society, he warned that if the " 'still small voice' of Nature is not now heard in America, she will by-and-by speak in the voice of the earthquake and the thunder; and though we apprehend no violence or bloodshed . . . [m]ay Heaven grant that the lowering

22. On the political subtext of Burkean aesthetics, see W. J. T. Mitchell, *Iconology: Image, Text, Ideology* (Chicago: University of Chicago Press, 1986), pp. 116–59.

23. Quoted from the *New York Tribune*, November 17, 1848, in "Our Art Union," *Bulletin of the American Art-Union* 1 (November 1848): 22.

thunder clouds which darken our own social firmament may equalize themselves by the gradual process of electrical induction, and not by violent and destructive explosions!" The writer went on to explain the beauty of nature's imperceptible internal adjustments: "Infinitely complicated though they [nature's forces] are, yet such is the precision of their movements that no jarring is felt, and no noise is heard, throughout the vast systems of infinite space." His choice of imagery betrays a longing frequently expressed by his contemporaries for a society that could accommodate its own internal pressures in a manner analogous to the self-regulating processes of nature.[24] What began as a vivid metaphor had become by the 1840s a model of actual historical dynamics.[25] This tendency of the language of metaphor eventually to become reified and assume material existence contributed to the ideological obfuscations embedded in linguistic choices themselves. Such confusion of metaphor with reality was abetted, however, by a deep imaginative association between social experience and natural energies.

The writings of Horace Bushnell, one of the nation's most influential ministers in the antebellum years, reveal the process through which the natural as a metaphor for moral operations was transformed into virtual identity with them. Much of Bushnell's early career was spent in explaining and justifying the Victorian social concept of environmental influence in terms that ultimately merged the moral and the material within a single pattern of causality.[26] Bushnell proposed an alternative to the older evangelical model of religious conversion. Genuine spiritual change, he and others argued, occurred through sustained and gradual influences rather than through a sudden, violent influx of energy from without. He warned against equating noise and thunder, the standard trappings of the older sublime, with authentic power:

24. *Univercoelum, and Spiritual Philosopher*, April 8, 1848, p. 297. One should bear in mind, however, that this gradualist strain coexisted alongside, and may have been a response to, a pronounced radical utopian impulse in the 1840s characterized by elaborate proposals for restructuring society. By the 1850s such utopianism had fallen off slightly from "the mad forties," when such activity peaked. See Robert S. Fogarty, *Dictionary of American Communal and Utopian History* (Westport, Conn.: Greenwood Press, 1980), p. xxiv.

25. For the manner in which language and metaphor shape reality, see Victor Turner, *Dramas, Fields, and Metaphors: Symbolic Action in Human Society* (Ithaca: Cornell University Press, 1974), pp. 23–30.

26. On the Victorian concept of moral influence, particularly through the agency of women, see Ann Douglas, *The Feminization of American Culture* (New York: Avon Books, 1977), chap. 2. David Miller, "Infection and Imagination: The Swamp and the Atmospheric Analogy," in *Dark Eden*, examines aspects of the doctrine of moral influence most troubling to contemporaries.

Behind the mere show, the outward noise and stir of the world, nature always conceals . . . the laws by which she rules. Who ever saw with the eye, for example, or heard with the ear, the exertions of that tremendous astronomic force, which every moment holds the compact of the physical universe together? The lightning is, in fact, but a mere fire-fly spark in comparison; but because it glares on the clouds, and thunders so terribly in the ear, and rives the tree or the rock where it falls, many will be ready to think that it is a vastly more potent agent than gravity.[27]

Bushnell went on to draw an explicit link between natural and social agencies: "Far down in the secret foundations of life and society, there lie concealed great laws and channels of influence, which make the race common to each other in all the main departments or divisions of the social mass—laws which often escape our notice altogether, but which are to society as gravity to the general system of God's works."[28] Such models of social causation drew force and logic from a vision of nature that bore little resemblance to the convulsive nature characteristic of the romantic sublime.

A variety of new scientific theories underwrote the reinterpretation of natural law in these years. In a major paradigm shift, scientific theory emphasized the uniform operation of natural forces over the periodic cataclysms that had previously constituted the chief epochs of natural history. Charles Lyell's uniformitarian theories offered an appealing model for historical operations. Images of gravity—the invisible force that regulated both the tides and the planetary orbits—furnished powerful natural types for social process.[29] Electromagnetism also provided social theorizers with a rich new model for understanding the mysterious agencies that molded both natural and social attractions.[30] Processes such as

27. Horace Bushnell, "Unconscious Influence," *National Preacher* 20 (August 1846): 171.

28. Ibid., p. 174. Related examples of the analogy drawn between natural and social processes are "Divine Power as Seen in the Phenomena of Life," *Godey's Lady's Magazine* 39 (July 1849): 49–50, and David Magie, *The Spring-Time of Life; or, Advice to Youth* (New York: R. Carter and Bros., 1853), p. 68: "The link is mysterious which binds human beings together, so that the heart of one answers to the heart of another, like the return of an echo; but such a link exists. . . . The influence is often silent and unperceived, like the rolling in of a wave in a quiet sea; but like that same wave it is mighty and resistless." Quoted in Karen Halttunen, *Confidence Men and Painted Women: A Study of Middle-Class Culture in America, 1830–1870* (New Haven: Yale University Press, 1982), p. 4.

29. Popular scientific texts such as Robert Hunt, *The Poetry of Science, or Studies of the Physical Phenomena of Nature* (Boston: Gould, Kendall, and Lincoln, 1850), originally published in London, included these chapter headings: "Gravitation," "Crystallogenic Forces," "Heat—Solar and Terrestrial," "Light," "Chemical Radiations," "Electricity," and "Magnetism."

30. Popular interest in such phenomena found expression in the theories of Franz Anton Mesmer and the pseudoscientific vogue of mesmerism. Mesmer's hypothesis of a universal fluid that linked the

chemical affinity, crystallization, and biological inception required a different set of images far removed from the violent convulsions of earthquakes, the explosive power of volcanoes, or the atmospheric shock of thunder and lightening.

To an extent the "objective" language of empirical science was itself gendered. The transformation from catastrophist theories of earth change to gradualist uniformitarian models bears the discursive imprint of feminine process and in-dwelling agencies. Ultimately it is a chicken-or-egg question whether new inter-pretations of physical phenomena influenced the discourse of feminine influence, or whether new images of the feminine found their way into other forms of discourse and systems of knowledge. Whatever the case, one ought to bear in mind that the current of cultural metaphor traveled in two directions at once.

Not only were the perception and discourse of natural agencies gendered, but so was their representation in painting. Critics, writers, and artists wrote about the properties of light and air in both nature and art in specifically feminine terms. These same terms were also applied to women and their effect on society. New in-terests in landscape painting coincided with emerging definitions of women's social agency. Each development challenged or qualified the grounds of cultural authority and assumptions by revisualizing nature—and society—as a self-generating femi-nized space.

The masculine orientation behind so many forms of cultural production, in-cluding representations of landscape, was universalized and naturalized. As such, its cultural mechanisms were neither evident nor open to criticism.[31] It is only in the light of recent gender-based cultural analysis that one can begin to isolate how gender worked as an organizing category in antebellum America. Increasingly gender formed an infinitely malleable category through which to understand both social formation and natural process. The entry into this gendered world is through the feminine principle as it was understood in the decade that Fred Lewis Pattee

physical with the moral worlds and that could be controlled for a variety of purposes had enjoyed considerable currency since its origins in the late eighteenth century. See Jay Fliegelman, *Prodigals and Pilgrims: The Revolution against Patriarchal Authority, 1750–1800* (New York: Cambridge University Press, 1982), pp. 104 and 289, n. 31; Robert Darnton, *Mesmerism and the End of the Enlightenment in France* (Cambridge: Harvard University Press, 1968).

31. Even the early feminist Margaret Fuller used the universalizing noun "Man" in the context of what is otherwise a radical rethinking of the usual dichotomy between the masculine and the feminine. See her 1845 essay "Woman in the Nineteenth Century," first published in the Transcenden-talist journal *The Dial* in July 1843, reprinted in Bell Gale Chevigny, *The Woman and the Myth: Margaret Fuller's Life and Writings* (Old Westbury, N.Y.: Feminist Press, 1976), p. 273.

dubbed "the feminine fifties." Descriptions of natural process increasingly emphasized gradual change and indwelling agencies manifest in gravity, electromagnetism, and biological inception. Changes in the iconography of landscape art paralleled these shifts in thinking. Both reveal a far greater responsiveness to the nondramatic elements of scene. Increasingly void displaced mass, and silent process displaced noisy manifestations of natural force. These images redefined the sources of nature's power.

By midcentury Jasper Cropsey, Sanford Gifford, and others influenced by the atmospheric treatment of mountainous subjects were producing views of mountain scenery seen through layers of palpable and subtly radiant air infusing the grand spaces of the New England wilderness, as in Sanford Gifford's *Early October in the White Mountains* (1867, figure 56).[32] Nowhere is the interest in opalescent distances and forms softened by veils of space and light more pronounced than in Gifford. From the early 1850s on, the object of his most refined investigations was what Ila Weiss has described as an "integrated color-field." Gifford devoted himself to depicting the medium itself through which the landscape is viewed, its assertive shapes and masses transformed into phantasmal, elusive forms that hover just beyond the boundary of fully palpable reality in a realm of "marginal visibility." Atmosphere—the color-bearing, light-infused air intervening between the viewer and the object of contemplation—was the perceptual medium that, like the domestic surroundings of the American male, transfigured the original subject, emphasizing instead the space through which it was viewed.[33] Such atmospheric veils not only softened contours but also moderated the sudden influx of sensation that had accompanied the experience of the sublime.

John Ferguson Weir described Gifford's technique in terms that suggest the new importance of atmosphere:

> Mr. Gifford varnishes the finished picture so many times with boiled oil, or some other semi-transparent or translucent substance, that a veil is made between the canvas and the spectator's eye—a veil which corresponds to the natural veil of the atmosphere . . . the object itself is of secondary importance. The really important thing is the veil or medium through which we see it. . . . As the spectator looks through this veil of varnish, the light is reflected and refracted just as it is through

32. David Huntington, *Art and the Excited Spirit: America in the Romantic Period* (Ann Arbor: University of Michigan Museum of Art, 1972), p. 24, compares Cole's Mount Washington, "a hoar-headed granite god, a New England Olympus," to that of Cropsey, whose later Mount Washington is "a golden-hued translucent screen, an object to trap the palpable radiance of air."

33. See Weiss, *Poetic Landscapes*, pp. 187, 223, 226.

Figure 56. Sanford Gifford, *Early October in the White Mountains,* 1867. Oil on canvas; 14⅛″ x 24″. Collection, Washington University Gallery of Art, St. Louis. Gift of Charles Parsons, 1905. Photo: Piaget.

> the atmosphere. . . . The surface of the picture . . . becomes transparent, and we look through it upon and into the scene beyond. In a word, the process of the artist is the process of Nature.[34]

The passage suggests the extent to which the literary mediation of the Sister Arts had given way to a greater reliance on the intrinsic qualities of the image and its ability to mimic the sensations and aesthetic perceptions encountered in nature itself. One no longer required an interpretive text; the image *was* the text.[35]

34. John Ferguson Weir, quoted in G. W. Sheldon, *American Painters* (1881; reprint, New York: Benjamin Blom, 1972), pp. 18–19.

35. See, for instance, John Ferguson Weir, "Sanford R. Gifford: His Life and Character as Artist and Man," in *Gifford Memorial Meeting of The Century, November 19, 1880* (New York: W. C. Martin, 1880 [?]; available on microfilm at Archives of American Art, Reel 2813, frames 117–229), in reference to Gifford's "search for the correspondence of art, that not merely reflect nature, but express, likewise, somewhat of that emotional experience that is kindled by the true and the beautiful." Equally symptomatic of the shift is George Inness's comment, in Sheldon, *American Painters,* p. 32, that the purpose of the painter is "simply to reproduce in other minds the impression which a scene has made

The development of public taste in scenery kept pace with the physical transformation of the wild into the settled and ordered landscape. In the words of Thomas Starr King, the liking for "wildness, ruggedness, and the feeling of mass and precipitous elevation" was a "mere appetite," destined to give way to an appreciation for "the refined grandeur, the chaste sublimity, the airy majesty overlaid with tender and polished bloom, in which the landscape splendor of a noble mountain lies."[36] Even Thoreau absorbed the contemporary preference for viewing mountains at a distance: "We take pleasure in beholding the form of a mountain in the horizon, as if by retiring to this distance we had then first conquered it by our vision, and were made privy to the design of the architect."[37] "Mount Washington and its lesser companions of the great mountain range," wrote Benjamin Champney much later, "are sufficiently far away to give them the charms of atmosphere and color, varying with almost every moment. This view has been painted many times and by artists too of great distinction, but never has the ideal been realized." Numerous painters attempted to capture the "elusive charms" of the view.[38] Variations on the composition described by Champney recur in paintings by members of the school, including Samuel Lancaster Gerry and John William Casilear, slightly later Aaron Draper Shattuck, and a host of others. In Gerry's *North Conway, New Hampshire* (1852, figure 57), North Kearsage Mountain is pushed to the background, while pastoral elements occupy the foreground.

The implications of this aesthetic transformation, however, extend well beyond the realm of taste. Atmospheric effects not only domesticated the sublime; they also threatened to displace it as a carrier of masculine will and to substitute a very different order of knowledge and causality symbolized by silent feminine influence rather than noisy manifestations of power.

In a story titled "I and My Chimney," Melville explores the displacement of patriarchal forms by feminine space. It pits the narrator against his wife and daughters in a battle to preserve the enormous central fireplace and chimney of his ancestral home from modern feminine improvements that would tear them out and substitute in their stead a grand hall. Supplanting the chimney, a symbol of the

upon him. A work of art does not appeal to the intellect. It does not appeal to the moral sense. Its aim is . . . to awaken an emotion."

36. Thomas Starr King, *The White Hills: Their Legends, Landscape, and Poetry* (Boston: Crosby, Nichols, Lee, 1860), p. 6.

37. *The Journal of Henry Thoreau,* ed. Bradford Torrey and Francis H. Allen, 14 vols. (Boston: Houghton, Mifflin, 1906), 1:270; quoted in Schneider, "Thoreau and Nineteenth-Century American Landscape Painting," p. 78.

38. Benjamin Champney, *Sixty Years' Memories of Art and Artists* (1900), ed. H. Barbara Weinberg (New York: Garland, 1977), p. 165; for other references to the North Conway area, see p. 155.

Figure 57. Samuel Lancaster Gerry, *North Conway, New Hampshire*, 1852. Oil on canvas; 40″ x 51¾″. Collection High Museum of Art, Atlanta. Acquired in honor of Mrs. Ronald W. Hartley, President 1978–79 of the Members Guild, in memory of her mother, Frances Haven Beers, 1978.55.

phallocentric world of the Puritan fathers, the hall represents for the narrator the feminine tyranny which he doggedly resists, remaining loyal to older ways. In Melville's sardonically humorous and many-layered allegory, mountains, along with ancient oaks and massive chimneys, are embattled vestiges of a patriarchal past under assault by the new cultural reign of women.[39] The narrator refers to an earlier

39. The association between ancient oaks and the colonial fathers of the nation was common at the time. Examples are the Charter Oak in Hartford, linked to an episode in the colonial history of Connecticut and painted by Frederic Church, and the Genesee Oaks of western New York, painted by

removal of fifteen feet of chimney as "a regicidal act" of "beheading," a dethroning that is both political and sexual.

Linking new spatial preferences to the decline of older forms of social and familial power, Melville makes explicit the association that was generally only implicit in sentimental imagery and rhetoric. The central drama turns on the opposition of mass and void. The removal of the chimney substitutes spatial absence for an authoritative presence, a babble of feminine voices for the single resonant voice of the father.[40]

The possibility of such a displacement of male authority generated anxiety and produced an oxymoronic resolution—a balanced coupling of opposites. Following a trip to the wilderness of Maine with Frederic Church, Theodore Winthrop wrote that "there is nothing so refined as the outline of a distant mountain: even a rose-leaf is stiff-edged and harsh in comparison. Nothing else has that *definite indefiniteness, that melting permanence, that evanescing changelessness.*"[41] In these opposing images Winthrop expressed the elusive quality of a mountain transformed by distance. Referring to Gifford's Tivoli, Weir described how the artist united two extremes—repose and power—"exercised seemingly without effort." Elsewhere in the same essay Weir described Gifford's style as uniting "beauty with character, delicacy with strength, in a marked degree."[42]

A concept deriving from rhetoric, the oxymoronic pointedly conjoined contradictory or incongruous terms. The descriptions of Winthrop and Weir negotiate a path between the sublime and the beautiful, the past and the present, masculine visionary power and feminine nature. In these same years numerous writers described the social influence of women in similarly oxymoronic imagery, prompted by a twofold anxiety about the excesses of masculine will and the growing claims women themselves were making for a less constricting definition of their social role.[43] Margaret Fuller defined this dual development of "Man" in terms of mas-

Asher B. Durand. See Franklin Kelly, *Frederic Edwin Church and the National Landscape* (Washington, D.C.: Smithsonian Institution Press, 1988), pp. 9–10 and 140, no. 37.

40. Allan Moore Emery, "The Political Significance of Melville's Chimney," *New England Quarterly* 55 (June 1982): 201–28, provides a political reading that complements my own. For another instance of how landscape was gendered, see A. J. Downing, *The Architecture of Country Houses* (New York: Dover Publications, 1969), pp. 263, 344–45.

41. Theodore Winthrop, *Life in the Open Air* (Boston: J. R. Osgood, 1871), p. 58, emphasis added. Quoted in Kelly, *Church and the National Landscape*, p. 92.

42. Weir, "Sanford R. Gifford," pp. 25, 28.

43. Two examples are Margaret Fuller, "Woman in the Nineteenth Century," pp. 241–78; and Elizabeth Cady Stanton, "Address Delivered at Seneca Falls" (July 19, 1848), in *Elizabeth Cady Stanton,*

culine and feminine elements that parallel the imagery of midcentury landscape description: "Energy and Harmony; Power and Beauty; Intellect and Love."[44] In related images women's influence, like nature's, modified substance with insubstantiality, like atmosphere softening mountains. R. C. Waterson, a minister from Boston and friend of William Cullen Bryant's, drew an extended metaphor of natural process in discussing female social influence:

> There is another source of moral influence in Nature, namely, her quietness. Ever moving on with incalculable force, and filled with mightiest energies, she is always calm. There is through all her motions perfect repose, a majestic tranquillity. See the flying orbs, how serenely they smile. Behold the blooming Spring, how gently she advances. Watch the growing forest, how gradual its growth. No one can have lived long amid the works of Nature, and not have been impressed by the calmness which pervades even her most prodigious revolutions. So peacefully does she move on, we can hardly realize the greatness of the work she is silently bringing about. We may be stirred by the rushing tornado, we may be awed by the fearful convulsions which threaten to burst asunder the globe; but all this does not elevate the mind like the quietness which she generally exhibits.[45]

Waterson's language conveys a powerful desire for change without action, growth without effort. His prose is oxymoronic: forceful quiet, energetic repose, calm revolution.

The southern writer Daniel R. Hundley also drew the analogy between feminine agency and the silent, invisible forces of natural process. "Woman finds her proper sphere and mission" in the school of the family, he wrote. "A God-given privilege and honor," woman's sphere

> is hers by right and by nature. . . . Woman wields a power, compared to which the lever of Archimedes was nothing more than a flexible blade of grass. She it is who rules the destinies of the world, not man. The raging tornado treads with the tramp of an army along the mountain's sides, uprooting loftiest cedars in its fury, but there its power ends; while the silent night dews, stealing without noise or bluster into the heart of the solidest rock, rend the very mountain itself asunder.

Employing a martial imagery that carried new meaning in the years immediately

Susan B. Anthony: Correspondence, Writings, Speeches, ed. Ellen Carol DuBois (New York: Schocken Books, 1981), pp. 27–35.

44. Fuller, "Woman in the Nineteenth Century," pp. 273–74.

45. R. C. Waterson, *Thoughts on Moral and Spiritual Culture* (Boston: Crocker and Ruggles, 1842), pp. 260–61.

preceding the Civil War, Hundley continued: "Man, although he shall march with banners flying and to the music of fife and drum to the world's end, will always find that there is a power behind the throne greater than the throne itself." Men were the merely mechanical instruments of social cohesion, "the cold hard iron of the telegraphic wires which span the surface of the civilized parts of our earth." The mysterious agents that infused matter with the spirit of life, "the electric flashes that vivify and move us," were "the heartthrobs and transmitted thoughts of our mothers."[46] Emerson, in other respects the cultural opposite of the hierarchically minded traditionalist Hundley, made a similar argument: "Let us have the true woman, the adorner, the hospitable, the religious heart, and no lawyer need be called in to write stipulations, the cunning clauses of provision, the strong investitures; for woman moulds the lawgiver and writes the law." Women were the organic binding agents of a culture only superficially held together by the mechanical and legalistic contrivances of men. They were the "delicate mercuries of imponderable and immaterial influences," shadowing forth coming events in their own finely tuned intuitions.[47]

The force of the feminine principle came from its siting simultaneously inside and outside of culture. Paradoxically, women were granted a major new influence in transforming culture from within even as they were largely denied agency as social actors. The situation is therefore more complicated than the simple dichotomy of nature/culture, female/male would suggest. For in the context of sentimental culture the feminine participated in both spheres, mediating between them. From this doubleness it drew its strength.[48] Intermediaries between nature and

46. Daniel R. Hundley, *Social Relations in Our Southern States,* ed. William J. Cooper, Jr. (1860; reprint, Baton Rouge: Louisiana State University Press, 1979), pp. 73–74. See also William R. Taylor, *Cavalier and Yankee: The Old South and American National Character* (New York: Braziller, 1961), pp. 162–63.

47. Ralph Waldo Emerson, "Woman," in *Miscellanies* (Boston: Houghton Mifflin, 1904), pp. 425, 406. In "Woman in the Nineteenth Century," Fuller writes of woman as possessing an "electrical," "magnetic" element: "The especial genius of Woman I believe to be electrical in movement, intuitive in function, spiritual in tendency" (pp. 260, 263).

48. On the gendering of the nature/culture dichotomy, see the essays in Michelle Zimbalist Rosaldo and Louise Lamphere, eds., *Woman, Culture, and Society* (Stanford: Stanford University Press, 1974), especially Sherry B. Ortner, "Is Female to Male as Nature Is to Culture?," pp. 67–87; Carolyn Merchant, *The Death of Nature: Women, Ecology, and the Scientific Revolution* (New York: Harper and Row, 1980); Carol P. MacCormack and Marilyn Strathern, eds., *Nature, Culture, and Gender* (New York: Cambridge University Press, 1980), especially essays by MacCormack, "Nature, Culture, and Gender: A Critique," pp. 1–24, Maurice Bloch and Jean H. Bloch, "Women and the Dialectics of Nature in Eighteenth-Century French Thought," pp. 25–41, and L. J. Jordanova, "Natural Facts: A Historical Perspective on Science and Sexuality," pp. 42–69; Carol Fabricant, "Binding and Dressing Nature's

society, women were the perfect instruments for reconciling opposing elements.[49] Acting as agents of the social order in the child-rearing process, they were simultaneously identified with nature by their role in biological nurture. Situated in the domestic sphere, they were quarantined off from public concerns and from the pollutions of market capitalism and political sectarianism. They were in short the vestals of public virtue, carefully preserved from corruption by their socially enforced domesticity.[50] Their power came from their liminality. Devoid of ego, women possessed a self-effacing transparency, which made them, like Hawthorne's Hilda in *The Marble Faun,* ideal copyists, transmitting uncorrupted the creative vision of the male artist. Like air and space softening the rugged forms of nature, women were the medium or transparent screen that vitiated the harsh outlines of social life. The realization of this ideal social role, however, rested on the presumed selflessness of women, and on their renunciation of all "narrowly" self-serving claims to autonomous identity or personal fulfillment.[51]

Like the objects of nature in midcentury landscape painting, women were defined by their atmospheric veils. Women, wrote Emerson, "are poets who believe in their own poetry. They emit from their pores a colored atmosphere . . . wave upon wave of rosy light, in which they walk evermore, and see all objects through

Loose Tresses: The Ideology of Augustan Landscape Design," in Roseanne Runte, ed., *Studies in Eighteenth-Century Culture,* vol. 8 (Madison: University of Wisconsin Press, 1979), pp. 109–35; and Fabricant, "The Aesthetics and Politics of Landscape in the Eighteenth Century," in Ralph Cohen, ed., *Studies in Eighteenth-Century British Art and Aesthetics* (Berkeley: University of California Press, 1985), pp. 49–81. Literary studies of the problem in the American context include Annette Kolodny, *The Lay of the Land: Metaphor as Experience and History in American Life and Letters* (Chapel Hill: University of North Carolina Press, 1975); and Kolodny, *The Land before Her: Fantasy and Experience of the American Frontiers, 1630–1860* (Chapel Hill: University of North Carolina Press, 1984). G. J. Barker-Benfield, *The Horrors of the Half-Known Life: Male Attitudes toward Women and Sexuality in Nineteenth-Century America* (New York: Harper and Row, 1976), also offers some interesting perspectives on the problem.

49. See Ortner, "Is Female to Male as Nature Is to Culture?"

50. Especially revealing on this point are the sections titled "Young Women in a Democracy" and "How the Americans Understand the Equality of the Sexes," nos. 39 and 41 in book 3 of Tocqueville's *Democracy in America,* trans. Henry Reeve (London: Saunders and Otley, 1835–40).

51. See Lori D. Ginzberg, "'Moral Suasion Is Moral Balderdash': Women, Politics, and Social Activism in the 1850s," *Journal of American History* 73 (December 1986): 601–22, on the history of the political uses of womanly virtue during the antebellum period and also after the war. Ginzberg (p. 615) notes "a waning of authority based on the special morality of "female" values" in the 1850s (evidence of women's displacement from the sphere of political action), and an increased emphasis on institutional and electoral means of change. In short, precisely when the concept of feminine influence was being challenged in the arena of political action it was deepening its hold in other areas of cultural expression. Such a development indicates the conservative nature of ideas about feminine influence in the 1850s and their growing distance from any direct connection to politics.

this warm-tinted mist that envelops them."[52] Such atmospheric feminine perception was embodied not only in the paintings of Gifford and Kensett but also in their subdued, virtually transparent personalities, and their qualities of visual and moral refinement. Kensett was eulogized as "a classic among our artists . . . free from tempting excesses." Though lacking in "the most exalted inspiration, . . . in his way, he is a preacher . . . [of] delicate and profound expression."[53] Characterized variously as "diligent, painstaking and laborious," refined yet modest and unassuming, Kensett merged with his art and his peculiar vision of nature in a mix that was deeply appealing to his contemporaries.[54] Aesthetic harmony and personal restraint conjoined in a figure who exuded moderation and industry. Kensett's landscapes proffered an aesthetic salve to sensibilities worn thin by the mounting rhetoric of war, subtly deflating the exalted imagery of earlier landscape. He was "not as romantic as Cole, nor had he the transfiguring imagination and grand historical vision of Turner."[55] He had, however, other qualities treasured by his generation.

Hailed by John Ferguson Weir as "our greatest landscape painter," Sanford Gifford, like Kensett, was as representative a figure of the 1850s and 1860s as his more influential contemporaries Church and Durand.[56] Gifford's understated style anticipated the mood-evoking tonalism of painting in the final quarter of the century.[57] Most prophetic was Gifford's relative indifference to the uses of art as an instrument of collective identity and his personally inflected experience of nature.

To understand the full significance of the midcentury inversion of the prevailing mountain-centered iconography that characterized European and American landscape painting, we must consider some of the meanings that attached to mountains as part of the Judeo-Christian inheritance. Indeed, these meanings are traceable to the origins of European culture itself. In Old Testament symbolism mountains were places of access to divine knowledge. In the early Protestant emblem tradition of Bunyan and others they signified spiritual travail and aspiration.[58] Into the nine-

52. Emerson, "Woman," p. 412.

53. Osgood, in *Proceedings*, pp. 20–22.

54. Henry Bellows, ibid., p. 18.

55. Osgood, ibid., p. 20.

56. "American Landscape Painters," *New Englander* 32 (January 1873): 147.

57. Perhaps because of Gifford's association with the Hudson River school, his anticipation of tonalism has gone unmarked, although Weiss, *Poetic Landscape,* p. 245, notes the more subjective nature of Gifford's mature style.

58. See Moore, "The Storm and the Harvest," chap. 5; Nicolson, *Mountain Gloom and Mountain Glory,* pp. 43–45. *Pilgrim's Progress* was a vital theme in midcentury Protestant culture, painted, among others, by George Inness, Daniel Huntington, Jasper Cropsey, and Frederic Church. In addition,

teenth century they served as "emblems most impressive of Almighty power and endless duration," "chosen places of the Divine presence and power on earth . . . [and] consecrated monuments of the greatness and glory of God."[59]

William Sonntag's *Mountain Landscape* (1854, figure 58) exalts wilderness and all its inherited associations with spiritual self-examination, moral pilgrimage, and, for his own generation, the titanic effort of conquest demanded by America's national mission. The painting, which carries on the high romantic Colean manner of the 1820s and 1830s, offers a telling contrast to Gifford's *Kauterskill Clove*. Its later date is suggested only by its precise, rather dry rendering of detail.

As natural signs mountains combined "Patriotism and Piety in a momentary perfection."[60] White Mountain landmarks such as Pulpit Rock in Crawford Notch and the Old Man of the Mountain in Franconia Notch carried the handprint of Providence. Towering above the steep walls of the Notch, the profile reminded visitors to the region of the special conversation they enjoyed with the Creator, carried out on ground hallowed by wilderness conquest.[61] Perhaps the most famous

Church, Cropsey, and others worked on an uncompleted panorama of Bunyan's allegory in 1850, noted in "Panorama of the Pilgrim's Progress," *Bulletin of the American Art-Union* 3 (August 1850): 82.

59. Charles Rockwell, *The Catskill Mountains and the Region Around: Their Scenery, Legends, and History; with Sketches in Prose and Verse, by Cooper, Irving, Bryant, Cole, and Others*, rev. ed. (New York: Taintor Bros., 1867), pp. vi–viii.

60. Rockwell, *The Catskill Mountains*, pp. vii–viii; Warren Burton, *The District School as It Was, Scenery-Showing, and Other Writings* (Boston: T. R. Marvin, 1852), p. 285. On the association between mountains and divinity, see Nicolson, *Mountain Gloom and Mountain Glory*, esp. pp. 2–6, 42–46. The subject of Moses and the religious symbolism of mountains was treated by Henry Cheever Pratt, a friend of Cole's, in his *Moses on the Mount* (1828–29: Shelburne Museum, formerly attributed to Cole), and by Cole's student Frederic Church, who painted *Moses Viewing the Promised Land* in 1846. The image of the mountain as the site of divine reckoning is exploited in Durand's *God's Judgment upon Gog* (ca. 1851, Chrysler Museum). King, *The White Hills*, p. 176, associates mountains specifically with prophet figures. The fullest development of the association, however, is in Ruskin, "The Mountain Glory," *Modern Painters*, vol. 4. See also Yi-Fu Tuan, *Topophilia: A Study of Environmental Perception, Attitudes, and Values* (Englewood Cliffs, N.J.: Prentice-Hall, 1974), pp. 70–74, on the changing significance of mountains.

61. The Old Man of the Mountain was the subject of Hawthorne's short story "The Great Stone Face." David Johnson's *Old Man of the Mountain* (1876, Collection of the State of New Hampshire), removes the feature to the remote distance, its sublimity domesticated by the presence of well-dressed tourists who sedately disport themselves around a lake. The work gives evidence that by the year it was painted, the symbolism of natural features only faintly echoed older Puritan habits of thought. Sanford Gifford also sketched the motif when he visited Franconia Notch in 1864. For other examples of the subject, see Donald Keyes et al., *The White Mountains: Place and Perception* (Hanover, N.H.: University Art Galleries, 1980), pp. 93, 101; Catherine Campbell, *New Hampshire Scenery* (Canaan, N.H.: Phoenix Publications for the New Hampshire Historical Society, 1985).

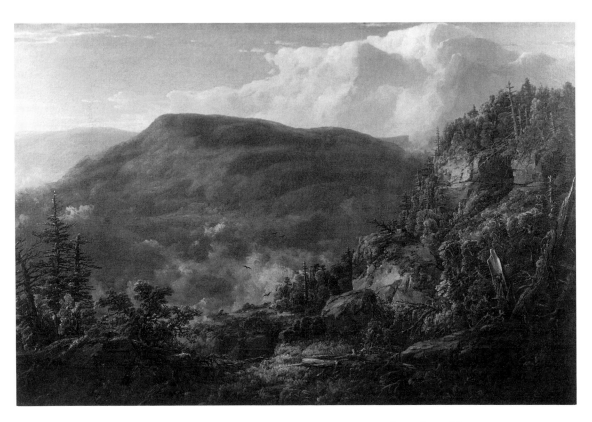

Figure 58. William Sonntag, *Mountain Landscape*, 1854. Oil on canvas; 32″ x 48″. Hackley Picture Fund, Courtesy of the Muskegon Museum of Art, Muskegon, Michigan.

instance of a mountain as tangible evidence of the covenant between God and his new chosen people was the Mountain of the Holy Cross in Colorado, first explored and documented by the surveying expedition of Ferdinand Vanderveer Hayden in 1873 and thereafter rapidly disseminated as a cultural icon through images such as Thomas Moran's *Mountain of the Holy Cross* (1875, Gene Autry Western Heritage Museum, Los Angeles). In the wake of the Civil War, the Mountain of the Holy Cross promised a renewal of the nation's broken covenant, prophesying the restoration of national faith through contact with the wilds of the West.[62]

Fitz Hugh Ludlow played on this habit of seeing providential emblems in the natural landscape in his 1870 account *The Heart of the Continent*. Traveling through the Rocky Mountains in Wyoming, Ludlow came upon a mountain peak—"sol-

62. Moran's painting is discussed by Joni Kinsey, "Sacred and Profane: Thomas Moran's *Mountain of the Holy Cross*," *Gateway Heritage* 11 (Summer 1990): 5–21.

emn, stern, and saturnine"—bearing an uncanny resemblance to John Calvin. Here the reference to Calvin, however, turns the conventional association inside out. Instead of demonstrating divine approval, Calvin's gloom-ridden visage conveys the sense of original sin and "Natural Depravity" to which he bore witness, and which Ludlow ironically evokes in the wastelands of the West. "Looking westward, round the globe, he sees plenty to derange his moral liver." Rather than sounding the conventional praise of the West as a new paradise, the visage suggests a radically fallen landscape.[63]

Mountains conveyed other kinds of symbolism directly relevant to a young republic. They were, as Warren Burton wrote, "the final citadel of national freedom . . . the last refuge of the patriot few." They carried a venerable association with the time-honored struggle for local autonomy fought against a usurping royal power. The link between mountains and liberty called to mind Vermont's Green Mountain Boys and, beyond America's own revolution, memories of William Tell and of the Celtic bard who hurled defiance from his mountain peak at the conquering armies of Edward the First, the subject of John Martin's *Bard* (ca. 1818, figure 59).[64] In such contexts mountains were symbols of independence from the patriarchal tyranny of the past.

At other times, as in the Presidential Range in New Hampshire, mountains memorialized the republic's own recent revolutionaries, transforming them into remote patriarchs. As emblems of permanence and unswaying majesty, the Presidential peaks symbolized a new secular order as stable as the "everlasting hills." They were constant reminders of what the republic meant.[65] Their associations with both patriarchal power and revolutionary energies gave substance to the idea of mountains as symbols of an older generation that had "fathered" the present order. The nationalist nomenclature of the Presidential range was a pointed instance of the long-established connection between mountains and patriarchal authority, whether of the scriptural, familial, or political variety. First named in 1820 by early settlers, New England's tallest peaks honored the major statesmen of

63. Fitz Hugh Ludlow, *The Heart of the Continent* (Cambridge: Riverside Press, 1870), pp. 234–35.

64. Burton, *The District School,* p. 281. On Ethan Allen and the Green Mountain Boys, see John McWilliams, "The Faces of Ethan Allen, 1760–1860," *New England Quarterly* 49 (June 1976): 257–82. On the significance of the Tell legend for the American revolutionary generation, see Fliegelman, *Prodigals and Pilgrims,* pp. 219–20. Eighteenth-century and later romantic interest in the legend of the Welsh bard is treated in Andrew Wilton, *Turner and the Sublime* (London: British Museum Publications, 1980). See also Nicolson, *Mountain Gloom and Mountain Glory,* pp. 56–57.

65. Contemporary representations associated Washington with lofty mythological and religious prototypes such as Zeus and Moses, both patriarchal figures. See Huntington, *Art and the Excited Spirit,* pp. 10–11.

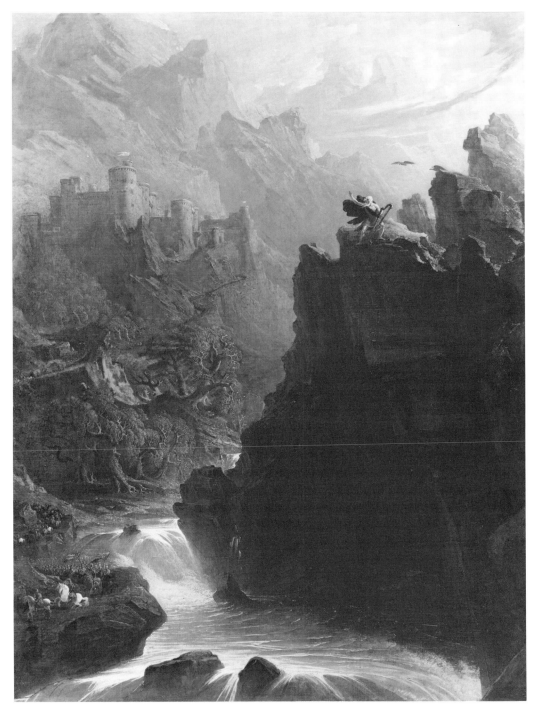

Figure 59. John Martin, *The Bard*, ca. 1818. Oil on canvas; 50″ x 40″. Yale Center for British Art, Paul Mellon Collection.

the republic: Franklin, Monroe, Adams, Madison, Jefferson, and later Clay and Webster, reserving for the highest the name of the nation's symbolic father.[66] Mount Washington was "the monarch hill of New England."[67] Such naming inscribed the divinely sanctioned political program into the very topography of the continent. Nonetheless, the major literary figure associated with the region— Thomas Starr King—denounced the "wretched jumble" that had supplanted the earlier evocative Indian place names, which predated the nationalist appropriation of the region.[68] A true New England patrician, King preferred local names over national ones flatly imposed on a primeval wilderness.

As interpreted by midcentury painters, mountains were the geological counterparts of Wordsworth's "emotion recollected in tranquillity." In their calm majesty they recalled by contrast the revolutionary turmoil of the past. As William McKendree Bryant wrote in a revealing image, mountains were "the type of the permanent, the changeless." He concluded with an image of forces in dynamic opposition: "The chief element of mountain scenery applicable in art is precisely this phase of calm, permanent immensity, in the midst of the mightiest strain of forces, *which we are accustomed to call the Sublime.* . . . The forces of violence, of negation—the chaotic elements—even these may be introduced . . . but only upon the express condition that they appear as subordinated, completely subdued—like Enceladus beneath Aetna." Here the sublime, previously associated with nature in conflict, is redefined in terms of "simple, severe, unchanging grandeur." Bryant's association was part of a broader change in the meaning of the sublime, a change that transformed mountains from stern symbols of the masculine power to define culture into emblems of domesticated might.[69]

As the living example of America's own patriarchs grew remote in time, they assumed the familiar attributes of political and national icons. Two-dimensionally flattened, removed from the experiences and historic memories of younger Ameri-

66. According to Lucy Crawford's narrative of early settlement in the area, a company of early settlers headed by Ethan Allen Crawford gave the titles of prominent men to the northern peaks of the White Mountains during an excursion in 1820. See Federal Writers' Project, *New Hampshire: A Guide to the Granite State* (Boston: Houghton Mifflin and Riverside Press, 1938), p. 511.

67. King, *The White Hills,* p. 163.

68. Ibid., p. 28. Other names of White Mountain peaks included Clinton, Lafayette, and Liberty.

69. William McKendree Bryant, *Philosophy of Landscape Painting* (St. Louis: St. Louis News Co., 1882), pp. 78, 88–89, 81 (emphasis added). Enceladus, the earth-born giant who conspired against Zeus, was defeated and transformed into the volcano Aetna. The Enceladus myth may therefore be the source of the emblematic association between Aetna and pride. See, for instance, Francis Quarles's *Emblems Divine and Moral* (1635). Melville used the image of Enceladus in his 1856 novel *Pierre, or The Ambiguities* (1856; reprint, New York: Grove Press, 1957).

cans, they became time-softened and veiled in a nostalgic haze which blunted and generalized those features once sharply etched by the events of history. As Mark Thistlethwaite has shown, representations of Washington by midcentury were laced with elements of genre.[70] The heroic, sublime "father of the nation" was scaled down, the tough fiber of his virtue made tender for feminized palates. Descriptions of the nation's patriarch emphasized that as he grew older, he took on a womanly appearance, a literal process of feminization.[71] The changing image of the founder revealed anxieties as well. From the vantage point of the mid-nineteenth century the revolutionary past was an age of heroes, contrasted to the spiritually and physically diminished present. People suspected that the national self was growing not only older and more feminized but also less virile.[72] The post-heroic generation seemed to be shrinking.[73]

The scaling down of the heroic subject is evident in natural as in human landscapes. In depicting Mount Washington after his travels to the White Mountains in the late 1820s, Cole employed the traditional language of the sublime, paralleling late eighteenth-century representations of Snowdon and other Welsh and Alpine peaks notable for their magnitude and their awesome geological features.[74]

70. Mark Edward Thistlethwaite, *The Image of George Washington: Studies in Mid-Nineteenth-Century American History Painting* (New York: Garland, 1979), pp. 140–41 and passim. This domestication of the male hero was not peculiar to painting in the United States. In France, Germany, and England, the traditional subjects of history painting were likewise shown in domestic situations. Examples include paintings by Ingres, Delacroix, Richard Parkes Bonington and others. See Robert Rosenblum and H. W. Janson, *19th-Century Art* (Englewood Cliffs, N.J./New York: Prentice-Hall/Abrams, 1984), pp. 264–69.

71. My use of this term throughout the chapter is indebted to Douglas, *The Feminization of American Culture*.

72. On the anxiety over the decreasing virility of the upper classes, see George M. Fredrickson, *The Inner Civil War: Northern Intellectuals and the Crisis of the Union* (New York: Harper Torchbooks, 1965), pp. 166–80; and T. J. Jackson Lears, *No Place of Grace: Antimodernism and the Transformation of American Culture* (New York: Pantheon Books, 1981), pp. 26–30, 107–24.

73. Melville's novel *Pierre* bitterly satirizes the displacement of masculine by feminine authority in his depiction of the Glendenning household. Also relevant are Fred Lewis Pattee, *The Feminine Fifties* (New York: D. Appleton-Century, 1940), and E. Douglas Branch, *The Sentimental Years, 1836–1860* (New York: D. Appleton-Century, 1934). Studies of the psychological, social, and political dimensions of this sense of generational inadequacy include George B. Forgie, *Patricide in the House Divided: A Psychological Interpretation of Lincoln and His Age* (New York: W. W. Norton, 1979); and Douglas, *The Feminization of American Culture*.

74. Examples are found in the work of Richard Wilson, Edward Dayes, Thomas Girtin, John Sell Cotman, Francis Towne, Turner, and others. See Lindsay Stainton, *British Landscape Watercolours, 1600–1860* (Cambridge: Cambridge University Press, 1985).

The classic midcentury image of the White Mountains, however, was Kensett's 1851 work *The White Mountains—Mount Washington* (plate 7).[75] *The White Mountains* situates the viewer at a high vantage point overlooking a shallow, bowl-shaped valley encircled by background hills and by the dark massed foliage in the foreground and middle ground. This natural boundary frames the scene, directing the focus inward on a landscape full of human incident in a recognizably narrative mode. A path leading down into this populated valley renders the view even more accessible. The space is structured according to a conventional pattern of diagonals defining alternating light and dark areas. Viewers of *The White Mountains* were invited to proceed stage by stage from the vestibule of foreground space to the rather tame middle distance to the remote wilderness of the mountains themselves, muted through tonal transitions and preceding forms.[76] The distant sublime is visually approached through the avenue of the picturesque.

The White Mountains was engraved by James Smillie for distribution by the American Art-Union in 1851. Further confirming its popularity as an image of the region, the painting served as the basis of a Currier and Ives print drawn by Frances Flora Palmer and published in 1860. Coming only four years after Kensett's return from Europe in 1847, the painting reveals the Claudean underpinnings of his early art. His treatment of White Mountain subjects suggests as well a debt to Constable, whose paintings of the Stour Valley, as Ronald Paulson has argued, likewise entail a "literary" structure.[77] Constable's *Stour Valley and Dedham Church* (n.d., figure 60) anticipates not only the naturalism of Kensett but the gradual transition from a rough foreground to a smooth, sunlit distance (without the background peak of Kensett's work). Much admired in America during the 1850s, Constable's oeuvre was linked with a landscape rich in human associations yet naturalistically observed, a landscape localized in his affections and full of feeling for the particularities of rural life.[78] Kensett and his contemporaries transformed Constable's

75. On the White Mountain school, see Keyes, *The White Mountains,* pp. 54–55. Kensett first journeyed to the White Mountains in the company of Benjamin Champney, the "founder" of the White Mountain school, and John William Casilear. See Driscoll and Howat, *John Frederick Kensett,* p. 63, for a discussion of this painting.

76. Another example of the sequential landscape as it was applied to more or less pure wilderness is David Johnson's *Chocorua Peak, New Hampshire* (1856). Kelly, *Church and the National Landscape,* p. 93, likewise concludes that the spatial organization of the painting, which allows the viewer to "conveniently traverse the landscape," sustains a view of nature as "a contained and orderly place."

77. Ronald Paulson, *Literary Landscape* (New Haven: Yale University Press, 1982), esp. pp. 107–20, argues that Constable's landscapes depart from the Sister Arts tradition of literary painting but reintroduce meaning into the landscape in the form of autobiography.

78. See Ann Bermingham, *Landscape and Ideology: The English Rustic Tradition, 1740–1860* (Berkeley: University of California Press, 1986); Driscoll and Howat, *Kensett,* pp. 52, 54, 59, 82, cite Kensett's

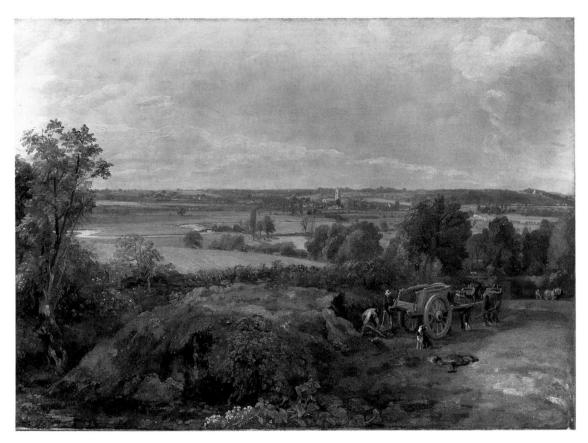

Figure 60. John Constable, *Stour Valley and Dedham Church*, n.d. Oil on canvas; 21⅞″ x 30⅝″. Warren Collection. Courtesy, Museum of Fine Arts, Boston.

more personal autobiographical involvement with a particular landscape by developing instead the collective historical and national associations of the White Mountain region.

The meaning attached to the spatial syntax of *The White Mountains* was national. In its narrative relationship between a sublime nature beyond the reach of the individual and a nature accommodated to human needs, it embodied the civilizing mission of republicanism. The aesthetic sequence of picturesque, beautiful, and sublime reinforced moral and social hierarchies.[79] Mount Washington presides

debt to Constable. Gifford likewise had an early exposure to the English artist. See Weiss, *Poetic Landscape,* pp. 171, 189, 203, on the Constable prints in Gifford's childhood home; "John Constable," *Bulletin of the American Art-Union*" 3 (September 1850): 90–91.

79. For a related discussion, see Moore, "That Cunning Alphabet," pp. 20–21: "Background sublimities could image the promise of the nation's special covenant with God, while pastoral

over the feminine valley below, whose tidy domesticity promises a stability and order that frames and organizes the majestic dimensions of the mountain just as the family furnished a foundation for the masculine hero.[80] Yet however domesticated, the mountain is still there, a reminder not only of geological upheaval but also of the political struggles of the founders. Like its namesake it is a "talisman of power," yet drained of its potency.[81] Thus rendered inert, it serves as a relic of the sublime history that preceded the tranquil present symbolized in the valley below.[82] Its sublimity, contextualized and contained, is no longer a threat but an assurance of moral grandeur, fathering patriotic emotions.

Read in temporal terms, *The White Mountains* reveals a comfortable accommodation of past and present. The heroic energies symbolized in mountains are scaled down to dimensions more appropriate to a sedate middle-class culture deeply concerned with preserving tokens of the past, such as the plaster busts of Washington that adorned so many Victorian parlors.[83] The controlled spatial sequence of the White Mountain formula, and the modulation of the sublime features of the landscape by the pastoral foreground, reveal not only an aesthetically but a socially conservative impulse toward domestication characterized by what Donald Keyes has called "reactionary ideals."[84]

Thoreau's response to the Maine wilderness at about the same period conveys a starkly different image of nature from that of the White Mountains expressed in Kensett's painting. On Mount Katahdin he found "Nature, . . . drear and inhuman . . . savage and awful, though beautiful. . . . Here was no man's garden, but the unhandseled globe." Here was "Matter, vast, terrific,—not man's Mother Earth

foreground could body forth fulfillment of the covenant," a program that "came to be known as the American 'picturesque.'" See also pp. 29, 33.

80. Driscoll and Howat, *Kensett*, p. 67, point out the nationalistic associations of the scene.

81. Thistlethwaite, *The Image of George Washington*, p. 208.

82. Paul Nagel, *This Sacred Trust: American Nationality, 1798–1898* (New York: Oxford University Press, 1971), pp. 83, 89–90.

83. See Thistlethwaite, *The Image of George Washington*, pp. 116–51, esp. 134, 138, on the domestication of Washington as national figurehead. Thistlethwaite also notes the static or "non-dynamic" form of official history paintings of Washington's administration, denoting "the myth of a stable, logical and calm leadership" (p. 166). The symbolic geography of the White Mountain School views accomplishes a similar purpose, situating revolutionary energies in a stable natural (and implicitly political) matrix.

84. Keyes, *The White Mountains*, p. 54, writes that the members of the school show "a place of retreat far from the incomprehensible crush of the urban and industrial world. . . . on the whole these painters give their numerous patrons the past, in content and in style." Keyes also notes the appearance of conventional formulas and the repetition of particular views in both painting and photography of the White Mountains. In some cases artists produced virtually the same picture.

that we have heard of, not for him to tread on, or be buried in,—no it were being too familiar even to let his bones lie there,—the home, this, of Necessity and Fate."[85] Such elemental knowledge was not for lesser humans, who belonged in the valley.

The generation of the 1850s generally preferred its mountain scenery scaled down or framed by more accessible landscape elements. The impulse toward miniaturization had been present from the time that landscape first rose to popularity in the 1820s. By midcentury it had assumed a formulaic quality. As a contributor to the *Bulletin of the American Art-Union* wrote: "The great effects which it might at first be thought our scenery should suggest, are less often attempted than those likely to impress the affections; and when they are, are less truly attained." The writer pointed specifically to the new preference for "woodland scenes" and for "the forests, rocks and rivers" in which American artists excelled, and which they characteristically preferred to the older sublime of mountainous heights and cavernous depths.[86] Landscape description revealed this impulse toward miniaturization. A nation of female readers both prompted and in turn responded to a new intimacy of presentation. Vignetted landscapes appeared in diminutive gift books. "I love little scenes and little things the world all over," wrote Sarah Edgarton Mayo during a journey through Pennsylvania in 1840. "There is sublimity in space, but beauty is made up of little parts. A tree, a knoll of flowers, a singing brook, a bird, a butterfly, a bee—are not these a picture? I love things *near;* a wavy horizon is beautiful, but give me to dwell in the shelter of hills, where the far-off is not known. I love not distant things; fancy must bring the beloved ever near me."[87]

Benjamin Champney, the proclaimed founder of the White Mountain school, echoed Mayo's preferences, describing "a new phase of nature" distinct from the sublime mountain scenery with which the region had earlier been associated.[88] By the mid-1850s "the meadows and the banks of the Saco were dotted all about with white umbrellas in great numbers" as artists flocked to the region, drawn to its inner recesses, its aura of natural antiquity, and its increasingly domesticated aspect.[89] Artists and tourists preferred scenery that, like the White Mountains, combined "passages of the sublime," suited to "those who have the physical strength and mental energy" to confront "deep chasms and frowning precipices,"

85. Henry David Thoreau, *Maine Woods* (Boston: Houghton Mifflin, 1892), p. 94.

86. "Some Remarks on Landscape Painting," p. 22.

87. *Selections from the Writings of Mrs. Sarah C. Edgarton Mayo* (Boston: Tompkins and Cornhill, 1849), p. 57. See also Douglas, *The Feminization of American Culture*, p. 130.

88. Champney, *Sixty Years' Memories*, p. 103.

89. Ibid., p. 106.

with a landscape easily digested in morsels.[90] For Frederick Law Olmsted mountains disturbed the soothing and wholesome effect of nature on the restless urban dweller. Describing scenery most appropriate to therapeutic landscapes such as Riverside Park in New York (figure 61), Olmsted wrote that their beauty "should be the beauty of the fields, the meadow, the prairie, of the green pastures, and the still waters. What we want to gain is tranquillity and rest to the mind. *Mountains suggest effort.*"[91] Writing from North Conway in 1855, Asher B. Durand was seduced by a "variety of delicious '*bits*'" of landscape—"luxurious fern and wild flowery plants," "masses of mossy rock and tangled roots," "miniature falls and sparkling rapids [that] refresh the Art-student, and nourish the dainty trout." Admitting his "predilection for such secluded recesses of quiet beauty," Durand nevertheless felt obliged to paint "the larger and more imposing features of landscape" for which the White Mountains were justly famed. He found himself torn, "like Garrick, between tragedy and comedy, not knowing which to choose." It is clear however, that he preferred less overwhelming subjects. In the end, weather confirmed his preference: "I have battled with the clouds and rains for the last fortnight to little purpose. Just as I commence my study of the mountains, they are veiled and disappear. . . . But the clouds do not descend to the valleys, they hide not the secluded stream, and the trees continue in their unveiled charms, lovely in shade as in sunshine."[92]

Such aesthetic preferences recall the direction of the most "advanced" art in the 1850s—the detailed Ruskinian plein-air studies of plants by American Pre-Raphaelites such as William Stillman, whose work, as he wrote of one picture, "was all foreground."[93] This emphasis on intimately rendered detail, evident in David

90. Asher B. Durand, "Correspondence" (letter from North Conway), *The Crayon*, August 29, 1855, p. 133. Champney, *Sixty Years' Memories*, p. 155, describes North Conway and the valley of the Saco in similar terms.

91. Frederick Law Olmsted, "Public Parks and the Enlargement of Towns," in *Civilizing American Cities: A Selection of Frederick Law Olmsted's Writings on City Landscape*, ed. S. B. Sutton (Boston: MIT Press, 1979), p. 81; emphasis added.

92. Durand, "Correspondence," p. 133.

93. William J. Stillman, *Autobiography of a Journalist* (London: Grant Richards, 1901), 1:149. Stillman goes on to write that a picture exhibited at the National Academy "gave rise to a hot discussion . . . the old school of painters denouncing such slavish imitation of nature." The emphasis on aesthetic breadth is repeated at 1:95–96, 117–18, 141, and elsewhere. Stillman is usually associated with the American Pre-Raphaelite study from nature, but as editor of *The Crayon*, a major art periodical of the 1850s, he reiterated the need for the integration and fusion of detail within the overall composition. Insistence on the superiority of imagination to mere imitation is also the keynote in "View-Taking," *The Crayon*, April 15, 1855, p. 236. This insistence, however, was not the case for the more radical journal of the next decade, the *New Path*, which advocated an extreme "truth to nature." On the

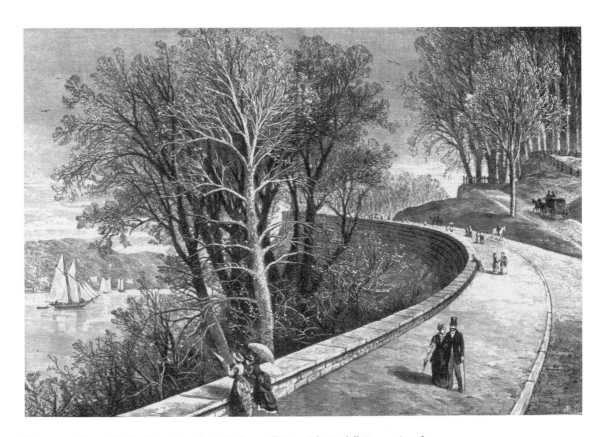

Figure 61. Granville Perkins after A. L. Jackson, "Riverside Park." Engraving from *Harper's Weekly,* April 24, 1880.

Johnson's *Forest Rocks* of 1851 (figure 62), represented a significant departure from the mainstream academic mode of grand panoramic, synthetic, or composed views. Yet Stillman himself did much to bridge this incipient rift when he became editor of *The Crayon* in 1856. For all its espousal of plein-air studies from nature, the periodical was equally clear about the subordinate place such studies occupied within the larger discipline of the landscape painter. The aesthetically conservative *Bulletin of the American Art-Union* likewise insisted on the "due subordination" of foreground to distance, the absence of which arose "from an enthusiastic desire . . . to realize truth to nature." The disdainful critic concluded: "The question is

American Pre-Raphaelites, see David Dickason, *The Daring Young Men: The Story of the American Pre-Raphaelites* (Bloomington: Indiana University Press, 1953); Linda Ferber and William Gerdts, *The New Path: Ruskin and the American Pre-Raphaelites* (New York: Schocken Books, 1985).

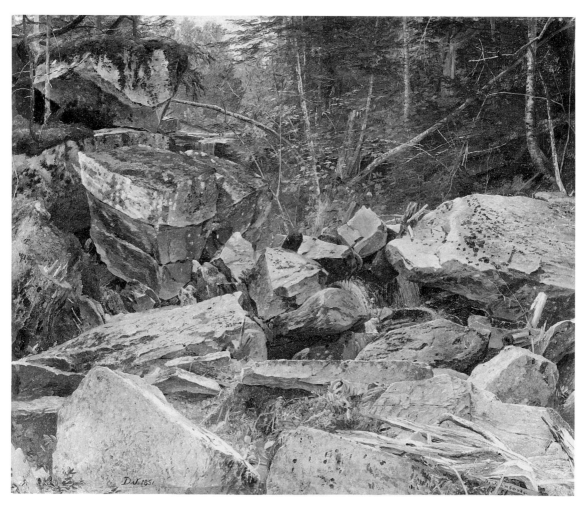

Figure 62. David Johnson, *Forest Rocks,* 1851. Oil on canvas; 17″ x 21″. The Cleveland Museum of Art, Mr. and Mrs. William H. Marlatt Fund, 67.125.

between Nature in her broad domain, and Man in his squalid kitchen-garden"; these two levels could not both "profitably possess the imagination at the same time."[94]

94. "Twenty-Sixth Exhibition of the National Academy of Design," *Bulletin of the American Art-Union* 4 (May 1851): 23. The contempt for imitation was characteristic of more conservative journals; see, for example, "The Fine Arts. Exhibition at the National Academy of Design," *Literary World,* May 15, 1846, p. 348, which complained of "the tricks and quibbles of empirical art." See also *North American Review* 83 (October 1856): 423.

Like miniaturization, the presence of borders and frames around nature comforted midcentury sensibilities exhausted by the rigors of the sublime. "Nature, like art," wrote the Reverend Sylvester Judd, "seems to require a border in order to be finished. The dressmaker hems and ruffles; . . . the painter never rests till his piece is framed. . . . An uninterrupted plane; a continuity of similar surface, vast, monotonous, silent,—is intolerable." Renouncing the older sublime of precipices and chasms over which the viewer hung giddily, Judd recommended that mountain glories be viewed through mediating frames: "Were you ever in a fine grove of a bright moonlight night? How different from standing upon a mountain at such a time! We recommend to any on an eminence to go back from the brink thereof, and stand in the forest, and look out through the breaks and crevices."[95] The preference for borders could be metaphorically extended to include the new taste for atmospheric effects that softened the direct encounter with mountain sublimities.

The changing representation of the Clove in the Catskill Mountains testifies to larger transformations within the landscape genre. The Clove was a frequent subject among northeastern artists from Cole through Durand and James David Smillie.[96] Cole's painting *The Clove, Catskills* (ca. 1827, figure 63) typifies his romantic sublime style of the 1820s. Here the mountains are assertive presences. Natural forms—columnar tables of rock and gnarled branches of dead trees—acquire a psychological charge in his early painting. The storm that sweeps across the landscape becomes an allegory of the soul, reflecting moral travail and evoking an interior world of psychic turmoil.

Sanford Gifford's *Kauterskill Clove* (1862, plate 8) in many ways epitomizes the aesthetic shift signaled by atmospheric luminism. The critical response to the painting demonstrates the shaping power of gender in the midcentury discourse of nature, revealing more clearly the links between the aesthetic and the social.

95. Arethusa Hall, comp., *Life and Character of the Rev. Sylvester Judd* (1854; reprint, Port Washington, N.Y.: Kennikat Press, 1971), pp. 459–60. See Douglas, *Feminization of American Culture*, p. 130. John Higham, *From Boundlessness to Consolidation: The Transformation of American Culture, 1848–1860* (Ann Arbor: William Clements Library, 1969), associates the aesthetic preference for stylized and contained forms with the social reorientation of midcentury.

96. Durand's *Kindred Spirits* is based on a composite view of the Clove. In 1866 Durand painted a *Kaaterskill Clove* (The Century Association) from the same vantage point as Cole's *Clove, The Catskills* (ca. 1827); James David Smillie, *Kaaterskill Clove* (1865, National Museum of American Art, Washington, D.C.), transforms the site into a picturesque vignette enjoyed by tourists. These versions all paint the Clove looking east toward the Hudson River; Sanford Gifford's view (plate 8) faces west, looking toward Haines Falls. See Kenneth Myers, *The Catskills: Painters, Writers, and Tourists in the Mountains, 1820–1895* (Yonkers, N.Y.: Hudson River Museum of Westchester, 1987), p. 182.

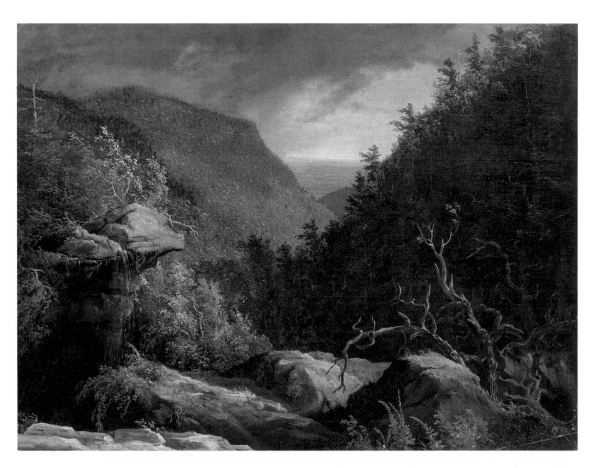

Figure 63. Thomas Cole, *The Clove, Catskills,* ca. 1827. Oil on canvas; 25″ x 33″. From the collection of the New Britain Museum of American Art, Connecticut, Charles F. Smith Fund. Photo: E. Irving Blomstrann.

Kauterskill Clove inverts the emphasis on natural topography charged with psychological or spiritual meaning. By dispensing with the forms and iconography that had invested nature with a personified moral presence, atmospheric luminism explored space as a self-evolving realm, an expanding circumference without a center. Gifford first painted the subject in 1849–50, producing at least four more major oils before his final treatment of the subject in 1880, the year of his death.[97]

97. A related sketch is "Kauterskill Clove, in the Catskills" of the same year (Art Institute, Chicago). The only finished oil versions of the subject that can still be located are the 1862 Metropolitan painting and the 1880 *October in the Catskills* at the Los Angeles County Museum of Art. In 1861 Gifford exhibited at the National Academy a now unlocated panoramic view (27″ × 54″) of the Clove titled

Instead of building the composition around the standard mountain-centered iconography of nature which had dominated earlier views of the Catskills, Gifford substituted a great light-filled spatial chamber in the center. Only Haines Falls in the remote distance resembles in any way a conventionally picturesque motif, yet this is so softened by veils of atmosphere that it is reduced to a glimmer of reflective light in the very center of the painting.[98] What occupies the place normally reserved for a central motif is the radiating, impalpable glow of the sun, whose light and heat hollow out a great well at the center of the composition with a force that seems to push the physical forms of the landscape to the margins of the painting. Topographical elements lose their distinctive outlines in the opalescent haze that is the real subject of the work. Yet far from being empty, this womblike space seems fully animate, its generative force touched into life by the warmth and light of the sun. The well of space at the center appears to expand with unconscious creation. Biological, natural time replaces historical time. As one rhapsodic reviewer wrote of a later work by Gifford: "Here is light and color, perfect fusion of tints and brushwork, free, hidden, and mysterious; here is the art that conceals art; here is a canvas from which light and warmth seem to radiate through air that floatingly fills all space."[99]

Kauterskill Clove never entirely renounces the discrete, anthropomorphized forms of the spatiotemporal mode, as is evident in the detailed foreground on the left. Only when one passes beyond this area are the true space-defining implications of light fully explored. The spectator seems nestled in the recesses of the earth, overwhelmed by nature's silent authority. The almost invisible figure of a hunter and his dog, who scramble up the foreground ledge, their vision blocked and their presence obscured by shadow, further suggests the incidental quality of the human presence. *Kauterskill Clove* places the viewer directly in front of the source of light. The effect is epiphanic. Access to knowledge is not through transformative labor,

Twilight in the Catskills—Kauterskill Clove; "Sketchings. The National Academy of Design," *The Crayon* 8, pt. 4 (April 1861): 94. Gifford's *Memorial Catalogue* listed some twenty-four sketches and studies of the subject; see *American Paradise,* pp. 222–25 on the painting. Gifford's viewpoint in the 1862 work relates to the engraving "View of Catskills" in William Cullen Bryant's two-volume *Picturesque America* (New York: D. Appleton, 1874), 2:130–31, for which it may have served as a source.

98. Compare this distant veiled view of Haines Falls with David Johnson's small plein-air sketch of 1849, reproduced in Gwendolyn Owens, *Nature Transcended: The Landscapes and Still Lifes of David Johnson (1827–1908)* (Ithaca: Herbert F. Johnson Museum of Art, 1988), p. 16.

99. "National Academy of Design," *New York Evening Post,* May 22, 1865, Curatorial Files, Metropolitan Museum of Art.

willful activity, or acquisitive vision, but through a direct identification with the source of power in nature.

Perhaps Gifford's boldest gesture, however, was to substitute a cavity in place of a mountain. The heart of Gifford's composition is a spatial void. Its real subject is air. "In landscape-painting," wrote G. W. Sheldon in reference to Gifford, "the color of the sky is the key-note of the picture . . . determining whether the impression shall be gay or grave, lively or severe; so much so, indeed, that landscape-painting may be called (what we have already said Mr. Gifford calls it) air-painting. . . . The condition—that is, the color—of the air is the one essential thing to be attended to in landscape-painting. If the painter misses that, he misses everything."[100] John Ferguson Weir, Gifford's friend and fellow artist, wrote of how "Gifford loved the light. His finest impressions were those derived from the landscape when the air is charged with an effulgence of irruptive and glowing light."[101]

Painted a year after the start of the Civil War, *Kauterskill Clove* renounces the rhetoric of physical and moral engagement. Gifford's painting, however, was symptomatic of the broader movement away from mountains and their baggage of strenuous moral attributes. His 1860 painting *The Wilderness* (figure 64) contains a mountain as its central motif. In place of rigorous moral encounter, however, is a poetics of space experienced imagistically. The lines "home of the red-brow'd hunter race" accompanied the catalogue entry when the painting was exhibited at the National Academy, providing a literary gloss on the two Indian figures who greet each other across the lake. This gloss comes as an afterthought, however, a vestige of an older literary landscape tradition now in its twilight. If any temporal dimension is implied in the spatial structure of the painting it is retrospective rather than progressive. The wilderness Arcadia that the painting nostalgically evokes was largely an imaginative artifact of a modernizing urban society.[102]

Gifford's indifference to the traditional iconography of mountains, although noted, remained unexamined at the time.[103] Only one contemporary of Gifford's identified the most striking feature of *Kauterskill Clove*—its subtle inversion of the iconography that informed earlier heroic landscape:

100. Sheldon, *American Painters*, p. 17.

101. Weir, "Sanford R. Gifford," p. 25.

102. This painting is discussed in *American Paradise*, pp. 218–20; Weiss, *Poetic Landscape*, pp. 16–17, 218–23.

103. Driscoll and Howat, *Kensett*, pp. 62–63, speak of the growing interest in "a sublime of peace, quiet, and harmony." Also helpful is Barbara Novak, "Sound and Silence: Changing Concepts of the Sublime," in *Nature and Culture: American Landscape Painting, 1825–1875* (New York: Oxford University Press, 1980), pp. 34–44.

Figure 64. Sanford Gifford, *The Wilderness*, 1860. Oil on canvas; 30″ x 54⁵⁄₁₆″. The Toledo Museum of Art. Purchased with funds from the Florence Scott Libbey Bequest in memory of her father, Maurice A. Scott.

We have heretofore recorded our satisfaction with the audacity shown by Gifford in selecting Kaaterskill gorge for a subject. We see no reason to revise last winter's verdict, now that the picture, plus a few more finishing touches, hangs in the Academy. The precipitation of one's whole artistic ability and reputation into a chasm several hundred times larger than that in which Quintus Curtius stopped for the good of Rome, is a piece of boldness only justified by its success. Gifford has so bathed this vast unrelieved depression in the face of nature with broad yellow sunshine, and interpreted its giant distances by such curiously skilful gradations of distinctness in its forest lining from ridge to base, that one begins to admire a gorge as he does a mountain—in fact, *as the largest kind of mountain turned inside out.*[104]

104. Rockwell, *The Catskill Mountains*, p. 321, quoting an article in the *New York Evening Post*, emphasis added. This passage actually refers to a now unlocated 1863 version of the subject, titled

Kauterskill Clove, a womblike gorge filled with life-giving light, is the landscape equivalent of the feminine principle, nurturing through self-negation rather than summoning spiritual aspiration through sublime example. In more senses than one it was a "mountain turned inside out," the inversion of the traditional iconography of mountains as masculine-centered symbols of religious exaltation, patriarchal authority, and the awesome, crushing might of nature. On another level it was an image of feminine introversion, of nature as a form of inner space associated with the inception of life itself.

The growing interest in atmosphere as the subject of landscape investigation meant that it was only one short step for Gifford to eliminate mountains altogether and to concentrate instead on the spaces between the mountains as atmospheric containers. His choice betokened a retreat from a public discourse that centered on landscape as a carrier of nationalist sentiment. *Kauterskill Clove* served far better as a subject of meditation and quiet reverie than as a public icon whose power came from shared communal convictions.

Thomas Starr King expressed the same inverted emphasis that led Gifford to choose a gorge rather than a mountain as his central motif in 1862 and 1863 when he wrote that mountains "are the exponents of the atmosphere. Nature upheaved them to be the huge *lay-figures* on which to show off the splendors of her aerial wardrobe and the resources of her millinery."[105] Here once again atmosphere and space prove a more compelling subject than form and mass. Mountains became little more than models clothed in air. King continued with his metaphor: mountains wear "by turns . . . thin draperies of haze, celestial lacework of distant rain, hoary wigs of cloud, . . . gorgeous embroidery of autumn frosts, and the flashing ermine dropped from the wintry sky. The majesty of a mountain depends on its outlines; its expression and beauty on the states of the air." King's conceit of a feminine atmosphere adorning a masculine mountain implies a kind of cross-dressing. The effect is to diminish the overpowering might of mountains, "civilizing" them by "taking the solidness and all the ruggedness of their foreground out," and tempering them with "expression and beauty," those two quintessential midcentury attributes of elevated landscape.[106] John Ruskin's vital influence is fully

Kauterskill Clove, in the Catskills. Rockwell describes a painting of the Clove by Gifford as "one of his simplest and most tender pictures . . . cradling a flood of summer sunlight, and clothed from bed to ridges with one glory of living green, mellowed through golden haze" (p. 347).

105. Letter from "T," "The Dixville Notch at the White Mountains, Columbia, New Hampshire, July 29, 1854," *Boston Daily Evening Transcript*, August 4, 1854, p. 2, cols. 1 and 2. Weiss, *Poetic Landscape*, p. 215, n. 56, attributes the letter to King, who was more than likely Gifford's guide and companion on a trip the artist made to the White Mountains in 1859.

106. Letter from "T." A related description of mountains is in Winthrop, *Life in the Open Air*, p. 58:

evident here. His great tribute to the beauties of aerial perspective appeared in volume four of *Modern Painters,* whose American edition came out in 1856. Yet also informing King's sustained metaphor is an image of women's role softening and refining the rugged masculine force of the social order.

Gifford not only turned mountains inside out to reveal gorges and chambers but also introjected the public meanings frequently carried by landscape motifs such as Mount Washington, emblem of the domesticated legacy of American independence. Gifford's Catskill gorge was not simply a spatial absence, for he imbued it with a different kind of presence. His image led beyond communal memories to a more occult ground of meaning. The vision of the viewer seems to be met and drawn in by a powerful force from within the painting. *Kauterskill Clove* implies a new interdependence in which nature is not only activated by but in turn appears to activate consciousness. Gifford's resonant chamber is brought into focus, as it were, by the absorbed gaze of the male landscape painter.

By moving away from the implicit association between vision and colonization implied in earlier sequential spatial formulas, Gifford gestured toward a new reciprocity between artist and nature. As John Ferguson Weir noted, Gifford's art lifted "the mind and sensibility . . . upon the place of apprehensive sympathies with nature."[107] The end result of this identification is to thwart the process of mental appropriation based on the separation of subject and object.[108] Yet if Gifford's image neglects the heroic public meanings attached to older landscape views, it *is* communal in another sense, referring as it does to the common source of all life in the generative womb of nature, and the source from which the artist drew his creativity. "As an artist," wrote Worthington Whittredge about Gifford, "he was born in the Catskill Mountains. He loved them as he loved his mother, and he could not long stay away from either."[109] Gifford's identification with a feminine, maternal nature was an often-observed mark of his character as an artist. He was

"Mountains make a background against which blue sky can be seen; between them and the eye are so many miles of visible atmosphere, domesticated, brought down to the regions of earth, not resting overhead, a vagueness and a void. Air . . . is collected and isolated by a mountain, so that the eye can comprehend it in nearer acquaintance." Quoted in Kelly, *Church and the National Landscape,* p. 92.

107. Weir, "American Landscape Painters," p. 146.

108. For a fuller exploration of the distinction between appropriative vision and absorption, see Miller, *Dark Eden,* pp. 118–24, 151–83.

109. Worthington Whittredge, "Address," in *Gifford Memorial Meeting,* p. 43. Compare this with James Jackson Jarves, *The Art-Idea,* ed. Benjamin Rowland (Cambridge: Belknap Press of Harvard University Press, 1960), p. 195: Inness's "vegetation has the qualities of tender growth; the earth has a sense of maternity; mountains, hills, and meadows, sunlight and shadow, all gleam with conscious existence, so that, unlike the generality of our landscape art, his does not hint a picture so much as a living realization of the affluence of nature."

repeatedly lauded by his fellow artists for his delicacy and chivalry toward women, "that sex to which we owe the highest elevation of our natures." His "cordial sympathy and interest for that which was womanly" was likewise noted.[110]

Subjective identification with the landscape in *Kauterskill Clove,* however, remains incomplete, as we are still outside the chamber. Vision and space, the male observer-subject and the feminine object, remain discrete. In this sense, while the new atmospheric mode in midcentury landscape expressed belief in feminine agency, in the end it reconfirmed the objectification of feminine influence as a therapeutic resource.

The nature-culture parallel underlying the atmospheric luminist conception of nature fulfilled the function of myth by attributing a natural origin to social processes. It transformed nature from a passive realm acted upon by Americans to an active authority that shaped the very conditions—the stage—of national history. The new authority vested in nature accorded well with the exceptionalist faith in America's difference from Europe by substituting natural laws for the historical laws that operated on the other side of the Atlantic.

This reassuring vision of natural laws shaping the social fabric was not left to rest merely on the fragile ground of metaphor, however. Society possessed an instrument of gradual, painless, and unceasing development in the figure of the American wife and mother, nature's own agent in the social realm. The moral influence of the American woman countered the disruptive force of ambition propelling the nation forward through economic development and territorial conquest, and threatening the stability of the social order through a *superflu* (in the words of Nathaniel Parker Willis) of acquisitive energy. The appearance of atmospheric luminism ultimately expressed, and itself reinforced, a new paradigm of natural process which carried an implicitly social message. The light-filled, space-expanding atmosphere of so much landscape painting of the time is the visual counterpart of the language of invisible agency—those silent forces that imperceptibly shaped both nature and society, of which women were the willing social instruments. "No community can isolate itself. The subtle influence which pervades the whole, permeates through every barrier, as little suspected and yet as effective as the magnetic or electric fluid in nature."[111] Atmospheric luminism was the perceptual and visual expression of a view of society in which no one stood alone, in which individual and community

110. Weir, "Sanford R. Gifford," p. 30. Jervis McEntee's address on the same occasion also commented on Gifford's deference toward women (p. 54).

111. Review, "Bushnell on Christian Nurture," *Biblical Repository and Princeton Review* 4 (October 1847): 503.

were fused through a single permeating environment of mutual influence. In nature as in society there was no absolute or unconditioned existence apart from the medium of perception. Sharp outlines and discrete contours were qualified and conditioned by atmosphere just as moral character was less the product of inborn traits than of familial, institutional, and social transactions. The boundaries between self and others gave way to a new emphasis on the common social and moral medium that carried those interpersonal influences, as subtle as the gravitational attraction between physical bodies.

By moving beyond the narrative or plot-based approach to landscape painting, Kensett, Gifford, and others who matured artistically in the middle of the nineteenth century also moved beyond a vision of nature shaped by human measures of time and by the dynamics of historical development. Their aesthetic exploration of space and atmosphere repudiated the heroic sublime of earlier romanticism, which projected the motions of the soul onto nature. As Henry Whitney Bellows wrote of Kensett: "He had none of the 'vaulting ambition that o'erleaps itself,' nothing of that impetuous passion for great achievements, which is often unaccompanied by the power of successful performance."[112] Describing the peace and calm induced by atmospheric landscapes, one writer used the sexually resonant imagery of blissful fulfillment to suggest the effect produced by such paintings, giving rest to imaginations exhausted by the feverish quest for immediacy of sensation. Such paintings were like "the settling of the quivering balance, the ultimate swell of the choir, the mellowness of the full noontide, the entire calm that succeeds both excitement and reaction—in a word, that completeness, satisfaction, content, which, like the calm glow of autumn, seem to fill all conscious desire, and hush the pleadings of expectancy. . . . Politicians talk of a balance of power; there is an equilibrium of soul somewhat analogous."[113]

Atmospheric imagery reaffirmed feminine values in the context of masculine assumptions. To emphasize space rather than mass countered an acquisitive mode of vision which inventoried the landscape, intent on penetrating and technologically mastering the continent. For a generation of romantic nationalists space was the neutral, inert, yet resistant medium which had to be conquered if culture was to be planted on the frontier. From the vantage point of eastern artists, many of whom were appalled by this crude effort of conquest, space assumed very different and more appealingly mysterious qualities. The oxymoronic coupling of strength and beauty, power and repose bridged the split between masculine force and feminine influence, conquest and absorption. Rhetorical and pictorial forms assisted this

112. Bellows, in *Proceedings*, p. 17.
113. "Our Artists," *Godey's Lady's Book* 34 (1846): 182.

generation of Americans to imagine nature—and society—in ways that accounted for both permanence and change, repose and power. Those who shared such habits of thought, whether ministers, social commentators, writers, or painters, could have it both ways, maintaining their allegiance to the values of the patriarchal past while finding spiritual and social nurture in a less demanding present.

Landscape artists, magically materializing the most subtle properties of light and air, evolved a new aesthetic language which addressed the anxieties associated with the post-heroic generation, combining the best of masculine and feminine elements. Imbued with the new feminine properties of space and light, nature was transformed into an expansive and inexhaustible realm—precisely what this later generation of landscape painters wished to believe about a nature that appeared increasingly fragile and finite. The art of Kensett and Gifford pays tribute to the feminine mystique of space, revealing a yearning to fuse male subject and feminized landscape object rather than pitting them against each other. The atmospheric luminist mode in their landscape art embraced a visual universe purged of time, progress, and history.

The deeply tragic import of Americans' will to inscribe nature with their own personal or national ambition was embodied in Melville's Ahab, maniacally struggling to dominate a natural world of unfathomable, elusive meanings.[114] It was this imperial quest for an expanded self acted out upon a passive nature against which the midcentury mode of atmospheric luminism was implicitly reacting. The aesthetic brings us back inevitably to the social, for atmospheric luminism employed the displaced language of nature to explore a cultural yearning for immersion, for refuge, a resistance to the pull of history and to the demands of progress. Yet in the end this aesthetic attempt to revalorize nature, to posit a purely unconscious mechanism of reform, foundered on the hard rock of national conflict, one more failed effort to give nature an authoritative voice in the formation of cultural identity.

114. See Herman Melville, "The Mast Head," in *Moby-Dick,* ed. Harrison Hayford and Herschel Parker (New York: W. W. Norton, 1967), chap. 35. Through Ishmael, Melville voiced another form of romantic fallacy—the quest for immersion, a sometimes fatal longing for an annihilation of ego through an absorption into what Melville called "the inscrutable tides of God."

Index

Hudson, John Bradley Jr., 108n.3
Hudson River school, 3–4, 76. *See also* First New York school
Humboldt, Alexander von, 134n.63, 195, 196, 201, 204, 205; concept of typical nature, 173–74
Hundley, Daniel R., 262–63
Hunter's Return, The (Cole), 52
Huntington, Daniel, 70, 95–98, 101n.93, 114–15, 265n.58
Huntington, David, 128

"I and My Chimney" (Melville), 189n.55, 259–61
Icebergs (Church), 132n.57, 203n.88
Illustrated London News, 160
Image Breaker (Leutze), 229n.55
Images, contrasted with language, 81, 198. *See also* Sister Arts theory
Imagination, 58–61, 81–82, 95, 195, 198n.79
Imperialism, defined, 39. *See also* Expansionism
Indian Hunter (Boutelle), 160n.58
Indians, American, 138n.2, 139, 143, 160n.56, 192; in Durand's *Progress,* 154, 159, 164–65
Indians, Salmon Falls (Seymour), 160n.58
Indian Surveying a Landscape (Boutelle), 160n.58
Infant school movement, 170–71
"Influence of the Plastic Arts, The" (Cole), 62–63
Inman, Henry, 236
In Nature's Wonderland (Doughty), 42
Inness, George, 108, 245, 258–59n.35, 265n.58, 285n.109; *Peace and Plenty,* 114, 135; *Peace and War,* 122; *Sign of Promise,* 113–14
In the Mountains (Bierstadt), 205
Irving, Washington, 163n.66, 221n.32
Isaiah, Book of, 124
Isham, Samuel, 76n.29, 247n.6
Israel Potter (Melville), 232–33

Jackson, Andrew, 25, 34, 36, 37, 38, 39
Jarves, James Jackson, 77, 81n.48, 121–22n.26, 197, 234–35; on exotic landscapes, 71, 236
Jefferson, Thomas, 142–43, 144, 234, 249
Jeffersonian Land Ordinance of 1785, 148
John Frederick Kensett: An American Master (Driscoll and Howat), 246n.5
Johnson, David, 260n.61, 272n.76, 276–77
Johnson, Eastman, 184, 224

Johnston, John R., 144–45
Journal of Henry Thoreau, The (Torrey and Allen), 180n.29
Juste milieu, 65, 72
"Justice and Expediency" (Whittier), 186n.47

Kaaterskill Clove (Durand), 279n.96
Kaaterskill Clove (Smillie), 279n.96
Kaaterskill Falls (Cole), 244
Kansas-Nebraska Act, 183
Kauterskill Clove (Gifford), pl. 8, 266, 279–84, 285, 286
"Kauterskill Clove, in the Catskills" (Sketch) (Gifford), 280n.97
Kavanagh (Longfellow), 157n.50
Kelly, Franklin, 1n.2, 68, 102
Kensett, John Frederick, 89, 96n.84, 141, 190, 192n.65, 243; *Lake George,* 246–47; *Mount Chocorua,* 248; *Rocky Landscape,* 158; stylistic choices of, 247–48; *View from Cozzens' Hotel near West Point,* 245; *View on the Hudson,* 244–45; vision of, 265, 287, 288; *The White Mountains—Mount Washington,* pl. 7, 229–30, 246–47, 272–74
Keyes, Donald, 274
Kindred Spirits (Durand), 93, 279
King, Thomas Starr, 89, 91–92, 150n.38, 154n.44, 266n.60; on divine intervention, 147; on mountains and atmosphere, 284; on names of White Mountains, 270; on public taste in scenery, 259
Kinmont, Alexander, 142n.17
Knapp, Samuel Lorenzo, 181
Knickerbocker, The, 225

Lake George (Kensett), 246–47
"Lake of the Dismal Swamp, The" (Currier and Ives), 231
Landscape art: alimentary metaphors for viewing of, 150; as art of the particular, 194–95; and borders, 279; documentation regarding, 18–19; and entrepreneurship, 69–72; expansion in subjects of, 234–36; without human actors, 109–10; importance of, in America, 1–2; and integration of parts into whole, 72, 74–75, 98; miniaturization of, 275–78; and national print culture, 8, 213; "national school" of, 3–4, 76–79, 90, 105; and national unity, 15–16, 216; northeastern dominance in, 77–79, 216–17, 225–28, 230–31, 233–34; pa-

trons of, 141, 157–59, 248; picturesque, 10–11, 147n.31, 158, 273; and point of view, 91–92, 148–49, 164–65; and property, 147–50, 152–54, 245; public taste in, 69–70, 82, 88–89, 90–91, 156–57, 259, 275–76; Revolutionary War themes in, 229–30, 234, 268, 270; scholarship on, 2–4; as school for citizenship, 13–14, 171; sexual metaphors for enjoyment of, 150–52; socializing role of, 11–13, 62–64; on southern themes, 231, 234, 236–41; as symbolic action, 12–13, 14; truth in, 87–88; on western themes, 231–33. *See also* Allegory; Atmospheric luminism; Pastoral landscape; Sequential landscape; *and specific artists*
Lane, Fitz Hugh, 14n.30, 244n.4
Lang, Louis, 78
Lanman, Charles, 67, 240n.84
Larcom, Lucy, 182n.37
Lawson-Peebles, Robert, 218
Lessing, G. E., 93
Letters from the Allegheny Mountains (Lanman), 240n.84
"Letters on Landscape Painting" (Durand), 74, 87, 95, 195n.70
Leutze, Emanuel, 229n.55
Life in the Open Air (Winthrop), 96n.84
Lifting of a Storm-Cloud (Church). *See New England Landscape*
Light Triumphant, The (Inness), 114
Lincoln, Abraham, 229
Literary publishing, 226
Literary World, 196n.75
Localism, 20, 162, 167, 168–71, 211–15; and associationism, 101; and national market, 14
Locke, John, 9
London Art Union, 226
Longfellow, Henry Wadsworth, 156n.50, 185
Lorrain, Claude, 82. *See also* Claudean composition
Lowell, James Russell, 178, 183–84n.45, 185, 187n.51
Ludlow, Fitz Hugh, 267–68
Lukács, Georg, 16n.33
Luminism, 134, 244n.4. *See also* Atmospheric luminism
Lyell, Charles, 154n.44, 255

McConkey, Benjamin, 140n.11
McEntee, Jervis, 108n.2, 175